D0026495

Modern
Sounds

Second Edition

The Artistry of Contemporary
JAZZ

THOMAS E. **LARSON**

Kendall Hunt
publishing company

Book Team

Chairman and Chief Executive Officer *Mark C. Falb*
President and Chief Operating Officer *Chad M. Chandlee*
Vice President, Higher Education *David L. Tart*
Director of Publishing Partnerships *Paul B. Carty*
Editorial Manager *Georgia Botsford*
Senior Editor *Lynnette Rogers*
Vice President, Operations *Timothy J. Beitzel*
Assistant Vice President, Production Services *Christine E. O'Brien*
Senior Production Editor *Mary Melloy*
Senior Permissions Coordinator *Renae Horstman*
Cover Designer *Marilyn Kupferschmidt*

Cover image © Shutterstock, Inc.

Kendall Hunt
publishing company

www.kendallhunt.com
Send all inquiries to:
4050 Westmark Drive
Dubuque, IA 52004-1840

Copyright © 2008, 2011 by Kendall Hunt Publishing Company

ISBN 978-0-7575-8973-7

All rights reserved. No part of this publication may be reproduced,
stored in a retrieval system, or transmitted, in any form or by any means,
electronic, mechanical, photocopying, recording, or otherwise,
without the prior written permission of the copyright owner.

Printed in the United States of America
10 9 8 7 6 5 4 3 2 1

Brief Contents

Contents

Preface

Nearly 70 years ago, a disparate group of revolutionaries began gathering to play music at impromptu jam sessions in little, out of the way clubs and cribs in Harlem with names like the Rhythm Club and the Nest. These sessions soon developed into an alternative music scene, where musicians were free to try out new musical ideas and experiments without worrying about whether they passed muster with the audience, booking agents or record executives. The music that developed over the next four to five years was fast, quirky and unpredictable, but it also had an unmistakable joyfulness about it that was borne out of the freedom to play music that was stimulating and risk-taking, and unfettered by commercial restraints. The emergence of this new music, which eventually became known as bebop, marked a critical moment in the history of jazz. From this moment on, jazz musicians would increasingly think of themselves as *artists* rather than entertainers. This dramatic change in philosophy would have tremendous consequences: jazz musicians in the future would now think of their music as a way to express themselves creatively, to explore the new and different, to challenge the norms and conventions of what had been done before. The musicians of the bebop generation not only created a new style of jazz, they set the tone and principles for the music's foreseeable future. And in doing so, they did nothing less than create the foundation for modern jazz.

Modern Sounds: The Artistry of Contemporary Jazz is about the journey, the musicians, and the music that has been created in the pursuit of artistic achievement over the last 60+ years. It is the story of Charlie Parker, Ornette Coleman, John Zorn and many others, the sacrifices they made, the risks they took, and the principles they stuck to. It is also the story of Stan Getz, Jimmy Smith, Dave Brubeck and more, who often had to make career choices based on balancing the need to be creative with the need to survive. Of course, many hundreds of musicians were involved in the story of modern jazz, and this text by necessity leaves out many of the foot soldiers that contributed ideas, techniques, or just their presence in a particular scene. The musicians that are included here were chosen for a specific contribution, their sense of timing within a particular movement, an event they were involved with, or as someone whose work is an exemplar of a style, scene or technique. Most often their complete oeuvre is not presented; to describe everything that each particular artist accomplished would detract from the larger narrative and make the text too tedious. For instance, Keith Jarrett has recorded more than 100 albums under his byline that encompass everything from spontaneous solo piano recitals to experimental world music and original orchestral works; although he is unusually prolific, he is not unlike many post 1970s jazz musicians who have felt increasingly free to become musical chameleons in their artistic pursuits. There are also non-musicians presented who played an important role, such as recording engineer Rudy Van Gelder and producer Creed Taylor.

The *Modern Sounds* text is organized in a way that is suitable for a semester course at the college level, either for music majors or non-majors. For those students who are new to jazz, a primer on how to define jazz and what to look for in a typical jazz performance has been added (Appendix A) at the back of the book. There is also a timeline of important events from each chapter in Appendix B. There are lists of key terms, names, places and music at the beginning of each chapter, as well as a timeline of significant events that are mentioned in the chapter. There are also 10 study questions at each chapter's end. And, there are performance review sheets included that can be filled out and handed in as assignments for students who attend local jazz performances.

This, the second edition of *Modern Sounds* comes bundled with a 4-month subscription to *Rhapsody*, the online music service, which allows students unlimited 24/7 access to the music referenced in the book and listened to in class. In addition, 54 recordings from *Rhapsody* have been featured in the text with synopses that provide interesting insights and information that can assist the student in further understanding the music and the recording artists. These recordings - six per chapter - were chosen as representative of the music styles and musicians covered in the text. In some cases these recordings may be challenging to common notions of what jazz is or isn't. But, as you weigh the merits of Kenny Werner's "west_coast_variant" or John Zorn's "Snagglepuss" and try to decide whether or not they are really jazz recordings, keep in mind that reviewers and critics were

doing the same thing with the recordings of Charlie Parker's 60 years ago and with Miles Davis 30 years ago. The author and publishers feel that a Rhapsody subscription is a much better tool to make music available in understanding the music than including CDs, which due to licensing issues would provide a more limited number of musical examples.

Another new feature to this edition is Appendix C, which includes links to Rhapsody playlists for each chapter. The recordings on the playlists consist of the six featured tracks as well as additional recordings that are referenced in the text and are relevant to the chapter.

It should be noted that this text is a little different than the standard jazz history text. Although chapter 1 contains a "Quick Look Back on the Early Years of Jazz," the real story of *Modern Sounds* begins at that moment when jazz became an art form. A third of the book is focused on the evolution of jazz since 1980, a period of time that is either ignored by most jazz history texts or is glossed over in a few pages. For example, one recent highly acclaimed jazz history book is nearly 900 pages long; the last 20 years are covered in less than 20 pages. Ken Burns, in his highly anticipated 2001 documentary *Jazz: a Film by Ken Burns* covered the years from 1961 to 2001 in their entirety into the 10th and final episode, and completely ignored everything after the early 1970s. This sort of lumping everything past 1980 or so into the summary is typical of current jazz texts. Clearly there is a need for a more complete documentation of contemporary jazz; this is exactly why *Modern Sounds* was written.

As previously mentioned, *Modern Sounds* may challenge and expand on what might be called a rather narrow definition of what jazz is to many people. This is one of the reoccurring issues throughout jazz history (and consequently this book), and has been summarized by the oft-asked question, "Is jazz dead?" If we continue to believe that the most contemporary examples of jazz are defined by what Miles Davis did in the 1960s, or Weather Report did in the 1970s, or Wynton Marsalis in the 1980s, then, yes, an argument could be made that jazz is dead. However, these examples are nothing more than significant signposts along a long and evolutionary road. During the last 20 years, a tremendous amount of incredibly creative and artistic music has been added to the jazz canon that is taking the art form into new and uncharted waters. A better question than "Is jazz dead?" might be "What exactly IS jazz?" Just as the moldy figs reacted negatively to bebop, and traditionalists reacted negatively to jazz/rock fusion, today many will probably react negatively to the use of a DJ in a band, or the use of music software being used to slice, dice and edit a performance after it was recorded, or the notion that Europeans can not only play jazz, they now may actually be taking the lead role in its evolution. To some, these developments may in fact signal the demise of a great musical tradition; however, they are in fact signs that it is very much alive and is embracing the culture, style, politics and events of the world that surrounds it.

It is my sincere hope that you enjoy *Modern Sounds: The Artistry of Contemporary Jazz*.

Tom Larson
January 2011

Acknowledgments

I would like to extend my grateful thanks to the following:

Kendall/Hunt Publishing and Development Editor Lynne Rogers.

Tad Hershorn at the Institute of Jazz Studies at Rutgers University for assistance with photo clearances; and the many photographers I have contacted whose beautiful work graces the pages of this text: Tad Hershorn, Peter Gannushkin, Dani Gurgel, Andrea Canter, Duncan Schiedt, Hans Arne Nakrem, Dragon Tasic and Dr. Steven Sussman.

The students in the honors program at the University of Nebraska-Lincoln who have assisted with research: Jennifer Anglin, Rishi Batra, Robyn Christenson, Emily Dwornicki, Meghen Friesen, Stephanie Krob, Katie Madsen, Amanda Nelson, Matthew Ray and Sarah Scofield.

Five musicians who provided their insights and opinions on the current jazz scene and what lies ahead: Wayne Horvitz, Dave Stryker, Michael Blanco, Chris Varga and Steve Doyle.

Finally, those closest to me: my wife, Kim Collier, my children Kalie, Will and Carolyn, and my parents. Roger and Shirley Larson, who fostered in me a love of music and gave me the support I needed to pursue that love.

Tom Larson

About the Author

Tom Larson teaches History of American Jazz, History of Rock Music, Digital Audio Production, and Jazz Piano at the University of Nebraska–Lincoln School of Music. In addition to authoring *Modern Sounds: The Artistry of Contemporary Jazz,* he is also the author of two other textbooks: *The History and Tradition of Jazz*, and *The History of Rock and Roll*, both published by Kendall/Hunt Publishing. His first CD of original jazz compositions, *Flashback*, was released in 2003. He has studied jazz piano with Dean Earle, Fred Hersch, Bruce Barth, and Kenny Werner, jazz arranging with Herb Pomeroy, and music composition with Robert Beadell and Randall Snyder. In addition to performing with jazz ensembles throughout the Midwest and East Coast, he has performed with Paul Shaffer, Victor Lewis, Dave Stryker, Bobby Shew, Claude Williams, Bo Diddley, the Omaha Symphony, the Nebraska Chamber Orchestra, the Nebraska Jazz Orchestra, and the University of Nebraska Jazz Quintet.

Tom also writes and produces music for documentary films; among his credits are the scores for three documentaries for the PBS *American Experience* series (a production of WGBH-TV, Boston): *In the White Man's Image*, *Around the World in 72 Days*, and *Monkey Trial*. He also scored the documentaries *Willa Cather: The Road is All* for WNET-TV (New York), *Ashes from the Dust* for the PBS series *NOVA*, and the PBS specials *Most Honorable Son*, *In Search of the Oregon Trail,* and *In Standing Bear's Footsteps*. Tom has written extensively for the University of Nebraska television network, South Dakota Public Broadcasting, and the University of Illinois Asian Studies Department. His music has also been used on the CBS-TV series *The District*. His commercial credits include music written for Phoenix-based Music Oasis, LA-based Music Animals, Chicago-based Pfeifer Music Partners and General Learning Communications, and advertising agencies in Nebraska.

A Lincoln native, Tom received a Bachelor of Music in Composition from Berklee College of Music in Boston, Massachusetts in 1977 and a Master of Music in Composition from the University of Nebraska-Lincoln in 1985. He is also an avid runner, and completed the Boston Marathon in 2005, 2006, and 2007.

You Say You Want a Revolution…

© 2011, francesco riccardo iacomini, Shutterstock, Inc.

Chapter 1

Key Terms, Music, Places, and Figures

Terms

New Orleans style
Collective improvisation
Creoles of Color
Legislative Code No. 111
Chicago style
Tin Pan Alley
Swing era
Head arrangements
Bebop
Vertical style
Recording ban
Afro-Cuban jazz
Down Beat magazine
Cabaret card
"Moldy Figs vs. Moderns"

Music (albums, works, etc.)

"Cherokee"

"Koko"
"Cubana Be Cubana Bop"

Places

Storyville
Savoy Ballroom
Cotton Club
Clark Monroe's Uptown House
Minton's Playhouse
52nd Street
Birdland
Five Spot Café

Figures

Buddy Bolden
Joe "King" Oliver
Jelly Roll Morton
Louis Armstrong
The Hot Five

Austin High Gang
Bix Beiderbecke
Red Hot Peppers
Duke Ellington
Benny Goodman
Count Basie
Art Tatum
Coleman Hawkins
Lester Young
Charlie Parker
John Birks "Dizzy" Gillespie
Chano Pozo
Thelonious Monk
Kenny Clarke
Max Roach
Charlie Christian
Bud Powell
Oscar Pettiford
Dexter Gordon

In its earliest years, **jazz** was the rock and roll of its time. 𝄢

From Dancehall to Concert Hall

It is often said that jazz is America's art form. Although this may be an apt description of jazz today, it certainly wasn't always the case. In its earliest years, jazz was the rock and roll of its time: rebellious, sexual, and lowbrow. It was music that many in polite society associated with prostitution, booze, drugs, and shady underworld characters. In other words, jazz suffered from an image problem. However, it struck a chord with many, especially young people, for whom jazz perfectly expressed their independent spirit and sense of identity. By the 1930s, jazz had cleaned up its reputation—thanks in part to a new name that had been attached to it: *swing*—to the point that it became the centerpiece of America's pop culture. The ecosystem of the swing era had many components—clothes, radio shows, dance fads, slang, and celebrities—but at its heart was the jumping, irresistible music. Jazz during the late 1930s and early 1940s had become urbane, disciplined, and the team orientation of the big band was a perfect reflection of the new mood and spirit of its birth country. But it was all downhill from there: the swing era was destined to be the apotheosis of jazz as popular music.

Although jazz had a ubiquitous presence in the dancehall during the swing era, it was mainly a no-show in the concert hall—pop and high culture were mutually exclusive, at least for the time being. But even as swing set in high gear, a new breed of musician was already laying the groundwork for the transformation of jazz into an intellectual artistic expression. By the late 1930s, jazz musicians were beginning to reshape the music in ways that would ultimately result in a fundamental shift in the way it was played, conceived, accepted, and perceived by audiences. By refusing to back down to commercial

pressures, by thinking of themselves as artists rather than entertainers, and by turning their back on the musical conventions of the music industry, these young, talented, and creative revolutionaries set the course for the future of jazz. From this critical moment on, jazz would increasingly be thought of as an art form rather than a retail product. From this point on, jazz musicians would strive to push the envelope to evolve their music in new and creative ways, and innovation and originality would become paramount to the development of their music.

This book studies the history, culture, personalities, and artistry of contemporary jazz from its beginnings up to the current scene. But before we investigate the who, what, where, and why of modern jazz, we will take a quick look back at the music's early years.

A Quick Look Back at the Early Years of Jazz

New Orleans

Jazz was born in the cribs, dancehalls, and sporting houses of New Orleans in the early years of the twentieth century. In this earliest form of jazz, known as the **New Orleans style,** the standard ensemble consisted of a front line of one or two cornets, a trombone, and one or two clarinets, and a rhythm section of drums, bass, violin, and either a piano, guitar, or banjo. Typically, the cornet played the melody in its middle register, the clarinet improvised around that melody in the upper register, and the trombone grunted and barked along in the lower range. This system of improvising and embellishing the melody, the most distinctive feature of the New Orleans Style became known as **collective improvisation.** The first jazz musicians were already making at least part of their living playing music, and were adept at playing the blues, ragtime, spirituals, and some forms of European music, such as waltzes and mazurkas. Combining these resources with syncopated rhythms allowed the pioneers of jazz to create music that was dynamic, spirited, and exciting to the audiences of their day. In the beginning, no single musician took the spotlight; the emphasis of the music was on the constant interaction of the ensemble.

The first-generation jazz musicians in New Orleans came primarily from two ethnic groups: African-Americans and **Creoles of Color.** Creole musicians were of European (mainly French) and African descent, and had a strong background in European music tradition. This means they not only could read music, but were also familiar with the repertoire of European classical music. Black musicians were skilled improvisers who, although they generally didn't read music, were particularly fluent at improvising and creating music that was hot and exciting, in contrast to the genteel music that Creoles played. When black and Creole musicians began playing together and exchanging ideas after the passage of **Legislative Code No. 111,** it was not long before a new hybrid music emerged—jazz—that contained elements from both cultures. Legend has it that the first musician to successfully do this was cornetist **Buddy Bolden,** a barber by day who supposedly played so loud he could be heard 10 miles away. Bolden fell victim to "occupational hazards" (i.e., too much alcohol) and as a result was never recorded. He was institutionalized after a breakdown in 1907, where he remained until his death in 1931. Although no recordings and only one photograph of Bolden exist, today he is generally regarded as the first true jazz musician.

> ### *Characteristics of the New Orleans Style*
> - Front line of cornet, clarinet, and valve or slide trombone
> - Rhythm section of drums, string bass, guitar, and violin
> - Collective improvisation
> - Upbeat, march rhythm
> - Syncopation, ragging ⌁

The first-generation jazz musicians in New Orleans came primarily from two ethnic groups: African-Americans and **Creoles of Color.**

> ### *Legislative Code No. 111*
> Passed in 1894 by the state of Louisiana, Legislative Code No. 111 was one of a number of "Jim Crow" laws passed in many Southern states in the years following Reconstruction to discriminate against blacks. With the passage of this particular law, Creole musicians were not allowed to play at high-class events and were forced to compete and eventually play with black musicians. ⌁

Storyville

Established in 1897, Storyville was a 38-square block district where prostitution was legal and regulated by the city. It was a major tourist attraction, popular with sailors at the nearby U.S. naval base. Storyville was shut down in 1917, after the United States entered World War I. ⚬

Characteristics of the Chicago Style

■ New Orleans front line, with saxophone increasingly added
■ Simple ensemble passages; de-emphasized collective improvisation
■ More emphasis on improvised solos in one-solo-at-a-time format
■ More drive and energy in the rhythm section ⚬

The Cotton Club

Known as "The Aristocrat of Harlem," the Cotton Club was an expensive nightclub at 142nd and Lenox Avenue, owned by gangster Owney Madden. With its log cabin facade and plantation house stage backdrop, it was designed to offer a voyeuristic view of African-American music and dance to the "whites only" audiences that patronized it. ⚬

Chicago

The jazz scene in New Orleans was not to last, however. After **Storyville**, the city's red light district, closed in 1917, many of the first generation jazz musicians began to leave town. Many took the Illinois Central Railroad north to Chicago, which in the 1920s became the most important city in the music's development. The New Orleans musicians that made the move to the Windy City included cornetist/bandleader **Joe "King" Oliver**, pianist/composer **Jelly Roll Morton**, and cornetist **Louis Armstrong.** Oliver arrived to Chicago in 1922 and secured a gig at Lincoln Gardens, a huge dancehall on the south side, and soon sent for his young protégé Armstrong. After making the first important jazz recordings together in 1923, Armstrong left Oliver's band and recorded sixty-five sides as the leader of the **Hot Five** (and later the Hot Seven). These recordings revolutionized jazz performance. Armstrong's solos were so dramatic, powerful, and inventive that it became clear that jazz was destined to become a soloist's art form rather than an ensemble-based music. Armstrong also brought a new vocabulary of jazz licks and phrasing that became so widely copied that they soon replaced the old ones from New Orleans. And, in perhaps his greatest achievement, Armstrong loosened up the ragged syncopations of early jazz and, in the process, codified modern swing rhythm.

Chicago was also where the first white musicians began to jump on the jazz bandwagon. Led by a group of suburban teenagers known as the **Austin High Gang** who had studiously observed Oliver, Armstrong, and other New Orleans expatriates, white musicians developed their own **Chicago style** of playing that was more driving and urban-sounding than the New Orleans style. The spiritual leader of this emerging milieu was cornetist **Bix Beiderbecke,** whose lyrical, understated solos offered an attractive alternative to the hot style of Armstrong. Bix was the music's first bohemian; unfortunately, his penchant for alcohol led to an early death at age twenty-eight. Jelly Roll Morton, a Creole who left New Orleans around 1903 and landed in Chicago in 1922, began writing tight-knit arrangements for his recording-only group, the **Red Hot Peppers,** thereby paving the way for the heavily orchestrated big bands of the swing era. As the music's first composer and arranger, Morton showed that jazz could be written down and still sound fresh and spontaneous.

New York, Kansas City, and the Swing Era

By the early 1930s, the jazz world had moved to New York, home of hundreds of clubs and dancehalls, radio networks, the major record labels, and the music publishing industry, known as **Tin Pan Alley.** Throughout the late 1920s and early 1930s, jazz bands began adding more horns (trumpets, trombones, and saxophones) to create enough power and volume to fill the larger venues such as Harlem's **Savoy Ballroom** and **Cotton Club.** Jazz rhythm sections also underwent changes, most noticeably transitioning to a smoother 4/4 rhythm from the choppy two-beat rhythm of the 1920s. Larger bands led to the rise of prominent arrangers such as Don Redman, Fletcher Henderson, and **Duke Ellington,** who standardized the way that big band jazz would sound. Ellington, who rose to fame with a four-year stint at the Cotton Club (1927–1931), established himself as the music's greatest composer by writing in a variety of styles, with

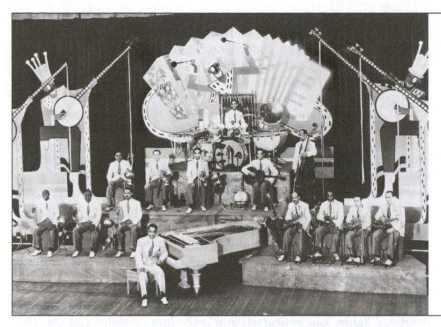

The Duke Ellington Orchestra (with Ellington at the piano) at the London Palladium in 1933.

pieces that ranged from popular dance tunes such as "In a Mellow Tone" to complex multi-movement suites like the 57-minute *Black, Brown and Beige.* He was also famous for showcasing the unique talents of his musicians, often wrapping them in impressionistic and dissonant harmonies that still sound fresh and contemporary today. Ellington also coined the name of the new emerging pop culture with his 1932 song "It Don't Mean a Thing If It Ain't Got That Swing."

The **swing era** began in 1935, the year that bandleader **Benny Goodman** began his dramatic rise to fame from his weekly appearances on the network radio show *Let's Dance.* Goodman was among the first to put together all the essential swing ingredients—a great band with hot arrangements, good soloists, and an attractive vocalist—but he was also blessed with being at the right place at the right time. In addition, Goodman benefited from being white; discrimination and segregation were common practices in the 1930s, and in fact, racial segregation was legal until the mid 1950s. The mechanisms of the music business of the time made it virtually impossible for a black band to achieve the kind of success that Goodman's did. Still, a number of black bands eventually did become extremely popular, including those led by Ellington, Cab Calloway, and **Count Basie.** Basie's Kansas City–based band introduced a simpler formula to swing: **head arrangements** with catchy riff melodies based on the 12-bar blues that out-swung everybody else. Kansas City jazz was the precursor to Rhythm and Blues, which was, in turn, a forerunner to rock and roll. Ironically, it was the increasing popularity of Rhythm and Blues (and Country Western) that helped bring an end to the swing era in the mid-1940s, when a new generation of young people came of age and began to search out their own musical identities.

The swing era was a time of musical consolidation, when the various ideas, innovations, and styles of the first thirty years of jazz melded into a unified sound. As author Alyn Shipton points out, swing music brought together "approaches to meter, chording, the voicing and arranging of melodies, and ways of building improvised solos."[1] Compared to pop music of other eras, much of swing music was surprisingly complex in its rhythms and harmonies. Although there were

Goodman was among the first to put together all the essential swing ingredients.

THE SWING ERA
The swing era is generally defined as the period from 1935–1946, when jazz (now known as *swing*) was the most popular music in America and at the center of a cultural zeitgeist, which included dance styles, clothing fashions, and slang language.

The increasing popularity of Rhythm and Blues (and Country Western) helped bring an end to the swing era.

The swing era was a time of musical consolidation. |₿

Head Arrangements
Arrangements that are created spontaneously in a jam session, often utilizing a 12-bar blues format with simple blues-based riff melodies that interact with each other in a call-and-response fashion. ∿

hundreds of bands that made their way playing banal stock arrangements, many of the arrangements of Ellington, Redman, and others were incredibly intricate and creative. Even so, swing was big business, and the realities of that meant that the music had to fit certain notions of commerciality. Just as soap makers need to make sure that their product meets the expectations of the consumer, swing bandleaders, musicians, and arrangers were held to similar standards. This was a time of musical standardization and homogenization, when music was a product that had to fit the economic strictures of the music business—when record companies, radio networks and their sponsors, dancehall owners, and jukebox operators all had their say in its manufacture, marketing, and distribution. Even the word *swing* was a nod to clever public relations; jazz was now able to escape its somewhat disreputable past simply by virtue of its new name.

In spite of its incredible popularity, swing soon became a drag to many musicians. Playing the same arrangements night after night—and often for several shows during the day—became boring and monotonous, the musical equivalent of working on an assembly line. Working conditions were less than ideal, with cramped stages, hot overhead lights, long rehearsals and recording sessions, and constant touring a fact of life. Many musicians found coping with all this difficult, and some turned to drugs and alcohol for comfort, while others simply quit the business. Certainly these difficulties were

Music Analysis

Track 1: "King Porter Stomp"

(Morton) Benny Goodman Orchestra recorded July 1, 1935 (3:07). Personnel: Goodman: clarinet; Bunny Berigan, Nate Kazebier, Ralph Muzzillo: trumpet; Red Ballard, Jack Lacey: trombone; Toots Mondello, Hymie Schertzer: alto sax; Dick Clark, Art Rollini: tenor sax; Frank Froeba: piano; George Van Eps: guitar; Harry Goodman: bass; Gene Krupa: drums; Fletcher Henderson: arranger

If there were ever a textbook big band arrangement that exemplifies the joyous dance music of the swing era, it would have to be Fletcher Henderson's "King Porter Stomp." This Jelly Roll Morton tune became the first hit of the swing era and employs all the arranging techniques that had been developed in the Henderson band by Don Redman, Benny Carter, and Fletcher and Horace Henderson. Recorded just a few weeks before Goodman's famous successful opening at the Palomar Ballroom, this superb recording gives the listener a glimpse what the Goodman Orchestra must have sounded like that night.

0:00	Introduction with muted trumpet solo by Bunny Berigan
0:11	Trumpet solo continues with soft backgrounds of sustained notes and short riffs in horns
0:32	Short interlude
0:37	Second theme is stated by the saxophones; rhythm section plays two-beat rhythm
0:58	Goodman takes clarinet solo, rhythm goes back to 4/4 rhythm
1:41	Trumpeter Bunny Berigan takes a dramatic solo with background sax riffs
2:02	Trombone solo (player unidentified), background riffs continue
2:22	Third theme is stated by the horn ensemble using block chord writing; rhythm section goes to two-beat rhythm while drummer Krupa accents horn lines
2:42	Call and response between brass and saxes leads to big ending

further compounded for black musicians, who were not afforded the same opportunities for making money or good working conditions as whites. For the most part, black bands had to travel farther for gigs, play for less money, had fewer possibilities to record, and had to generally deal with all sorts of inconveniences—restricted access to facilities, restaurants, and hotels, etc.—that resulted from the racial attitudes of the 1930s and 1940s. The mechanisms of the swing era were definitely more well-suited to white musicians, and led to frustration and alienation for black musicians, particularly the most creative ones.

The Emergence of Bebop

Minton's and the Harlem Jam Session Scene

It was the alienation and frustration ultimately led to the creation of bebop, the first modern jazz style. Unbeknownst to almost everyone, just as jazz was reaching the zenith of its popularity, a combination of factors was coming into play that would ultimately transform jazz. As Scott DeVeaux has summarized, three things occurred nearly simultaneously that facilitated the birth of bebop:

- The music industry lured young, highly skilled, predominantly black musicians to New York City from various locales around the country.
- The racial inequities of the music industry ensured that their talents would not be properly rewarded or recognized.
- The dynamics of the Harlem jam session scene allowed them an outlet and purpose to express themselves in an artistic fashion.

According to DeVeaux, "Without these circumstances, it is unlikely that there would have been a bebop movement."[2] Although these circumstances did indeed fall neatly into place, they did nothing more than give the young pioneers of bebop an opportunity. Without their restless energy and willingness to go against accepted musical convention, their moment might have been lost. Because swing died a quick death once the war was over, without the existence of the revolutionary music that these intrepid musicians created, jazz as a music form might have died as well.

The after-hours jam session was a welcome relief from the tedious drudgery of the swing band for many musicians in the late 1930s. Jam sessions, or "cutting contests" as they were sometimes called, usually featured a rhythm section that provided the foundation for the attending saxophonists, trumpeters, and trombonists to try to "cut" or outplay each other with the superior musicality and technique of their solo improvisations. In addition to establishing the pecking orders of the soloists, jam sessions also created an environment where new ideas and concepts could be worked out. They became an essential part of the working musicians continuing education, the "jazzman's true academy,"[3] as Ralph Ellison put it. Here, in the heat of competitive battle, musicians were tested on their skills at improvising, their grasp of harmony, their technical prowess, and their knowledge of the repertoire of standard tunes. No one could rest on his reputation, which was put on the line night after night. Jam sessions were also a place where social networking took place and where relatively unknown musicians could get noticed. In the confines of the world of swing, jam sessions took on added significance

Jam sessions were also a place where social networking took place and where relatively unknown musicians could get noticed.

MUSIC ANALYSIS

TRACK 2: "SWING TO BOP"

(D.R.) Charlie Christian recorded at Minton's Playhouse May 12, 1941 (8:53). Personnel: Charlie Christian: electric guitar; Joe Guy: trumpet; Nick Fenton: bass; Kenny Clarke: drums; unknown pianist

Among the regulars at the seminal Minton's Monday night jam sessions was guitarist Charlie Christian, who had come to New York from his native Oklahoma City after joining the Benny Goodman Orchestra in 1939. Because he died at age 25 from tuberculosis, few recordings of Christian exist other than the ones he made with Goodman's swing-oriented small groups. Fortunately for bebop historians, music engineer Jerry Newman took a wire recorder to Minton's in May 1941 and captured Christian and the Minton's house band at the very moment they were making the transition from swing to bebop. Newman turned on his recorder as Christian was completing the first of a six-chorus solo, after which trumpeter

Joe Guy and an unknown pianist also solo. (Thelonious Monk was the regular Minton's pianist, but he is clearly not the pianist on this recording.) Although Newman labeled the song "Swing to Bop" when he later released it commercially, the word bebop or bop had been coined in 1941. The tune is actually a hit from the swing era entitled "Topsy," although the musicians never actually play the melody. Charlie Christian redefined the role of the guitar from a strictly rhythm instrument to one that could also function as a solo instrument. His lines (melodic riffs) also incorporated the extended chord intervals that were rapidly becoming a part of the bebop vocabulary. He died less than a year after this seminal recording was made. (ref: *The Great American Songbook: The Stories Behind the Standards* by Chuck Denison; liner notes to *Charlie Christian: Genius of the Electric Guitar* by Chris Albertson; *Jazz* by Gary Giddins and Scott DeVeaux)

Clubs that sponsored jam sessions: **Rhythm Club** on 132nd Street, the **Hoofers Club,** the **Heatwave,** and the **Nest.**

as a place where musicians could play whatever they wanted to play—*for themselves*—rather than what the audience demanded.

For the best and brightest young musicians in New York, the most dynamic jam session scene was in Harlem, the predominantly black neighborhood on the north side of Manhattan. Harlem was home to a number of small nightclubs that, through actively encouraging musicians to hold jam sessions, gave rise to an alternative music scene that began to flourish in the late 1930s. Among the many clubs that sponsored jam sessions were the Rhythm Club on 132nd Street, which held sessions as early as 1930,[4] the Hoofers Club, the Heatwave and the Nest. The most important and famous of the Harlem jam sessions were held at **Clark Monroe's Uptown House** and **Minton's Playhouse.** Minton's was opened in 1938 in the Cecil Hotel on West 118th Street by tenor saxophonist Henry Minton. To bolster the club's standing among musicians, Minton in 1940 hired ex-bandleader Teddy Hill to manage the club and foster a jam-friendly environment. Hill began offering free food to musicians on Monday "Celebrity Nights," and Minton's quickly became the place where New York's most-talented, young musicians came to flex their musical muscles and try out new experiments in rhythm, harmony, and melody. Minton's became so popular that eventually its sessions began to attract famous jazz musicians such as Benny Goodman, Roy Eldridge, and Coleman Hawkins, as well as talented out-of-towners like alto saxophonist Charlie Parker from Kansas City and guitarist Charlie Christian from Oklahoma City.

The Bebop Esprit de Corps

Key to the success of the Minton's sessions was the rhythm section hired by Hill, which included two major innovators: Thelonious Monk on piano and Kenny Clarke on drums. Although Monk was an unusually reticent man and had a style that most observers categorized as unorthodox, he was already exploring new dissonances and reharmonization techniques that in time became cornerstones of bebop. Clarke brought innovations to the drum set that became staples of modern jazz. He was the first drummer to begin using his left hand and both feet primarily to provide spontaneous accents to the music, while keeping time with his right hand on the ride cymbal. This concept, revolutionary at the time, essentially codified modern drumming. Clarke began testing this out while playing with Teddy Hill's big band in the late 1930s, and although Hill eventually warmed to the style (and hired him to play at Minton's), ironically at first he disliked it so much he fired Clarke for a few months.

Although the young participants of the Harlem scene were an idiosyncratic bunch from all over the county, they had much in common: They were young, black, and disenchanted with the mainstream music industry. The esprit de corps that developed soon fostered a counterculture mentality that rejected the conventions and norms of society and the music business, while simultaneously developing a new set of cultural values. Beboppers began to develop their own slang language (e.g., far-out, cat, man, dig) and their own style of dress. Although they dressed conservatively with coats, ties, and white shirts, they often added accessories that were subtle digs at society. According to Amiri Baraka, "The goatee, beret, and window-pane glasses [favored by Dizzy Gillespie and others] were no accident. They pointed toward a way of thinking, an emotional and psychological resolution of some not so obscure social need or attitude. It was the beginning of the Negro's fluency with . . . Western nonconformity."[5] The bebop counterculture, which some have called the first counterculture in American history, also spawned an insidious epidemic of narcotics addiction that would plague the jazz community for many years. "We were the first generation to rebel, playing bebop, trying to be different, going through a lot of changes and getting strung out in the process," wrote pianist Hampton Hawes.[6] While marijuana had been fashionable with earlier generations of jazz musicians, the new drug of choice was heroin.

Even although the alternative scene in Harlem is largely credited with much of the creation of bebop, it was soon eclipsed by another scene that emerged in midtown Manhattan along **52nd Street** between Fifth and Sixth Avenues. The clubs in this self-contained little jazz village, located in the basements of the brownstones that lined both sides of the street, were so numerous that the area became known as "Swing Street" and "The Street That Never Slept." Because of their small size, clubs along 52nd Street such as the Downbeat, the Three Deuces, and the Hickory House generally featured small groups, including those fronted by Coleman Hawkins and Billie Holiday, and solo artists, such as pianist Art Tatum. In 1943, Dizzy Gillespie fronted the first bebop group to perform outside Harlem at another 52nd Street club, the Onyx. The close proximity of these clubs to one another encouraged musicians to wander about during their breaks, check out what was happening next door, and often "sit in" with neighboring bands. It was here that many jazz musicians heard **bebop** for the first

Clubs on 52nd Street in the 1940s
- Downbeat
- Famous Door
- Flamingo Club
- Hickory House
- Jimmy Ryan's
- Kelly's Stables
- Onyx
- Spotlight
- Three Deuces
- Yacht Club ♫

time, including Chicago-era drummer Dave Tough, who described the experience this way:

> "As we walked in, see, these cats snatched up their horns and blew crazy stuff. One would stop all of a sudden and another would start for no reason at all. We could never tell when a solo was supposed to begin or end. Then they all quit at once and walked off the stand. It scared us."[7]

Defining Bebop

It's no wonder that Tough and other established musicians were disconcerted when confronted with bebop. It was a stark contrast from swing, and really any previous jazz style. Bebop was fast, furious, explosive, and technically demanding to play. Many musicians, although not at first fully comprehending the music, understood instinctively that suddenly the bar had not only been raised, but raised by several notches. It was "more intricate, more bluesy, more swinging, more everything,"[8] according to one. When put into the context of the non-demanding nature of making a living playing swing, it's easy to see how many veteran jazz musicians felt their careers and even their self-esteems threatened.

Bebop was in many ways a consolidation of the innovations of some of the more progressive musicians of the previous decade, including:

- Pianist **Art Tatum,** who not only played with breathtaking virtuosity, but also created extensive reharmonizations of existing chord structures.
- Tenor saxophonist **Coleman Hawkins,** whose **vertical style** of improvisation required a moment-by-moment analysis of the passing harmonies.
- Tenor saxophonist **Lester Young,** whose floating rhythmic approach and emphasis on melody gave his solos a singing, fluid quality.

Building upon these foundations, beboppers began to fundamentally restructure jazz. Bebop emphasizes the virtuosity of the soloist in a small group setting (usually trumpet, saxophone, piano, bass, and drums), stripping away the elaborate orchestration of the big band. The arrangements—if one could call them that—are simple, even nonexistent. The tune, or head, is typically stated once or twice in unison by the horns, followed by a succession of soloists, with a return to the head. Bebop is explosive and usually played fast (as if to emphasize that it was *not* dance music), and in spite of its frenetic quality has an uplifting exuberance: a "joy of creation and delight in newness."[9] It also added new layers of complexity to the melodic, harmonic, and rhythmic conventions of jazz, making it much more demanding to play and to listen to. In a nutshell, here are the ways that the three basic elements of music were changed in bebop.

- **Melody:** Unlike the predictable, repeating riffs of earlier jazz, bebop melodies are nearly unsingable, twisting and turning in unexpected ways, and with odd intervals and syncopations. Because the heads are so difficult, they are usually played in unison and without ornamentation, as opposed to the usual custom of embellishing or jazzing up a Tin Pan Alley tune.

Bebop was fast, furious, explosive, and technically demanding to play. It emphasizes the virtuosity of the soloist in a small group setting.

VERTICAL STYLE OF IMPROVISATION
A method of improvising based on using chord tones (which are stacked vertically in notated music) rather than pure melody (which is notated horizontally).

- **Harmony:** Although most of the bebop repertoire is based on 12-bar blues or pre-existing song forms, bebop musicians habitually reharmonize these songs by substituting new chords for the old ones and adding new passing chords. The result is music that is harmonically more complex and more demanding for the soloist to navigate through.
- **Rhythm:** Bebop is much more syncopated and rhythmically unpredictable than any jazz that preceded it. The source of much of this rhythmic variety came from drummers such as Kenny Clarke, who began abandoning the swing practice of hitting the bass drum on every beat, replacing it instead with spontaneous, syncopated accents that became known as dropping bombs. Bebop pianists began playing with a more percussive and syncopated way of feeding chords to the soloists, which is known as comping. Bebop melodies are likewise rhythmically more interesting and complex.

Bebop Repertoire

Beboppers also developed their own new repertoire of tunes, largely because of a two-year **recording ban** imposed by the American Federation of Musicians in 1942. The union went on strike to protest the increased use of recordings instead of live music on the radio, which, they argued, put musicians out of work. The dispute ended in 1944 only after the distributors of recorded music (including record labels, juke box operators, radio networks, etc.) agreed to pay a small royalty to the publishers and composers of the music. In the resulting shakeup of the radio, music licensing and recording industries, a number of small independent record labels began recording bebop and other non-mainstream music styles that the major labels—Decca, RCA Victor, and Columbia—wouldn't. With profit margins slim, the bebop indie labels, which included Commodore, Savoy and Blue Note, found that they could avoid paying the publishing royalty if the beboppers recorded their own compositions rather than already published music. Since most beboppers were used to improvising over the chords of existing Tin Pan Alley tunes, the most practical way to write new tunes was to replace those melodies with new, boppish heads (melodies can be copyrighted, chord progressions can't). As a result, "Anthropology" was written using the same chord progression as "I Got Rhythm," "Ornithology" came from "How High the Moon," and "Groovin' High" from "Whispering." It is a testament to the inventiveness of the bop composers that their new tunes are often played by jazz musicians today more frequently than the original songs on which they were based.

The bebop pioneers who converged in New York City came from all over the country. Kenny Clarke was from Pittsburgh; Thelonious Monk from North Carolina; Oscar Pettiford and Charlie Christian from Oklahoma; and Al Haig from New Jersey. They came not to shake up the jazz world, but simply to make a living playing in swing bands. When it became clear to them that the world of swing would not sufficiently reward or recognize their talents, they began to focus their energies elsewhere. The early careers of the two most important bebop pioneers—Charlie Parker and Dizzy Gillespie—are typical of this storyline. Born in South Carolina, Gillespie moved to New York in 1937 and worked his way up through a succession of swing bands, eventually

The Recording Ban of 1942

On August 1, 1942, the American Federation of Musicians went on strike in a bitter standoff with the recording industry. At issue was a demand for a small royalty to be paid by the radio and jukebox industry to composers and publishers for the use of recorded songs. The issue was settled in 1944 and the strike ended, but not before many music fans began to increasingly listen to Rhythm and Blues and Country Western, whose performers typically were not union members and kept recording new music during the strike. ⮜

joining the popular Cab Calloway Orchestra in 1939. Parker grew up in Kansas City and worked in several area blues-based swing bands, including the Jay McShann Orchestra, before moving to New York in 1942. Independently from one another, each musician began to attract attention with their solos on recordings made with these bands in the late 1930s and early 1940s, although Gillespie was also on the scene in New York at this time. They met, it is believed, on June 24, 1940, when the Calloway Orchestra was on tour in Kansas City.[10] According to legend, they jammed for several hours that night, becoming fast friends when realizing that they were both on the same musical path. Once both were in New York, Parker and Gillespie played together in the swing bands of Earl "Fatha" Hines and Billy Eckstine from 1943–1944, before fronting their own bebop quintet on 52nd Street in 1945. The recordings they made together in 1945 were the first glimpse of modern jazz to much of the world outside of Harlem.

The Architects

Charlie Parker: Tormented Genius

As much as Parker and Gillespie had in common, their differences were striking. **Charlie Parker** (August 29, 1920–March 12, 1955) was a mercurial and mysterious figure whose career was marked by moments of unbelievable musical genius and devastating embarrassments. One early low point came in early 1937, when as a 16-year-old, he decided to sit in at a jam session presided over by Basie drummer Jo Jones at Kansas City's Reno Club. The neophyte Parker, playing at his first big-time jam session, became so disoriented during his solo that Jones threw his crash cymbal on the floor, prompting laughter and cat-calls from the audience. Humiliated but undaunted, Parker spent the next several months "woodshedding" (i.e., practicing intensely) and learning the recorded solos of Lester Young while gigging in the Ozarks before returning to Kansas City, musically a new man. After a short stint with McShann (during which he earned the nickname "Yardbird" or simply "Bird"), in 1938, Parker moved to New York where

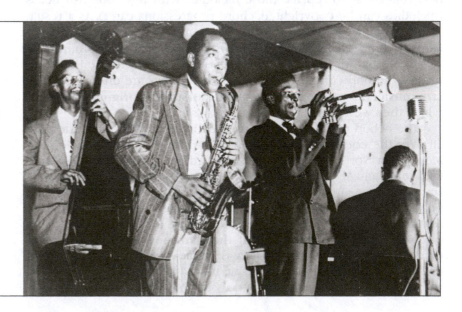

Charlie Parker. (Left to Right) Bassist Tommy Potter, Charlie Parker, Miles Davis and pianist Duke Jordan perform at the Three Deuces on 52nd Street in August 1947. Hidden in the background is drummer Max Roach.

he took part in jam sessions and washed dishes to make ends meet. During this time, he began to conceive of a new way of improvising, which ultimately came to fruition in December 1939 during an all-night jam session at Dan Wall's Chili House at 139th and Seventh Avenue. While playing the standard "**Cherokee,**" and building on the vertical concept of using chord structures to base his note selection, Parker began to use the extended intervals of each chord in his solo. It was a breakthrough. "By using the higher intervals in a chord as a melody line and backing them with appropriately related changes, I could play the thing I'd been hearing. I came alive."[11] Today this concept is imbedded in the genetic code of nearly all jazz improvisation. Combined with his use of blues tonalities from his Kansas City roots, Parker, like Armstrong before him, brought a new vocabulary to jazz.

Not long after this, Parker returned to Kansas City and the McShann Orchestra before moving permanently to New York in 1942. By this time, however, he was a committed heroin user, after being introduced to the drug at age fifteen while growing up unsupervised in the wide-open milieu of Kansas City's Pendergast era. Heroin's effects—(along with his massive intake of alcohol and Benzedrine)—would ultimately wreak havoc on Parker's life and career, causing him to live hand-to-mouth much of the time, and forcing him to put his horn in hoc on a regular basis. He became notorious for showing up late to gigs, and nodding off on stage, and would often miss them entirely. After a complete breakdown in 1946, he was able to put his life back together for a while. In 1955, at age thirty-four, he died after a long, slow decline in health. Heroin's most staggering effect was not on Parker, but the jazz community as a whole. Erroneously connecting Parker's genius with his drug use, many jazz musicians began using heroin in an attempt to achieve his mystique and cool outsider status, and as a shortcut to reaching musical greatness. By becoming such an integral part of the entire jazz counterculture mentality of the 1940s and 50s, narcotics use also became popular in the surrounding hip ecosystem of bohemians and beat writers. Although Charlie Parker was not solely responsible for the heroin epidemic, he was clearly a mythic hero and role model for many of the hipsters, outcasts, and artists of the era who also became addicts.

Parker's first recordings and gigs as a leader came in 1945. He co-led a quintet with Gillespie at the Three Deuces on 52nd Street from March to July, and also appeared at New York's Town Hall on June 22, making it one of the first bebop groups to emerge from the world of the after-hours jam sessions. Parker's recording debut as a leader came on November 26, when he cut several of his original compositions, including "**Koko,**" a stunning reworking of "Cherokee," the song with which he achieved his breakthrough in 1939. By this time Parker had replaced Gillespie in his regular working band with Miles Davis, who at nineteen years old was still a novice player. However, Gillespie was at the November 26, 1939, session, and ended up filling in on piano for the non-showing Bud Powell and on trumpet for Davis on "Koko," who was reportedly too nervous to play the demanding part. The "Koko" session is one of the most celebrated in jazz history, in part for its all-star cast of Parker, Gillespie, Davis, and drummer Max Roach, but also for capturing for the first time the explosive virtuosity that Charlie Parker was capable of when he was focused. "Koko" is documentation of a musical genius at work.

Soon after the November 26, 1939, session, Parker reunited with Gillespie and traveled with a new band to Los Angeles for an extended

"**Cherokee**"—a popular standard from the swing era; Charlie Parker achieved a musical epiphany while playing this song in 1939..

MUSIC ANALYSIS

TRACK 3: "KOKO"

(Parker) Charlie Parker and His Re-Boppers, recorded November 26, 1945 (2:53). Personnel: Charlie Parker, alto saxophone; Dizzy Gillespie, trumpet; Argonne Thornton (Sadik Hakim), piano; Curly Russell, bass; Max Roach, drums.

Charlie Parker's recording of "Koko" is one of the most remarkable and mysterious recordings in the history of jazz. A reworking of the swing era hit "Cherokee," the song displays Parker's astonishing technique in a solo that author Ted Gioia notes "few other saxophonists of the day could have *played,* let alone improvise." The session at which "Koko" was recorded was somewhat chaotic, and because of the confusion over the exact details of who played and who was there, it has achieved mythic status. Apparently, pianist Bud Powell was supposed to play but didn't show; the little known Argonne Thornton (who later became known as Sadik Hakim) was hastily recruited as a substitute. Although it is sometimes reported that Dizzy Gillespie played piano on "Koko," most scholars believe that Thornton

is in fact the pianist. Also present was nineteen-year-old trumpeter Miles Davis, who played on the other recordings made that day, but not on "Koko." "I didn't really think I was ready," he said later. "I wasn't going to get out there and embarrass myself." In the end, Dizzy Gillespie played both trumpet *and* piano on this legendary recording.

0:00	Introduction: pre-arranged melody is stated in unison by Charlie Parker and Dizzy Gillespie (with Harmon mute) and is intertwined with improvised solos from each; drummer Max Roach accompanies using brushes on the snare drum
0:25	First chorus: improvised head is stated by Parker on alto saxophone, while Gillespie switches to piano and Roach switches to sticks
1:16	Second chorus: Parker solos
2:07	Drummer Roach solos using primarily snare and bass drums
2:29	Head is restated

stay at Billy Berg's, a club in Hollywood. It was yet another dramatic debut for bebop, this time for a West Coast audience. However, after an enthusiastic and crowded opening night, attendance dropped off as patrons became unenthusiastic, if not outwardly hostile, to the new music. For Parker, difficulty in finding a reliable source of dope made the trip unbearable. By the time the Berg's engagement ended in early February 1946, Bird was so desperate for money to get a fix that he sold his airline ticket and missed the flight back to New York. Remaining in Los Angeles for the next several months, he signed a contract with the start-up label Dial, but turned right around and assigned half of his royalties to his drug dealer Emry Byrd, whom Parker would later immortalize with his composition "Moose the Mooche," the dealer's nickname. By mid-summer, Parker was in a depleted state and could hardly play his horn at an infamous July 29, 1946 recording session. Once the session was over, Parker returned to his hotel only to be arrested after setting his room on fire when dozing off into a stupor while smoking a cigarette. He spent the next six months recuperating and cleaning up in the Camarillo State Hospital.

When Parker finally returned to New York in March 1947, the musicians in the nascent bebop movement and the hipster community treated him as a conquering hero. For a few short years, he was at the top of his form and made some of the greatest recordings of his career; however, it wasn't long before he fell back into heavy drug

usage. Bird's last years were marked by erratic and sometimes pathetic behavior (although there were still moments of unparalleled musical greatness). Two events illustrate the ups and downs of Parker's later life. His performance at a September 29, 1947, concert at Carnegie Hall in which he was reunited with Gillespie was blistering, described by biographer Ross Russell as one of Parker's "fire eating nights," and "a display of astonishing musical powers."[12] On the other extreme, at his final gig on March 6, 1955, at **Birdland,** the New York club opened in 1949 and named in his honor, Parker got into a drunken shouting match with pianist Bud Powell that ended with a disgusted bassist Charles Mingus telling the audience, "Ladies and gentlemen, please don't associate me with any of this . . . These are sick people." Charlie Parker died in the apartment of jazz patron Baroness Pannonica de Koenigswarter six days later, lonely, depressed, sick, and exhausted.

Dizzy Gillespie: The Schoolmaster

Although **John Birks "Dizzy" Gillespie** (October 21, 1917–January 6, 1993) was one of the acknowledged leaders of the bebop revolution, he was hardly the prototypical bopper. Organized, levelheaded, a practical joker, natural teacher, and born entertainer, Gillespie was every bit the musical genius of Parker without the accompanying tragic personal drama. Gillespie played as a sideman in big bands from 1937 through 1944, and his love for the format led him to start his own in 1945. His improvisational experiments first began to surface while playing in the popular Cab Calloway Orchestra. Between sets while working with Calloway at the Cotton Club, Gillespie and bassist Milt Hinton would often go up to the rooftop and work out chord substitutions to use during Gillespie's solos. Although he initially featured Gillespie frequently during shows, Calloway eventually tired of the experimental solo ideas, calling them "Chinese music," and began to feature other players instead. Gillespie also antagonized Calloway with a relentless barrage of pranks and horseplay, and finally was fired after a heated argument with the bandleader in 1941 over a spitball thrown on stage.

Even though Dizzy was by this time making the Harlem jam session scene, he continued to stay close to the big band environment. He began writing arrangements while playing with Calloway, and became friends with Cuban arranger Mario Bauza, who ignited a life-long interest in Latin music. "I became enthralled with it when I met Bauza . . . I'm just freakish for Latin music, because it's multirhythmic."[13] Around this time Gillespie began writing original compositions like "Woody 'n' You," and "Salt Peanuts," and some, like "A Night in Tunisia," which combined Latin rhythmic elements with bebop melodies and harmonies. Gillespie co-led a small bebop group with

Birdland

Opened on December 15, 1949, near the corner of 52nd and Broadway in New York, Birdland immediately became the "Jazz Corner of the World," as it billed itself. Opening night included a live radio broadcast with performances by Lester Young, Stan Getz, Lennie Tristano, and its namesake, Charlie "Bird" Parker himself. During the 1950s and 1960s, countless live albums were recorded at the club. One of the club's more unusual features was its master of ceremonies, Pee Wee Marquette, who stood less than four feet tall. The original club closed in 1965, but today a new club named Birdland exists at 315 West 44th Street.

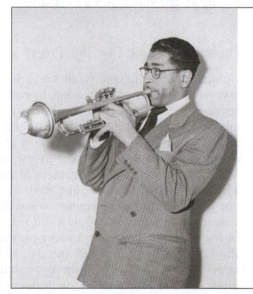

Trumpeter Dizzy Gillespie, wearing his usual natty attire and windowpane glasses.

Characteristics of Afro-Cuban Jazz

- Complex rhythms from Cuba, Latin America, and Africa intertwined with bebop melodies and improvisation
- Percussion instruments such as bongos, congas, and timbales frequently incorporated into the jazz rhythm section ~

"Cubana Be Cubana Bop," one of the first examples of modal harmony used in a jazz context. |B

Down Beat *magazine*

First published in 1935, *Down Beat* has become the most respected magazine in jazz journalism. In addition to printing stories about musicians and musical trends, record reviews, and annual polls by critics and readers, the magazine has also become famous for its "Blindfold Tests" in which musicians are asked to rate records and identify the artists without being told who they are. Occasionally, a very famous musician will be completely stumped. ~

bassist Oscar Pettiford in November 1943 at the Onyx, the first of its kind on 52nd Street. Because many of bebop's innovations were still new, Dizzy found himself teaching its harmonic underpinnings to group members, just as he had with Hinton on the roof of the Cotton Club. Gillespie's willingness to teach others the ins and outs of bebop harmony became legendary among musicians; he became known to many as "the schoolmaster." The Onyx band also formed the foundation for a recording session on February 16, 1944, which is often referred to as the first bebop recording. Ostensibly led by the venerable Coleman Hawkins, Gillespie is clearly the musical leader on the date: while Hawkins's solos are melodically and rhythmically tied to the swing tradition, Gillespie's solos display a fully developed modern bebop style.

After working with Parker in the Hines and Eckstine bands and at the Three Deuces in early 1945, Gillespie started his first big band, the Hep-sations of 1945, which toured from July through September. Featuring essentially big band bebop, the tour was unsuccessful. Gillepsie returned to leading his own big band in 1946, this time including singer Ella Fitzgerald, whose star status brought the band more popular success. But the most important member of this big band was Cuban percussionist **Chano Pozo,** whom Gillespie first introduced at a Carnegie Hall concert on September 29, 1947. Pozo (Luciano Pozo y Gonzales) brought powerful West African–influenced conga playing and primal chants to the band, and was featured that night on the premier of George Russell's **"Cubana Be Cubana Bop,"** one of the first examples of modal harmony used in a jazz context. This song, along with Gillespie compositions "A Night in Tunisia" and "Manteca" first introduced a new hybrid jazz style known as **Afro-Cuban jazz.** Although Pozo was a hit at Carnegie Hall, he was not universally accepted. A few nights later at Boston's Symphony Hall, many black audience members were embarrassed when confronted with his African costume and his exuberant playing and chanting. Russell, who himself is black and was at the concert, later wrote, "The cultural snow job had worked so ruthlessly that for the black race in America at the time its native culture was severed from it completely. They were taught to be ashamed of it."[14] Pozo's stay with the band was brief. He was murdered on December 2, 1948, at a bar in Harlem during an argument over a drug deal.

Thelonious Monk: The High Priest

Unlike Parker, Gillespie went on to lead a long and prosperous life, involving himself in educational projects and constant touring and recording. The two bebop masters did occasionally reunite, most famously at the previously mentioned 1947 Carnegie Hall concert and a May 15, 1953, All-Star concert at Massey Hall in Toronto, with drummer Max Roach, Bud Powell, and bassist Charles Mingus. Somewhat in between the careers of Parker and Gillespie was that of **Thelonious Monk,** who, like Bird, was a mysterious figure, but was not prone to Bird's destructive behavior, and, like Gillespie, achieved considerable fame, although it did not come until past the midpoint of his life and except for a short period in the 1960s was limited to the jazz world. Monk (October 10, 1917–February 17, 1982) was a large (six foot two, weighing more than 200 pounds) and unusually quiet man, and because of his reticent personality his history is not

MUSIC ANALYSIS

TRACK 4: "MANTECA"

(Gillespie/Pozo/Fuller) Dizzy Gillespie and His Orchestra recorded in New York on December 30, 1947 (3:06). Personnel: Gillespie, Dave Burns, Benny Bailey, Lamar Wright Jr, Elmon Wright: trumpet; Ted Kelly, Bill Shepherd: trombone; John Brown, Howard Johnson: alto sax; George 'Big Nick' Nicholas, Joe Gayles: tenor sax; Cecil Payne: baritone sax; John Lewis: piano; Al McKibbon: bass; Kenny Clark: drums; Chano Pozo: conga, vocals; Gil Fuller: arranger.

"Manteca" is an example of the Afro-Cuban style that Dizzy Gillespie and Cuban percussionist Chano Pozo created in 1946 with the innovative Dizzy Gillespie Orchestra. One of the central features of this arrangement is the layering of as many as four different elements on top of each other (as in the introduction), as well as retaining bebop characteristics (as in the improvised solos in the bridges to each chorus). Much of the credit for the structure of the song goes to Gil Fuller, who pieced together themes by Pozo and

Gillespie before writing the dramatic arrangement. One can also hear the exuberant Pozo shouting the song title—which means grease or lard in Spanish, but was also Cuban slang for marijuana—at various places within the piece.

0:00	Introduction: first entrance is by bass and bongos, then saxophones, brass, and finally Dizzy Gillespie's improvised trumpet solo
0:38	First chorus: head is stated by saxophones, answered by brass section
1:00	Bridge to first chorus with short solo by Gillespie
1:34	Short interlude based on introduction
1:48	Second chorus: tenor sax solo by George Nicholas
2:10	Bridge to second chorus, with another Gillespie solo
2:44	Fade out with bass and bongos before "boom-boom" ending

as well documented as that of Parker and Gillespie. His family moved to New York's San Juan Hill district in 1923 from North Carolina. Little is known of his early years, except that he was largely self-taught and did some traveling accompanying a singing evangelist. By the time he was hired to play in the Minton's house band in 1940, Monk was already experimenting with unorthodox harmonies and dissonances. He also played in an extremely aggressive manner, with great rhythmic feel and offbeat, percussive accents. For Monk, his contribution to the new music at the Minton's jams was just doing what came naturally. "Bebop wasn't developed in any deliberate way," he told **Down Beat** magazine in 1947. "For my part, I'll say it was just the style of music I happened to play."[15] Together with drummer Kenny Clarke, Monk helped revamp the jazz rhythm section. His harmonic innovations were also not lost on Gillespie, who learned many of his ideas from Monk during this time.

Although fame came fairly quickly to Parker and Gillespie, it eluded Monk, in part because of his retiring manner, but mostly because of his unusual style. Many outside the bebop inner circle considered Monk to be a hack, certainly not on the same level with his more famous counterparts. However, Coleman Hawkins recognized his genius early on and hired him in 1944 for an extended stay at Kelly's Stables on 52nd Street and for a recording session, Monk's

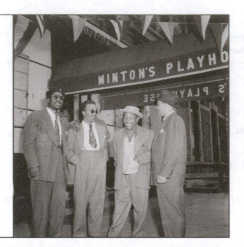

Minton's (left to right): Pianist Thelonious Monk, trumpeters Howard McGhee and Roy Eldridge and manager Teddy Hill stand in front of Minton's Playhouse in September 1947.

first. Another early convert was Miles Davis, who wrote in his autobiography, "If I hadn't met him in 1945 when I came to New York, I wouldn't have progressed too well." Around 1940, Monk also began writing tunes that were often perfect reflections of his playing style: percussive, harmonically adventurous, and extremely rhythmic. Among his early compositions were "Epistrophy," "Thelonious," and the darkly beautiful " 'Round Midnight," all of which are today jazz standards. Although other musicians soon began recording them, Monk himself did not record any of his tunes for years, simply because he did not have a recording contract. It wasn't until the tiny start-up label Blue Note signed him in 1947—when he was thirty years old—that Monk was able to record under his own name. In spite of being warmly received by musicians and a few critics, and the tireless efforts of Lorraine Lion (wife of Blue Note founder Alfred Lion, who came up with the idea of promoting Monk as the 'High Priest' of bebop) to promote them, Monk's first albums, *Thelonious Monk—Genius of Modern Music Vols. 1 and 2* did not catch on with the general public.

Nonetheless, Monk's Blue Note albums are among the most important of the bop era, if for no other reason than they contain his first recordings of many of his classic standards, including "Well, You Needn't," "Off Minor," "In Walked Bud," "Ruby, My Dear," and " 'Round Midnight." Monk's melodies are among the most distinctive in modern jazz, simple but unpredictable, familiar sounding yet idiosyncratic. His songs carry his "distinctive, trademark harmonies and quirky rhythms, his runs, his suspenseful hesitations that sounded like "think" time and that reflect the nervousness of the post-World War II era, and his transcendent gift for sculpting hypnotic musical interludes from abstractions, swinging all the time,"[16] according to his biographer Leslie Gourse. Monk is often regarded as second only to Ellington as a jazz composer, and his songs have endured just as well as the Duke's as jazz standards. (Monk's high regard as a composer stands in spite of limiting himself almost exclusively to 12-bar blues and standard song forms, while composers such as Ellington and Charles Mingus experimented with longer forms and multi-movement compositions.) Because Monk was able to permeate so much of his whimsical personality and his musical logic into his composing, jazz musicians often find themselves playing his songs differently than they play songs written by other composers. It is as if there is an unwritten rule that to play Monk effectively, a player must first get into a "Monkish" frame of mind.

The next ten years were trying for Monk. He was dropped by Blue Note in 1952, signed with Prestige for a few years, and then moved to Riverside, which bought out his contract for all of $108.27 in 1955. Most damaging however was his 1951 drug bust, stemming from an incident where narcotics officers found a bag of dope in the car in which Monk and pianist Bud Powell were sitting. Although the bag was Powell's, a gifted but emotionally unstable pianist with a drug habit, Monk took the rap for his friend. After his release from spending sixty

Monk's Classic Standards

- "Well, You Needn't"
- "Off Minor"
- "In Walked Bud"
- "Ruby, My Dear"
- " 'Round Midnight"

MUSIC ANALYSIS

TRACK 5: "THELONIOUS"

(Monk) Thelonious Monk from the album *Thelonious Monk—Genius of Modern Music Volume 1* recorded October 15, 1947 at WOR Studios, New York (3:01). Personnel: Thelonious Monk: piano; Idrees Sulieman: trumpet; Danny Quebec West: alto sax; Billy Smith: tenor sax; Gene Ramey: bass; Art Blakey: drums.

"Thelonious" was the last of four original compositions recorded at Thelonious Monk's first recording session as a leader, which was also his first for the fledgling Blue Note label, with whom he had signed earlier in the year. Little known and possessing an enigmatic playing style, Monk presented a marketing challenge to Blue Note, who decided to promote him as "the high priest of bebop, the mysterious and legendary figure who is responsible for the entire new trend in music; the genius behind the entire movement." Although sales of the album *Thelonious Monk— Genius of Modern Music Volume 1* were not impressive, Monk began receiving positive reviews from the jazz press, and his prospects for wider recognition seemed good. This particular recording reveals Monk's risk-taking nature to already be firmly in place. The melody to "Thelonious" is largely built on repeating a single note—B-flat—as chords

descend from it. Although there are three horns on the recording, they are used unconventionally only to voice chords (which the piano customarily does) while Monk himself plays the melody (which the horns typically do). Monk's solo—the only one on the record—is a delightful mix of bebop and the earlier jazz piano style known as stride. This recording is considered to be the first of Monk's many masterpieces. (ref: *Jazz: A Regional Exploration* by Scott Yanow; *Thelonious Monk: His Life and Music* by Thomas Fitterling; *Jazz* by Gary Giddins and Scott DeVeaux.)

0.00	Introduction, first by Thelonious Monk on piano followed by a quick fill by drummer Art Blakey
0.09	Monk states the melody on piano with horn players Idrees Sulieman, Danny Quebec West and Billy Smith playing background harmonies
0.49	1st chorus piano solo, horns lay out
1.31	2nd chorus piano solo starts with stride left hand
2.11	3rd chorus piano solo
2.41	Horns enter on last "A" section of 3rd chorus
2.53	Monk plays short cadenza as horns hold the last chord

days in jail, Monk lost his **cabaret card,** and with it his right to play in liquor establishments in New York. For the next six difficult years, supported in part by his wife Nellie, Monk stayed at home but continued to write and record. Finally, in June 1957, he made a triumphant return with a six-month engagement at the **Five Spot Café,** a Greenwich Village watering hole, with a new quartet that included the up-and-coming tenor player John Coltrane. This, along with the release of the critically acclaimed album *Brilliant Corners,* finally gave Thelonious Monk the due respect that had eluded him for so long. Monk stayed in the limelight throughout the late 1950s and 1960s, eventually signing with industry giant Columbia and getting a cover story in *Time* magazine in 1964. He continued to write new material, mostly for his working quartet, which included a long association with tenor player Charlie Rouse. However, as jazz trends changed in the late 1960s and 1970s, Monk continued to perform in the same style that he always had, leading to some criticism that he was merely repeating himself. After an appearance at Carnegie Hall in 1976, he stopped performing and spent his last years in and out of hospitals and out of public view.

Cabaret Card

A permit issued by the City of New York, which musicians were required to possess to work in liquor establishments in the city. Many jazz musicians, including Charlie Parker, Thelonious Monk, and Billie Holiday, lost their cards for drug-related offenses. Their use was discontinued in 1960.

Max Roach playing at Boston's Storyville Jazz Club in 1977.

Much has been written over the years about Monk's erratic behavior, which included a penchant for lapsing into periods of reclusiveness, a habit of occasionally getting up to dance during his performances, laconic speech and his taciturn manner. Monk has been described as eccentric, child-like, out of touch with the world around him, and even crazy. Attaching this narrative to his idiosyncratic playing style has created the myth of the "eccentric genius" as a way to summarize Monk in a concise, convenient way.

Of course the truth about Monk's ways is much more complicated than this. In his exhaustively researched 2009 book *Thelonious Monk: The Life and times of an American Original,* Robin D. G. Kelly discloses that in reality Monk suffered from bipolar disorder, a fact that was not discovered until late in his life due to the general state of psychiatry and lack of information about the condition. For much of his life, Monk's episodes were misdiagnosed, resulting in long hospitalizations and wrongly prescribed medication. It is only through Kelly's unprecedented access to private family records and conversations with immediate family members, including Monk's widow Nellie just before her own death, that the truth has finally emerged.

Other Bebop Pioneers

As mentioned earlier in this chapter, one of the most important architects of early bebop was **Kenny Clarke** (January 9, 1914–January 26, 1985), who modernized jazz drumming and by extension the jazz rhythm section. Clarke was not only the house drummer during the Minton's heydays, he was a constant presence in the New York scene throughout the 1940s. In 1952, he became a founding member of the innovative Modern Jazz Quartet (discussed in chapter 2), and eventually moved to Paris, where he lived until his death.

Drummer **Max Roach** (January 10, 1924–August 16, 2007) had an illustrious career that extended well beyond the bebop era, but in the beginning he was the drummer of choice in the bebop milieu. Building on the innovations of Kenny Clarke, Roach made the drum set a fully mutli-timbral and polyrhythmic instrument. Roach was a ubiquitous presence in the early years of bebop, working with the previously mentioned Gillespie/Pettiford quintet's Onyx Club gig and recording session, the first Parker/Gillespie Quintet at the Three Deuces, the Town Hall concert and the seminal "Koko" session, all from 1945, Bud Powell's and Miles Davis's first recordings as leaders in 1947, and the Massey Hall concert in 1953. Even after the heydays of bebop were over, Roach seemed to be involved in just about every important jazz event or recording in the 1950s and early 1960s. In his later years, he wrote music for plays by Sam Shepard and dance pieces by Alvin Ailey and collaborated with gospel choirs, video

Max Roach became the first jazz musician to win a MacArthur Fellowship "genius award" in 1988.

artists, and hip-hop artists. He became one of the first jazz musicians to teach at the college level when he became a professor at the University of Massachusetts in 1972, and became the first jazz musician to win a MacArthur Fellowship "genius award" in 1988. Roach's important milestones beyond bebop will be further examined throughout the next few chapters of this text.

Although electric guitarist **Charlie Christian** (1916–1942) died an early death from tuberculosis at age 25, he made an important contribution to the development of bebop. He was discovered by talent scout John Hammond, who flew him to Los Angeles in 1939 to audition with the Benny Goodman Orchestra. Goodman hired Christian on the spot after hearing him play an inventive solo on the obscure tune "Rose Room" that lasted some forty minutes. Because Goodman was headquartered in New York for much of 1940 and early 1941, Christian was able to regularly attend the after-hours jam sessions at Minton's and other Harlem clubs. At this time, the electric guitar was a novelty in jazz, and the conventional method was to play solos that were chordal in nature. Christian was a pioneer in both playing single-note runs (like a saxophonist or trumpeter) and using an amplifier to correctly balance his sound with the other instruments in the band. Although the Belgian guitarist Django Reinhardt was also moving in the same direction at roughly the same time, he was working in Paris and was therefore inconsequential to the incubation of bebop.

Fashioning a style that integrated the virtuosity of Art Tatum with the harmonic and melodic innovations of bebop, **Bud Powell** (1924–1966) became the prototype bebop pianist, and the most influential of his generation. Growing up in New York City, he studied classical music before turning his attention to jazz and ultimately became a protégé of Thelonious Monk, whose harmonic ideas he adopted. Although Powell occasionally played in an intricate two-handed style reminiscent of Tatum, it was his penchant for playing lightning-fast, single-note improvised runs in the right hand with minimal left-hand accompaniment that streamlined and modernized jazz piano. When playing in this manner, Powell's virtuosity was every bit on par with Parker and Gillespie. Powell's life was marred by alcohol and drug issues, and the emotional problems that began surfacing after a racially motivated savage head beating by police in Philadelphia in 1945. His mental condition worsened dramatically after being committed to a psychiatric hospital in 1947, where his treatment included electro-shock therapy and dousing in ammoniac water. He lived in Paris from 1959 to 1964, and his life there was portrayed in the 1986 film *'Round Midnight*.

One of the first bass players in jazz to become a competent soloist was **Oscar Pettiford** (1922–1960). His first important gig was with the swing band led by Charlie Barnet, which he joined in 1942. Showing remarkable progress, in May 1943, he moved to New York and soon after became the house bassist at Minton's. In November, he and Dizzy Gillespie fronted a quintet at the Onyx Club with drummer Max Roach, tenor saxophonist Budd Johnson, and pianist George Wallington. This group is often referred to as the first bebop combo to perform outside Harlem. It also established the bebop standard of having the trumpet and saxophone play the tune's head in unison. Pettiford also played on the February 16, 1944, recording session with Gillespie and Coleman Hawkins, which is regarded as the first bebop recording.

MUSIC ANALYSIS

TRACK 6: "LONG TALL DEXTER"

(Gordon) Dexter Gordon Quintet recorded January 29, 1946 in New York (3:01). Personnel: Dexter Gordon: tenor sax; Leonard Hawkins: trumpet; Bud Powell: piano; Curley Russell: bass; Max Roach: drums.

As a regular presence on 52nd Street in the mid-1940s, **Dexter Gordon** "perhaps more than any of the others transferred the characteristics of bop to the tenor," according to critic Leonard Feather. Although Gordon was originally from Los Angeles, when he moved to New York in 1945 he quickly became a fixture on the scene, casting a lasting impression for his broad-shouldered playing style and, standing six foot five inches tall, his imposing presence. Gordon's style was an amalgam of the huskily aggressive tone of Coleman Hawkins and the laid-back rhythmic looseness of Lest Young. Although he stayed in New York only until 1947 (his career will be further explored in Chapter 5) before returning to Los Angeles, Gordon took part in one of the important recording sessions in the early years of bebop. The session, put together for Savoy Records, features a group made up of many of the styles' important early contributors, including drummer Max Roach, pianist Bud Powell, and bassist Curley Russell. Trumpeter Leonard Hawkins was a high school friend of Roach's from Brooklyn who was making his recording debut. "Long Tall Dexter," a Gordon original, is based on the 12-bar blues, and is one of three from the session that reference his name in the title (the others being "Dexter Rides Again" and "Dexter Digs In"). (Reference: *Dexter Gordon: A Musical Biography* by Stan Britt; *The Book of Jazz* by Leonard Feather; *Jazz* by Gary Giddins and Scott DeVeaux.)

Time	
0.00	Drummer Max Roach plays short introduction
0.04	Tenor saxophonist Dexter Gordon and trumpeter Leonard Hawkins play head in unison
0.18	Head is repeated
0.32	Short interlude
0.37	Tenor sax solo by Gordon begins; five choruses total
1.43	Short interlude
1.49	Trumpet solo by Hawkins begins; two choruses
2.13	Piano solo by Bud Powell begins; two choruses
2.42	New head is played for one chorus, song ends

Bebop: Initial Reaction and Lasting Impact

Bebop dramatically tilted the playing field for jazz musicians in the 1940s, and the reaction to it was anything but nonchalant. Predictably, swing and older musicians were antagonized by the aloof manner of the beboppers and resented their role in messing up the good thing they had going. Swing bandleader Tommy Dorsey said, "Bebop has set music back twenty years." Charlie Barnet said, "The boppers were a bunch of fumblers who . . . effectively delivered the death blow to the big bands as we had known them." Even the normally effervescent Louis Armstrong called it a "modern malice" that is "really no good and you got no melody to remember and no beat to dance to."[17] Non-musicians were equally unimpressed. Impresario John Hammond stated, "To me, bebop is a collection of nauseating clichés, repeated ad infinitum." Columnist Jimmy Cannon quipped that "Bebop to me sounds like a hardware store in an earthquake."[18] Perhaps the most vitriolic war of words was carried on by jazz critics, for whom bebop rekindled an already existing old versus new debate. To some critics,

swing was already a bastardization of the "traditional" jazz from New Orleans; bebop was nothing but a further reach into noise and chaos. The two principal archrivals in the critic feud were bebop supporter Barry Ulanov and traditionalist Rudi Blesh, who aired out their differences in a series of "Bands for Bonds" radio programs. Ulanov threw gasoline on the fire with a November 1947 article in *Metronome* called "**Moldy Figs vs. Moderns**," coining the term that has been used every since to describe jazz musicians who were not keeping up with the current trends. For a while the moldy figs held their own, however, as a short-lived New Orleans renaissance rekindled the careers of many of the surviving stars of jazz's early years.

Bebop has had a dramatic and long-lasting impact on jazz. Its techniques, rhythms, harmonies, and melodies remain part of the jazz DNA to this day. As previously discussed at the beginning of this chapter, its emergence signaled the moment when jazz musicians began to redefine their relationship to their music. Although it can accurately be labeled a revolution, in the end it was also an important part of jazz evolution, and the foundation from which most modern jazz is built. Here are five reasons why the bebop movement was so profoundly influential:

> *Six Reasons Why the Bebop Movement was so Profoundly Influential*
> - Art Music
> - Innovation
> - Individualism
> - Vocabulary
> - Political Activism
> - Artistic Influence ⤳

- **Art Music:** Bebop signaled the moment when jazz was no longer thought of as entertainment or dance music. From this point on, jazz would be considered as a platform for creative expression—in essence, an art form. Although this brought new respectability to jazz and jazz musicians, it also ensured that jazz would eventually lose most of its popular appeal.
- **Innovation:** As art music, bebop brought a new zeitgeist to jazz, that musicians should now look to innovate not from within the existing norms and conventions, but from beyond them, a sensibility that would spawn a flowering of different stylistic approaches during the 1950s and inhabits the creative process in jazz to this day.
- **Individualism:** With bebop, the focus of jazz would now turn to the individual rather than the ensemble. Although it is true that Louis Armstrong first articulated the shift to the soloist in the 1920s, the jazz mainstream continued to move toward a team-oriented approach to performance, culminating in the swing era. Bebop brought Armstrong's innovation to full fruition.
- **Vocabulary:** Bebop brought a new vocabulary of melodic licks and phrases to jazz, making those from the swing era outdated. This vocabulary is still part of the genetic code of jazz.
- **Political Activism:** With its roots tied to the frustrations of black musicians and the institutional racism of the swing era, bebop laid the groundwork for future political activism by black jazz musicians throughout the 1950s and 1960s, particularly by those from the hard bop and free jazz movements.

Bebop's influence has extended past the jazz world. Its explosive, spontaneous and highly improvisational nature helped unleash a new artistic license in art and literature. Among those inspired by bebop musicians were abstract expressionist artists such as Jackson Pollock and beat writers like Jack Kerouac, both of whom began to work in the same speed and immediacy present in a bebop performance.

But most importantly, as the first style of modern jazz, bebop became the foundation for nearly every jazz style and practice that

has evolved since the 1940s. Its impact was felt almost immediately, as we shall see in the next chapter.

Notes

1. Shipton, Alyn: *A New History of Jazz,* pg 437
2. DeVeaux, Scott: *The Birth of Bebop,* pg 171
3. Ellison, Ralph: *Shadow and Act,* pg 208; and DeVeaux, pg 212
4. DeVeaux, pg 209
5. Baraka, Amiri: *Blues People,* pg 201; and Leland, John: *Hip: The History,* pg 111
6. Hawes, Hampton and Asher, Don: *Raise Up Off Me: A Portrait of Hampton Hawes,* pg 8
7. Stearns, Marshall: *The Story of Jazz,* pg 224
8. Pepper, Art and Laurie: *Straight Life,* pg 374
9. Rosenthal, David H., *Hard Bop: Jazz & Black Music 1955–1965,* pg 18
10. Shipton, Alyn: *Groovin' High,* pg 69
11. "No Bop Roots in Jazz: Parker," Levin and Wilson, *Down Beat,* Sept 9, 1949.
12. Russell, Ross: *Bird Lives!,* pg 248
13. Interview with Charles Fox, 8/31/76
14. Interview with the BBC, 6/29/92
15. Bill Gottlieb, *Down Beat,* 9/47, as quoted in *Straight No Chaser,* pg 24
16. Gourse, Leslie: *Straight, No Chaser,* pg 65
17. "'Bop Will Kill Business Unless It Kills Itself First'—Louis Armstrong," *Down Beat,* April 7, 1948
18. As quoted in *Bird Lives!,* pg 173

Study Questions for Chapter 1

1. Describe the sound of New Orleans jazz, how the music was organized and performed, and what instruments were used.

2. Describe why and when the jazz scenes developed in Chicago, Kansas City, and New York, and list the characteristics of the music from each city.

3. Generally describe the commercial realities of the swing era and some of the challenges that were presented to jazz musicians during that time.

4. Briefly explain why, when, and where bebop emerged. Make a general profile of the first generation of bebop musicians.

5. What was so attractive about the after-hours jam session scene to the nascent bebop musicians? Where did these jam sessions take place?

6. Describe the bebop "esprit de corps." What steps did bebop musicians take to foster a counter-culture mentality?

7. Describe why the song "Cherokee" and the subsequent recording of "Koko" are important.

8. What are some of the reasons that one might characterize Dizzy Gillespie as being an atypical bebop musician?

9. Describe why Thelonious Monk had such a hard time achieving recognition and how and why he ultimately did.

10. Why was bebop so profoundly influential to the history of jazz?

Let's Cool One

© 2011, Jason Keith Heydorn, Shutterstock, Inc.

Chapter **2**

Key Terms, Music, Places, Figures and Bands

Terms

Newport Jazz Festival
Jazz at the Philharmonic
Cool jazz
The Lydian Chromatic Concept of Tonal Organization
Third Stream
West Coast jazz
Straight Life
Overdub
Fugue

Music (albums, works, etc.)

Art Pepper Meets the Rhythm Section
Birth of the Cool
City of Glass
Modern Sounds
Time Out

Places

Lenox School of Jazz
Central Avenue
Lighthouse Café
The Haig
New School of Music

Figures and Bands

George Wein
Norman Granz
Miles Davis
Miles Davis Nonet
Gil Evans
Claude Thornhill Orchestra
Stan Kenton
George Russell
Gunther Schuller
Howard Rumsey's Lighthouse All-Stars
Shorty Rogers
Gerry Mulligan
Chet Baker
Gerry Mulligan Quartet
Dave Brubeck
Dave Brubeck Octet
Paul Desmond
Dave Brubeck Quartet
Art Pepper
Lennie Tristano
Modern Jazz Quartet
John Lewis
Milt Jackson

Beyond Bebop

Jazz Matures

As a new generation of music fans came of age, swing suddenly became out of fashion..

What happened after the dust settled from the bebop revolution? How profound would bebop's aftereffects be? When and where would the first signs of post-bop jazz begin to surface? And, as jazz moved into the future, which musicians would be at the vanguard? The answers to these questions began to become self-evident even as the bop revolution was still in progress. Jazz—and America for that matter—was in a transitional state in the mid to late 1940s. As World War II was coming to an end, the sense of teamwork borne out of the difficulties of the Depression and the war began to dissipate into a new sense of purpose as GIs came home, went back to school, got married, bought homes in the suburbs, and began to raise families. For many, it was the time to set out on their own paths to achieve the American Dream. Individuality replaced teamwork in the fabric of everyday life. As a new generation of music fans came of age, swing suddenly became out of fashion, and as big bands became the dinosaurs of a past musical age, few of them survived the decade. A brief but severe economic recession set in, which together with a newly imposed 30 percent amusement tax on dancehalls sounded the death knell of that other staple of the swing era: public dancing. Bebop, with its explosiveness and unsettling modernism, seemed to be a perfect complement to the new Atomic Age, but it was unlistenable to many music fans. Many began to vacate the jazz scene altogether and investigate other types of music. During the years leading

up to the birth of rock and roll, music fans tuned out jazz and tuned into pop singers and the increasingly popular styles of Country Western and Rhythm and Blues. In other words, goodbye Benny Goodman, Glenn Miller, and Duke Ellington; hello Frank Sinatra, Hank Williams, and Louis Jordan.

In spite of these developments, jazz not only endured, but thrived. As the newness of bebop wore off, jazz began to take on a new role in the consciousness of society. This was nothing new. Since its inception, jazz had undergone a number of personality changes. Starting out as the music of the whorehouse in the 1910s, it moved to the speakeasy in the 1920s, the dancehall and radio broadcast in the 1930s, and finally to the counterculture in the 1940s. Now, at the beginning of the 1950s, jazz was maturing and, for the first time, attaining a new status of social and artistic respectability. Critics and reviewers began referring to it as "America's art form," a designation that would have been laughable ten years earlier. Middle class readers of *Esquire, Harper's, The Saturday Review,* and *The New Yorker* could now find regular jazz columns in the pages of those popular magazines. The U.S. State Department began sending jazz musicians on European tours to promote jazz as a cultural symbol of American freedom as part of its efforts to win the Cold War. Willis Conover played jazz on his Voice of America radio programs broadcast into the Iron Curtain countries for the same reason. Conover often stated that jazz is "a democratic music. People in other countries, in other political situations, detect this element of freedom in jazz. There isn't any elaborate reasoning involved. They can feel it—emotionally. They love jazz because they love freedom."[1]

So, jazz was suddenly respectable and patriotic. Well, kind of. The average American was not quite ready for a jazz musician to move in next door—far from it. As bebop pushed them out of the center of pop culture, jazz musicians—along with beat writers, abstract expressionist painters, and method actors—began to take on the status of the freethinking maverick, the rebellious outsider who was in conflict with the straight-laced conservatism of the era. Jazz musicians in the 1950s became associated with an attitude of aloofness, of hip nonconformity, of *cool*. In a sense, they were the connecting link between the bebop counterculture and the coming rock and roll explosion. As author John Leland put it, "Against the chilly climate of the Eisenhower and McCarthy years, they created a model for the mass counterculture of the 1960s, in which rock and roll codified rebellion as personal style."[2] Jazz musicians such as Chet Baker, Gil Evans, and Miles Davis defined cool in the 1950s, and created a blueprint that was followed by other hipsters, including Jack Kerouac, Jackson Pollock, and Hollywood actors James Dean and Marlon Brando. This world of the heroic outsider fashioned after jazz musicians was celebrated in literary works such as David Riesman's *The Lonely Crowd* (1950), C. Wright Mills's *White Collar* (1951) and William Whyte's *The Organization Man* (1956). According to Scott Saul, 1950s hipsters and jazz musicians seemed to "have some crucial, if puzzling, answers for those seeking to understand the newest forms of political dissent," and "offered a model of tough urban manhood and gave a powerful counterimage to the suburban dad minding his barbeque and commuting dutifully to work."[3]

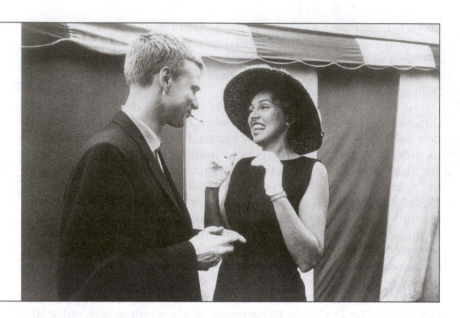

Baritone saxophonist Gerry Mulligan and vocalist Anita O'Day at the 1958 Newport Jazz Festival. (From the film *Jazz on a Summer's Day.*)

Jazz in Film and Festival

Another example of how jazz was becoming repositioned in the cultural context was the growing number of jazz-oriented soundtracks for Hollywood films. That is not to say that jazz in film was anything new. During the 1930s and 1940s, jazz was routinely used in light, upbeat, swing-themed films with flimsy feel good plots. But by the 1950s, it became *de rigueur* to use jazz soundtracks for dark, edgy urban film noir, stories where the main character was a loner, misfit, or in some way menacing. Some good examples were *A Streetcar Named Desire* (1951, music composed by Alex North and starring Marlon Brando), *The Man with the Golden Arm* (1955, music by Elmer Bernstein, starring Frank Sinatra), *Sweet Smell of Success* (1957, music by Bernstein, starring Tony Curtis), *Anatomy of a Murder* (1959, music by Duke Ellington, starring Ben Gazzara), and *Shadows* (1959, music by Charles Mingus, starring Ben Carruthers). Miles Davis recorded a largely improvised score for Louis Malle's 1957 film *Ascenseur pour l'Echafaud (Lift to the Scaffold)*. Films in the 1950s also began to feature jazz musicians as serious actors (*The Subterraneans,* based on Jack Kerouac's novel, has cameo appearances by saxophonists Gerry Mulligan and Art Pepper and vocalist Carmen MacRae) rather than as mugging minstrels, as had been the case with the many appearances by Louis Armstrong (such as his part in the 1947 film *New Orleans*).

The 1950s also saw the birth of the outdoor jazz festival. In 1954, Boston nightclub owner **George Wein** was invited by tobacco heir Louis Lorillard and his wife Elaine to produce an outdoor jazz concert in their hometown of Newport, Rhode Island. The jazz-loving Lorillards were interested in elevating the music to a higher cultural plateau, and figured that a concert in their exclusive resort town would be just the ticket. The first **Newport Jazz Festival** took place in July 1954, featuring Ella Fitzgerald, Dizzy Gillespie, the Modern Jazz Quartet, Gerry Mulligan, Lennie Tristano, and Billie Holiday, among others. Stan Kenton served as the master of ceremonies. In its first four years, Newport was the only jazz festival in the country, allowing it unprecedented coverage in the national media as a cultural event.

The 1950s saw the birth of the outdoor jazz festival. The first **Newport Jazz Festival** took place in July 1954, featuring Ella Fitzgerald, Dizzy Gillespie, the Modern Jazz Quartet, Gerry Mulligan, Lennie Tristano, and Billie Holiday. ♪♪

Among the memorable moments from those first years were Miles Davis's rendition of " 'Round Midnight" in 1955 that turned him into a star; Duke Ellington's 1956 performance of "Diminuendo and Crescendo in Blue," which reinvigorated his career; and the entire 1958 festival, which became the setting for the documentary film *Jazz on a Summer's Day,* featuring Thelonious Monk, singer Anita O'Day, Gerry Mulligan, and others. Newport also experienced controversy in 1960 and 1971, when riots broke out among disgruntled youth who were unable to gain entrance. Charles Mingus, Max Roach, and other musicians also staged an "anti-festival" in 1960 to protest the festival's hiring and racial policies (see Chapter 3). Eventually, festivals in Monterey, California, and other places were initiated, and by the end of the decade jazz festivals were drawing more than 300,000 fans annually. Wein went on to found the New Orleans Jazz and Heritage Festival and the Playboy Jazz Festival in Los Angeles, as well as the Newport Folk Festival. As the granddaddy of all jazz festivals, Newport, now sponsored by JVC, has continued to thrive, and continues to be staged annually.

Jazz was becoming more at home in the concert hall in the late 1940s and the 1950s as well. In 1944, Hollywood film editor **Norman Granz** decided to stage a concert version of a jam session at the Los Angeles Philharmonic Auditorium. The concert, which he called **Jazz at the Philharmonic,** featured honking tenor saxophonist Illinois Jacquet, guitarist Les Paul, and others. The concert was a sensational success. This was *not* a formal setting, á la a symphony orchestra concert, but it was nevertheless in the concert hall. (A good indication of the non-formality of the JATP concerts is found in the fact that Granz soon had to move out of Philharmonic Hall because audience members were getting too rowdy and dancing in the aisles.) Granz began booking other equally successful concerts at various venues around town, all under the original name (or the abbreviation JATP). Subsequent national and international concert tours were staged, featuring such prominent names as Charlie Parker, Dizzy Gillespie, Lester Young, Coleman Hawkins, Billie Holiday, and Ella Fitzgerald. Granz also recorded the concerts and sold the records on his Verve and Norgran labels, bringing the jam session ambience home to millions of fans.

Miles Davis and the Birth of the Cool

The Birth of the Cool

If jazz musicians in the 1950s were becoming associated with the ethos of cool, it was because the music itself was turning cool. Although there have long been cool-leaning jazz players (Chicagoans Bix Beiderbecke and Frank Trumbauer come to mind), the first modern cool stylist was arguably tenor saxophonist Lester Young. Young, who first gained attention in Kansas City with the Basie band, played with a rhythmic freedom that was highly influential to beboppers, and a light, airy tone and lyrical approach to soloing that became a staple of 1950s cool. Evidence that a new, post-bebop cooler approach was in the offing started appearing in the late 1940s work of pianist Lennie Tristano, arranger Tad Dameron, and **Miles Davis,** all of whom worked out of New York. Davis's nine-piece band, the **Miles Davis Nonet,** was not the only medium-sized post-bebop band that

Cool Jazz—a jazz style from the 1950s that is characterized by restraint and European influences. Sometimes known as West Coast Jazz.

The **Claude Thornhill Orchestra,** a big band noted for its occasional use of unusual instrumentation, including tuba and French horns.

was experimenting with a different approach (Dave Brubeck's Octet being a prime example), but by virtue of the important musicians involved and the quality of the groups music, it has become widely recognized as the band that first defined the sound of **cool jazz.** The recordings that the Nonet made in 1949 and 1950 are among the most important in the history of jazz. Davis, the group's putative leader, played trumpet; composed and arranged for the group; organized the rehearsals and recording sessions; and booked the few club gigs that came their way. Other members included pianist John Lewis, baritone saxophonist Gerry Mulligan, alto saxophonist Lee Konitz, and drummer Max Roach.

Although he did not actually play in the group, the Nonet's spiritual leader was Canadian composer/arranger **Gil Evans,** a tall, lanky bohemian whom Davis would later describe as "hipper than hip." Evans first achieved prominence in Hollywood arranging for Bob Hope's TV show and the Southern California–based **Claude Thornhill Orchestra,** a big band noted for its occasional use of unusual instrumentation, including tuba and French horns. In particular, his Thornhill arrangements of Charlie Parker's "Anthropology" and "Yardbird Suite" drew the attention of those in the New York scene. After a stint in the army, in the spring of 1946 Evans moved to New York, where his West 55th Street one-room basement apartment situated behind a Chinese laundry became a hangout spot for Davis and the rest of the aspiring young musicians who would form the nucleus of the Nonet. (Both Mulligan and Konitz had connections with the Thornhill group as players, and Mulligan also as an arranger.) Putting together an unusual instrumentation of trumpet, trombone, tuba, French horn, alto saxophone, baritone saxophone, piano, bass, and drums, Evans, Davis, Mulligan, and Lewis wrote compositions and arrangements inspired by the unusual sound of the Thornhill band. Although the group recorded twelve songs at three sessions between January 1949 and March 1950, and managed to book a couple of weeks at the Royal Roost and Clique Club in late 1948 opening for the Count Basie Orchestra, it soon became clear that financial success was not imminent. They quietly disbanded in 1950.

If the Miles Davis Nonet became important only in retrospect, it is only partly because several of the group's members—Davis, Evans, Mulligan, and Lewis in particular—would turn out to be some of the most important jazz figures of the 1950s and 1960s. More importantly, the relatively small output of music they created set the tone for the post-bebop expansion of jazz performance, composition, and arranging that would influence the entire jazz world in the 1950s. It was complex, lyrical, full of subtle shadings in tone color and dissonance, and inventive in the way it combines pre-arranged orchestration with improvised solos. It was graceful and orchestral, with neither the explosiveness of bebop or the trite clichés of swing. It represented a return to ensemble playing, so common during the swing era but nearly abandoned during the bebop revolution, but yet it was something entirely new and different. It was the very essence of the cool attitude of the 1950s. Even so, it was ahead of its time—it wasn't until 1954 that Capitol Records even bothered to release all twelve compositions on the appropriately named ***Birth of the Cool*** album. Capitol's timing was superb. By then, cool jazz had a burgeoning scene in Los Angeles and was garnering national attention. (In fact, an East Coast–West Coast rivalry was soon brewing in the press,

MUSIC ANALYSIS

TRACK 7: "VENUS DE MILO"

(Mulligan) Miles Davis Nonet recorded April 22, 1949 (3:10). Personnel: Miles Davis: trumpet; Gerry Mulligan: baritone sax; Lee Konitz: alto sax; J. J. Johnson: trombone; Sandy Siegelstein: French horn; John Barber: tuba; John Lewis: piano; Nelson Boyd: bass; Kenny Clarke: drums; Gerry Mulligan: arranger

Although Miles Davis and Gil Evans have received the bulk of the credit for the innovative and influential music of the *Birth of the Cool* band, the most important contributor as arranger and composer was Gerry Mulligan. Mulligan, who also played baritone sax with the group, arranged two pieces written by others ("Darn That Dream" and "Godchild") and wrote and arranged three more— "Jeru," "Rocker," and "Venus de Milo." On "Venus de Milo," Mulligan has perfectly captured the mood and spirit of the Davis group, with tight ensemble arranging, interesting counterpoint melodies and carefully integrating improvised solos into the fab-ric of the piece. "Venus de Milo" was recorded at the second of the three Davis Nonet sessions. Because the sessions were spread out over a 14-month period, the group experienced some shifts in personnel—the most notable on "Venus de Milo" being the replacement of regular drummer Max Roach by Minton's veteran Kenny Clarke. The final session did not take place until nearly one year later, shortly before the group disbanded due to lack interest by the public or the record industry. (ref: *The Blackwell Guide to Recorded Jazz* by Barry Dean Kernfield))

	
0:00	Song begins without introduction; melody is stated by all six horns at times, occasionally by Miles Davis on trumpet or Davis and alto saxophonist Lee Konitz in unison
1:06	Trumpet solo by Davis
1:54	Gerry Mulligan baritone sax solo
2:18	All six horns re-enter with head in harmony

predating a similar rivalry in rap music by some forty years.) Cool jazz is post-bebop in sound and ideology. It retains much of bop's melodic and harmonic ideas, but pares down the frenzied emotion and explosiveness. Although there were a number of differing stylistic nuances and shadings, cool jazz embodies a number of generalities that can be summarized here:

- **Light:** Cool jazz horn players tend to play with a light, airy tone. Rhythm section musicians, particularly drummers, also play with a lighter touch.
- **Laid Back:** Cool jazz generally has a relaxed, non-frantic quality that is present even at faster tempos. Rhythms and hard accents are smoothed out.
- **Lyrical:** Melodic content, whether written or improvised, retains a boppish quality, but tends to be lyrical (singing in nature) rather than "hot."
- **European:** Cool jazz emphasizes an intellectual and somewhat formal sound reminiscent of European classical music, rather than a more spontaneous and emotional approach.
- **Arranged:** Cool jazz puts emphasis on written arrangements over pure improvisation, generally finding a compromise in this regard somewhere between swing and bebop.

§ *Important Members of the Miles Davis Nonet*

- Miles Davis–trumpet
- Gerry Mulligan–baritone saxophone, composer, arranger
- Lee Konitz–alto saxophone
- John Lewis–piano, composer, arranger
- Max Roach–drums
- Gil Evans–composer, arranger ∿

Miles: The Early Years

The diaspora of talent from the Miles Davis Nonet (sometimes referred to as the Birth of the Cool band) would go on to make major contributions to jazz in the coming years—Mulligan as a respected composer, arranger, and baritone saxophonist; Lewis as the leader of the Modern Jazz Quartet; Roach as a bandleader, composer, and drummer; and French horn player Gunther Schuller as a composer, author, and educator. But the most important and influential member of the group would turn out to be its leader. Born into an upper middle class family in East St. Louis, Illinois, Miles Dewey Davis III (May 26, 1926–September 28, 1991) began playing trumpet as a teenager and worked his way up through the ranks of local swing bands. In the spring of 1944, he filled in for two weeks with the visiting Billy Eckstine band at the Riviera Club in St. Louis, and forged friendships with the band's all-star lineup, including Charlie Parker and Dizzy Gillespie. With their encouragement, Davis moved to New York in September (after graduating from high school), ostensibly to attend the Julliard School of Music, but realistically to become part of the city's music scene. (Davis got the approval of his skeptical parents to move to New York only after agreeing to enroll in school, but he dropped out within a year.)

Once in New York, Davis reconnected with Bird, and took part in several of the saxophonist's club dates and recordings (the famous "Koko" session in late 1945 was only his *second* recording date). After Parker's sixteen-month stay in California and return to New York, Davis became a regular member of Bird's quintet from March 1947 through December 1948. Playing next to a musician of Parker's stature on a nightly basis enabled Davis to experience tremendous growth as an artist in a relatively short period of time. He was also able to avoid the "working your way up through the ranks" struggle that most musicians deal with when moving to New York—playing with Parker gave him instant street cred. It was during his tenure with Parker that Davis began to develop his pared down, moody trumpet style, after coming to grips with the fact that he was never going to be another Dizzy Gillespie. Davis also became acquainted with Gil Evans, whose innovative arrangements he loved, and began hanging out at his apartment. Despite their differences—Evans, being fourteen years older and white—the two became life-long best friends. As he grew tired of the daily traumas of Parker's drugged out lifestyle (which he later described as "childish, stupid bullshit"[5]), Davis, along with Evans and the others, began to formulate plans to create the famous Nonet.

By the time the Nonet broke up in 1950, however, Davis, like Parker and so many other musicians of the era, had himself fallen victim to heroin addiction. The next three years of his life could best be described as a descent into hell. Finally, in late 1953, he returned to his father's farm in rural Illinois, checked himself into the guesthouse, and kicked the habit cold turkey. Although the weeklong experience was arguably the lowest point in his life (which he painfully documents in his autobiography, writing in part: "if somebody could guarantee that you would die in two seconds, you would take it"[6]), it was a turning point, and Davis's career quickly rebounded. 1954 would see the release of both the *Birth of the Cool* album and Davis's critically acclaimed new album *Walkin'*. In 1955,

his first appearance at the Newport Jazz Festival turned him into a star. "I got a long standing ovation. When I got off the bandstand, everybody was looking at me like I was a king or something . . . all the musicians there were treating me like I was a god." It was an early triumph in a long career, which will be told throughout the following pages of this text.

The Euro Connection: Kenton, Russell, and Schuller

Cool jazz unquestionably had a strong connection to the European musical tradition, but there were other jazz strains emerging in the post-bebop era that had even stronger ties to classical music. Synthesizing classical music with American cultural music was nothing new. One of the earliest endeavors was Scott Joplin's 1903 ragtime opera *A Guest of Honor* in 1903. Later undertakings included George Gershwin's 1935 folk opera *Porgy and Bess* and Duke Ellington's 1943's multi-movement suite *Black, Brown and Beige* (many of Ellington's more expansive works from the 1940s and later are by most definitions classical music). Bandleader Woody Herman commissioned Russian composer Igor Stravinsky to write the nine-minute, three-movement *Ebony Concerto,* which premiered in 1946 at Carnegie Hall. The reframing of jazz as an art form brought new energy into the idea that jazz and classical were joined at the hip, and very rapidly, new works began to materialize. As the 1940s moved into the 1950s, three men—a bandleader and two composers— became the new leaders of this movement.

Stan Kenton (December 15, 1911–August 25, 1979) first came to prominence in the 1940s with his West Coast-based big band. By the 1950s, his band had become a stepping-stone for many of the best and the brightest players in Los Angeles, including Art Pepper, Shorty Rogers, Shelly Manne, and Stan Getz. Kenton's arrangers, however,

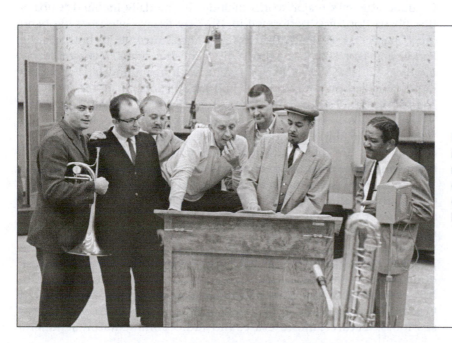

Bandleader Stan Kenton (center) in the early 1960s with arranger/ mellophonium player Gene Roland (left), arranger Lennie Niehaus (2nd from left) and arranger Bill Holman (3rd from right).

made as much of an impact on the jazz world as his many outstanding players. Throughout the 1950s, arrangers such as Bill Russo, Pete Rugolo, Shorty Rogers, Lennie Niehaus, Gerry Mulligan, and Bill Holman stretched the boundaries of jazz with an approach Kenton called "neophonic" (Greek for "new sounds"). Kenton's ambitious goals for his band were revealed in the names he gave its different incarnations: "Progressive Jazz," "Artistry in Rhythm," "Innovations in Modern Music," and so on. These bands evoked either a strong love or strong distaste; no one was seemingly ambivalent. The word *bombastic* is commonly used to describe his music. (Commenting on the modern leanings of the band, comedian Mort Saul once quipped that "About that Stan Kenton band: a waiter dropped a tray and three couples got up to dance."[7]) The most extreme example of Kenton's avant-garde side came from the idiosyncratic composer/arranger Bob Graettinger, who in 1948 delivered his four-part suite titled *City of Glass.* The piece, which took Graettinger a year to complete, is one of the most adventurous in modern jazz. Its premier in Chicago was greeted with several moments of stunned silence, followed by a thunderous standing ovation.

George Russell is one of the most important and most overlooked composers and theorists in American music history. Russell (born June 23, 1923) moved to New York in the early 1940s from his native Cincinnati and before long was hanging out with Miles Davis and the rest at Gil Evans's one-room apartment. While confined to a hospital to recuperate from tuberculosis in 1945, he began formulating the principles for his magnum opus, *The Lydian Chromatic Concept of Tonal Organization.* One of the basic principles outlined in the book is that there are relationships between chords and modes, or scales, which can be used in composing or improvising music. Russell also applies the laws of physics to postulate that the ancient Greek Lydian scale, rather than the major scale, should be the dominant tonality in Western music. First published in 1953, *The Lydian Chromatic Concept* became one of the most influential books on music theory ever written, and was inspirational to the later modal works of Miles Davis, Bill Evans, and John Coltrane. Russell's major works include the modally inclined "Cubana Be-Cubana Bop," first performed in 1947 by Dizzy Gillespie's big band (See Chapter 1); 1949's "A Bird in Igor's Yard," a tribute to both Charlie Parker and Igor Stravinsky; the 1957 orchestral suite *All About Rosie;* 1958's *New York, N.Y.,* a five-part suite with a running hipster monologue provided by Jon Hendricks; and *Jazz in the Space Age,* an avant-garde big band suite from 1960. Russell's 1956 album *The Jazz Workshop* also contains several adventurous pieces, including "Concerto for Billy the Kid," a feature for pianist Bill Evans. Russell's compositions are thickly textured, harmonically and rhythmically risk-taking, and make great use of counterpoint.

George Russell's nearest equal as jazz/classical synthesist is **Gunther Schuller** (born November 22, 1925). To call Schuller merely a composer would ignore a large portion of his life's work. He is a noted author of jazz history and French horn technique books, as well as numerous articles. He has also been an educator of private jazz and classical students, as well as serving for many years as president of the New England Conservatory of Music, where he established the jazz program; French horn player with the Metropolitan Opera for 14 years (he also played on one of the *Birth of the Cool* sessions); lecturer; music critic; and radio commentator. Schuller's

George Russell's **The Lydian Chromatic Concept of Tonal Organization** was the first theoretical contribution to come from jazz and was responsible for introducing modal improvisation, which resulted in the seminal recording of Miles Davis's *Kind of Blue.*

MUSIC ANALYSIS

TRACK 8: "CITY OF GLASS—DANCE BEFORE THE MIRROR"

(Graettinger) Stan Kenton Orchestra recorded December 5 and 7, 1951, Hollywood (4:25). Personnel: John Howell, Maynard Ferguson, Conte Candoli, Stu Williamson, John Coppola: trumpet; Harry Betts, Bob Fitzpatrick, Bill Russo, Dick Kenney: trombone; George Roberts: bass trombone; John Graas, Lloyd Otto, George Price: French horn; Stan Fletcher: tuba; Bud Shank: alto sax, flute; Art Pepper: alto sax, clarinet; Bob Cooper: tenor sax, oboe, English horn; Bart Cardarell: tenor sax, bassoon; Bob Gioga: baritone sax, bass clarinet; Alex Law, Earl Cornwell, Phil Davidson, Maurice Konkel, Barton Gray, Seb Mercurio, Danny Napolitano, Dwight Mumma, Charlie Scarle, Ben Zimberoff: violin; Paul Israel, Aaron Shapiro, Dave Smiley: viola; Gregory Bemko, Zachary Bock, Mary Jane Gillan: cello; Stan Kenton: piano; Ralph Blaze: guitar; Abe Luboff, Don Bagley: bass; Shelly Manne: drums.

This is the second of four movements to Bob Graettinger's monumental City of Glass, performed by the Stan Kenton Orchestra. Graettinger was a true eccentric; he lived alone in a sparsely furnished room above a garage in Hollywood, subsisting on fried eggs, milk, vitamin supplements and a $25 weekly salary from Kenton. He had one blue suit that he wore incessantly, with pants held up by a strand of rope instead of a belt. He also dispensed with conventional music score paper, using instead graph paper onto which he drew

brightly colored hieroglyphs that corresponded in some way to the sounds and pitches of the various instruments. He then wrote commentary to accompany the score such as "Ripples then waves . . . desert sounds . . . those fool birds again." An earlier piece he had written for Kenton, "Thermopylae" was so far out that the bandleader wasn't sure if it was "genius or a bunch of crap." *City of Glass* is Graettinger's impressions of a city filled with skyscrapers and large structures; in this movement he uses different instruments from the Kenton Orchestra—expanded to 40 musicians—to represent the various buildings. This recording of the work came three years after its premier at the Chicago Civic Opera House. (ref: *West Coast Jazz: Modern Jazz in California 1945–1960* by Ted Gioia; *The Essential Jazz Records, Vol. 2* by Max Harrison, Charles Fox, Eric Thacker, and Stuart Nicholson)

	
0:00	Dramatic intro with strings and percussion
0:19	Brass and woodwinds enter
1:18	Rhythm changes to swing rhythm; saxes eventually take over the melody
1:48	Strings take over melody, swing rhythm continues, saxes and brass play background melodies
2.41	Short string interlude eventually gives way to:
3.20	"Shout chorus" by full horn section, track ends with a trombone "blat"

interest in combining the jazz and classical aesthetics led him to coin the phrase "**Third Stream**" during a lecture at Brandeis University in 1957. Although composers had been combining the disparate "streams" of jazz and classical in various ways for many years, actually giving it a name and advocating its advancement was controversial at the time. "People now forget that we were at the barricades back then, and it was a battlefield out there," Schuller recently commented. "The critical fraternity lashed out against the concept; since many of them were conservative, they just didn't want to see anything new beyond bebop."[8] Schuller was also instrumental in founding the short-lived **Lenox School of Jazz** in Lenox, Massachusetts, an early jazz

Although composer Gunther Schuller coined the phrase **"Third Stream"** to describe a fusion of classical music and jazz in 1957, it, in fact, had been going on for many years. Early in the twentieth century, European composers such as Igor Stravinsky and Claude Debussy were already incorporating jazz tonalities and rhythms into their music. Many of Duke Ellington's extended works from the 1940s and beyond were also fusing classical and jazz elements. ⚐

education academy that ran from 1957 to 1960 and whose instructors included George Russell, John Lewis, Dizzy Gillespie, and Schuller himself.

West Coast Jazz

The Scene

If jazz in the 1950s was becoming cool, was there a better locale for it to call home than Southern California? The area was becoming *the* place to be for hundreds of thousands of immigrants from the east, lured by industrial and aerospace jobs, warm weather, beaches, and Disneyland. At the same time, the local jazz scene in Los Angeles was coming alive with a revitalized popularity. Jazz had been a presence in Los Angeles for many years, especially along **Central Avenue,** the twelve-mile long north-south thoroughfare running south through the city's black neighborhoods that was home to dozens of jazz and blues venues, a sort of 52nd Street West. Among the many clubs were Lovejoy's, the Downbeat, the Turban Lounge, and Club Alabam, a huge hall with a balcony, spacious dancefloor and eighty-foot bar.[9] The scene was a hub of activity, as bandleader Lee Young remembered: "Within two blocks they had about six clubs where musicians were working, and so, like, we used to take long intermissions and go across the street and listen. We'd go next door and they'd come over to hear us play."[10] Both Charlie Parker and Dizzy Gillespie were regular participants at after-hours jam sessions on Central Avenue during their late 1945/early 1946 residency at Billy Berg's. During Parker's sixteen-month residency in the city, he was a constant presence at clubs like the Club Hi De Ho on Western Avenue and the Finale in Little Tokyo. Jam sessions at these clubs, which often featured future stars Miles Davis, Gerry Mulligan, and Stan Getz, rivaled those of its more famous East Coast counterpart, Minton's. Dexter Gordon and Charles Mingus, two influential musicians who will be discussed in later chapters, were also active participants in the Central Avenue scene at this time. Soon after Mulligan put together a quartet to play at a small club on Wilshire Boulevard in 1952, the Los Angeles jazz scene exploded onto the national stage, and to many fans, *cool* became synonymous with West Coast jazz.

One of the most famous jazz venues in Los Angeles during the 1950s was the **Lighthouse Café** in Hermosa Beach. Still in business to this day, the Lighthouse, at 30 Pier Avenue, is literally no more than a hundred feet from the Pacific Ocean. The music performed there was, geographically at least, about as West Coast as you can get. In May 1949, bass player Howard Rumsey talked the club's proprietor into sponsoring Sunday afternoon jam sessions, which became so popular that in time they were expanded to six nights a week. In 1951, Rumsey decided to formalize a permanent group, the **Howard Rumsey's Lighthouse All-Stars.** The All-Stars, which stayed together throughout the 1950s, included at one time or another a who's who of the West Coast scene, including **Shorty Rogers** and Maynard Ferguson on trumpet, Bud Shank on alto saxophone, Jimmy Giuffre on tenor saxophone, Frank Rosolino on trombone, and drummer Shelly Manne. Most of the musicians who worked at the Lighthouse had at one time played in the Stan Kenton Orchestra, which had as

many as twenty members at times. (In fact, pictures of Kenton graced one end of the room.)[11] Several All-Star albums were produced throughout the decade, including two recorded live at the club. In the early 1950s, The Lighthouse musicians started a tradition that became almost as famous as the club itself: marathon Sunday jam sessions that started at 2:00 P.M. and ran until 2:00 A.M.—twelve hours straight! But, as Shorty Rogers later recalled, it was "just a wonderful time, a family feeling. A lot of personal friendships and relationships were started there. It was just great."[12]

Black and White

The beginnings of the **West Coast jazz** scene can be traced to two events from the early 1950s. The most publicized was the Gerry Mulligan Quartet's gig in the summer of 1952 at the Haig, which brought fame to both Mulligan and Chet Baker, and drew in packed houses every night. Preceding that however, was the release of a *Birth of the Cool*-like album called ***Modern Sounds,*** recorded in October 1951 by Shorty Rogers and His Giants. Rogers, who played trumpet on and arranged the music for the album, used an eight-piece band that included trumpet, tenor saxophone, alto saxophone, tuba, and French horn, an instrumentation inspired by Davis's Nonet recordings. By incorporating the laid-back and relaxed tone of *Birth of the Cool,* with *Modern Sounds* Rogers set the tone for what would in time be called the "West Coast sound." Rogers, who honed his arranging skills with both the Woody Herman and Stan Kenton bands, went on to become the face of West Coast jazz, with a constant presence with the Lighthouse All-Stars, the release of several innovative albums under his own name, and a lucrative career writing arrangements and scores for television and films. Rogers even had a cameo appearance in the film *The Man With the Golden Arm.* By the 1960s, Rogers was working almost exclusively in the studios as both writer and player, a lucrative alternative to the nightly grind of the club scene, which in Los Angeles began to dry up in the late 1950s. As the center for television and film production, Los Angeles' studio gigs were a powerful magnet that pulled in musicians like Rogers from all over the country. Session work was not terribly creative—you just showed up and played what was put in front of you—but it required a specialized skill set that included sight-reading, familiarity with a variety of styles, improvising, technical mastery of ones instrument, and being able to double on other instruments. Generally speaking, the kind of skills that came with traditional European musical training.

Obviously, not every musician possessed the skills necessary to work in the studios, but this in itself does not explain why the world of the 1950s L.A. session musician was an overwhelmingly white one. Although it is undoubtedly true that white musicians in the post-war years generally had better financial resources available to them to attend college and study music, it is also true that there were many qualified black musicians who were kept out of the studios for no other reason than their race. Among the few blacks who made it in were saxophonist Buddy Collette and bassist Charles Mingus. Collette, who also played flute and clarinet, reported that he could make $130 for a three-hour TV session, while other musicians (including Charlie Parker, who envied Collette's middle class lifestyle) who were kept out of the studios could make at most

West Coast jazz is a term often used to describe the cool jazz of the 1950s. West Coast jazz and cool jazz are interchangeable terms..

$200 for playing an *entire week* in a club. "There were lots of very capable musicians who were not allowed in, and when you look at their worldwide reputations you wonder why," related jazz writer Kirk Silsbee.[13] It wasn't just the studios that discriminated against black musicians in Los Angeles; there were also two musician's union locals, one for blacks and one for whites, a convenient institutional method of siphoning off the best jobs for whites.* Collette, Mingus, and others were instrumental in unifying the two unions into Local 47 in 1953 after years of hard work, but by then Mingus had left for New York, in part because of the discrimination he encountered in Los Angeles. Even the Lighthouse house band, which in its early years contained such luminary black musicians as Sonny Criss, Hampton Hawes, and Teddy Edwards, became suspiciously whiter as the jam sessions became more popular. Although one could argue about whether it was racism or other factors that rooted these problems, it cannot be argued that the musicians who benefited the most from the popularity of the West Coast cool scene were overwhelmingly white, as we shall see throughout this chapter. As the 1950s wore on, many of the finest black musicians in Los Angeles, including Hawes, Criss, and Dexter Gordon were forced to either leave town or play in low-rent strip joints and cocktail lounges as the Central Avenue scene slowly withered up and died.

Gerry Mulligan/Chet Baker: Pianoless on the Pacific

Members of the Gerry Mulligan "Pianoless" Quartet
- Gerry Mulligan–baritone saxophone
- Chet Baker–trumpet
- Bob Whitlock–bass
- Chico Hamilton–drums ♫

After the breakup of the Miles Davis Nonet, baritone saxophonist **Gerry Mulligan** was the first of its former band members to achieve fame. His popular 1952 pianoless quartet with **Chet Baker** more or less kick-started the Los Angeles cool jazz scene into high gear. Mulligan (April 6, 1927–January 20, 1996) was born to an Irish Catholic family in Queens, New York. He played piano and clarinet in his youth, but switched to the saxophone when he started playing professionally as a teen. He began arranging for sweet dance bands at 17, and his skills developed quickly. When he was 18, Mulligan attended a jam session with Charlie Parker, who then commissioned him to write two pieces for his string ensemble. Mulligan's association with Bird led him to Gil Evans, who brought him into the Thornhill band, which ultimately led to his association with the Miles Davis Nonet. He was the most prolific of the Nonet's writers, composing and arranging three of their twelve pieces and arranging two others. Once the Nonet disbanded, however, times got tough. In 1952, a broke and jobless Mulligan spent several months hitchhiking to Los

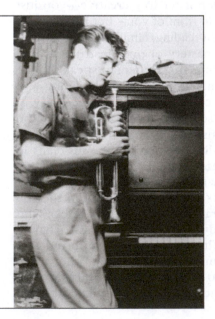
Trumpeter Chet Baker, in an undated photo from the 1950s.

*To be fair to Los Angeles, it should be pointed out that at the time every major city in the United States (with the exception of New York) had separate, segregated unions.

MUSIC ANALYSIS

TRACK 9: "LINE FOR LYONS"

(Mulligan) Gerry Mulligan Quartet recorded in San Francisco, September 2, 1952 (2:31). Personnel: Gerry Mulligan: baritone sax; Chet Baker: trumpet; Carson Smith: bass; Chico Hamilton: drums.

This recording of Gerry Mulligan's composition "Line For Lyons" exemplifies the relaxed and understated sound of the famous pianoless quartet he led with trumpeter Chet Baker. The group used several techniques to create a variety of sound textures, including two-part counterpoint during the head, Mulligan's counter-melody during Baker's solo, and collective improvisation during the last chorus. The mood is serene and relaxed and yet retains an air of hip intellectualism that perfectly fit the cultural association that jazz was achieving in the 1950s. Much ado has been made over the group's lack of piano, but in fact other examples of famous jazz groups without "essential" rhythm instruments are not uncommon—the Benny Goodman Trio (clarinet, piano and drums—no bass) and the Art Tatum Trio (piano, bass and guitar—no drums) being just two examples. In any event, the lack of piano added to the group's mystique and helped showcase the intricate and interesting counterpoint between the trumpet and baritone sax. "Line For Lyons" was recorded shortly after the group began their famous engagement at the Haig in Los Angeles. (ref: *Visions of Jazz: The First Century* by Gary Giddons)

0:00	Song starts without introduction; head is played by baritone sax and trumpet in two-part counterpoint with bass and drums (using brushes) accompaniment.
0:46	Short baritone saxophone solo by Gerry Mulligan.
1:11	Short solo by trumpeter Chet Baker with background harmony line on baritone sax by Mulligan.
1:35	Collective improvisation by Baker and Mulligan.
1:58	Restatement of the head.

Angeles, in the same way as Sal Paradise in Jack Kerouac's yet-to-be-released novel *On the Road.* In Los Angeles, he picked up work writing arrangements for the Stan Kenton Orchestra, and also began attending weekly jam sessions at the **Haig,** a tiny club on Wilshire Boulevard. It was there that he met the young up-and-coming trumpeter/singer Chet Baker, who had recently revived his going nowhere career with a short tour with Charlie Parker. The tour brought Baker instant credibility in the jazz world, and upon its completion, Baker, like Mulligan, began attending the sessions at the Haig.

The Haig was a converted bungalow that seated less than one hundred, but was already establishing itself as one of the city's top jazz clubs. Its weekly jam sessions allowed Mulligan and Baker to slowly establish a musical chemistry, and in July 1952 the club's manager offered them a regular Monday night gig. There was one proviso, however: the grand piano would have to stay in storage to allow more customer seating.* With just enough room for four musicians, the **Gerry Mulligan Quartet** made its debut, with Mulligan, Baker, Chico Hamilton on drums, and Bob Whitlock on bass—and no pianist. Mulligan wrote nearly all the music for the group, but it was often his

*Although there are also reports that Mulligan preferred not to have a piano, allowing the group to explore new contrapuntal experiments.

improvised interplay with Baker that created the interesting counterpoint that the group became known for. "Chet had a fantastic ear," Mulligan related. "He would pick up on things I improvised as if we had them all written out in advance."[14] The absence of a piano was actually an advantage for the group, as it served to highlight the creative interaction between the two horn players. The music of the quartet was serene and melodic. Although it retained a spontaneous feel, there was a chamber music quality to it as well. With Mulligan's boyish face and crew cut, Baker's Brando-esque sex appeal, and their laid-back sound, the group quickly became a smash hit. Soon, their gigs at the Haig were playing to sellout crowds. Their tenure was short, however, as a drug bust in the summer of 1953 put Mulligan in prison for six months. In the meantime, Baker's career took off as both a trumpet player and as a distinctive vocal stylist after his recording of "My Funny Valentine" became a hit. Baker went on to an up-and-down career that was tormented by a lingering heroin addiction, which resulted in his untimely and mysterious death in Amsterdam in 1988. Mulligan fared better. He kicked his addiction and abruptly left California for good, embittered by his brush with the law there. Ironically, the famous pianoless quartet for which he is today most famous is one of his few ventures into small group jazz in his long career, most of which was spent arranging for and leading larger ensembles—on the East Coast. Among the many tunes he composed that are today jazz standards associated with the cool school are "Walking Shoes," "Bernie's Tune," and "Line for Lyons."

Dave Brubeck/Paul Desmond: 2+2+2+3=Swing

The West Coast musician that achieved the greatest commercial success over the length of his career was pianist/composer **Dave Brubeck.** Brubeck (born December 6, 1920) was born in Concord, California, and grew up on an isolated 45,000-acre cattle ranch outside Ione, 155 miles east of San Francisco. Brubeck's mother, a classically trained pianist, taught him piano, although in his youth he was perfectly content to pursue the life of a cowboy. When he entered the College of the Pacific, he was at first a veterinary student, but by his second year he had transferred to music. By this time, Brubeck had played a variety of jazz and dance gigs, and was showing promise as a talented pianist who could improvise. He suffered one problem: he could not read music. When the dean of the music school realized this, he threatened to kick Brubeck out of school, but relented after the young musician promised to never pursue a teaching career. Soon after this incident, Brubeck transferred to Mills College in Oakland to study with noted composer Darius Milhaud. Between 1940 and 1949, sandwiched around a short stint in the army (1944–1945), Brubeck completed his college degree while surrounding himself with a group of Milhaud's most creative students. By 1946, the Milhaud clique (known on campus as "the eight") had started an octet with the stated purpose of playing experimental compositions and arrangements written by its members. In addition to Brubeck, the octet included drummer Cal Tjader (who would later make a name for himself as a popular bandleader) and a talented alto saxophonist named Paul Breitenfeld. Being a student group was both help and hindrance. Although there was no pressure to write music that was commercially viable, their only gig opportunities were at other colleges—for

no pay. The music of the **Dave Brubeck Octet** was adventurous, imaginative, and surprisingly similar to that of the Miles Davis Nonet, although the two bands were operating on opposite coasts and most likely had no knowledge of each other's activities.

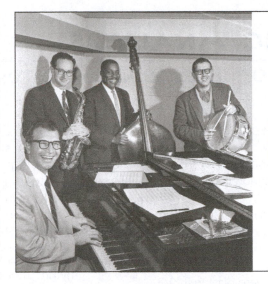

The Dave Brubeck Quartet in 1958; (left to right) Brubeck, Paul Desmond, Eugene Wright and Joe Morello.

Once out of school, Brubeck formed a piano-bass-drums trio that garnered a local following and eventually a contract with Fantasy Records. However, a near fatal swimming accident in Hawaii in early 1951 forced him to stop playing and recuperate for several months. As a result of the accident, Brubeck had to change his playing to a more percussive, block chordal style to compensate for the loss of dexterity in his fingers. When he returned to playing later in the summer, Brubeck added alto saxophonist and former octet member Paul Breitenfeld (who now called himself **Paul Desmond**) to the group. Desmond's style was lyrical and economical, his tone smooth and light. In short, his playing was a marked contrast to Brubeck's heavy handedness. Critics through the years have compared Desmond's playing to a dry martini, but have generally been less than kind to Brubeck. Some say he can't swing, is too bombastic, and too classically oriented; others compare him favorably to Monk. In spite of their differing styles, the **Dave Brubeck Quartet,** with Desmond on alto saxophone, Eugene Wright on bass, and Joe Morello on drums worked together seamlessly, and quickly developed a rabid fan base. Their college-themed albums, *Jazz at Oberlin, Jazz Goes to College,* and *Jazz Goes to Junior College,* made them especially popular on college campuses. From the Bay area Brubeck's fame exploded to the national level, and by 1954 he was on the cover of *Time* magazine.

The greatest achievement of the Brubeck Quartet was the 1959 album **Time Out,** an experimental venture in odd time meters. Playing music with anything but four beats to the measure was uncommon at the time, and the songs on *Time Out* are all built around unusual time groupings. For instance, the opening track, Brubeck's "Blue Rondo á la Turk," has nine beats per measure, organized in 2+2+2+3 groupings. Desmond's "Take Five," rhythmically challenging with five beats per bar, has such a catchy melody that it became a Number 25 hit in 1961—a remarkable achievement for an instrumental jazz recording (and an undanceable one at that). *Time Out* was a huge, popular success (although more than one critic attacked it as no more than a clever stunt). The album eventually reached Number 2 on the pop charts and achieved gold certification (sales of 500,000 units) in 1963. (In 1997, it went platinum, when sales hit one million units.) As one of the defining albums from one of the landmark years of recorded jazz, *Time Out* helped inspire other jazz musicians to begin working in odd meters, which today is a common practice. Brubeck has endured his share of criticism. In addition

Members of the Dave Brubeck Quartet

- Paul Desmond–alto saxophone
- Dave Brubeck–piano
- Eugene Wright–bass
- Joe Morello–drums ♪

MUSIC ANALYSIS

TRACK 10: "BLUE RONDO Á LA TURK"

(Brubeck) Dave Brubeck Quartet from the album *Time Out*, recorded August 18, 1959 (6:43). Personnel: Dave Brubeck: piano; Paul Desmond: alto sax; Gene Wright: bass; Joe Morello: drums

When Dave Brubeck decided to record an album using odd time signatures, one of his strongest inspirations came from the Turkish musicians he had heard effortlessly playing in 9/8 time while serving in the US Army. "They were playing in 9/8, all improvising just like it was American blues. And I thought, 'Jeez, why don't I learn how to do that?'" Although jazz musicians by 1959 were familiar with playing in 3/4 and 6/8 time signatures, playing in meters of 5 or 9 (both of which Brubeck uses on *Time Out*) was considered to be extremely out of the ordinary. "Blue Rondo á la Turk" incorporates the same rhythm (2+2+2+3) that Brubeck heard the Turks playing, which he incorporates into a whirling dervish theme (in classical rondo form) that eventually settles on a very West Coast-ish, laid back 12-bar blues (in conventional 4/4

time). Throughout most of the first solo (by alto saxophonist Paul Desmond), Brubeck lays completely out, serving to highlight the contrast between the altoist's lyricism and the bombastic tone of Brubeck's own solo that follows. (ref: *Jazz: a Film by Ken Burns*, interview with Brubeck; liner notes to *Time Out* by Steve Race)

0:00	Song starts with signature 2+2+2+3 rhythm; theme played at first by pianist Dave Brubeck; drummer Joe Morello, bassist Eugene Wright and alto saxophonist Paul Desmond enter in sequential fashion
0:33	Second theme stated; again at 0.56
1:19	Third theme is stated
1:52	Alto saxophone solo by Desmond in 4/4 swing rhythm, occasionally interrupted by quotes from the 2+2+2+3 rhythm in the first chorus; five choruses total
3.53	Brubeck piano solo; four choruses total
5.34	Desmond re-enters with 2+2+2+3
5.53	Head is restated, track ends

to the knocks on his playing style, his popularity and enormous record sales in the 1950s and 1960s exposed him to charges of selling out, which was contrary to the existing notion that jazz was an "outsider" art form that should not have a wide audience. In the post–swing era jazz world, Dave Brubeck was one of very few musicians who had to worry about such criticism, at least until the 1970s.

Art Pepper: Tormented Storyteller

Another musician who had a constant presence in the L.A. scene, whether at the Lighthouse, in recording studios, or drug treatment facilities was alto saxophonist **Art Pepper.** Pepper (September 1, 1925–June 15, 1982) was one of the most gifted—and tormented— musicians in the history of jazz. His prodigious talent first landed him a job with the Stan Kenton Orchestra in 1943, when he was seventeen years old. After spending the next eight years alternating with Kenton and service in the army, Pepper made his way as a freelance musician until his first drug bust in 1953. From this point on, as painfully detailed in his riveting autobiography **Straight Life,** Pepper's life is almost completely dominated by his drug addiction and inability to manage even the most routine daily activities that made him seem to welcome incarceration. (As he explains it, the book's title is not a reference to being

sober, but feeling straight or normal only *after* getting high.) As the 1950s progressed, he spent time in and out of prison, and often went long stretches without playing his horn. In spite of his problems, Pepper was still able to make beautiful records that are awe-inspiring.

One of his most legendary record dates occurred on January 19, 1957. Pepper's second wife Diane arranged a session with the great Miles Davis rhythm section (pianist Red Garland, bass player Paul Chambers, and drummer Philly Joe Jones) at a local studio. Fearing that his self-destructive tendencies might cause him to sabotage the session if he knew about it too far in advance, Diane waited until the morning of the session to inform Art, who supposedly was strung out on heroin and had not played for months. "I got my horn out of the closet, and it looked like some stranger," he related. "It looked like something from another life." Hardly able to get his alto saxophone to work after six months of disuse and in his drug-induced state, Pepper was nervous and awestruck when he arrived at the studio and met the waiting musicians. In spite of all signs pointing to a total disaster, the album, ***Art Pepper Meets the Rhythm Section***, turned out beautifully, and Pepper's playing was superb. (His perverse sense of hubris is revealed by his summation of the session: "No one else could have done it. Unless it was someone as steeped in the genius role as I was. Born, bred, and raised, nothing but a total genius! Ha! Ahahaha![15]) The album earned five stars (out of five) from *Down Beat*. Pepper also made a very satisfying album in 1959 with an eleven-piece *Birth of the Cool*-esque band called *Art Pepper +Eleven: Modern Jazz Classics*, with arrangements by Marty Paich. Pepper's drug problems intensified in the 1960s, and he spent most of the decade either in prison at San Quentin prison or the experimental and controversial Synanon treatment facility in Santa Monica. After these difficult years, his once beautiful, singing sweet tone became harsh, reflecting the dues he had paid due to his personal traumas. He managed to make a comeback of sorts in the 1970s with an album recorded live at the Village Vanguard before writing *Straight Life* in 1979 with his third wife, Laurie.

Other Cool Jazz Artists

Lennie Tristano: Sightless Visionary

As we have previously discussed, cool jazz was by no means an exclusively West Coast phenomenon. Although cool was "in the air" in the 1950s, and although the national media was focused on the West Coast scene, it's clear that cool incubated in New York in the 1940s. While historians have duly noted Miles Davis's pioneering work with the Birth of the Cool band, pianist/composer **Lennie Tristano** was playing music that arguably could be called cool several years before Davis. Tristano (March 19, 1919–November 18, 1978) was an enigmatic figure in jazz. To begin with, his music is hard to categorize. Although he is generally cast with the cool movement (as he is here), there is wide disagreement as to exactly how to classify him. For instance, noted jazz scholar Gunther Schuller puts him in the swing era, while historian Ted Gioia classifies him as a bebopper. In addition, Tristano's music was unyielding cerebral, a fact he readily admitted but was unwilling to do anything about. "It would be useless for me to play something I don't feel," he said when asked why he didn't

MUSIC ANALYSIS

TRACK 11: "YOU'D BE SO NICE TO COME HOME TO"

(Porter) Art Pepper from the album *Art Pepper Meets the Rhythm Section* recorded at Contemporary Studios in Hollywood, CA January 19, 1957 (5:30). Personnel: Art Pepper: alto sax; Red Garland: piano; Paul Chambers: bass; Philly Joe Jones: drums

"You'd Be So Nice to Come Home To" was written by Tin Pan Alley giant Cole Porter for the 1943 film *Something to Shout About*, and in the years since it has become one of the favorite standards among jazz musicians. Art Pepper's recording of the song was the first thing that he and the Miles Davis rhythm section recorded on January 19, 1957 for the album *Art Pepper Meets the Rhythm Section*. Although Pepper claims in his autobiography *Straight Life* that he had not played his horn for months because he was too strung out on heroin, there is ample discography evidence that he had actually been active in recording sessions in the

weeks leading up to this one. In any event, the recording is a powerful documentation of one of the most inventive of the West Coast soloists in the 1950s and 1960s. (ref: Jazz Discography Project, www.jazzdisco.org)

0:00	Song starts with an intro by pianist Red Garland, accompanied by drummer Philly Joe Jones
0:10	Art Pepper enters with the head
1:51	As the head ends, the rhythm section breaks for Pepper to begin the first of two solo choruses
1:37	Pepper begins second chorus
2.20	Pianist Garland begins soloing
3.03	Bassist Paul Chambers solos
3.46	Pepper and drummer Philly Joe Jones trade 4s for one and one-half choruses
4.50	Last half of head is restated, track ends

temper his style to build a wider audience, "I wouldn't be playing anything good.[16] Tristano also led a somewhat cloistered life. He didn't record or perform often. When he did, it was usually only with a select group of musical compadres.

Blinded by an illness shortly after his birth, Tristano grew up in Chicago, where he got a college degree and started his professional career. In 1946, at age 27, he moved to New York, where he was enthusiastically received by the jazz community and press, winning *Metronome* magazine's 1947 Musician of the Year Award. Soon after arriving in New York, Tristano began making what are, in retrospect, astonishing recordings with a piano-bass-guitar trio. His advanced use of harmonic abstraction in the 1946 recording of "I Can't Get Started" is almost indefinable in the context of its time, and it is a prophetic glimpse of how jazz piano might sound forty years in the future. Around this time, Tristano began working with the musicians with whom he would work for most of his career: tenor player Warne Marsh, guitarist Billy Bauer, and alto saxophone player Lee Konitz (of the Davis Nonet). Although the music of this sextet (with added bassist and drummer) has a perceptible boppish influence, it is tightly restrained and overly brainy sounding. It is music that is hard to pin down categorically, but it is certainly progressive for its time.

Throughout the late 1940s and 1950s, Tristano often experimented outside the confines of cool. On May 16, 1949, his group recorded "Intuition" and "Digression," two improvised pieces that were spontaneously composed while the tape was running. They are

considered to be the first recordings that can realistically be called free jazz, even though they predated the free jazz movement by ten years. In 1953, Tristano recorded the harshly atonal "Descent Into the Maelstrom," which could easily be mistaken for the work of free jazz pianist Cecil Taylor (although Taylor couldn't have heard the piece—it wasn't released until the 1980s). On "Maelstrom" and later works like "Turkish Mambo," Tristano would **overdub** as many as three piano parts, becoming the first jazz musician to make use of a technique that was new and controversial at the time but is commonly used today. Tristano is also famous for opening the **New School of Music,** the first school dedicated to the study of jazz, in Flushing, New York, in 1951. Although he closed the school in 1956, he continued to teach privately, and counted such famed musicians as Charles Mingus, Phil Woods, and Marian McPartland among his many students. Tristano performed less frequently in the 1960s and 1970s, and died of a heart attack at age fifty-nine.

Overdub The process of combining new material with material already existing on tape is known as overdubbing. In the 1940s and early 1950s, this process usually involved using two monaural tape decks; later, tape recorders with three, four, eight and up to twenty-four tracks were used, making the process much simpler and commonly used.

The MJQ: Fugues and Formality

More than any other performing group of the cool movement, the **Modern Jazz Quartet** (MJQ) immersed itself in the tradition and culture of European classical music. More comfortable in the concert hall than the nightclub or dancehall, the MJQ adopted European form structures in their compositions and the formalities of a night at the symphony in their performances, right down to dressing themselves in tuxedos. The band evolved in the early 1950s when pianist **John Lewis,** vibraphonist **Milt Jackson,** and drummer Kenny Clarke played together in small groups led by Dizzy Gillespie, and later with bassist Ray Brown as the Milt Jackson Quartet. When Brown left and was replaced by Percy Heath in 1952, the MJQ was born. This was a highly pedigreed group: Lewis was a former Miles Davis Nonet member; Clarke was the formative bebop drummer in the Minton's house band; and Jackson was by then universally accepted as the first great bebop vibraphonist. Their direction was clear from the beginning. "We sat down right at the start and talked about it, and we decided between us all the stuff about what we would wear and how we would behave and all of that," Jackson recalled. "And we chose the name of the band—the Modern Jazz Quartet, and that was that."[17] "The Modern Jazz Quartet took such a divergent point of view in its whole presentation of music, that a lot of the jazz purists were offended by it," states A. B. Spellman. "There was a sort of assumption that jazz musicians

Members of the Modern Jazz Quartet
- John Lewis–piano
- Milt Jackson–vibes
- Percy Heath–bass
- Connie Kay–drums

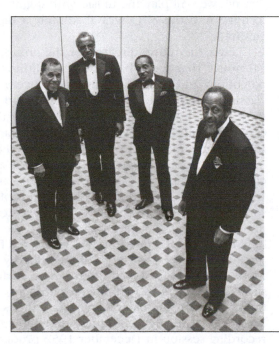

The Modern Jazz Quarter in an undated photo from the 1980s; (left to right) pianist John Lewis, drummer Connie Kaye, vibraphonist Milt Jackson, bassist Percy Heath.

MUSIC ANALYSIS

TRACK 12: "VENDOME"

(Lewis) Modern Jazz Quartet recorded in New York on December 22, 1952 (3:13). Personnel: John Lewis: piano; Milt Jackson: vibes; Percy Heath: bass; Kenny Clarke: drums (Prestige)

Soon after John Lewis, Milt Jackson, Percy Heath, and Kenny Clarke first recorded together as a quartet on August 24, 1951 (as the Milt Jackson Quartet), a decision was made to continue recording as a formal group. "Vendome," recorded at the group's first recording session as the Modern Jazz Quartet, is an early example of the MJQ's affinity for the **fugue**, a classical form in which a theme is stated individually by each instrument before embarking on a number of contrapuntal variations. In "Vendome," the theme is first stated by Jackson on vibes, then by Lewis on piano; the two then replace the intricate pre-composed counterpoint of a classical fugue with improvisations that retain the basic formal character of the theme. The MJQ revisited the fugue several times during their long career, including "Little David's Fugue," "A Fugue For Music Inn," "Three Windows," and "Alexander's Fugue." All of these pieces (including "Vendome") were written by Lewis, who loved the music of J. S. Bach (perhaps the greatest fugal composer) and earned a Master of Music degree from the Manhattan School of Music in 1953, a rarity for a jazz musician at that time. (ref: liner notes to *Pyramid; Cookin': Hard Bop and Soul Jazz 1954–65* by Kenny Mathieson)

0:00	Song starts with vibraphonist Milt Jackson stating the three-measure theme; pianist John Lewis then picks up the theme; it is then restated by each
0:20	Vibes solo by Jackson
0:45	Pianist Lewis restates theme
0:57	Piano solo by Lewis
1:15	Vibes restate theme
2:03	Vibes solo by Lewis
2:49	Theme is restated for the last time

ought to be somewhat funky, that they had to be people who had suffered a great deal. But here is someone who has taken the approach that no, we will play the music with dignity that serious music ought to have. And the MJQ was absolutely a dignified and very serious ensemble."[18]

Lewis, the music director for the group, had an interest in classical music that went back to his childhood: "My fascination with polyphony and European music began very early, while I was having classical piano lessons . . . my most wonderful discovery from that time was when I first heard Bach."[19] Without Lewis's classically restrained influence, the MJQ could have easily been categorized as a hard bop group. Jackson was a purebred bebopper whose fiery playing was seemingly at odds with Lewis. It is a testament to both musicians' arbitrating skills (and those of Heath and drummer Connie Kay, who replaced Clarke in 1955) that their collective endeavor worked so well. Just as one might expect at a classical music recital or a symphony concert, MJQ performances saw the musicians walk onstage, bow, and play their music in well-mannered fashion without talking to the audience. Their music borrowed heavily from European tradition. Lewis and Jackson would often create intricate polyphony between the piano and vibes that was reminiscent of the baroque compositional style of J. S. Bach. Lewis sometimes wrote pieces that used European forms such as **fugues** and multi-movement suites. Their first recording session in December 1952 produced the fugal "Vendome,"

A **fugue** is a formal structure first used during the Baroque era (1600–1750) that makes extensive use of counterpoint (two or more melodies occurring simultaneously) based on an opening theme or subject.

as well as the four-movement "La Ronde Suite," based on Dizzy Gillespie's "Two Bass Hit." In the early 1960s, the group began dis-banding during the summer months so Lewis could concentrate on his composing. In 1974, they broke up because Jackson wanted to concentrate on his solo career. Starting in the early 1980s, they reunited from time to time. Lewis was also one of the first major jazz figures to embrace the radical music of Ornette Coleman in 1959.

The cool/West Coast movement helped momentarily revitalize the popularity of jazz after the end of the swing era. As the first major post-bebop style, cool jazz put into motion an expansion of jazz styles and artistic approaches that would continue in earnest throughout the 1950s and beyond. Variations and offshoots of cool jazz continued to be popular, and this text will explore them further in Chapter 5.

Notes

1. Randall, Edward L.: "The Voice of American Jazz," *High Fidelity,* August 1958
2. Leland, John: *Hip: The History,* pg 112
3. Saul, Scott: *Freedom Is, Freedom Ain't,* pgs 33–34
4. Davis, Miles and Troupe, Quincy: *Miles: The Autobiography,* pg 122
5. Ibid, pg 114
6. Ibid, pg 170
7. Quoted in Lee, William and Coke, Audree: *Stan Kenton, Artistry in Rhythm,* pg 120
8. Quoted in "Third Stream Jazz: Musical Crossroads or Parallel Worlds," by Marc Chénard, scena.org, March 2001
9. Gordon, Robert: *Jazz West Coast,* pg 24
10. Pepper, Art and Pepper, Laurie: *Straight Life,* pg 46
11. From *Los Angeles Mirror* article by Dick Williams, 10/16/54
12. Gordon, Robert: *Jazz West Coast,* from author interview with Shorty Rogers, 1/20/83, pg 61
13. Hoskins, Barney: *Waiting for the Sun: Strange Days, Weird Scenes,* and *The Sound of Los Angeles,* pg 16
14. Quote from Micklin, Bob: "Chet Baker Knows the Blues," *Milwaukee Journal,* 9/23/73
15. Both quotes from Pepper, Art and Pepper, Laurie: *Straight Life,* pg 192
16. *Down Beat* article, 10/6/50
17. Milt Jackson interview from Mathieson, Kenny: *Cookin': Hard Bop and Soul Jazz 1954-65,* pg 109
18. A. B. Spellman interview at npr.org, June 11, 2005
19. Shipton, Alyn: *A New History of Jazz,* pg 697

Study Questions for Chapter 2

1. What were some of the signs emerging in the 1950s that jazz was being viewed in a significantly different light in American and world culture?

2. Describe some of the ways in which the Miles Davis Nonet and its music were different than anything that had come before it.

3. In what ways did cool jazz differ musically from bebop? From swing?

4. Make a list of some of the important musical and literary works (and their authors) that attempted to strengthen the ties between jazz and European classical music.

5. Describe some of the characteristics, venues, and other aspects of the Southern California jazz scene in the 1950s.

6. What were some of the difficulties and challenges facing black musicians in the L.A. scene in the 1950s?

7. Describe the unique features and characteristics of the Gerry Mulligan Quartet.

8. Describe why and how the Dave Brubeck Quartet album *Time Out* became so important and influential.

9. Name some of the innovations and progressive concepts that Lennie Tristano brought to jazz.

10. What are some of the ways that the Modern Jazz Quartet attempted to link themselves to European classical traditions?

The Soul of Jazz

© 2011, emin kuliyev, Shutterstock, Inc.

Chapter 3

Key Terms, Music, Figures and Bands

Terms

33-1/3 rpm album
Rhythm and Blues (R&B)
Hard bop
Brown vs. Board of Education of Topeka, Kansas
Blue Note Records
Harmon mute
Sheets of sound
Modal harmony
Jazz Workshop
Town Hall Concert
Cliff Walk Manor "anti-festival"

Music (albums, works, etc.)

Moanin'
Song for My Father
Saxophone Colossus
Kind of Blue
Giant Steps
Mingus Ah Um
We Insist! The Freedom Now Suite

Figures and Bands

Alfred Lion
Francis Wolf
Rudy Van Gelder
The Jazz Messengers
Art Blakey
Horace Silver
Clifford Brown–Max Roach Quintet
Clifford Brown
Sonny Rollins
The Miles Davis 50s Quintet
John Coltrane
Bill Evans
Charles Mingus
Abbey Lincoln

Sounds of the Inner City

The Other Side of Cool

By the 1950s, bebop had assimilated itself into the core of mainstream jazz. What once was a revolution was now part of the evolution of jazz, and proof that jazz could adapt to the rapidly changing fabric of American culture. Bebop's melodies, phrasing, harmonies, and syncopated rhythms were no longer shocking; they were now imbedded in the creative thinking of the contemporary jazz musician. By the early 1950s, the debate over moldy figs versus moderns was, well, *moldy,* as the moderns had prevailed. Even cool jazz, with its casual nonchalance and restrained, intellectual leanings, was post-bebop in sound and conception. Although its day had passed as the new kid on the block, bebop had made an indelible mark, and had permanently changed the sound and mindset of jazz. If any interested observer had missed the emergence of bebop in the 1940s with even a short Rip Van Winkle-like nap, he would have awoke to a dramatically altered jazz world in the 1950s.

Much of the discussion at the beginning of Chapter 2 concerned the new cultural context in which jazz musicians found themselves in the 1950s. They were now key players in the new, non-conformist hipster zeitgeist, a world that was also inhabited by intellectuals of the literary and visual arts. It was a self-determined world that rejected the values of the prevailing conservative Cold War popular culture. Jazz may have lost the grip it had on pop culture in the 1940s, but it now had a new role that was more substantial than just music for dancing. Jazz was now the music of the cool outsider, the bohemian, the beat writer, and the abstract expressionist. At college campuses and at hip nightclubs all across America, the "in" crowd was hanging out listening to the sounds of cool jazz, whether live or on the newly introduced **33-1/3 rpm album.** However, this moment in

time would not make it beyond the 1950s, as two primary forces emerged that dramatically impacted jazz and reshaped American culture by the end of the decade. The first of these, television, saw explosive growth in popularity in the ten years following World War II, when the number of television sets jumped 5,000% from 10,000 to 50 million. Television had a profound effect on how Americans spent time entertaining and looking at themselves. It also helped subvert the iconic cool hipster when the laughable and harmless "beatnik"* character Maynard G. Krebs was introduced on the 1959 series *The Many Loves of Doby Gillis.* The second force, rock and roll, became the ultimate jazz foil, and almost immediately began to siphon off young record buyers and club audiences. Rock quickly became the new teen obsession—much like jazz had been in the swing era—and, by the early 1960s, young people who might have been digging Gerry Mulligan or Miles Davis a few years earlier were now getting into Bob Dylan and the Beatles. Before they finally embraced it in in the 1970s, jazz musicians tended to view rock music as their mortal enemy. A good case could be made that in fact it was.

While cool jazz was perfectly suited for the 1950s hip young intellectual, it was virtually non-existent in another segment of American society. The world described in this text thus far—the world of the painter, the bohemian, the beat writer and the college student—was a predominantly *white* world. And so, not coincidentally, virtually all of the musicians who played cool jazz were white (the prime exceptions being Miles Davis, George Russell and the members of the MJQ). Cool jazz had absolutely no stick in the black community. On the other hand, as the 1940s wound down, neither did bebop. In fact, jazz—the music that was born and raised in black neighborhoods all across America throughout the first half of the twentieth century—was now losing its standing in those very same communities. Since the mid-1940s—around the time that bebop appeared—the black consumer audience had increasingly been tuning into **Rhythm and Blues (R&B),** and record sales of artists such as Lionel Hampton, Wynonie Harris, and Louis Jordan began supplanting those of jazz artists. Hampton, the former vibist of the Benny Goodman Quartet, had two huge hits in the 1940s, "Flying Home" and "Hey! Ba-Ba-Re-Bop." Jordan, a singer and alto saxophonist and former member of the swing era Chick Webb Orchestra, had an astounding eighteen Number 1 and fifty-four Top Ten hits on the R&B charts in the 1940s with his band the Tympany Five. (In fact, Jordan's 113 weeks at Number 1 on the R&B charts is still a record—Stevie Wonder is second with seventy weeks at Number 1.)

A New Mainstream

Rhythm and Blues, at least from a jazz musicians point of view, was a simpler style than jazz, primarily built upon the 12-bar blues with a boogie-woogie bass line and a honking tenor saxophone. It was high-energy, driving, and, perhaps most importantly, it had vocals. Its roots were in jazz, illustrated by the fact that there wasn't even a *Billboard* chart for R&B until 1949 (the year the term Rhythm and Blues was

33-1/3 RPM ALBUM
Introduced by Columbia Records in 1948, the album, called the LP (long-playing format) was a marked improvement over the previous 78 rpm standard. In addition to being made from vinyl (rather than shellac), which improved fidelity and reduced surface, LPs allowed up to twenty-three minutes of music to be put on each side of the record, resulting in the birth of the record album, which included several songs on each side rather than just one. 🅑

Rhythm and Blues (R&B) is a more dance-oriented and commercial evolution of the electrified urban blues that first emerged in Chicago in the 1940s. R&B bands often used electric instruments such as guitars, bass guitars, and Hammond organs; horn sections; and a vocalist. Although the term was not coined until 1949, the music style was already popular by then, with jazz veteran Lionel Hampton having one of the first R&B hits in 1942 with "Flying Home." 🅑

*The word *beatnik* was a Yiddish-esque amalgam of *beat*—as in beat writer—and *Sputnik,* the Soviet satellite that ushered in the space age with its launch in October 1957.

coined). Previously, all records from black artists were listed under the "race" category, which meant that Count Basie and Billie Holiday were in effect competing against the Tympany Five (and losing). Because this divergence of styles in black pop music had never existed before the late 1940s, black jazz musicians in the early 1950s were seemingly at a crossroads. Should they stick to their principles and continue playing jazz, or should they bow to commercial pressures and start playing R&B? It seems that Hampton and Jordan had already made their choice, and soon more jazz players would follow. Some respected jazz musicians from the 1940s, such as Gene Ammons and Johnny Griffin, did dabble in R&B, at least for a while. But the fact is that this wasn't much of a decision for a lot of younger jazz musicians who were just coming of age at the end of the 1940s. They were already listening to R&B on jukeboxes and black radio stations, and were the first to begin synthesizing it into their music in one way or another. So by the mid 1950s, a new hybrid style was emerging that embraced both the nuances of bebop with the music of black popular tradition. This new style was known as **hard bop,** and it became the new mainstream sound of jazz in the 1950s.

R&B's popularity was only part of the story behind the rise of hard bop. The post-war years were also a time when black Americans were becoming more politically active about changing the status quo of race relations, in particular the segregation and discrimination that was common, blatant, and legal.* Beginning in the late 1940s and early 1950s, small gains were made in court cases, especially in the area of public education. The burgeoning civil rights movement gained real momentum with the May 17, 1954 ***Brown vs. Board of Education of Topeka, Kansas*** landmark ruling by the U.S. Supreme Court, which dismantled racial segregation in public schools. This ruling heightened expectations of change, which in turn fueled demonstrations, strikes, and more court cases throughout the 1950s, generating real progress that culminated in the passing of important civil rights legislation in the 1960s. Rising expectations also had an effect on black music (as culture always has on music) and, accordingly it is not coincidental that the first hard bop recordings and the first records in the new black pop style, soul, were made within months of the *Brown* ruling. The timelines of hard bop, soul music, and the civil rights movement are surprisingly similar, with a starting point in 1954 and a gradual loss of momentum and relevance by the end of the 1960s. Author Scott Saul also makes an interesting correlation between hard bop and the civil rights movement, in that neither was about absolute freedom from the establishment. Instead, both were concerned with working inside their respective existing frameworks. Just as hard bop musicians "engaged with the idioms and structures established by their fellow musicians," (such as the 12-bar blues), civil rights activists "aimed to participate fully in American life—in schools, parks, public transport, and so on."[1] The movement to achieve total freedom, at least in the jazz world, would come, but not quite yet.

Hard bop enthusiastically embraced gospel music, the blues, and R&B—in other words, more traditional black roots music, which by definition is simpler harmonically, rhythmically, and melodically than

*In 1896, the U.S. Supreme Court ruled in *Plessy vs. Ferguson* that separate facilities for blacks and whites was constitutional, as long as they were equal.

bebop. Combining those elements with the artistry of post-bebop modern jazz created a hybrid that was expressive and explosive—what Saul calls "unabashedly urban music, music that had a gemlike toughness and brilliance, a balance of glamour and grit. Jazz before had been 'hot' or 'cool,' but hard bop was intense, soulful, unfussy, insistent—too agitated to be simply hot, too moody to be simply cool."[2] Admittedly, throwing the blues, gospel, R&B, and bebop in together creates a pretty big umbrella to work under, and arriving at a clear-cut definition of hard bop is somewhat problematic (author David Rosenthal offers one solution to this issue by breaking hard bop musicians down into four categories[3]). However, the following characteristics are generally existent in most hard bop performances:

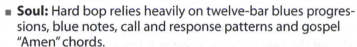

Characteristics of Hard Bop

- **Soul:** Hard bop relies heavily on twelve-bar blues progressions, blue notes, call and response patterns and gospel "Amen" chords.
- **Power:** Horn players tend to play with power and an edgy, brassy tone. Rhythm section players "dig in" and play with great forcefulness.
- **Virtuoso:** Hard bop musicians concern themselves with the technical mastery of their instruments. Like bebop, the focus of the music is often on the improvised solo.
- **Rhythm:** There is great emphasis on "the groove," using walking bass or other strong rhythmic patterns.
- **Quintet:** The typical instrumentation in hard bop is taken from bebop combos: trumpet/tenor or alto saxophone/ piano/ bass/drums.

Blue Note: The Sound of Hard Bop

Hard bop was an urban, East Coast music, and its ground zero was New York City. The city had been the center of the jazz universe since the early 1930s, and with acknowledgements to the burgeoning West Coast scene, continued to be so throughout the hard bop era. There were of course the clubs—Birdland, the Five Spot, the Cellar Café, the Half Note, Café Bohemia, the Village Vanguard—which provided steady work for musicians (and where many live albums of the era were recorded). New York in the 1950s was also home to the "big four" independent labels that specialized in hard bop—Blue Note, Prestige, Riverside and Savoy—that drew musicians from Philadelphia, Detroit and, other cities that had no discernable recording industries of their own. Of the hard bop independents, **Blue Note** was the most respected among musicians. Founded in 1939 by German immigrants **Alfred Lion** and **Francis Wolf,** the label developed a well-earned reputation for its meticulous standards of preparation and production, as confirmed by the often-heard quote, "The difference between Blue Note and Prestige was two days' rehearsal."[4] Lion, who produced the sessions, was noted for his uncompromising standards as well as his great affection for the music and the musicians he recorded. "He would dance to the music when it was going on—that's when you

knew he was happy," related fellow producer Bob Beldon.[5] Wolf was a gifted photographer who took the black and white photos that grace the covers of the albums and have become nearly as famous as the records. Wolf's covers often depicted musicians in the studio or club, hard at work, a marked contrast to the "lite" layouts of pretty girls and sunny beaches pictured on West Coast cover art. From its humble beginnings, Blue Note was one of the first labels to jump on the bebop bandwagon (and gave Thelonious Monk his first contract in 1947) and became the label of note for hard boppers such Art Blakey, Horace Silver, and many others throughout the 1950s and 1960s.

Blue Note's hard bop recordings had a distinctive "sound" that was due in large part to the work of recording engineer **Rudy Van Gelder.** In the early 1950s, Van Gelder, then in his late twenties, was an optometrist by day whose hobby was making records for friends and local musicians in the evening. Because recording was a sidelight for him at this point, Van Gelder used his parent's home in Hackensack, New Jersey, as his studio, with the living room as the recording room and the kitchen as the control room. In 1952, he was introduced to Alfred Lion, who was impressed with the quality of his work, and the two began a working relationship that lasted until Lion retired in 1967. During this time, Van Gelder essentially crafted the sound of hard bop, an astounding accomplishment when considering his makeshift studio and equipment. "When I started making records, there was no quality recording equipment available to me. I had to build my own mixer."[6] It is not unusual to see lamps or TV consoles—his parent's living room fixtures—in the background of the photos taken by Wolf at the sessions. The grind of working all day and recording at night eventually took its toll on Van Gelder. In 1959, he gave up his optometry practice and went to work full time in a new state-of-the-art recording facility that he built in Englewood Cliffs, New Jersey. Van Gelder also worked for labels other than Blue Note, and throughout the 1950s and 1960s, he recorded many of the most important jazz albums of the era, including *Song for My Father, Moanin',* John Coltrane's *Blue Trane,* and Jimmy Smith's *Home Cookin'* for Blue Note; Miles Davis's *Workin', Cookin', Steamin', Relaxin',* and Sonny Rollins's *Saxophone Colossus,* all for Prestige; and Coltrane's *A Love Supreme* for Impulse! At the time of this writing, Van Gelder at eighty-two years of age is working on 24-bit digital remasters of many of his original classic Blue Note albums.

Important Hard Bop Artists

Art Blakey and the Jazz Messengers: Jazz Academy

The group that more or less defined the sound of hard bop was **the Jazz Messengers.** The Messengers were founded in 1954 by drummer Art Blakey and pianist Horace Silver, who co-led the group until Silver left to start his own group in 1956. Under Blakey's leadership, the Messengers became a virtual academy of hard bop, in which young, up-and-coming musicians were mentored in the ways of music and life until they were ready to go out on their own. Born in Pittsburgh, **Art Blakey** (October 11, 1919–October 16, 1990) moved to New York in 1942 and made his recording debut in 1944 as the drummer for the innovative Billy Eckstine Orchestra, with whom

Drummer Art Blakey, leader of the Jazz Messengers.

he played (along with Charlie Parker and Dizzy Gillespie) until the group broke up in 1947. Following his stint with Eckstine, Blakey traveled to West Africa, where he converted to Islam and took the name Abdullah Ibn Buhaina. (Over the years, many of his young charges knew him as Buhaina or simply "Bu.") Upon his return to New York, Blakey spent several years freelancing, recording with Thelonious Monk, Charlie Parker, and Miles Davis, among others. During this time he was developing a powerful drumming style that was loud, aggressive, and relentlessly swinging, which would in time become a signature part of the Jazz Messengers sound. Blakey's style also made use of dramatic changes in dynamics, allowing him to move explosively from soft to loud passages, which drove the band with a great sense of urgency and excitement.

In February 1954, Blakey put together a quintet to play a date at New York's Birdland, which was recorded by Blue Note. The group, the first edition of what would eventually be the Jazz Messengers, included Blakey, Silver, trumpeter Clifford Brown, alto saxophonist Lou Donaldson, and bassist Curly Russell. In November the group recorded their first studio album for Blue Note, *Horace Silver and the Jazz Messengers,* the title of which reflects the important role Silver played in the band's formative years. Silver not only wrote six of the other seven songs from the album, including their first hit single "The Preacher," but also brought a distinctive and funky piano style that helped define the sound of the Messengers. After Silver left the group, Blakey began adopting his policy of hiring promising young musicians and letting them go once they "were ready." "When these guys get too old, I'm going to get some new ones," he often quipped. "This isn't the post office, you know."[7] One of the first truly great editions of the Messengers was the 1958–1959 group that included trumpeter Lee Morgan, tenor saxophonist Benny Golson, and pianist Bobby Timmons. This group recorded one of the defining albums of the hard bop genre in 1958, titled **Moanin',** which included Timmons's distinctive title track and Golson's classic "Blues

Selected Important Members of the Jazz Messengers

- Art Blakey–leader, drums
- Horace Silver–piano (1954–1956)
- 1958–59: Benny Golson (tenor saxophone), Lee Morgan (trumpet)
- 1959–61: Wayne Shorter (tenor saxophone), Lee Morgan (trumpet)
- 1961–64: Wayne Shorter (tenor saxophone), Freddie Hubbard (trumpet), Curtis Fuller (trombone)
- 1977–80: Bobby Watson (alto saxophone), Valery Ponomarev (trumpet)
- 1980–82: Branford Marsalis (tenor saxophone), Wynton Marsalis (trumpet)

March." Other memorable Messengers lineups included the 1959–1961 edition with Morgan and Wayne Shorter on tenor saxophone; the 1961–1964 group that included Shorter, trumpeter Freddie Hubbard, and trombonist Curtis Fuller; and the early 1980s group that included brothers Wynton and Branford Marsalis on trumpet and tenor saxophone, respectively. These musicians and many others went on to important careers in jazz, and most credited Blakey with not only being a mentor but a father figure as well. "The lessons I learned from him will stick with me forever," commented alto saxophonist Bobby Watson (a Messenger from 1977–1981). "He made a leader out of me, he taught me how to build a solo, and he taught me how to love myself."[8] Blakey led the Messengers with full fury until his death.

Horace Silver: Hard Bop Tunesmith

The most prolific songwriter of the hard bop era was **Horace Silver** (born September 2, 1928), whose many jazz standards include "Song for My Father," "Nica's Dream," and "Sister Sadie." Silver also developed a unique piano style that is often referred to as "funky." What is funky? In Silver's words, "Funky just means earthy, coming out of the blues and gospel thing, but it's not a style, it's a feel, an approach to playing.

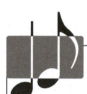

MUSIC ANALYSIS

TRACK 13: "BACKSTAGE SALLY"

(Shorter) Art Blakey and the Jazz Messengers from the album *Buhaina's Delight* recorded November 28, 1961 at Van Gelder Studios, Englewood Cliffs, New Jersey (5:58). Personnel: Art Blakey: drums; Freddie Hubbard: trumpet; Curtis Fuller: trombone; Wayne Shorter: tenor sax; Cedar Walton: piano; Jymie Merritt: bass.

"Backstage Sally" comes from the second album recorded by Art Blakey's Jazz Messengers for the legendary Blue Note label. The song was written and arranged by tenor saxophonist Wayne Shorter, musical director for the group at the time. With the addition of trombonist Curtis Fuller, this version of the Messengers became one of the few with three horns (their more typical front line consisting of trumpet and saxophone only). This was only the third session with the Messengers for trumpeter Freddie Hubbard, who would go on to become one of the most sought after sidemen in the 1960s and 1970s and a star in his own right. All of the elements that characterize the

Messengers can be found in the recording of "Backstage Sally," including crisp, bluesy arrangements, a hard driving groove, excellent soloists and of course, the fiery playing of Blakey.

0:00	Head is stated by horns in unison; drummer Art Blakey immediately sets up the shuffle beat, one of the signature sounds of the band; Blakey also occasionally punctuates with explosive changes in dynamics
0:32	Repeat of head
1:04	Tenor sax solo by Wayne Shorter; rhythm section continues shuffle groove with occasional accents; trumpet and trombone also play background riffs
2:09	Trombonist Curtis Fuller solos
2:41	Trumpeter Freddie Hubbard solos
3.43	Pianist Cedar Walton solos
4.46	Head is restated and repeated; track ends with a drum flourish by Blakey

The funk element came from my love for black gospel music and the blues, a combination of those two. It was really just a natural evolution."[9] Silver's father was of Portuguese descent and a native of the Cape Verde Islands (a group of islands off the West Coast of Africa), and Horace grew up listening to the folk music of his father's native land. Those influences later surfaced in his own compositions, including "The Cape Verdean Blues" and his biggest hit "Song for My Father." Silver made his recording debut in 1950 on a Stan Getz album, and was a much in demand session musician in the early 1950s before hooking up with Blakey to form the Jazz Messengers. After leaving the group, Silver put together his own quintet, which modeled the Messengers in both instrumentation and sound. Memorable lineups have included the 1959-1964 group with Blue Mitchell on trumpet and Junior Cook on tenor saxophone—which is often called his finest—and the 1965-1967 edition with Woody Shaw on trumpet and Joe Henderson on tenor saxophone.

Silver's quintets have always been a showcase for his composing and arranging talents, and over the years he has written hundreds of songs. One of group's most popular albums was 1964's *Song for My Father,* which incorporated Latin rhythms, another common influence in Silver's music. The title tune, a bossa nova, was written following a trip to Rio de Janeiro at the invitation of bandleader Sergio Mendes. "They were all into this bossa nova thing, which as you know was greatly inspired by our American jazz. So I got back to New York and I said, 'I'll try to write a tune using that rhythm' I realized the melody I came up with was akin to Cape Verdean—like something my dad would play. That song was 'Song for My Father'." The album cover features a photo of his father, John Tavares Silver. Horace Silver is still writing music, and recently wrote his autobiography *Let's Get to the Nitty Gritty.* In 2005, he received the Presidential Merit Award from the Grammy Awards.

The Clifford Brown–Max Roach Quintet

Although it existed for only two years, the **Clifford Brown–Max Roach Quintet** left a legacy as one of the hardest swinging hard bop combos of the era. Led by two of jazz's most admired musicians, the group was characterized by fiery playing and Brown's compositions and innovative arrangements of jazz standards. By the time the band formed in 1954, Roach's career was already well-established (see Chapter 1); at only twenty-three years of age, trumpeter **Clifford Brown's** was just beginning. Brown (October 30, 1930-June 26, 1956) distinguished himself early on as atypical of his generation of jazz musicians. He was college educated, having attended Maryland State University, where he studied composition and arranging. He was also, perhaps more importantly, an abstainer of drug and alcohol use. By the time he was in his late teens, he was already playing with the top tier of musicians in New York. By his early twenties, he was being called "The New Dizzy."[10] His career was put on hold for a year when he was involved in a severe auto accident in June 1950 that put him for a while in a full body cast. After recovering, he toured Europe and Africa with Lionel Hampton and participated in the February 1954 live recording of the Art Blakey Quintet at Birdland. Later that year, Brown went to Los Angeles to form the new quintet with Roach, which, after some initial personnel changes established Harold Land

on tenor saxophone, Richie Powell on piano, and George Morrow on bass. Throughout their two-year existence, the group was in the studio frequently, often recording Brown's own compositions, which included "Daahoud," "Joy Spring" (written for his fiancé LaRue), and the contrapuntal "Jacqui." Brown also crafted bright, cheery arrangements of jazz standards, including Cole Porter's "I Get a Kick Out of You" and "Love Is a Many Splendored Thing" from the 1955 hit film of the same name. In 1955, Land left the group and was replaced by tenor saxophonist Sonny Rollins, bringing together in one group Brown, Roach, and Rollins—three of the biggest names in jazz.

Brownie's outgoing, upbeat personality and his aversion to drugs was a breath of fresh air for jazz. The rise to fame of a clean living musician, coming just as Charlie Parker—the spiritual leader of the drug counterculture—was nearing the end of his life seemed to be part of some sort of cosmic morality play. Tragically, however, Brown's life would soon be over as well. In the wee hours of June 26, 1956, in a driving rainstorm on the Pennsylvania Turnpike, the car in which he was riding slid off the road and down a 75-foot embankment, killing Brown and pianist Richie Powell and his wife instantly. Brown had been at a jam session in Philadelphia (which was recorded and later released), and was on his way to a gig in Chicago. He was twenty-five years old. Upon hearing the news, his fellow musicians were devastated. Some, like Sonny Rollins (who had endured his share of drug problems), reflected on a life well lived: "Clifford was a profound influence on my personal life. He showed me that it was possible to live a good, clean life and still be a good jazz musician."[11] Although a replacement was hired to take Brown's place in the quintet (Kenny Dorham), things just weren't the same without him, and the group soon disbanded. Brown's death caused his co-leader Max Roach to plunge into an extended period of depression and heavy drinking that took years to overcome. However, Roach kept working and recording prolifically until his later years (see the discussion of Roach's *We Insist! The Freedom Now Suite* at the end of this chapter). He died in 2007 at age 83.

Miles Davis/Sonny Rollins/John Coltrane

The First Quintet

When we last visited Miles Davis, it was 1954 and he was re-emerging from the throws of heroin addiction. Although his career was getting back on track with the release of *Birth of the Cool* and *Walkin'*, Miles's real breakthrough came on July 17, 1955, at the second annual Newport Jazz Festival, where his rendition of "'Round Midnight" with an all-star pickup group (that included the song's composer Thelonious Monk) mesmerized the audience. The jazz press was also impressed. *Down Beat* wrote, "Miles played thrillingly, and indicated his comeback is in full stride." *Metronome* wrote that Miles "Blew better than anyone else during the three nights"[12] of the festival. With his newfound fame came a stream of offers from jazz clubs (including a contract guaranteeing twenty weeks a year at Birdland), which allowed Davis to put together a steady, working group for the first time in his career. After some personnel shuffling, the new group, a quintet, made its debut at the Café Bohemia in late July with Red Garland on piano, Philly Joe Jones on drums, Paul Chambers on bass,

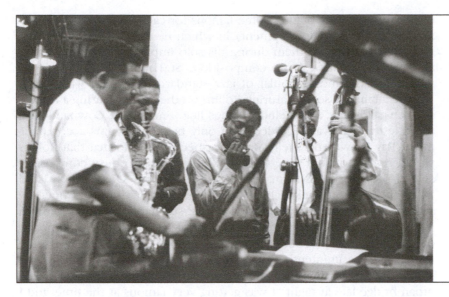

Miles Davis during the recording of *Kind of Blue,* March 2, 1959. (Left to right) Cannonball Adderley, John Coltrane, Davis, Paul Chambers.

and Sonny Rollins on tenor saxophone. It was the beginning of the first Miles Davis Quintet, sometimes called the **"50s Quintet."**

Sonny Rollins (born September 7, 1930) would not last long with the group, however. Like many others of the era, he was battling a nasty heroin addiction. In his early career, Rollins withdrew from the scene from time to time to try to get his addiction under control. Born in 1930, he grew up in the Sugar Hill section of Harlem, which by the early 1940s had a vibrant scene of young jazz musicians that also included Jackie McLean, Kenny Drew, and Art Taylor. Rollins soon outshone them all. "Sonny influenced everybody uptown, playing every instrument," recalled McLean. "There were a lot of musicians in our neighborhood . . . Sonny was the leader of all of them."[13] By the time he joined the Davis Quintet, Rollins had already recorded with Davis, Monk, Art Blakey, the MJQ, and Bud Powell, and released his own debut album, titled *Moving Out,* for Prestige. He had also nurtured a huge, dark, Coleman Hawkins-esque sound that he combined with a heavy bebop influence. After just a few gigs with the Davis group, he left to check himself into a drug treatment facility in Louisville, Kentucky. After his release, he played with the Brown–Roach Quintet from late 1955 until Brown's untimely death in 1956.

> **Members of the Miles Davis 50s Quintet**
> - Miles Davis–trumpet
> - John Coltrane–tenor saxophone
> - Red Garland–piano
> - Paul Chambers–bass
> - Philly Joe Jones–drums

The Bridge

Overcoming his addiction enabled Rollins to embark on an intensely creative period in which he recorded two landmark albums, **Saxophone Colossus** (1956) and *Way Out West* (1957). On the former, Rollins made extensive use of a

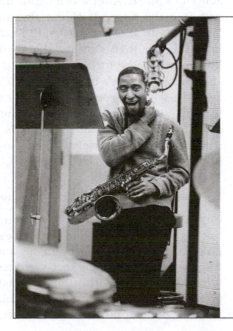

Sonny Rollins in the studio during the recording of his *What's New* album, April 1962.

technique that he would become famous for called "thematic improvisation," (or melodic development), in which he developed themes and multiple variations of them during his solo improvisations. The album also introduced his calypso composition, "St. Thomas," which today is still one of the most popular of jazz standards. *Way Out West* was a "theme" album of sorts, featuring Rollins on the cover wearing a holster and ten-gallon hat, and included songs like "I'm an Old Cowhand" and the title track. It was recorded with only bass and drums accompaniment (Ray Brown and Shelly Manne, respectively), a format that Rollins would return to from time to time. Rollins was also busy composing, and his compositions from this period, including "Oleo," "Doxy," and "Airegin" (Nigeria spelled backwards), have over the years become among the most often performed in the standard jazz repertoire. In 1959, he once again withdrew from the music scene, this time not to conquer an addiction, but to further develop himself musically. During this respite, he unintentionally created one of the most enduring and iconic images in all of jazz: the lonely saxophonist practicing on an urban bridge late at night. "I was getting very famous at the time, and I felt I needed to brush up on various aspects of my craft. I felt I was getting too much, too soon, so I said, 'Wait a minute, I'm going to do it my way.' I wanted to get myself together, on my own. I used to practice on the Bridge, the Williamsburg Bridge, because I was living on the Lower East Side at the time."[14] Sonny Rollins eventually returned to gigging and recording in 1961, and recorded an album appropriately titled *The Bridge* in 1962.

Once Rollins left the group, Miles Davis turned to his second choice, a young, relatively unknown tenor saxophonist from Philadelphia named **John Coltrane.** Davis had first heard Coltrane play several years earlier, at a time when Rollins was clearly the superior player. Davis felt that Coltrane had tremendous potential, and had kept an eye on his progress. Coltrane (September 23, 1926–July 17, 1967) was born in Hamlet, North Carolina, to a religious family (both grandfathers were preachers), and spent most of his childhood in nearby High Point. By 1943, the year he moved to Philadelphia, he was playing the alto saxophone and began attending the Ornstein School of Music. After a brief stint in the Navy, he began working his way into the music business, first in Philadelphia and eventually in New York. In the late 1940s, Coltrane played in a variety of bands, including the R&B cum jazz bands of Earl Bostic, Eddie "Cleanhead" Vinson, where he first switched to the tenor saxophone, and eventually Dizzy Gillespie's big band. By the early 1950s, he had also become a junkie, which forced Gillespie to eventually let him go. In the years leading up to joining the Davis Quintet, Coltrane struggled to make a living (often playing in R&B bands where he had to play honking solos and "walk the bar") while trying to manage his addiction. When Rollins suddenly left Davis's group, Coltrane got his opportunity.

Workin', Steamin', Cookin', and Relaxin'

Coltrane by this time was developing a huge, penetrating sound that one writer described as "of the hardest iron and the surface of brightly polished metal."[15] At this point, he was also somewhat of a diamond in the rough, playing solos that were technically adventurous but somewhat unfocused. Although he was quiet, earnest, and spiritually grounded, his playing was so forceful that one reviewer called him an "angry young tenor."[16] Critics were generally divided. While some

MUSIC ANALYSIS

TRACK 14: "ST. THOMAS"

(Rollins) Sonny Rollins from the album *Saxophone Colossus* recorded June 22, 1956 at Van Gelder Studios, Hackensack, New Jersey (6:47). Personnel: Sonny Rollins: tenor sax; Tommy Flanagan: piano; Doug Watkins: bass; Max Roach: drums.

Tenor saxophonist Sonny Rollins experienced one of the most intensely creative periods of his career between his 1955 and 1959 "sabbaticals" from jazz. During this time, he released two of his most important albums, *Saxophone Colossus* and *Way Out West,* and wrote a number of compositions that are still jazz standards to this day. Perhaps Rollins' most enduring tune is the calypso-flavored "St. Thomas," the first of many he wrote in the style originating from the island of Trinidad. "St. Thomas" also contains one of the first recorded examples of Rollins' solo technique known as thematic improvisation, in which he develops entire sections of an improvisation based on a singular melodic phrase. "Rollins broke with bebop's tendency to favor improvised melodies grounded on a song's harmonies," write authors Gary Giddins and Scott DeVeaux, and instead "reprises key phrases during the course of an improvisation as touchstones, reminding the listener that he is elaborating on a particular melody and not just its harmonic underpinnings." Joining Rollins on the one-day session (in which the entire album was recorded) was original Jazz Messengers member Doug Watkins on bass, bebop go-to drummer Max Roach, and the respected Tommy Flanagan on piano. (ref: *Jazz* by Gary Giddins and Scott DeVeaux.)

0.00	Song starts with drummer Max Roach setting up the calypso rhythm
0.18	Head is stated twice by tenor saxophonist Sonny Rollins
0.55	Rollins begins first of five choruses with a good example of thematic improvisation as he continually restates a two-note theme
2.29	Drum solo by Roach
3.53	Rollins begins a new, four chorus solo as Roach switches to more conventional swing rhythm
5.02	Pianist Tommy Flanagan solos
6.10	Head is restated twice by Rollins

praised his playing, one wrote of his "contempt for the audience"[17] and that his solos sounded like "epileptic fits of passion."[18] Another compared his sound to a barking dog. Clearly, Coltrane was not cut from the same cloth as any other tenor player of the era. But his presence gave an added dimension and flexibility to the Davis group, making it capable of dramatic contrasts within the context of one song. Unlike Coltrane's solos, Davis's were concise and economical, brooding and melancholy. By using a **Harmon mute** pressed closely to the microphone and staying in the middle register of the horn, he created a sense of great intimacy and drama. Coltrane on the other hand, played in all registers and filled his solos with as many notes as seemingly possible. When pianist Garland soloed, his light touch and swinging style turned the group into a bouncy, intimate piano trio. Moving through the contrasting musical contexts created by Davis, Coltrane, and Garland made the Miles Davis Quintet in effect three groups in one.

Following Davis's appearance at Newport, Columbia Records—the largest of the major labels—began pursuing Davis, who was locked into a long-term deal with the smaller Prestige, to whom he still owed four albums. After some legal wrangling, Davis resolved the issue by recording enough material to fulfill his obligation to Prestige

in two marathon sessions on May 11 and October 26, 1956. The songs on the resulting albums, *Workin', Steamin', Cookin'* and *Relaxin' with the Miles Davis Quintet,* are mostly first takes, and capture the quintet as they might sound in a club setting. Prestige's one-at-a-time release of these albums coincided with Columbia's marketing campaign, and together they turned Davis into a jazz superstar. At thirty years of age, he was handsome and charismatic. With his fondness for elegant Italian suits, expensive sports cars, and beautiful women, he was the very epitome of cool. His music, which was both accessible and authentic, drew a large base of both black and white fans, which translated into packed club dates and, by jazz standards, huge record sales. His first Columbia release, *'Round About Midnight* came out in 1957 and was warmly received. In January 1958, he was written up in *Time* magazine—further proof that he had become a true cultural icon. In spite of his fame, however, Davis still had to endure the indignities of racism. In one well-publicized 1959 incident, he was beaten bloody by a policeman while innocently standing on the sidewalk outside Birdland, where he was working.

Spiritual Awakening

Just as Davis's career started revving up, he began to grow weary of Coltrane's increasingly drug- and alcohol-related erratic behavior (having been there–done that himself) and fired him in late 1956. For several months, Coltrane sank into deep despair, often too depressed to play. Finally, in the spring of 1957, he bottomed out. Guided by a life changing religious epiphany, Coltrane stopped using heroin and alcohol completely. "I experienced, by the grace of God, a spiritual awakening which was to lead me to a richer, fuller, more productive life . . . I humbly asked to be given the means and privilege to make others happy through music."[19] For Coltrane, God was non-denominational—neither Christian, Muslim, nor Judaic. To him, the pursuit of a higher spiritual consciousness was a path to absolute harmony with the universe, and a journey that would consume the last ten years of his life. At roughly the same time, Coltrane joined the Thelonious Monk Quartet for a six-month engagement at the Five Spot in Greenwich Village. Stretching out night after night on Monk's challenging compositions, Coltrane embarked on a period of self-discovery that allowed him to experiment with new rhythmic and harmonic ideas. With ever increasing focus and technical mastery of his horn, Coltrane's solos began to resemble tidal waves of notes, which one critic labeled **"sheets of sound."**[20] The first recorded example of the sheets of sound technique can be found on "Traneing In," recorded in August 1957, roughly at the midpoint of the Five Spot engagement. On his "Traneing In" solo (and others from this period that use the sheets of sound technique), Coltrane sounds as if he is light years ahead of the rhythm section—and, in fact, he is. With Monk's guidance, he also learned how to play multiphonics (two notes simultaneously). In September, Coltrane recorded his only Blue Note album *Blue Train,* which featured original compositions such as "Moment's Notice" and "Lazy Bird." When Davis asked him to return to his group in early 1958, Coltrane accepted.

Davis by now had expanded his group with the addition of alto saxophonist Julian "Cannonball" Adderley. The sextet's first album release was titled *Milestones,* whose title track was Davis's first

venture into **modal harmony.** "Milestones" had a simple melody and a harmonic structure that contained only two scales or "modes" instead of chords. Modal harmony, which dates back to ancient Greece, is typically simpler than conventional chordal harmony. In this respect, it represented a dramatic departure from post-bebop jazz harmony, whose chord progressions had grown increasingly complex. Davis wrote "Milestones" after spending an evening with composer/ arranger George Russell, whose seminal book *The Lydian Chromatic Concept of Tonal Organization* had outlined his theories on the relationships between chords and scales, and the use of modal harmony in jazz. Davis was fascinated by Russell's ideas and eagerly embraced them. "I think a movement in jazz is beginning away from the conventional string of chords, and a return to emphasis on melodic rather than harmonic variation. There will be fewer chords but infinite possibilities as to what to do with them."[21] Although Coltrane was at first cautious about modal harmony, he ultimately embraced it to a much greater degree than even Davis, and used it as the basis for much of his own music in the early 1960s.

Shortly after recording *Milestones,* Davis brought in pianist **Bill Evans** to replace Red Garland, and replaced drummer Philly Joe Jones with Jimmy Cobb. Evans had worked on several recordings with George Russell before joining the Davis group, and was a fellow traveler in the modal jazz camp. He was, however, an outsider of sorts in the Davis group. He had an extensive academic background, was a relatively newcomer to the New York jazz scene, and was white. Davis received his share of criticism from other black musicians for hiring a white pianist, but held his ground, saying that Evans brought the "quiet fire" he was looking for. Davis's words summed up Evans's style perfectly for, although he played with great intensity and drive, he was more understated and introspective than Garland and other hard bop pianists. In spite of Davis's endorsement, in the end Evans never felt comfortable with the group and quit by the end of the year. But Miles brought him back in early 1959 to collaborate on one of the most influential jazz albums in history, *Kind of Blue.*

Kind of Blue

Kind of Blue is often called the first modal jazz album, a description that is more figurative than literal (although the only true modal tunes are "So What" and "Flamenco Sketches," both the two 12-bar blues tunes, "Freddie Freeloader" and "All Blues" bear a strong modal affinity). The albums opening track, Davis's "So What," is constructed from just two modes (scales) set half step apart from each other—there is no other conventional harmonic movement. Another unique feature is that the bass plays the melody. However, as innovative as "So What" is, the album's most revolutionary achievement is Davis's "Flamenco Sketches," a composition built on "a series of five scales, each to be played as long as the soloist wishes until he has completed the series."[22] In other words, the form is completely elastic and open to be expanded or contracted in a spontaneous manner by the performers. This was a breakthrough of tremendous consequence to the future of jazz, as forms up to this point had customarily been rigidly set and religiously followed. "Flamenco Sketches" further breaks from convention by having no pre-composed melody. The album's fifth cut is the

Modal harmony is harmony that is comprised of scales rather than chords. Modes (scales) were first used in music by the ancient Greeks, who gave the seven modes the names that are still used today.

languid "Blue in Green," a tune credited to Davis but usually attributed to Evans. *Kind of Blue* has a relaxed, spacious, impressionistic quality that is typical of modal jazz, making it an extraordinarily easy listen. The playing, by perhaps the greatest assemblage of talent in jazz history, is superb. The two sessions for the album, on March 2 and April 22, 1959, were models of efficiency, with Davis presenting rough outline sketches of the songs to the musicians, sight unseen and without prior rehearsal, and recording them in first takes ("Flamenco Sketches" was the only song requiring a second complete take). By doing this, Davis was able to capture the spontaneous and inventive performances of his players.

Despite the impressive critical response to *Kind of Blue,* the Miles Davis Sextet broke up a month after it was recorded. The group was simply too good to stay together. John Coltrane, Bill Evans, and Cannonball Adderley all left to start their own groups. Within two weeks of recording *Kind of Blue,* Coltrane made his own definitive album statement with a project that was conceptually completely the opposite of Davis's masterpiece. Earlier that year, Coltrane had signed with Atlantic Records, a sign that he too was becoming a jazz superstar. His first solo release for the label, ***Giant Steps,*** is a culmination of his fascination with complex chord structures that first emerged with his song "Moment's Notice" from *Blue Train.* The title track is a minefield of chords and keys played astonishingly fast at nearly 300 beats per minute. To this day, mastery of the harmonic complexities of "Giant Steps" is a benchmark by which jazz musicians measure themselves. Coltrane, of course, smokes through the changes like a hot knife through butter. (His pianist, Tommy Flanagan fares less well and has a difficult time navigating through his short solo, an indication of just how unusual and challenging the harmonies were at the time.) *Giant Steps* was a transitional album in the sense that, although it was the first album in which Coltrane

MUSIC ANALYSIS

TRACK 15: "GIANT STEPS"

(Coltrane) John Coltrane Quartet from the album *Giant Steps* recorded at Atlantic Studios, New York City on May 5, 1959 (4:43). Personnel: Coltrane: tenor sax; Tommy Flanagan: piano; Paul Chambers: bass; Art Taylor: drums

Since its release in 1959, John Coltrane's "Giant Steps" has become a benchmark by which jazz musicians judge the merits of their improvisational skills. In some respects the tune is one of the most difficult ever written to improvise on, in that it's rapid fire chord changes outline a tonal center that is constantly shifting between the keys of B, G, and Eb. During this period, Coltrane also wrote other tunes that experimented with shifting tonalities,

including "Moment's Notice" and "Countdown," a technique that was inspired by the bridge to the 1937 Rodgers and Hart song "Have You Met Miss Jones?" In spite of its difficult chord changes and brisk tempo, "Giant Steps" has become one of the most recorded songs in jazz, as many musicians regard it as a sort of musical Mt. Everest.

0:00	Head is stated twice by tenor saxophonist John Coltrane
0:27	Eleven-chorus tenor sax solo by Coltrane
2:53	Pianist Tommy Flanagan solos for four choruses
3:43	Coltrane solos for two more choruses
4:09	Head is played twice

MUSIC ANALYSIS

TRACK 16: "FLAMENCO SKETCHES"

(Davis) Miles Davis Sextet from the album *Kind of Blue* recorded at the Columbia 30th Street Studios, New York on April 22, 1959 (9:25). Personnel: Miles Davis: trumpet; John Coltrane: tenor sax; Cannonball Adderley: alto sax; Bill Evans: piano; Paul Chambers: bass; Jimmy Cobb: drums

"Flamenco Sketches" was the first song recorded on the second and final day of sessions for Miles Davis's landmark album *Kind of Blue*. Although the song is credited to Davis (as are all of the compositions on the album), it is widely believed that "Flamenco Sketches" was co-authored by pianist Bill Evans and patterned after Evans's largely improvised composition "Piece Peace" from his 1958 album *Everybody Digs Bill Evans*. The song was really just a sketch of five scales that Evans brought to the session; each musician was allowed to solo on each scale as long as he wished before cueing the band to move onto the next scale. There was also no pre-composed melody. These peculiarities made "Flamenco Sketches" the most difficult song from *Kind of Blue* to record. After a complete first take was recorded, it was decided that a second take would be attempted. However, it took five tries before a second take of the song—the one that ultimately made it onto the album—was recorded in its entirety. (ref: *Kind of Blue: The Making of the Miles Davis Masterpiece* by Ashley Kahn)

0.00	Introduction vamp by Bill Evans and Paul Chambers
0.18	Miles Davis solos with Harmon muted trumpet
2.02	Tenor saxophone solo by John Coltrane
3.46	Alto saxophone solo by Cannonball Adderley
5.56	Piano solo by Bill Evans
7.47	Davis re-enters with solo, track ends

wrote all the songs (including the beautiful "Naima," written for his wife), it would be the last in which he focused on complex chord structures. In fact, with the release of *Kind of Blue* and Ornette Coleman's soon to be released *The Shape of Jazz to Come*, the era of complicated chord progressions, first introduced by the beboppers in the 1940s, seemed to be coming to a close. *Giant Steps* was the era's epilogue. Coltrane's next major album release would cast him in a completely new direction that would ultimately put him in the vanguard of a new jazz era.

Charles Mingus: Voice of the Apocalypse

Shouts, Cries, and Moans

Charles Mingus was the most independent thinker of the hard bop era, an iconoclastic figure who did things his way and under his own terms. Although he is often compared to Duke Ellington (who is often characterized as a musician "beyond category"), Mingus embraced an even larger scope of influences in creating music that was incredibly varied and unique, yet always bore his unmistakable mark. As such, it is somewhat unfair to even categorize him at all, but his musical influences and his peak creative years have their strongest connections with hard bop. Mingus embraced everything he did with guns blazing, which made his life turbulent and a constant struggle. Of the many

facets of Mingus's life, three stand out as the most important: (1) his music, which included some of the most adventurous compositions and arrangements of the era; (2) his entrepreneurial ventures, through which he fought the status quo of the white controlled jazz industry (and included three record labels, two publishing companies, a jazz collective, and a "School of Art, Music, and Gymnastics"); and (3) his combative, confrontational, and un-predictable personality, which made him, according to critic Gary Giddons, "jazz's most persistently apocalyptic voice."[23]

Mingus (April 22, 1922–January 5, 1979) was born in Nogales, Arizona, but grew up in the Watts ghetto in Los Angeles. Because his black father was light-skinned and his mother was of Chinese descent, young Charles's skin tone was such that he was not accepted by either black or white classmates. Being ostracized by both groups left a deep impression on young Charles, and issues of bigotry and racism would become central to his adult life and his music. His mother died when he was an infant. His stepmother gave him an early introduction to black gospel music (against his conservative Methodist father's wishes) by taking him to the Holiness Church, where "People went into trances and the congregation's response was wilder and more uninhibited than in the Methodist church. The blues was in the Holiness churches—moaning and riffs and that sort of thing between the audience and the preacher."[24] The undeniable influences from the Holiness Church—shouts, cries, calls and response, the blues—would remain with Mingus and be a constant feature in the music he wrote throughout his life. After starting on the trombone and moving to the cello, young Mingus settled on the bass as a teen, and progressed quickly. After finishing high school, Mingus endured the usual struggles as he worked his way up the local music scene, but by his early twenties was gigging with Louis Armstrong, Lee Young (Lester's brother), and eventually Lionel Hampton, with whom he played from 1947–1948. Mingus was by this time a much-in-demand sideman who was working in recording studios frequently, and had also begun writing somewhat adventurous music. However, things would occasionally down, and at one point during this time he was forced to briefly take a job as a mailman to make ends meet. His uncompromising nature was also beginning to emerge. He was fired by Hampton after refusing to let the vibist use his mallets on Mingus's bass as part of the act. He also was instrumental in getting the segregated black and white Los Angeles

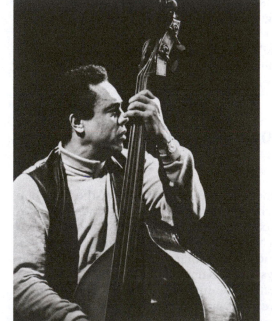

Charles Mingus, "Jazz's most persistently apocalyptic voice."

musicians unions to merge after finding himself often denied job opportunities because of his race. In 1950, Mingus put together a trio with vibist Red Norvo and guitarist Tal Farlow at the Haig (where Gerry Mulligan would soon convene his famous quartet), which garnered him a great deal of exposure and respect. In the summer of 1951, he moved to New York.

The Jazz Workshop

In New York, Mingus soon found himself gigging and recording with Miles Davis and Charlie Parker. His live performances with Parker included the famous May 1953 Massey Hall concert in Toronto and Bird's disastrous final gig at Birdland in March 1955. In 1952, Mingus founded Debut Records with drummer Max Roach, the first of his various business ventures with which he attempted to control his own economic destiny. Soon afterward, Mingus founded the **Jazz Workshop,** which became his working band (and the name of one of his publishing companies) for the duration of his career. The Workshop, usually in the form of a medium-sized ensemble, was a musical laboratory for experimental new compositions. Members were often forced to endure long, demanding rehearsals (causing some to call it a "sweatshop") and the uncompromising standards of its leader. Among those who passed through the Workshop were saxophonists Eric Dolphy, Jackie McLean, Rahsaan Roland Kirk, and John Handy, pianist Jaki Byard, trombonist Jimmy Knepper, and Mingus's longtime drummer, Dannie Richmond. Like Ellington, Mingus wrote specifically with his players' abilities in mind, although he encouraged a much more interactive and spontaneous performance environment. Mingus was also a musical chameleon who refused to settle into a comfort zone with his writing, constantly changing direction by incorporating an endless supply of influences. His rational? "A preacher preaches a different sermon every Sunday. You turn to a different page."[25]

The next ten years were a period of intensive creative output for Mingus. In 1956, he recorded "Pithecanthropus Erectus," a ten-minute tone poem that was "my conception of the modern counterpart of the first man to stand erect," who "goes out to rule the world, if not the universe"[26] and eventually fails and is destroyed. He recorded prolifically in the late 1950s, releasing four LPs in both 1957 and 1959 alone. *The Clown*, from 1957, contains his famous "Haitian Fight Song," an angry diatribe against prejudice and persecution, which contains one of the most sinister bass riffs in the history of jazz. In 1959, Mingus recorded what is often considered his best album, **_Mingus Ah Um,_** which explores the balance between the spontaneous and the pre-composed, and contains several of his enduring masterpieces: "Better Git It in Your Soul," which captures the raw essence of the Holiness Church meetings through shouts, hollers, hand claps, and calls and response; "Goodbye Porkpie Hat," a bluesy requiem to the recently deceased Lester Young; and "Fables of Faubus," a biting (yet musically comical) critique of Arkansas Governor Orville Faubus's attempt to block the entry of the first black students into Little Rock's Central High. Mingus's political interest surfaced again in 1960, when he co-staged the "anti-festival" held simultaneously with the Newport Jazz Festival (which is discussed in greater detail later in this chapter). In 1963, he recorded a solo piano album, titled *Mingus Plays Piano,* in

which he performs three largely spontaneous improvisations, a practice that Keith Jarrett would expand upon further in the 1970s. Also in early 1963, Mingus recorded *Black Saint and the Sinner Lady,* an epic 37-minute ballet written in the form of a six-part suite. *Black Saint—* arguably Mingus's finest work as composer and arranger—was written for eleven musicians who are at times featured soloists (á la Ellington), at times collectively improvising, and at other times scored in rich, thickly textured orchestration. Mingus created a sense of great emotional tension and release through the use of blues tonalities and the increasing and decreasing of tempos. There are several "open" modal sections where Mingus later overdubbed solos, which along with his liberal use of editing make the recording one of the most advanced of its time in its use of studio technology.

The Town Hall Concert

On October 12, 1962, Mingus attempted one of his most ambitious endeavors, a big band recording in front of a live audience, in what has become known as the **Town Hall Concert**. He was unusually slow in getting the scores to his copyists and in the days leading up to the concert, a general state of frenzied urgency set in. (The day before the concert, an angry Mingus punched copyist/trombonist Jimmy Knepper in the mouth, breaking his tooth; Knepper, whose playing was permanently damaged in the incident later filed a lawsuit—and won.) By show time, with the under-rehearsed music still only partially copied, a team of copyists sat at a table on stage, feverishly copying parts and rushing them to the players as they performed. In the end, the performance was, for the audience at least, a musical train wreck, more of a recording session or rehearsal than a concert. The promoter came on at intermission, offering those in attendance their money back; many took him up on the offer and left. Afterward, producer George Wein managed to salvage the best parts of the more than two-hour recording and release a surprisingly good LP of the concert that received 5 stars when it was reviewed in *Down Beat*.

Mingus often took out his rage on inattentive audiences, castigating those who were too busy socializing to listen to the music. In one well-publicized incident at the Five Spot, he threw his bass across the floor and then stomped it into splinters. His uninhibited emotionalism was also evident in his 1971 autobiography, *Beneath the Underdog: The World as Composed by Mingus,* a bizarre and disturbing book that examines, among other things the relationship between playing jazz and pimping. During the 1970s, Mingus taught at the State University of New York at Buffalo, received several grants and honorary degrees, and was able to get his major works performed on a more regular basis. In 1977, he was diagnosed with amyotrophic lateral sclerosis (Lou Gehrig's disease), which eventually caused his death in 1979 in Mexico, where he had traveled with his fourth wife Susan to receive experimental treatment. His ashes were later scattered in the Ganges River in India. After his death, a previously unknown two-hour, nineteen-movement suite entitled *Epitaph* was discovered, which was performed for the first time in 1989 and again in April 2007 during the celebration of Mingus's eighty-fifth birthday. It was conducted on both occasions by Gunther Schuller, who called it "the most important prophetic statement in the history of jazz." Today, Mingus's music is kept alive through the legacy

MUSIC ANALYSIS

TRACK 17: "FREEDOM—PART TWO (AKA CLARK IN THE DARK)"

(Mingus) Charles Mingus from the album *Town Hall Concert* recorded at Town Hall, New York City on October 12, 1962 (3:02). Personnel: Ed Armour, Rolf Ericson, Lonnie Hillyer, Ernie Royal, Clark Terry, Richard Williams, Snooky Young: trumpet; Eddie Bert, Jimmy Cleveland, Willie Dennis, Paul Faulise, Quentin Jackson, Britt Woodman: trombone; Romeo Penque: oboe; Danny Bank: contrabass clarinet; Buddy Collette, Eric Dolphy, Charlie Mariano, Charles McPherson: alto sax; George Berg, Zoot Sims: tenor sax; Pepper Adams, Jerome Richardson: baritone sax; Warren Smith: vibes, percussion; Toshiko Akiyoshi, Jaki Byard: piano; Les Spann: guitar;: Charles Mingus, Milt Hinton: bass; Dannie Richmond: drums; Grady Tate: percussion

Charles Mingus's 1964 Town Hall Concert was portrayed by some in attendance and more than one reviewer as an abject failure, but this view is largely due to a misconception about the nature of the event. While those in the audience thought they were attending a concert that was going to be recorded, Mingus himself was apparently under the impression that it was to be more recording session than concert. As such, there were copyists on stage handing music to the musicians as they worked; there were also a number of false starts and retakes—the kinds of things that typically happen in a recording session. The musicians were also somewhat confused: after arriving in concert

attire and figuring out what was going on, many loosened their ties, and some even lit up cigarettes. Mingus showed up wearing jeans and a T-shirt. To further add to the confusion, stagehands pulled the curtains during the final number, an impromptu jam on Duke Ellington's "In a Mellow Tone." Despite the massive misconceptions with the staging of the concert, it was an undertaking of almost mythic ambitions: a two-hour concert of original music for a 30-piece orchestra. And in the end, Mingus's vision was justified: the LP of the concert won the 1963 *Down Beat Critics* Poll as Album of the Year. (ref: liner notes to *Charles Mingus: The Complete Town Hall Concert* by Brian Priestley; "Town Hall Train Wreck: Why Charles Mingus Came to Grief in 1962" by Gene Santoro, *Village Voice*, June 7, 2000)

0.00	Introduction: saxophones play low register riff while muted brass play mournful chords in background; bass and drums play a laid back two-beat rhythm
0.17	Clark Terry plays a plunger muted trumpet solo; rhythm section continues; brass play a variety of melodic background riffs
2.04	Trumpet solo ends; call and response between brass and saxophones ends in a tone cluster and drum crash

bands that regularly perform in New York and around the world: The Mingus Dynasty, The Mingus Orchestra, and The Mingus Big Band.

Freedom Now!

Jazz and the Movement

Charles Mingus was not the only musician of the era who became politically involved. After all, part of the hard bop aesthetic was formed by the political and social realities of being a black musician in the 1950s. As the civil rights movement intensified, so did the rhet-

oric and activism against segregation in the South. Events that tested Southern compliance with the *Brown vs. Board of Education* ruling included the 1956 Montgomery bus boycott, the 1960 lunch counter sit-ins, and the 1961 freedom rides. Hard bop musicians were keenly aware of the implications of these acts on their music. "Musicians play because of the world around them and what goes on," saxophonist Jackie McLean said. "The civil rights movement. People were screaming. And so the music went that way."[27] Within a short time span, black jazz musicians showed their support for the cause by releasing a spate of civil rights-themed recordings that included Sonny Rollins's *The Freedom Suite* (1958), Randy Weston's *Uhuru Africa* (1960), Oliver Nelson's *Afro-American Sketches* (1961), Art Blakey's *The Freedom Rider* (1961), Max Roach's *Percussion Bittersweet* (1961), and Jackie McLean's *Let Freedom Ring* (1961).

The most significant of these was **We Insist! The Freedom Now Suite,** released in 1960 by drummer Max Roach and singer/civil rights activist Oscar Brown, Jr. The multi-movement suite was inspired by an incident in a Greensboro, North Carolina, Woolworth's lunch counter where four black students were refused service, and the wave of sit-in protests that followed. From that starting point, Roach, who wrote the music, and Brown, who wrote the words, took up the general themes of slavery and emancipation. Roach employed an instrumentation that included three drummers and Nigerian percussionist Olatunji, a horn section that included veteran tenor man Coleman Hawkins, and singer **Abbey Lincoln,** Roach's future wife. The music is powerful and intense, portraying with great emotion the anger of the time. "Driva Man," about the lookout for escaped slaves, features a scorching solo by Hawkins, "All Africa" features an extended percussion break with Roach and his percussionists. The most electrifying moments in *We Insist!,* however, come in the "Protest" segment of the piece titled "Triptych: Prayer/Protest/Peace," when Lincoln erupts into primal screams accompanied by free form drumming. "'Protest' may be the most hair-raising ninety seconds of jazz in existence," states Scott Saul. "Lincoln screams with uninterrupted fury and at high volume, in an act of aggression that doubles as the sound of hurt."[28] Producer Nat Hentoff called it "a final, uncontrollable unleashing of rage and anger."[29]

Anti-Festival

Protest also erupted at the 1960 Newport Jazz Festival, although not all of it was politically motivated. On Saturday night, July 2, the crowd was so large at the festival site in Freebody Park that more than 10,000 young fans were turned away. Angry and to one degree or another drunk, the youths proceeded to riot, throwing beer cans, overturning cars, and smashing windows. The rest of the festival was cancelled. Critics made note of the fact that the festival had been increasingly relying on rock and roll artists like Chuck Berry at the expense of jazz artists to draw crowds. It was also noted that, although most of the concert attendees—and all of the rioters—were white, nearly all of the performers were black. These issues, along with a payment policy that rewarded popular artists over more innovative and ambitious ones were at the heart of the other protest at Newport in 1960, the **Cliff Walk Manor "anti-festival."** Staged just three blocks away from Freebody Park on the grounds of the Cliff Walk Manor Hotel, this festival was organized by Charles Mingus and Max Roach, who took complete control of building stages, promotion

MUSIC ANALYSIS

TRACK 18: "TRIPTYCH: PRAYER/PROTEST/PEACE"

(Roach) Max Roach from the album *We Insist! The Freedom Now Suite* recorded at Nola Penthouse Studios, New York on September 6, 1960 (8:10). Personnel: Abbey Lincoln: vocal; Max Roach: drums

"Triptych: Prayer/Protest/Peace" is the third of five pieces contained in Max Roach's seminal civil rights LP *We Insist! The Freedom Now Suite,* and by far the most volatile. The only performers are Roach and his future wife, singer Abbey Lincoln, whose performance consists primarily of a mournful, funereal improvisation—until the middle "Protest" section, in which she erupts into a screaming rage. (The "Protest" segment is where this track begins.) "I didn't think that screaming was really music, I didn't think it was musical. But it turned out to be," Lincoln later recalled. It is chilling to listen to—even to this day – and is a perfect reflection of the turbulent 1960s. Lincoln, whose given name is Anna Marie Wooldridge, was given her stage name by manager Bob Russell when he said tongue in cheek, "Abraham Lincoln didn't free the slaves, but maybe you can handle it." Lincoln sings with a powerful conviction on three of the other cuts from We Insist!, with lyrics written by Oscar Brown, Jr. The cover—a picture of three young black men sitting at a lunch counter while a white soda jerk stares at them in the background—is a somber reminder of the events that inspired the album, the protests that followed the February 1, 1960 lunch counter incident in Greensboro, North Carolina. (ref: *Jazz: a Film by Ken Burns*, interview with Lincoln; "Abbey Lincoln in Command" by *Larry Blumenfeld, The Wall Street Journal*, July 18, 2007; interview with Lara Pellegrinelli)

0.00	"Prayer" section begins with drummer Max Roach playing sparse fills; singer Abby Lincoln soon enters with ad-lib wordless vocal
3.37	"Protest" section begins with animated drums rolls, screaming vocals
4.57	"Peace" section begins; music is similar to "Prayer"; track ends softly

(which included Mingus driving through town shouting "Come to my festival!"), erecting fences, and collecting contributions from the audience. The idea was to sidestep the festival and the entire jazz industry, with its institutional racism and over-commercialization. From Thursday's opening, which drew ten fans, to Sunday's finale, which drew more than six hundred—all of whom were peaceful—Cliff Walk Manor was deemed a successful rebuke to the main festival. Artists who appeared over the four days included Roach, Mingus's Jazz Workshop, Coleman Hawkins, Roy Eldridge, and Jo Jones. Also appearing was a revolutionary performer who had shaken up the jazz world eight months earlier and is who at the heart of the discussion in the next chapter. His name was Ornette Coleman.

Notes

1. Saul, Scott: *Freedom Is, Freedom Ain't*, pg 16
2. Ibid, pg 2
3. Rosenthal, David H: *Hard Bop: Jazz & Black Music 1955-1965*, pgs 44-45
4. Attributed to producer Bob Porter, found in Rosenthal, pg 120
5. NPR interview, 1/23/99
6. Interview with Jeff Forlenza in *Mix* magazine, 5/1/05
7. Quotes from Bobby Watson in Goldsher, Alan: *Hard Bop Academy*, pg xii
8. Ibid
9. Mathieson, Kenny: *Cookin': Hard Bop and Soul Jazz 1954-65*, pg 41
10. Critic Nat Hentoff wrote a flattering 4/54 *Down Beat* article, titled "Clifford Brown—The New Dizzy"
11. Goldberg, Joe: *Jazz Masters of the 50s*, pg 94
12. Both quotes as reported in Nisenson, Eric: *'Round About Midnight: A Portrait of Miles Davis*, pg 104
13. Spellman, A. B.: *Black Music: Four Lives*, pg 192
14. From an undated interview in *Jazz Central Station*
15. Litweiler, John: *The Freedom Principle: Jazz After 1958*, pg 84
16. Porter: *John Coltrane: His Life and Music*, pg 139; Don Gold reporting on Coltrane at the 1958 Newport Jazz Festival
17. Tynan, John: *Down Beat*, 10/14/60
18. Ibid.
19. From the liner notes to John Coltrane's *A Love Supreme*
20. Gitler, Ira: "'Trane on the Track," *Down Beat*, 10/16/58
21. Hentoff, Nat: "An Afternoon with Miles Davis," *Jazz Panorama*, pg 167
22. From Bill Evans's liner notes to *Kind of Blue*
23. Giddons, Gary: *Visions of Jazz: The First Century*, pg 446
24. Quoted by Nat Hentoff in liner notes to *Charles Mingus—A Modern Jazz Symposium of Music and Poetry*, October 1957; also in Priestly, Brian: *Mingus*, pg 4
25. Mingus, Sue: *Tonight at Noon: A Love Story*, pg 38; also Saul, pg 180
26. From the liner notes to *Pithecanthropus Erectus*
27. Quoted from interview in *Jazz: A Film by Ken Burns*
28. Saul, pg 95
29. Hentoff, Nat: CD insert notes to *We Insist!: The Freedom Now Suite*

Study Questions for Chapter 3

1. Name some of the cultural and musical forces that influenced the music of black jazz musicians in the 1950s.

2. What were some of the clubs and record labels in New York that supported hard bop musicians? Which was the most important label and why?

3. Why were the Jazz Messengers such an influential group? Why is Art Blakey important?

4. Describe why Clifford Brown's rise to fame was so important. What were his contributions to the Clifford Brown–Max Roach Quintet?

5. Why did Sonny Rollins quit the Miles Davis Quintet? Name some of his achievements as a solo artist in the last half of the 1950s.

6. Describe Miles Davis's career path in the 1950s (highlights, recordings, etc.), and some of the reasons why he became a star during this time.

7. Describe how John Coltrane was advancing himself musically in the 1950s. What were some of the things that affected his career and development during this time?

8. Name some of the characteristics of *Kind of Blue*. Why is it such an influential album?

9. Name some of the things that influenced Charles Mingus's music and his outlook on life. In what ways is he comparable to Duke Ellington?

10. Name some of the artistic endeavors by black jazz musicians in the late 1950s and early 1960s to advance the civil rights movement. Describe the characteristics of the album *We Insist! The Freedom Now Suite.*

The New Thing

© 2011, Mark Yuill, Shutterstock, Inc.

Chapter 4

Key Terms, Music, Places, Figures and Bands

Terms

The New Thing
Free jazz
Atonal
The October Revolution in Jazz
Studio Rivbea

Music (albums, works, etc.)

Kind of Blue, Time Out, Mingus Ah Um, Giant Steps, The Shape of Jazz to Come
Unit Structures

Live at the Village Vanguard
A Love Supreme
Out to Lunch!
Angels and Demons at Play

Places

Five Spot Café

Figures and Bands

Ornette Coleman
Cecil Taylor
The John Coltrane Quartet

Eric Dolphy
Sun Ra
Myth Science Arkestra
Archie Shepp
Albert Ayler
Bill Dixon
Association for the Advancement of Creative Musicians (AACM)
Art Ensemble of Chicago
Sam Rivers

Members of the Ornette Coleman Quartet at the Five Spot, 1959

- Ornette Coleman– alto saxophone
- Don Cherry–pocket trumpet, cornet
- Charlie Haden–bass
- Billy Higgins–drums

The Shape of Jazz to Come

On November 17, 1959, the Ornette Coleman Quartet opened at the **Five Spot Café** at Cooper Square in New York's East Village. The club was a small watering hole favored by the abstract expressionist painters and beat writers who made up the city's avant-garde arts community, and was the site of Thelonious Monk's celebrated six-month engagement two years earlier. Coleman had never played in New York City before, and few people had actually heard him or his records. However, reports had been filtering in over the summer that he was a gifted and uniquely original improviser who was going to have a profound effect on jazz. One of the first such reports came from no less than the respected leader of the MJQ, John Lewis, who, speaking of Coleman and his front line mate Don Cherry, said, "They play together like I've never heard anybody play together. Ornette is, in a sense, an extension of Charlie Parker." Coleman and Cherry are extending "the basic ideas of Bird until they are not playing an imitation but actually something new. I think that they may have come up with something . . . very fresh and exciting."[1] The equally respected critic Martin Williams wrote: "What Ornette Coleman is doing on alto will affect the whole character of jazz music profoundly and pervasively."[2] By November, the buzz surrounding the Five Spot engagement had reached a fever pitch. It seemed as though everyone in the New York jazz and arts community was anxious to hear what all the fuss was about. Among the many who flocked to the Five Spot were the music luminaries Leonard Bernstein, Gunther Schuller, and John Hammond. With the overflow crowds, the band was able to extend their engagement by another two months.

Those in attendance experienced one of the most surreal moments in the history of jazz. For one thing, this was a very different looking band. The leader was a small, wiry man who played a white plastic saxophone. His front line partner, Cherry, played the tiny pocket trumpet. Together, they gave the impression that they were playing toy instruments. Bassist Charlie Haden and drummer Billy Higgins were, like Coleman and Cherry, unknowns in New York's

tight-knit jazz community. The band was integrated (Haden was white), a rarity in a time of solidarity among black jazz musicians. There was no pianist. But the most startling thing about the band was their music—it was loud, noisy, chaotic, disorganized, and unstructured. There were no familiar standards. The improvisations seemed to be coming not from the now familiar bebop licks, but from some new foreign jazz vocabulary. Some in the audience were appalled by Coleman's seeming complete lack of conventional technical playing skills. Some called him a fake and left before they could finish their drink. Miles Davis famously said, "The man is all screwed up inside,"[3] while trumpeter Roy Eldridge said, "I think he's jiving, baby. He's putting everybody on."[4] Others said he was the real deal and was playing music that was as revolutionary as bebop had been fifteen years earlier. The mainstream media—including *Newsweek* and *Harper's Bazaar*—ran stories, and in a redux of the "Moldy Figs vs. Moderns" debates of the 1940s, the jazz periodicals were filled with prominent musicians weighing in on one side or another. No one was ambivalent in the controversy. By the time the Five Spot gig was over in early 1960, it seemed that jazz was about to embark on a journey with destination unknown.

1959: The Beginning of Beyond

In fact, by the end of the 1950s, jazz needed to go in a new direction. Creativity and fresh ideas in hard bop and cool were at low ebb, and clichés were becoming commonplace. One writer said that by 1958, "You could tell what a new tune played by the Jazz Messengers would sound like before you heard it."[5] Perhaps it was inevitable that change was on the horizon, as jazz musicians had been striving since the bebop years to constantly innovate and restructure rules. And so it was that in 1959, jazz experienced one of the most artistically creative years in its history. Coleman's debut at the Five Spot culminated a year that saw the release of a number of albums that explored new innovations that together established the notion that "jazz was not just on yet another new course but was rapidly expanding like a galaxy."[6] The groundbreaking albums from 1959 were:

- Miles Davis's *Kind of Blue,* which abandoned the elaborate chord structures of bebop and replaced them with simple modal frameworks, and also utilized a flexible form on "Flamenco Sketches"
- Dave Brubeck's *Time Out,* which explored odd and complex time signatures
- Charles Mingus's *Mingus Ah Um,* which struck a balance between precomposed orchestral jazz and spontaneous free improvisation
- John Coltrane's *Giant Steps,* which, although mostly served as a signpost of the end of the era of overly complex chords structures, was nonetheless the pinnacle of this approach and a benchmark in Coltrane's career
- Ornette Coleman's *The Shape of Jazz to Come,* which broke from nearly all the norms and traditions of jazz, and helped open up a brave new world liberated from conventional chordal or harmonic rigidity

The New Thing—the term first applied to the style that became known as free jazz.

Free Jazz—a jazz style from the 1960s that is characterized by a willingness to break conventional rules and norms.

Atonality is the abandonment of the primary key center or tonality that is present in most Western music (jazz, classical, pop, etc.). Atonal music can sound as if it has no direction or resolution.

The groundbreaking music that Ornette Coleman unleashed in 1959 was initially called **The New Thing,** but his 1960 album *Free Jazz* gave the movement its permanent name. The **free jazz** movement was as revolutionary as bebop had been to an earlier generation; but whereas bebop had built upon the earlier traditions of jazz and was soon absorbed into the jazz ethos, free jazz went about destroying existing traditions and forced nothing less than a rethinking of the creative process. The new frame of mind, of musically leaving things unresolved, which musicians call "playing outside"—a sort of musical "thinking outside the box"—would ultimately have a dramatic impact on the jazz of the 1960s and beyond. In fact, the idea that any musical tradition or convention is open for reinterpretation still guides the creative process for many current jazz musicians. What were these traditions that were attacked, and how did free jazz differ in its approach to them?

- **Form:** Nearly all jazz performance before 1959 adhered to strict song forms (Davis's "Flamenco Sketches" being one noteworthy exception). A song's chorus—its underlying framework—whether 12 or 32 bars long, was strictly followed as if set in stone. Free jazz often dispensed with formal choruses and the head/one-at-a-time solos/head structure in favor of a more spontaneous and open-ended approach.

- **Tonality:** Although dissonance has always been an integral part of jazz, it had generally been used within the context of accepted Western musical melodic and harmonic conventions. Jazz musicians traditionally used dissonant notes as a way of adding tension that they would in turn resolve to reduce the tension and propel the music forward. Free jazz musicians disregarded the tendency to resolve dissonances, and often play in an **atonal** fashion.

- **Vocabulary:** Up until 1959, there had always been an accepted jazz vernacular or language. As we have seen, periodically an innovator comes along who single-handedly rewrites the vocabulary, such as Louis Armstrong did in the 1920s and Charlie Parker did in the 1940s. These masters brought a new vocabulary to replace the old. Free jazz not only rid itself of the current language, but also rejected the very notion of establishing a new standard vocabulary.

- **Role-Playing:** By 1959, the roles that each instrument performed in a group setting were well-established: bass players walked, pianists comped, drummers provided the rhythmic drive, horn players played the melody, etc. Free jazz challenged all of these traditional roles, both by casting instruments into different roles (for example, using drums primarily for adding tonal color rather than rhythm) but also by using non-traditional instrumental groupings.

- **Sound:** Jazz musicians before 1959 were very traditional in their approach to creating sound from their instruments. Even the saxophone, which has the most flexibility of tonal variation of any of the jazz wind instruments, was played in a conventional manner. Free jazz musicians (horn players in particular) explored new ways of producing sound, including squawks, screams, animalistic cries, talking, and microtonal tunings.

- **Commerciality:** From the very beginning, jazz musicians have balanced commercial considerations with creativity. Building an

audience and making a living through record sales, radio airplay, and live performances in clubs were important considerations for even the most innovative musicians—that is, until free jazz came along. By the nature of the music they played, free jazz musicians undermined their ability to achieve any sort of commercial viability.

In the culture of the free jazz movement, all of these principles were under attack. However, free jazz proponents typically did not throw the baby out with the bath water; most often choices were made about which rules to keep and which to reject. For instance, while Ornette Coleman's 1959 group radically departed from conventional performance in nearly all of the above-mentioned areas, the songs they played generally all included an opening statement of the head, an improvised solo section that followed, and a concluding restatement of the head. Although the drums and bass sometimes strayed from conventional time keeping, they still worked in a supportive role to the soloists. This approach of picking and choosing which traditional rules to retain and which to discard would become one of the basic tenets of playing outside.

It is of interest to note that Ornette Coleman and the free jazz proponents who followed him were not the first to test the waters of free expression in jazz. John Coltrane challenged jazz convention with the use of multiphonics and his so-called sheets of sound, techniques that he perfected while playing with Monk in 1957 (at the very same Five Spot Café). In 1949, Lennie Tristano made what are considered to be the first free jazz recordings and recorded the atonal "Descent into the Maelstrom" in 1953. As early as 1948, Gunther Schuller wrote a piece titled "Atonal Studies for Jazz." But these efforts were largely academic "shots in the dark" and curiosities to the jazz mainstream. Ornette Coleman, on the other hand, was an artist fully committed to the idea of free expression. Coleman was willing to make the necessary sacrifices to achieve his ambitions (and we shall see how great those sacrifices were). He became the lightening rod for the burgeoning free jazz movement, and paved the way for Cecil Taylor, Eric Dolphy, Archie Shepp, and others. Although many in the mainstream jazz community at first rejected free jazz, by the end of the 1960s, most were embracing it in one way or another, even those who were at first skeptical if not downright hostile to it. The list of the converted included Sonny Rollins, Miles Davis, Charles Mingus, Wayne Shorter, and the man who would briefly take over the leadership of the free jazz movement before his premature death, John Coltrane.

Ornette Coleman: Patron Saint of Freedom

Paid *Not* to Play

Ornette Coleman's (born March 19, 1930) road to jazz immortality at the Five Spot was long and difficult. Born in Fort Worth, Texas, Coleman's father died when he was seven, forcing the family into extreme poverty. When he was fourteen, his mother scraped together enough money to buy him an alto saxophone, which he taught himself to play. Within a year, he was sitting in with local R&B bands. Playing Forth Worth's black nightclub circuit, Coleman developed a

Alto saxophonist Ornette Coleman in the studio, with bassist Charlie Haden seen in the background.

raunchy, gutbucket sound and style in tune with the R&B cum jazz bands of the era. By his late teens, Coleman was listening to and learning how to play bebop, learning how to read music, and generally working his way into more upscale club work. He was also beginning to realize that R&B and bebop were too restrictive for the music that he wanted to play, and he started to develop an eccentric style and sound that was outside the realm of either. In 1949, he played in several traveling minstrel shows and R&B bands, with which he would occasionally launch into an experimental, unconventional solo. After one such solo in Baton Rouge, a young woman enticed Coleman to step outside during the break, where he was surrounded by three men who savagely beat him and smashed his horn. He spent the next six months in New Orleans working odd jobs while trying to occasionally sit in with local bands. His now developing idiosyncratic style, however, caused most musicians to either walk off the stage or refuse to let him continue. Undaunted, he persevered: "I had been practicing all the time I was on the road with those minstrels and R&B groups. I had a lot of ideas that I just couldn't keep down. I kept hearing all kind of possibilities and I wanted to play them."[7]

By 1950, Coleman joined a road band, but the leader soon tired of his playing so much that he actually paid him not to play, and he fired him as soon as they reached Los Angeles. Stranded, Coleman moved into a Skid Row hotel and lived off canned foods his mother mailed to him for a while before giving up and moving back home to Fort Worth. Two years later, Coleman returned to Los Angeles and found the local jazz musicians were still nearly unanimous in their disdain for his playing. By now he was also wearing a beard, long hair and homemade clothes, and according to one musician, looked like "some kind of black Christ figure, but no Christ anybody had ever seen before."[8] Rejection was a common theme to Coleman's life at this point. One night he went to the Tympani Club to sit in with Charlie Parker, but was told to leave. Another night Dexter Gordon chased him off the bandstand. The Max Roach and Clifford Brown rhythm section packed up their instruments and left once he tried to sit in with them. Unable to get work as a musician, Coleman had to take on a variety of day jobs to support himself, including babysitting. Eventually he managed to hook up with other like-minded young musicians who, like himself, were on the outer fringe of the local scene, and began rehearsing with them in a garage. During these sessions, which included future Five Spot band mates Don Cherry and Billy Higgins, musicians freely and openly exchanged ideas about creating a new language for playing music. They also began learning

MUSIC ANALYSIS

TRACK 19: "LONELY WOMAN"

(Coleman) Ornette Coleman Quartet from the album *The Shape of Jazz to Come* recorded in Los Angeles, May 22, 1959 (6:51). Personnel: Ornette Coleman: alto sax; Don Cherry: cornet; Charlie Haden: bass; Billy Higgins: drums.

1959 was not only an important year in jazz history ("The Beginning of Beyond"), but also in the career of Ornette Coleman. In addition to making his New York debut at the Five Spot in November, he recorded his final album for the LA-based Contemporary Records and made his major label debut with the release of *The Shape of Jazz to Come* on Atlantic. The album begins with what is arguably Coleman's most famous and often-performed composition, "Lonely Woman," a song inspired by a painting he saw in an art gallery in 1954. Perhaps what makes the song so attractive to musicians and listeners is a timeless quality that is created by juxtaposing a free flowing, contemplative melody over a rhythmic bed that is at once understated and urgent. The effect is powerful. The song's harmony does not come from the actual stating of chords (the conventional method), but instead is implied by the interaction of the melodic line played by the horns with Charlie Haden's creative bass playing. The song's architecture is its most conventional aspect, rising out of nothingness, hitting its high point midway through with Coleman's urgent solo, before disappearing once again like a lonely woman in the night. (ref: *Black Music: Four Lives* by A. B. Spellman; *Jazz* by Gary Giddins and Scott DeVeaux.)

0.00	Bassist Charlie Haden and drummer Billy Higgins set up a rhythm that is driving yet has no metric sense (it is impossible to establish a downbeat or sense that there are measures)
0.18	Ornette Coleman and Don Cherry (alto sax and cornet, respectively) enter with statement of head
1.47	As rhythm section continues, Coleman begins alto sax solo
2.23	Background line played by Cherry
2.56	Coleman and Cherry restate head
4.35	Haden and Higgins continue, track fades out

Coleman's newly written original compositions. Although their music was too avant-garde to play in clubs, they managed to get an audition and sign a contract with the small local Contemporary label. In February and March 1958, Coleman, Cherry, Higgins, bassist Don Payne, and pianist Walter Norris recorded *The Music of Ornette Coleman—Something Else!!!!* Despite generally favorable reviews, sales were non-existent.

Fury at the Five Spot

Over the next year, Coleman hooked up with two musicians who were to become pivotal to advancing his career: the MJQ's John Lewis and bassist Charlie Haden. Lewis helped Coleman enroll at the esteemed Lenox School of Jazz in the summer of 1959 (where the faculty included Lewis, Gunther Schuller, and George Russell), and secure a contract with Atlantic Records. Charlie Haden proved to be the perfect bassist to complement Coleman's exploratory style, allowing the group to go without a pianist and open up to further experimentation. This was a different kind of pianoless group than the

famous Gerry Mulligan Quartet of 1952, which stuck religiously to chord progressions and forms. Going pianoless for the Coleman Quartet meant that there was no longer a need to follow established chord changes—an important difference. In 1959 alone, the quartet—Coleman, Cherry, Higgins, and Haden—recorded five albums, including two, the appropriately titled *The Shape of Jazz to Come* and *Change of the Century*, which predated the Five Spot engagement and helped establish Coleman as the visionary leader of the "New Thing." He continued to record prolifically and perform often, including several lengthy stays at the Five Spot.

On December 21, 1960, Coleman recorded the seminal yet controversial album *Free Jazz: A Collective Improvisation* using a double quartet—Coleman, Cherry, Higgins, and bassist Scott LaFaro (who appear in the left channel of the stereo mix) and Charlie Haden, trumpeter Freddie Hubbard, bass clarinetist Eric Dolphy, and drummer Ed Blackwell (heard in the right channel). The album consists of one song, "Free Jazz" of thirty-seven minutes in length. (On its original album release, "Free Jazz" fades out at the end of Side 1 and continues on Side 2; on the compact disc release, it appears as it was recorded: without interruption.) It is one of the most talked about albums in history, and perhaps one of the most misunderstood. On first hearing, "Free Jazz" has the sound of total cacophony, as if the eight musicians are involved in some sort of musical science fiction project. Upon closer inspection, however, the inner construction of the piece becomes clear. There are several sections to the composition, each led by a different "soloist"; the sections are connected by transitional passages. Ekkehard Jost describes the albums modus operandi as "ideas introduced by the 'soloist' of a given section are spontaneously paraphrased by the other players, developed further, and handed back to the originator in altered form."[9] Overall, the album is an important milestone in redefining the highly structured jazz performance form that had been religiously followed since the 1920s. It also paid tribute to the abstract expressionists who frequented the Five Spot by putting a reproduction of Jackson Pollock's drip painting *White Light* on the cover.

The Crude Stables

In the short time between his debut at the Five Spot and the release of *Free Jazz*, Ornette Coleman managed to completely reshape the jazz zeitgeist, but he found himself still bound by playing at what saxophonist Archie Shepp referred to as "the crude stables (clubs) where black men are groomed and paced like thoroughbreds to run until they bleed."[10] When he found out that Dave Brubeck played at the Five Spot for twice the money he received, often for smaller crowds, Coleman tripled his fee but was not hired back. Attempting to take things under his own control, Coleman produced a concert of his music at New York's Town Hall on December 21, 1962. After the event barely broke even, a despondent Coleman withdrew from the music business for more than two years. When he returned in January 1965, in an engagement at the Village Vanguard, he was playing trumpet and violin, which, like the saxophone, he had taught himself to play. He also had a new group—a trio—that consisted of himself, David Izenzon on bass, and Charles Moffett on drums. In a controversial move, he recorded the 1966 album *The Empty Foxhole* with his

ten-year-old son Denardo on drums. Throughout the late 1960s, he began to expand his horizons, writing music for small string and wood-wind ensembles as well as major orchestral works such as 1972's *Skies of America,* recorded with the London Symphony Orchestra. In the 1970s and 1980s, he began experimenting with electronic free funk with his group Prime Time (Chapter 7), which has at times included two electric guitars, two drummers, and two bassists. His other record-ing projects in his later career include 1985's *Song X,* a collaboration with guitarist Pat Metheny, and his collaboration with composer Howard Shore for the soundtrack to the film *Naked Lunch* in 1992.

Ornette Coleman is one of the most important figures in the his-tory of jazz. As we shall see, his influence on jazz in the 1960s was dramatic and indisputable. Like Louis Armstrong and Charlie Parker before him, Coleman's playing introduced a new vision for jazz and a new vocabulary. He was widely criticized for his lack of traditional technique and general playing skills when he broke onto the scene, but in retrospect, it is all too obvious that his style, like those of Armstrong and Parker, was deeply rooted in the blues and was always intensely lyrical. His compositions, which include "Lonely Woman," "Una Muy Bonita," "Peace," and "Congeniality," have not quite achieved the rank of jazz standards, yet they have become ingrained in the jazz repertoire. Coleman's music has also been interpreted in a number of different stylistic settings (one measure of determining its enduring quality), including thrash-metal (by John Zorn), country (Richard Greene), introspective solo piano (Fred Hersch), and fusion (Pat Metheny). On February 11, 2007, Coleman was awarded a Lifetime Achievement Award at the forty-ninth Grammy Awards telecast, at which time he remarked, "It's good to know that human beings know of you and have some faith in what you're trying to do."

Cecil Taylor: The Seer

Imaginary Concerts

"Call Ornette the shepherd and Cecil the seer," said tenor saxophonist Albert Ayler in describing the roles of the two free jazz visionaries of the 1960s. Although they are often mentioned in the same breath, Ornette Coleman and **Cecil Taylor** came from remarkably different backgrounds and carved out different niches for themselves in the free jazz movement. Living in New York City, Taylor (born March 15, 1929) began taking piano lessons at age five at the urging of his mother, a former actress and dancer. It is notable that he also studied percussion in his youth. In 1951, he enrolled at the prestigious New England Conservatory of Music (NEC) in Boston where he stud-ied theory, composition, and piano graduating in 1953. Although Taylor encountered institutional discrimination at NEC and later claimed, "I learned more music from [listening to] Duke Ellington than I ever learned from the New England Conservatory,"[11] he also assimilated the works of the European avant-garde composers Arnold Schoenberg, Anton Webern, Bela Bartók, and Igor Stravinsky, all of whom became powerful influences in his own music. But Taylor had also made a strong connection to jazz by this time. His musical idol was Duke Ellington, who came from a similar middle-class background and whose music often combined elements of the European and

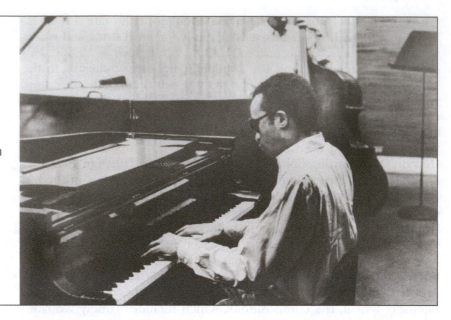

Cecil Taylor, in an undated photo from the 1960s.

African musical traditions. Taylor also became interested in the piano playing of Dave Brubeck and Lennie Tristano (who often played Boston nightclubs) primarily because of their European influenced styles. Of Brubeck he said, "I was very impressed with the depth and texture of his harmony," whereas Tristano "was able to construct a solo on the piano" and had "the line thing,"[12] referring to his long melodic improvisations. Both thick harmonic textures and complex melodic lines became important elements in Taylor's mature piano style.

Upon graduation from NEC in 1953, Taylor moved back to New York, where, as in Coleman's early career, he often found himself matched with musicians unable to understand his style or unwilling to work with him for long. However, like Coleman, he eventually gravitated to the fringes of the music scene where he found kindred spirits. He released his first album in 1956, *Jazz Advance,* which included three musicians with whom he would work often over the next few years: bassist Buell Neidlinger, soprano saxophonist Steve Lacy, and drummer Dennis Charles. Although the album contains tunes by Monk and Ellington and two standards, elements of Taylor's avant-garde style are already present, including the use of dense tone clusters, an extremely percussive attack, and very fast Tristano-like melodic lines. In addition, his playing had a non-flowing, rigid rhythmic quality, and did not swing in the conventional sense. Like Monk and Brubeck before him, Taylor would generate much discussion from critics for years over this aspect of his playing. The album generated positive response from jazz critics Whitney Balliett and Martin Williams, and helped Taylor secure a six-week engagement at the Five Spot (which helped establish it as the hang for avant-gardists) and an appearance at the 1957 Newport Jazz Festival (albeit a sparsely attended afternoon session). Then, suddenly for some reason, work became scarce and hard to come by. To make ends meet, Taylor worked at various times as a deliveryman, cook, dishwasher, and record salesman. He held imaginary concerts in his loft to try to retain the energy of performing before live audiences. He was encountering the same obstacles in New York that Ornette Coleman

MUSIC ANALYSIS

TRACK 20: "WITH (EXIT)"

(Taylor) Cecil Taylor from the album *Conquistador!* recorded October 6, 1966 at Van Gelder Studios, Englewood Cliffs, New Jersey (19:22). Personnel: Cecil Taylor: piano; Bill Dixon: trumpet; Jimmy Lyons: alto sax; Henry Grimes, Alan Silva: bass; Andrew Cyrille: drums

"With (exit)" is a great example of the challenging music that Cecil Taylor wrote and recorded in 1966 during one of the most intensely creative periods of his career. By this time Taylor had dispensed with conventional pulse-driven music in favor of that which was metrically free and often required his performers to abandon their conventional instrumental roles. Needless to say, it also put great demands on his audience as well; critic Leonard Feather once said after a Taylor performance that "anyone working with a jackhammer could have achieved the same results." Taylor recorded three albums that year, *Unit Structures, Conquistador!*, and *Student Studies*, and while each employs his working quartet of saxophonist Jimmy Lyons, bassist Alan Silva, and drummer Andrew Cyrille, Taylor augmented the first two with additional musicians. On *Conquistador!*, Taylor brings in trumpeter Bill Dixon ("The October Revolution in Jazz" producer), who plays an extended solo in the song's middle section, and a second bassist, Henry Grimes, who spends much of "With (exit)" creating sweeping harmonic effects. Although today *Unit Structures* and *Conquistador!* are regarded as classics, Taylor's music continued to be obtuse to many, and he only recorded two more albums in the 1960s. (ref: "A Conversation with Gary Giddins," *Jerry Jazz Musician*, March 13, 2003; *The Freedom Principle: Jazz After 1958* by John Litweiler)

was encountering simultaneously in Los Angeles: hostility from audiences, club owners, and even fellow musicians. Singer Billy Eckstine said of one of Taylor's albums, "It sounds like somebody trying either to tune a piano—or to chop it up."[13] Taylor noted with irony that in 1961, when a feature article on him appeared in *Down Beat,* he was washing dishes, "but by that time I knew why I was washing dishes."[14]

Undeterred, Taylor continued to record and perform sparingly with the Neidlinger/Lacy/Charles group. In 1958, he recorded for the first and only time with John Coltrane on the album *Cecil Taylor—Hard Driving Jazz,* a session in which trumpeter Kenny Dorham reportedly chafed at Taylor's comping behind his solos. (The album was later released under Coltrane's name as *Coltrane Time.*) In the early 1960s, Taylor began integrating other saxophonists into his group, including young tenor players Archie Shepp and Albert Ayler, and alto player Jimmy Lyons in 1962, with whom he would play continuously well into the 1980s. Taylor began to depart from music based on a traditional beat with the addition of drummers Sunny Murray in 1960 and Andrew Cyrille in 1964. Excellent examples of the metrically free rhythmic direction of the group (by now known as the Unit) can be heard in the 1966 albums ***Unit Structures*** and *Conquistador.* Liberating himself from a steady beat became one more barrier for Taylor's audiences to work through however, and paying jobs remained scarce throughout the

1960s. In the 1970s, as Black Studies departments were initiated on college campuses in response to the civil rights movement, Taylor obtained teaching appointments at the University of Wisconsin, Antioch College, and Glassboro State College. He also received a Guggenheim Fellowship in 1973. He has also often performed and recorded in solo piano settings, which display his tremendous explosiveness and aggressive style. One of his most important solo piano albums is *Silent Tongues,* recorded live in 1974. Taylor also participated in one of the more interesting piano recitals in jazz history on April 17, 1977, when he and Kansas City blues pianist Mary Lou Williams performed a duet at Carnegie Hall, which one reviewer described as "madness."

John Coltrane: Avant-Garde Avatar

The Coltrane Quartet

As the 1950s came to an end, John Coltrane was at an artistic threshold. His 1959 landmark album *Giant Steps* was the culmination of the first part of his career, which was characterized by his sheets of sound technique, his fascination with complex harmonies, and his membership in Miles Davis's Quintet and Sextet. But now it was time to go in a new direction, away from the complexities of *Giant Steps* and toward the simple, wide-open modal structures of Davis's *Kind of Blue.* It was also time to lead his own working group for the first time in his life. A few weeks after quitting Davis's group in early 1960, Coltrane opened at New York's Jazz Gallery with his new group, the **John Coltrane Quartet,** which initially included bassist Steve Davis, drummer Pete La Roca, and pianist Steve Kuhn. Although the eight-week gig was a success, soon after it ended Coltrane made personnel changes that brought in 21-year-old McCoy Tyner on piano and Elvin Jones on drums. Both were perfect complements for Coltrane: Tyner's comping was energetic and had an open quality that lent itself to freer improvisation, while Jones

§ *Members of The Classic John Coltrane Quartet*

- John Coltrane–tenor, soprano saxophone
- McCoy Tyner–piano
- Jimmy Garrison–bass
- Elvin Jones–drums ∿

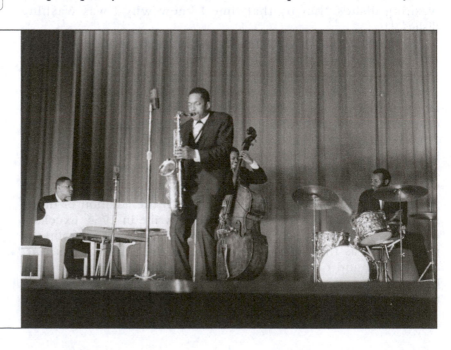

The John Coltrane Quartet in 1962. (Left to right) McCoy Tyner, John Coltrane, Jimmy Garrison, Elvin Jones.

was a bombastic, polyrhythmic powerhouse who could provide the energy and support for long, extended solos. Around this time, Coltrane also began playing the soprano saxophone, an instrument pitched an octave higher than the tenor, and one that had been largely ignored by jazz musicians since Sidney Bechet played it in the 1920s (one notable exception was Cecil Taylor's colleague Steve Lacy). The first full album recorded by the new quartet was *My Favorite Things,* whose title track came from the Rodgers and Hammerstein musical *The Sound of Music.* Both the uplifting rendition of that song and the album as a whole were a hit with fans and critics. It was the listening public's first hearing of Coltrane on the soprano saxophone and the modal harmonies that would characterize much of his new group's music. The title track alone contains several extended, open-ended modal improvisations by both Coltrane and Tyner.

Over the next two years, Coltrane continued to explore modal harmonies, longer and longer solo improvisations, and the soprano saxophone. There were personnel changes as well. Bassist Davis was replaced by Reggie Workman, who was in turn replaced by Jimmy Garrison, completing the lineup that is often called the "classic" Coltrane Quartet. In 1961, Coltrane signed with producer Bob Thiele's new Impulse! label, and given a $50,000 advance—big money for a jazz artist at the time. Coltrane also added a fifth member to the group, bass clarinetist **Eric Dolphy,** a veteran of both Charles Mingus's groups and Ornette Coleman's *Free Jazz* album. Dolphy (who would stay with the group for roughly six months) improvised in a style that bordered on the fringes of free jazz, and often evoked screams, squawks, and other non-traditional sounds. One of the first albums from the new group was *Live at the Village Vanguard,* recorded in early November 1961 at the storied Greenwich Village club. It proved to be controversial, especially for those who had become accustomed to the joyous sound of Coltrane on "My Favorite Things." *Live at the Village Vanguard* contains only three songs, and Side B consists of only one song, the sixteen-minute, 12-bar blues "Chasin' the Trane." Coltrane's high-energy eighty-chorus solo, played with only bass and drums accompaniment, is filled with wails, cries, and screams. It is as intense as anything that he had recorded to this point.

A Love Supreme

By this time, Coltrane (and Dolphy to a lesser extent) was getting a fair share of criticism not only for the length of his solos (which in clubs would often last half an hour or longer), but also for their content. One of the many critics was *Down Beat* associate editor John Tynan, who wrote a scathing review criticizing both saxophonists after hearing them perform live. Tynan termed what he heard "musical nonsense . . . a horrifying demonstration of what appears to be a growing anti-jazz trend," and "gobbledegook," and that "Coltrane and Dolphy seem intent on deliberately destroying the essence of jazz."[15] Coltrane, a gentle and earnest man, took the criticism in stride, saying that the solos were long because the musicians in the band "try to use all their resources in their solos. Everybody has quite a bit to work on."[16] But Coltrane wasn't just about long, exploratory solos. In 1962 and 1963, he released three albums of standards that bewildered

MUSIC ANALYSIS

TRACK 21: "CHASIN' THE TRANE"

(Coltrane) John Coltrane Quartet from the album *Live at the Village Vanguard* recorded November 2, 1961 (16:11). Personnel: John Coltrane: tenor sax; Jimmy Garrison: bass; Elvin Jones: drums

At over 16 minutes in length, "Chasin' the Trane" takes up the entire Side B of John Coltrane's legendary album *Live at the Village Vanguard.* At the time this recording was made, Coltrane had just signed with Impulse! Records, switching from Atlantic, where he had first achieved commercial success with his album *My Favorite Things.* Coltrane had also added bass clarinetist/alto saxophonist Eric Dolphy to his quartet, although Dolphy and pianist McCoy Tyner do not perform on this particular cut. By the time "Chasin' the

Trane" was recorded, Coltrane's solos were becoming more exploratory, often lasting for half an hour or longer and containing unconventional sounds and effects (to the great consternation of the critics of the day). "Chasin' the Trane" is exemplary of this approach, and Coltrane's endurance and force of will are astonishing, as is the constant support and drive that bassist Jimmy Garrison and drummer Elvin Jones provide. Another interesting observation about "Chasin' the Trane" comes from critic Gary Giddins, who notes that the song doesn't really have a beginning or an ending: it just starts and stops. "The performance is all middle, an immense tide, a transition." (ref: *Visions of Jazz: The First Century* by Gary Giddins)

many critics and fans. On each of them, *Ballads, Duke Ellington and John Coltrane,* and *John Coltrane and Johnny Hartman,* he plays with beautiful lyricism. In 1964, he also released the somber *Crescent,* an album in which he does not even solo on Side B. Although these albums do not necessarily indicate a change of direction for Coltrane, they do point out that he was a deeply sensitive musician who could play in a variety of different styles and could nuance his playing as he saw fit. (Remember, he played on two of the era's most conceptually dissimilar jazz albums within a couple of weeks of each other in 1959, *Kind of Blue* and *Giant Steps.*)

But in fact, Coltrane was moving in a new direction with his music. Like every other jazz musician in the early 1960s, he was clearly aware of the "New Thing" movement and the work of Ornette Coleman, Cecil Taylor, and others. Although his long exploratory solos in the early 1960s were clear signs that he was heading in the direction of musical freedom, it wasn't until the end of 1964 that he began to totally commit to free jazz. The album that signaled a transition to this most turbulent and final chapter to Coltrane's career, *A Love Supreme,* is also perhaps his greatest. Recorded in one night, December 9, 1964, at the Van Gelder Studio, the album is a four-part meditation inspired by his decision to refocus on his spiritual awakening of 1957. It is a deeply moving, devotional album, a musical meditation. The four parts, "Acknowledgement," "Resolution," "Pursuance," and "Psalm" recall a personal religious journey—Coltrane's own—and, in this way, it is also his most intimate and confessional album. It also marked a turning point, for this moment on, Coltrane's music would get increasingly spiritual, freer, and adventurous. Other spiritually bound albums include *Meditations* and *Transition,* both from 1965. Clearly, he was

MUSIC ANALYSIS

TRACK 22: "ACKNOWLEDGEMENT"

(Coltrane) John Coltrane Quartet from the album *A Love Supreme* recorded at the Van Gelder Studio, Englewood Cliffs, New Jersey, on December 9, 1964 (7:47). Personnel: Coltrane: tenor saxophone; McCoy Tyner: piano; Elvin Jones: drums; Jimmy Garrison: basss

In 1964, four years after forming his quartet, John Coltrane had a spiritual reawakening, in which he refocused himself on the personal religious journey that he had embarked on in 1957. The result was his greatest album, *A Love Supreme*. Recorded in one night at the Van Gelder Studio, *A Love Supreme* is a four-part meditation, and his most personal album. From this point on until his death in July 1967, Coltrane's music became increasingly spiritual and more musically adventurous. The tone for the album is set immediately with Coltrane's opening fanfare-like theme and the suspended cymbal work of drummer Elvin Jones. The nearly 33 minutes-long album is hypnotic and meditative,

and at times seems to stretch the boundaries of physical endurance for the players—and the listeners. The excerpt presented here is the first four minutes of Part I; subsequent parts are entitled "Resolution," "Pursuance" and "Psalm."

0:00	Opening fanfare played by John Coltrane; pianist McCoy Tyner plays tremolo chords, while drummer Elvin Jones plays suspended cymbal rolls
0:31	Bassist Jimmy Garrison begins playing the hypnotic four-note ostinato on which the movement is built; Jones and Tyner make entrances
1:04	Coltrane enters; in the course of his long, exploratory improvisation he quotes the bass ostinato on several occasions, often plays in the altissimo register (above the standard range of the tenor sax), and plays multi-phonics (two notes simultaneously), which he does at 3:51

on a spiritual path on the last years of his life; however, there is also strong hearsay evidence that Coltrane was also experimenting with LSD during this period, a hallucinogen that was legal until late 1966. Coltrane's interest in the music of other cultures was also a part of his musical explorations, with compositions such as "Africa," "India," and "Liberia" from this period being among the best examples. Later compositions such as "Kulu Sé Mama" and "Ogunde" used African instruments such as the bata drum and kalimba, as well as African vocalizations.

The Final Chapter

On June 28, 1965, Coltrane recorded *Ascension*, one of the most controversial albums of his career, and one that exceeded even Ornette Coleman's *Free Jazz* in the scope of its assault on musical convention. The music on *Ascension*—one forty-minute collective improvisation—is played by an eleven-piece ensemble that included his regular quartet, a second bassist, two additional tenor players, two trumpet players, and two alto players. Although the album is infinitely more difficult to listen to than *Free Jazz,* and is probably not as successful on an aesthetic level, it did put Coltrane into the vanguard of the free jazz movement. From the standpoint of an artistic commentary on the turbulent state of American society in the 1960s, however, *Ascension* is more

successful than any other jazz album of the era (although there is no proof that this was Coltrane's intent). Other adventurous albums followed, including *Kulu Sé Mama, Om, Sun Ship, Expression* (in which he plays flute), and *Interstellar Space* (a duet with his new drummer Rashied Ali). Unfortunately, Coltrane's headfirst leap into free jazz did not last long. His health began rapidly deteriorating in 1966 due to the onset of liver cancer. At his last live performance, at the African Arts Center in Harlem on April 23, 1967, he was overweight and had to sit down while playing. He died on July 17.

John Coltrane was the most influential musician of the 1960s. Musicians who dismissed Ornette Coleman and Cecil Taylor (who came into jazz as "outsiders"), could not ignore Coltrane's musical journey, for he was the ultimate "insider" who worked his way up through the ranks as a sideman in the 1950s and eventually led his own group, which ultimately shaped the dialogue of the free jazz movement in the 1960s. His influence was seemingly ubiquitous. Saxophonists almost immediately started to harden their sound to emulate his. Jazz musicians on all instruments started to play longer solos and investigate his ideas in modal improvisation. Even rock bands, most famously the Grateful Dead and the Doors, were avid fans who modeled their improvisations after the Coltrane Quartet. Coltrane was a prolific composer, whose many compositions range from the harmonically complex "Giant Steps" to beautiful ballads like "Naima," thirty-two-bar modal tunes like "Impressions," and mesmerizing hypnotic works such as "Alabama." He was also a gifted interpreter of other composer's works: witness his rendition of "My Favorite Things." In the mid-1960s, he won nearly every *Down Beat* readers poll on both tenor and soprano saxophone, while his quartet was winning for best group. He popularized the soprano sax, an instrument on which nearly every jazz saxophonist now doubles. His passionate quest for spiritual purity was an inspiration to musicians and fans alike. Above all, he was a restless seeker of new ideas, new knowledge, and new ways to increase his understanding of music and his own humanity. This was the driving force behind his remarkable musical evolution.

"There is never any end. There are always new sounds to imagine, new feelings to get at. And always, there is the need to keep purifying these feelings and sounds so that we can really see what we've discovered in its pure state. So that we can see more clearly what we are. But to do that at each stage, we have to keep on cleaning the mirror."[17]

Eric Dolphy: Out to Lunch

Making Music with the Birds

In some ways, Eric Dolphy's career resembled that of his friend John Coltrane. Both men worked their way up through the ranks as sidemen in prominent jazz groups before embarking on brief but prolific solo careers. Both succumbed early to fatal disease—Coltrane at age forty to cancer, Dolphy at age thirty-six to diabetes. Both produced some of the most provocative music of the 1960s in their final

years; however, Dolphy never reaped the financial gains from record sales or live performances that came to Coltrane, and struggled to make ends meet to the very end of his life. Dolphy also abstained from drugs and alcohol throughout his life. Dolphy was a rare multi-instrumentalist who was equally at home on the alto saxophone, clarinet, bass clarinet, and flute, and was the first jazz musician to really excel at playing the latter two. Although his roots were planted deeply in bebop and hard bop, by the end of his life, he had developed a uniquely individual and virtuosic style that fully embraced the avant-garde. Dolphy (June 20, 1928–June 29, 1964) was born in Los Angeles, where his first exposure to music came from singing in the church choir. He later picked up the clarinet and flute, and often practiced the flute in his backyard where he mimicked the songs of birds. He soon began playing the alto saxophone, and, by his late teens, started to work in R&B bands along Central Avenue. Around this time, he turned his attention to jazz, and by his mid-twenties had become a well-respected figure in the local underground scene, often jamming with the struggling Ornette Coleman. In 1958, he gained national exposure for the first time by joining the popular Chico Hamilton Quintet, with whom he played until the group broke up in November 1959. Then, just as Coleman was making his debut in Greenwich Village, Dolphy moved to New York and joined Charles Mingus's Jazz Workshop.

Eric Dolphy, in a photograph taken in Bologna, Italy, shortly before his death.

Dolphy quickly became a major player in the New York jazz scene. In 1960 alone, he recorded three albums under his own name, toured Europe with Mingus, played on Ornette Coleman's *Free Jazz* album, and took part in the Cliff Walk Manor anti-festival at Newport. (Incredibly, Dolphy's third album *Far Cry* was recorded in its entirety on the same day that he recorded Coleman's *Free Jazz*.) By this time, Dolphy was already demonstrating his musical trademarks: the use of several woodwind instruments and the complete technical mastery of each, a willingness to take chances musically, being comfortable playing in both "inside" and "outside" settings, and the writing of strikingly original compositions. His first album, *Outward Bound*, includes solos on bass clarinet, alto saxophone, and flute. The album contains one of the most definitive recordings of the jazz standard "On Green Dolphin Street." His second album, *Out There*, pairs Dolphy and future Miles Davis bassist Ron Carter on cello, backed with only bass and drums support (making it one of the few jazz albums until recent years to use the cello as a front line instrument). His third album, *Far Cry*, includes a beautiful solo alto saxophone

MUSIC ANALYSIS
TRACK 23: "THE BARON"

(Dolphy) Eric Dolphy Quartet from the album *Out There* recorded August 15, 1960 at Van Gelder Studio, Englewood Cliffs, New Jersey (2:55). Personnel: Eric Dolphy: bass clarinet; Ron Carter: cello; George Duvivier: bass; Roy Haynes: drums

Eric Dolphy's second album *Out There* is a fascinating listen as a showcase for Dolphy's multi-instrument virtuosity (he plays alto sax, flute, clarinet and bass clarinet) and compositional skills (he wrote four of the seven compositions). It is also unusual in the respect that well-known bassist Ron Carter plays cello, an instrument occasionally used in the Chico Hamilton Quintet in the late 1950s, a group of which Dolphy had briefly been a member. Dolphy also eliminates the piano on the album, a practice that had become de rigueur in the free jazz world since Ornette Coleman burst on to the scene in 1959.

Dolphy himself was coming into his own at the time he recorded *Out There*: earlier in the year he participated in the legendary Cliff Walk Manor 'anti-festival' with Charles Mingus and Max Roach; later in the year he would quit Mingus's Jazz Workshop (an indication of his growing stature as a leader and sought-after sideman) and participate on Ornette Coleman's seminal album *Free Jazz*. (ref: *Eric Dolphy: A Musical Biography and Discography* by Vladimir Simosko and Barry Tepperman; *The Freedom Principle: Jazz After 1958* by John Litweiler)

0:00	Head is stated by Eric Dolphy on bass clarinet and Ron Carter on cello
0:40	Cello solo by Carter
1:18	Bass clarinet solo by Dolphy
2:41	Last snippet of the head is restated by Dolphy and Carter

recording (rare for the time) of the standard "Tenderly." Dolphy's work with Mingus was also compelling. His bass clarinet work on "What Love" (from *Charles Mingus Presents Charles Mingus*) evokes the sound and inflections of speech, including squawks, grunts and cries.

Although Dolphy would continue to work with Mingus off and on until his death, he also recorded and performed with a who's who of the jazz world, most famously a six-month stint with John Coltrane in 1961–1962. By the early 1960s, Dolphy had earned a reputation as an experimentalist on par with Ornette Coleman, but because he was so technically proficient on his various instruments and was easily able to fit into any musical context, he was in great demand as a sideman (unlike Coleman). Consequently, Dolphy can be heard playing in an avant-garde style with Coltrane or Mingus and playing lyrically beautiful in other settings (a great example being his "'Round About Midnight" alto saxophone solo on George Russell's *Ezz-thetics* album). He also recorded frequently with the MJQ's John Lewis, Gil Evans, pianist Andrew Hill, and trumpeter Booker Little. Dolphy's crowning achievement is his 1964 album ***Out to Lunch!*** Recorded in one day (as were most Dolphy albums) at the Van Gelder Studios, the album features Dolphy on alto saxophone, bass clarinet, and flute in a quintet setting that includes Freddie Hubbard on trumpet, eighteen-year-old Tony Williams on drums, and Bobby Hutcherson on vibes. The five songs, all Dolphy originals, include "Hat and Beard," which evokes Thelonious Monk; "Gazzelloni," named after classical flautist Severino Gazzelloni; and "Straight Up and Down," which conjures up images of a staggering drunk. Although the music is highly structured and

organized in a conventional manner, Dolphy and his musicians play with an "outside" approach that gives the album an avant-garde sound. Soon after the recording, he left on a European tour with Charles Mingus. On June 28, Dolphy collapsed in Berlin, and was taken to the hospital, where he died the next day after falling into a diabetic coma.

Sun Ra: Intergalactic Traveller

Saturn Calling

One of the few free jazz musicians to work in the environment of a big band was Herman Poole Blount, who throughout much of his career went by the name **Sun Ra.** Ra was an enigmatic figure who succeeded in surrounding himself in an aura of mystery through his often puzzling music, the cultishness of his band (known variously as the **Myth Science Arkestra,** the Solar Myth Arkestra, and other names, they lived together and spent many hours in closed rehearsal) and his cryptic statements about his music and his purpose in being here in the first place (he claimed he was from Saturn). For example: "I never wanted to be a part of planet Earth, and I did everything not to be a part of it. I never wanted their money or their fame, and anything I do for this planet is because the Creator of the universe is making me do it." In addition, he said, "I've chosen intergalactic music, or it has chosen me. Intergalactic music concerns the music of the galaxies. It concerns intergalactic thought, intergalactic travel, so it is really outside the realm of the future on the turning points of the impossible, but it is still existent, as astronomy testifies."[18] With statements such as these, Sun Ra gives notice to his listeners: prepare thyself for the unexpected.

Sun Ra (May 22, 1914–May 30, 1993) was born and raised in Birmingham, Alabama. In his youth, he studied piano and was already writing songs by his early teens. Sometime around 1936 or 1937, he claimed he was abducted by aliens and taken to Saturn. "My whole body changed into something else . . . I wasn't in human form . . . they teleported me and I was down on a stage with them . . . they had one little antenna on each ear. A little antenna over each eye. They told me . . . I would speak [through music] and the world would listen."[19] Although the effects of this experience would be

Sun Ra, whose "slave name" was Herman Poole Blount.

life changing, they would not surface immediately. In the mid-1940s, he moved to Chicago where he spent a number of years arranging music for the floorshows at the Club DeLisa. In 1952, he legally changed his name to Le Sony'r Ra to rid himself of his "slave name" of Blount. Around this time, he put his first band together, which from the beginning experimented with exotic costumes and unusual African instruments, and over time gradually expanded into a big band. Although many of the arrangements were fairly conventional and bebop influenced, there were also occasionally hypnotic modal tunes, as evidenced by the variety of music on the 1957 album *Supersonic Jazz*. On this album, Sun Ra used an electric piano, making him one of the first jazz musicians (other than guitarists and organists) to use electronic instruments. It was also during the late 1950s that the group began calling itself the Arkestra and wearing the outer space and Egyptian-themed costuming that would become staples of their live performances.

In 1961, in the group—which by this time included long-standing members John Gilmore, Marshall Allen, and Pat Patrick (all saxophonists)—moved to New York. With few prospects for generating income through gigs and the increased cost of living in New York, the band began living communally. With the move, the focus of their music began to gradually shift toward free jazz, beginning with the transitional album *The Futuristic Sounds of Sun Ra* (1961) and continuing through ***Angels and Demons at Play*** (recorded in 1956, released in 1963). By 1965 and the release of *The Heliocentric Worlds of Sun Ra,* an album with no apparent pre-arranged musical components of any kind, the evolution to free jazz was complete. Sun Ra took part in the October Revolution in Jazz in 1964 and joined the Jazz Composers Guild for a brief period. In 1966, the band got a steady Monday night gig at Slug's Saloon in New York's Lower East Side, which gave them steady exposure in the city's avant-garde art scene for several years. Sometime in the late 1960s, the Arkestra moved to the Germantown section of Philadelphia, where they remained until their leader's death in 1993. Sun Ra continued to write, record, and tour until the end, and continued to experiment with electronic keyboards, including the clavioline, which he used extensively on 1965's *The Magic City,* and the Moog synthesizer, which he used as early as 1969. Other highlights from his last years included a stint as an artist in residence at UC Berkeley and an appearance on *Saturday Night Live* in 1978.

Archie Shepp and Albert Ayler

Two other notable free jazz musicians were tenor saxophonists Archie Shepp and Albert Ayler. **Archie Shepp** (born May 24, 1937) was born in Florida but grew up in Philadelphia, where he started playing the saxophone in high school. After graduating in 1959 from Goddard College in Vermont where he studied drama, he attempted to work his way into an acting career without luck. In 1960, he began playing with Cecil Taylor, with whom he made five albums in 1960 and 1961. Shepp formed a Coleman-esque pianoless quintet in 1963, the New York Contemporary Five with trumpeter Don Cherry, alto saxophone player John Tchicai, bassist Don Moore, and drummer J. C. Moses. Together, they recorded four albums in a two-year period. Around this time, he befriended John Coltrane, who

recommended that Shepp be signed to Impulse! Records, with whom he released his 1964 album *Four for Trane* with a four-horn pianoless sextet. Shepp also began working with Coltrane around this time, recording an unreleased version of *A Love Supreme* with Coltrane's group the day after the released version was recorded and also taking part in Coltrane's album *Ascension* in 1965. In the late 1960s, Shepp became increasingly Afro-centric in his political stance, which is reflected in his albums *Fire Music* and *The Magic of Ju-Ju* from that period.

Albert Ayler (July 13, 1936–November 25, 1970) was born in Cleveland, where he worked his way up through the city's R&B scene in his late teens. After a mid-1950s stint in the army, Ayler found little success in renewing his music career, so he moved to Sweden in 1962, where he made his first recordings. Upon his return to the United States in 1964, he recorded his breakthrough album, *Spiritual Unity,* which was a trio date with bassist Gary Peacock and drummer Sunny Murray. By this time, Ayler was stretching the boundaries of not only jazz, but also conventional saxophone playing in a quest to extend beyond playing mere notes and instead to create pure sound. His playing included squawks, squeaks, barks, moans, and what Ted Gioia has described as "hieroglyphics of sound representing some hitherto unknown sublunar mode; tones Adolphe Sax never dreamed of, and Selmer never sanctioned,"[20] (referencing the instrument's inventor and top manufacturer). Having said that, Ayler's compositions are often comprised of simple folk-like melodies, as in "Ghosts" from *Spiritual Unity.* In 1965, Ayler began working with his brother, trumpeter Donald Ayler, and their music slowly drifted away from free jazz into rock, R&B, blues, and gospel-influenced music. Alyer's final years were spent largely in poverty. He disappeared on November 5, 1970; his body was found floating in the East River on November 25. Although rumors persisted about suicide or foul play, his death has never been explained.

The 1960s Free Jazz Collectives

The October Revolution

The free jazz movement emerged at an inauspicious moment in jazz history. By 1960, the rising popularity of folk and especially rock music had already begun to eat away at the core at jazz's core audience of middle-class students and young professionals. The black audience, which had already started to turn away from jazz in the early 1950s (see Chapter 3) was increasingly tuning in to R&B and soul music. Nightclubs and coffeehouses that had historically committed to booking jazz acts were closing or changing their music policies. Radio stations and record companies were also moving with the audience, as evidenced by Berry Gordy Jr., who went bankrupt as the owner of a jazz record store but turned his next venture, the soul-oriented Motown Records, into the largest black-owned corporation in America. With declining record sales and fewer venues available at which to play, jazz musicians were facing some serious challenges to earning a living. Enter free jazz, a music whose abstractness and non-commercial qualities made it difficult for even the most committed jazz fans to grasp, and the problem of maintaining an audience became even more complicated.

However, the free jazz musicians gave it their best shot. One of the first attempts to garner support for their cause occurred from October 1 to 4, 1964, when trumpeter **Bill Dixon** produced "**The October Revolution in Jazz**" at the Cellar Café on West 91st Street in New York to prove that "the music is not ahead of the people—all it needs is a chance to be heard." In addition to non-stop musical performances by known and unknown free jazz musicians, the festival included panel discussions on topics such as "The Economics of Jazz," "Jim Crow and Crow Jim," and "The Rise of Folk Music and the Decline of Jazz." Among the panelists were musicians Cecil Taylor and Steve Lacy, writers LeRoi Jones (who later became known as Amiri Baraka) and A. B. Spellman, and other members of the black cognoscenti who were attempting to rally around free jazz as a source of a new black artistic rebirth, for "African Americans to take pride in a history and culture distinctly separate from white traditions."[21] Because the very nature of free jazz was rebellious, and because most of its practitioners were black, it became an attractive vehicle for cultural nationalists such as Baraka and Spellman to rally around. Problematic to this stance was the fact that the audience for free jazz was predominantly white intellectuals and bohemians, as were the "gatekeepers," the club owners and festival organizers. Black audiences in general seemed to care less about free jazz, prompting jazz critic Eric Hobsbawm to famously quip that if Ornette Coleman "were to blow in Small's Paradise in Harlem, it would clear the place in five minutes."[22] Indeed, Baraka, Spellman and their cohorts held their gatherings in Greenwich Village rather than in Harlem.

The October Revolution, which drew 700 people who paid $1 each, demonstrated that there was not only a pool of experimental musicians in New York and an audience to hear them, but also that musicians could take the initiative to address the issues that confronted them. With one successful venture under his belt, promoter Bill Dixon then established the Jazz Composers Guild (JCG), an interracial cooperative whose purpose was to sponsor concerts and to collectively bargain with record companies. Although the JCG soon fell apart, its spirit caught on and inspired the formation of a number of other cooperatives throughout the country, including the Black Arts Repertory Theater-School (BARTS) and the Collective Black Artists in New York, the **Association for the Advancement of Creative Musicians (AACM)** in Chicago, the Black Artists Group in St. Louis, and the Los Angeles-based Union of God's Musicians and Artists Ascension (UGMAA). It is estimated that there were as many as 150 such collectives in existence by the early 1970s. Although these collectives often sponsored a variety of community outreach programs such as classes in writing, acting, and dance, their main activity was to support musical endeavors, including grant writing and the creation of new works, concerts, and recordings. Several working bands emerged that often took on the collective nature of their sponsoring organizations, including the UGMAA's Pan Afrikan Peoples Arkestra and, most famously, the AACM's Art Ensemble of Chicago.

The AACM and the New York Loft Scene

The origins of the **Art Ensemble of Chicago** (and the AACM) stem from an early 1960s ensemble known as the Experimental Band, led by pianist/composer Muhal Richard Abrams. From the beginning, the group encouraged a collaborative approach to making music, a vibe that fostered the creation of both the AACM (founded in 1965 by

Members of the Art Ensemble of Chicago

- Lester Bowie–trumpet
- Roscoe Mitchell–saxophone
- Joseph Jarman–saxophone
- Muhal Richard Abrams–piano, composer
- Malachi Favors Maghostut–bass
- Philip Wilson–drums

MUSIC ANALYSIS

TRACK 24: "NONAAH"

(Mitchell) Art Ensemble of Chicago from the album *Fanfare for the Warriors* recorded September 6-8, 1973 at Paragon Studios Chicago, Ill. (7:58). Personnel: Lester Bowie: trumpet, percussion; Malachi Favors Maghostut: bass, percussion; Joseph Jarman: saxophone, clarinet, percussion; Roscoe Mitchell: saxophones, clarinet, flute, percussion; Don Moye: drums, percussion; Muhal Richard Abrams: piano

"Nonaah" (pronounced No-Nay-Ah) comes from the Art Ensemble of Chicago's only LP release in 1973, *Fanfare for the Warriors*. The album was released near the end of the groups prolific early years between 1969 and 1974, when they released no less than eighteen albums (seven in 1969 alone). The song is a good example of the group's more ensemble-oriented approach to free jazz, as it starts off with a dense blast of pointillistic fury from the entire group that continues for more than a minute before breaking down into a lengthy and inspired piano solo by Muhal Richard Abrams. The song's composer, Roscoe Mitchell, later released two different renditions of the song on his double album *Nohaah*, which won the 1978 *Down Beat* Critics Poll Record of the Year Award. The two versions presented on that album, one a 21-minute solo recorded at a festival in Switzerland, the other a 17-minute quartet arrangement for four saxophones, allow Mitchell to further explore the possibilities of this composition. (ref: *Jazz* by Gary Giddins and Scott DeVeaux; *Roscoe Mitchell: Nonaah* by Clifford Allen, *All About Jazz*)

0.00	Track begins with all instruments playing "pointillistically"
0.17	Rhythm section drops out, horns continue in similar fashion
0.38	Rhythm section re-enters
1.12	Piano solo by Muhal Richard Abrams begins with only drum and bass accompaniment; no set pulse is apparent
3.22	Saxophone solo (uncredited) begins; Abrams' playing evolves into supportive role
5.27	Other horn players re-enter, track ends suddenly

The Art Ensemble of Chicago. (Left to right) Trumpeter Lester Bowie, percussionist Famoudou Don Moye, bassist Malachi Favors Maghostut, saxophonists Roscoe Mitchell and Joseph Jarman.

Abrams) and the Art Ensemble. By the mid-1960s, this spirit of musical cooperation (without any prospects for financial gain) had created a vibrant free jazz scene in Chicago that rivaled New York's and included concerts, theatrical performances, and jam sessions. A byproduct of this scene, the Art Ensemble of Chicago, included AACM members Lester Bowie (trumpet), Malachi Favors Maghostut (bass), Roscoe Mitchell and Joseph Jarman (saxophone), and Philip Wilson (drums). Performances by the group were a ritualistic experience, embracing the traditions of African griots with the use of face painting, African costumes and masks, vocal chants, and an assortment of as many as 500 instruments. Their music could be described as meditative collective improvisation, creating a hypnotic mood rather than the more aggressive sound of the New York free jazzers. The musicians in the group resisted labeling what they played as jazz, preferring instead to call it "Great Black Music." Unable to support themselves in their hometown, the Art Ensemble moved to Paris from 1969 to 1972, where they were warmly received by an audience primarily of young white bohemians. After returning to the United States, they signed with Atlantic Records and remained together until 1993, although they have reformed in various configurations since then. Both Bowie and Maghostut have died in recent years.

By the mid-1970s, the free jazz—or avant-garde, as it was now being called—scene had fallen on hard times. With most of the jazz world focusing on the experiments in fusing jazz and rock (see Chapter 6), it seemed as if no one was much interested in the "New Thing" anymore. Club dates were hard to come by, and record contracts—well, don't even ask. However, around this time a few entrepreneurial free jazzers decided to take things into their own hands. In New York's Lower East Side, the traditional homebase of the city's avant-garde arts scene, they began to set up studios in abandoned warehouses and run-down buildings where they could jam and put on concerts, free from the concerns of commercial endeavors. One of the most influential musicians in the burgeoning loft scene (although few performance spaces were actually in lofts) was saxophonist/composer **Sam Rivers,** who in 1970 with his wife Beatrice opened **Studio Rivbea,** a performance space on Bond Street. Rivers was one of the working class in jazz throughout the 1960s, a musician who was widely respected as an early (albeit brief) member of the famous Miles Davis 1960s Quintet and a Blue Note artist. Studio Rivbea became a hub of the 1970s loft scene in the Lower East Side, which developed into something even more than just a supportive environment for creative musicians. Besides Studio Rivbea, by the mid-1970s, the scene included John Fischer's Environ, Joe Lee Wilson's Ladies Fort, Mike Morgenstern's Jazzmania,[23] David Murray's Studio Infinity, and a club called the Tin Palace. These and other lofts served as much as community centers for artists and musicians and adventurous audiences as they did music venues. Among the noted jazz musicians who were active in the loft scene were Anthony Braxton, Julius Hemphill, Lester Bowie, Arthur Blythe, and Oliver Lake. In May 1976, Rivers hosted a series known as the Wildflower concerts, featuring nearly 100 musicians. The recordings of the Wildflower concerts were released on five albums called *Wildflowers: The New York Loft Jazz Sessions.* These are today available on Knit Classics Records as a three compact disc set with the same name. The prime years for the loft scene were 1974–1984, after which they began to fold up as neighborhood rents

increased. In 1987, the Knitting Factory opened (see Chapter 8) to carry on the tradition of adventurous jazz from the Lower East Side.

Notes

1. Spellman, A. B.: *Black Music: Four lives,* pg 80
2. Williams, Martin: "Letter from Lenox, Massachusetts," *Jazz Review,* 1959
3. Hentoff, Nat: *The Jazz Life,* pg 248
4. Ibid., pg 228
5. Spellman, pg 119
6. Brubeck, Darius: "1959: The Beginning of Beyond," *The Cambridge Companion to Jazz,* pg 195
7. Spellman, pg 102
8. Attributed to Don Cherry in Spellman, A. B.: *Black Music: Four Lives,* pg 108
9. Jost, Ekkehard: *Free Jazz,* pg 59
10. *Down Beat,* 12/16/1965
11. Spellman, pg 55
12. Ibid., pgs 61–62
13. Feather, Leonard: "Blindfold Test: Billy Eckstine," *Down Beat,* 12/21/61, pg 45
14. Quote from J. B. Figbi, "Cecil Taylor: African Code, Black Methodology," *Down Beat,* 4/10/75
15. Tynan, John: "Take Five," *Down Beat,* 11/23/61, pg 40
16. DeMichael, Don: "John Coltrane and Eric Dolphy Answer the Jazz Critics," *Down Beat,* 4/12/62
17. Quoted by Nat Hentoff in the liner notes to the John Coltrane album *Meditations*
18. From the program notes to a November 8, 1970, concert at Queen Elizabeth Hall in London by Sun Ra and the Intergalactic Research Arkestra
19. Szwed, John F: *Space Is the Place: The Lives and Times of Sun Ra,* pgs 28–29
20. Gioia, Ted: *The History of Jazz,* pg 353
21. Anderson, Iain: *This Is Our Music,* pg 96
22. Hobsbawm quoted in Nat Hentoff, "Jazz in Print," *Jazz Review,* 11/60, pg 34
23. Giddins, Gary: "New York's Lofty Intentions," *Jazz Times,* 9/2006, pg 20

Study Questions for Chapter 4

1. Why was 1959 such a pivotal year in jazz history? Give some examples.

2. Describe some of the ways in which free jazz breaks from jazz tradition.

3. Describe some of the obstacles that Ornette Coleman encountered as he tried to get his career established in the 1950s.

4. Name some of Cecil Taylor's musical influences. In what ways is he an atypical free jazz musician?

5. What are some of the defining characteristics of the early years of the John Coltrane Quartet?

6. Describe the album *A Love Supreme.* Why is it considered to be a transitional album in Coltrane's career?

7. Identify some of the reasons that Eric Dolphy was unique as an instrumentalist, composer, and recording artist.

8. Describe some of the ways in which Sun Ra's music and performances were unique. How did his personal life affect his music?

9. What was the October Revolution in Jazz? How did it influence the course of the free jazz movement?

10. Describe the 1970s New York loft scene. Who is Sam Rivers and why was he important?

The Other Side of the '60s and '70s

© 2011, DeshaCAM, Shutterstock, Inc.

Chapter 5

Key Terms, Music, Figures and Bands

Terms

Bossa nova
Soul jazz
Hammond B3
Octave
Ostinato
CTI Records
ECM Records
World music

Music (albums, works, etc.)

Getz/Gilberto
Home Cookin'
Sunday at the Village Vanguard
Waltz for Debby
The Bridge
Homecoming: Live at the Village Vanguard
Red Clay
Solo Concerts Bremen/Lausanne

Figures and Bands

Stan Getz
João Gilberto
Antonio Carlos Jobim
Astrud Gilberto
Jimmy Smith
Julian "Cannonball" Adderley
Nat Adderley
Wes Montgomery
Bill Evans
Scott LaFaro
Bill Evans Trio
Miles Davis 60s Quintet
Sonny Rollins
Dexter Gordon
Freddie Hubbard
Keith Jarrett
Keith Jarrett Belonging Quartet
Creed Taylor
Manfred Eicher

Meanwhile, Behind the Bluster of the New Thing . . .

During the 1960s and 1970s, two stylistic movements were successful in focusing the attention of jazz musicians, fans, and critics, and seemed to push most of the other jazz artistic endeavors to the sidelines. The onset of free jazz in 1959 and jazz/rock fusion in 1969 (discussed in detail in Chapter 6) became weathervane moments in jazz history, when the rules changed and everyone had to change with them. As we have seen and will continue to see, some jazz musicians jumped into the fray with abandon; others, Sonny Rollins being a prime example, appeared to be lost in the desert and not sure which direction to go. Jazz in the 1960s and 1970s, however, was not merely a two-dimensional world; there was, in fact, a multifaceted and diverse climate of artistic and creative activity, as many musicians chose to operate outside the spheres of free jazz and fusion. In fact, even more than the 1950s, jazz experienced dramatic diversification during the two-decade long period that began in 1959. 1959, the "Beginning of Beyond" year, was the year in which the release of several groundbreaking albums signaled a new era of expanding artistic notions in jazz. Although perhaps not as controversial or groundbreaking as the work of Ornette Coleman or jazz/rock patriarch Miles Davis, the other side of the 1960s and 1970s was rich in creative activity. During this period, Bill Evans, a quiet and introverted yet brilliant pianist redefined the piano trio. Stan Getz, a Jewish saxophonist from the Bronx, imported a darkly romantic new style from Brazil. Pianist Keith Jarrett began performing solo piano recitals that were complex, beautiful—and completely spontaneously composed. Miles Davis, in the years before he began experimenting with rock rhythms and instruments, put together what is arguably the most creative and innovative band of his career, if not in all of jazz history. But there's more! In April 1964, as rock music was trying its best to steamroll jazz out of

existence, Louis Armstrong, then in his sixties, knocked the Beatles off the Number 1 spot on the *Billboard* Top 100 with his recording of "Hello Dolly." It was a small victory in a war that jazz would ultimately lose, but it was a victory nonetheless.

Stan Getz: Bossa Nova Man

A Nice Bunch of Guys

Stan Getz was one of the most important stylists to play the tenor saxophone in the modern jazz era. Although his silky smooth tone was rooted in the tradition of Lester Young and he was schooled in the swing bands of Stan Kenton and Woody Herman, Getz defined the modern cool sound of the tenor in the 1950s and 1960s. In addition, his popular bossa nova recordings in the early 1960s started an American love affair with the music of Brazil that continues to this day. Getz (February 2, 1927–June 6, 1991), the son of Ukrainian Jewish immigrant parents, was raised in the East Bronx, New York. His father bought him a saxophone when he was thirteen, and the instrument brought a previously absent focus to his life. "In my neighborhood my choice was: be a bum or escape. So I became a music kid, practicing eight hours a day. I was a withdrawn, hypersensitive kid."[1] Within a year Getz was gigging around town at Bar Mitzvahs and the like, and was accepted into the All City High School Orchestra. At sixteen, he joined the musicians union; by the age of seventeen he was playing tenor saxophone with Kenton and living in California. By this time, he was learning Lester Young's recorded solos note for note, and consciously copying his sound. To Getz, the key to Young's tone was the absence of "reediness": "I always wanted to take as much reediness out of the sound and hear more of the breath. I came from an era when we didn't use electronic instruments, and I discovered that my dark sound could be heard across a room clearer than somebody with a reedy sound."[2]

After a short stint with Kenton and the Benny Goodman Orchestra, Getz joined Woody Herman's Second Herd (the famous "Four Brothers" band with four tenor saxophones), and established his reputation with an attention getting eight-bar solo on the 1948 recording "Early Autumn." Soon after, he left Herman's band to establish his own career. With his baby face and cool, romantic playing style, Getz quickly became a star. In December 1949 (while still only twenty-two years old), he played alongside Charlie Parker and his idol Lester Young at the grand opening of Birdland. Earlier in the

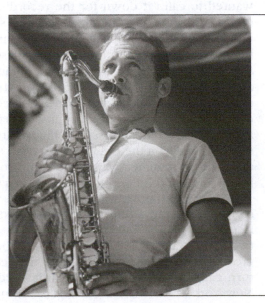

Tenor saxophonist Stan Getz, whose albums *Jazz Samba* and *Getz/Gilberto* made the bossa nova popular in the United States.

year, he was named the *Metronome* Musician of the Year and came in second in the *Down Beat* Readers Poll. Unfortunately, Getz was by this time addicted to heroin (which he had started using while playing with Kenton) and suffering severe bouts of depression. His moods were unpredictable (saxophonist Zoot Sims once famously quipped that "Yeah, Stan's a nice bunch of guys!"), and he sometimes flew into fits of uncontrolled rage. He managed to keep his personal traumas hidden from public view until a botched attempt to rob a drug store in Seattle for morphine in February 1954 garnered national attention (with an infamous photo of him taken in the backseat of a squad car) and a six-month jail sentence. For the next several years, Getz's life was a mess (including an unpleasant divorce and tax problems), although somehow he was able to keep his playing at a high level while winning the *Down Beat* and *Metronome* saxophone polls nearly every year. In 1958, he moved to Denmark, and was able to sustain a comfortable life there for a while, but soon found that his celebrity in the United States was slipping. In 1960, he returned to New York.

The New Flair

1959 was a year of remarkable change in jazz. The seminal albums (*Kind of Blue, Time Out, The Shape of Jazz to Come,* etc.), the new modal and free jazz styles, Ornette Coleman's celebrated Five Spot engagement, and John Coltrane's rising status as a star with a new quartet all served to take Stan Getz out of the public radar screen. He attempted to get back on track with an innovative Third Stream album, *Focus,* recorded in July 1961 with the Beaux Arts String Quartet. Although the critics applauded and it won a Grammy Award, record sales were flat. Getz soon got what turned out to be a career changing break however, when guitarist Charlie Byrd introduced him to a new jazz style called **bossa nova** that Byrd had discovered while touring Brazil. Bossa nova was the creation of guitarist **João Gilberto** and composer **Antonio Carlos Jobim,** who fused jazz harmonies with the native Brazilian beat known as the samba. "João and I felt that Brazilian music had been too much a storm on the sea, and we wanted to calm it down for the recording studio," Jobim said. "You could call bossa nova a clean, washed samba, without loss of the momentum."[3] The term literally meant "new flair." "In Portuguese, a *bossa . . .* has come to mean a flair for something. So if a guy has a *bossa* for something, it is a talent for something. And *bossa nova* was a 'new flair.'"[4] Getz was immediately attracted to the slow, moody, seductive style, and he and Byrd recorded an album of bossa novas called *Jazz Samba* in one day in February 1962. *Jazz Samba* was an unprecedented success that hit Number 1 in March 1963, spent seventy weeks on the charts, kick started a national bossa nova craze, and won a Grammy Award. One song from the album, "Desafinado" broke into the Top Twenty and also won a Grammy.

Getz's next move was to collaborate with the originators of the style, Jobim and Gilberto. Jobim had studied European classical music and bebop, and in the mid 1950s began trying to merge the two with Brazilian folk music. His collaborations with Gilberto had created a bossa nova craze in their native country in 1958, which in turn caught the attention of Charlie Byrd. Getz brought the two to New York in 1962 for a concert at Carnegie Hall, and work on an

Bossa Nova—a Brazilian jazz style developed by Antonio Carlos Jobim and João Gilberto in the 1950s.

MUSIC ANALYSIS

TRACK 25: "CORCOVADO (QUIET NIGHTS OF QUIET STARS)"

(Jobim) Stan Getz and João Gilberto from the album *Getz/Gilberto* recorded March 18, 1963 (4:16). Personnel: Getz: tenor sax; João Gilberto: guitar, vocal; Astrud Gilberto: vocal; Antonio Carlos Jobim: piano; Keeter Betts: bass; Milton Banana: drums

"Corcovado" is a great example of the Brazilian bossa nova that Stan Getz helped popularize in the early 1960s with his collaborations with João and Astrud Gilberto and Antonio Carlos Jobim. The song is one of Jobim's many compositions that have since become jazz standards, and the composer also plays piano on this album as well as a tasteful solo on this song. Getz also delivers a beautifully lyrical solo that demonstrates why he was the leading tenor player of the cool style.

	
0:00	Song starts with Astrud Gilberto singing one half verse in English, accompanied by Antonio Carlos Jobim on piano
0:30	Stan Getz plays a short tenor sax solo with João Gilberto accompanying on acoustic guitar; bass and drums also enter
0:49	First chorus: João Gilberto sings verse in Portuguese
1:53	Second chorus: tenor sax solo by Getz
2:56	Third chorus: piano solo by Jobim over the first half of the chorus
3.26	Gilberto re-enters singing the last verse
4.00	Getz re-enters with tag ending

album began in early 1963. Gilberto brought along his pretty wife **Astrud Gilberto** to the sessions, and Getz soon realized that although she had never sung professionally, she had a cool, seductive voice that was perfect for the project. "Gilberto and Jobim didn't want Astrud on it. Astrud wasn't a professional singer; she was a housewife. But when I wanted translations of what was going on, and she sang 'Ipanema' and 'Corcovado.' I thought the words in English were very nice . . . and Astrud sounded good enough to put on the record."[5] The resulting album, *Getz/Gilberto* was an even bigger smash than its predecessor, reaching Number 2 (beaten only by the Beatles' *A Hard Days Night*) and becoming Getz's only gold record. One of Jobim's six songs from the album, "The Girl From Ipanema" reached Number 5 and made a star out of Astrud Gilberto. In 1965, "Ipanema" won a Grammy for Single of the Year, while *Getz/Gilberto* won three more, including Album of the Year. Although Getz's emotional problems continued (he attempted suicide just days after his successes at the Grammy Awards ceremonies), he continued to record until the end of his life. Among the highlights of his post-bossa nova years were two collaborations with pianist Chick Corea, 1967's *Sweet Rain* and 1972's *Captain Marvel*.

Soul Jazz: Hard Bop Meets Soul

As we learned in Chapter 3, both hard bop and soul music emerged soon after the landmark May 17, 1954, *Brown vs. Board of*

Soul Jazz—a popular substyle of hard bop that drew heavily from R&B and soul music influences.

Education of Topeka, Kansas ruling. Both styles reflected the rising optimism among African-Americans that progress on racial discrimination and segregation would be imminent. Although both hard bop and soul were heavily influenced by R&B, it was fairly easy to distinguish between the two styles, the most obvious differences being that soul music was from its inception intended to be commercial pop music, and usually had vocals. Hard bop, on the other hand, was instrumental music, and was approached from a jazz musician's point of view, retaining a strong connection to bebop. If one were to think of the two styles as being on opposite ends of a musical seesaw, **soul jazz** would be at the mid-point, a natural blending of the two. In other words, it was a more commercial version of hard bop or a more jazz oriented version of soul (or yet another way to look at it: somewhere between Art Blakey and Ray Charles). The song that really created the template for soul jazz was Horace Silver's "The Preacher" from the 1954 debut album of the Jazz Messengers. "The Preacher" was a bluesy, gospel-tinged, groove-oriented song with a strong melody and simplified harmonies; it's "down home" quality seemingly had something for everyone that liked hard bop, the blues, R&B, or soul. (Most of Silver's other compositions clearly fall into the hard bop mold, which is where he is categorized in this text.) Using "The Preacher" as a starting point for the nascent style, soul jazz thus began in the mid 1950s. However, because the music earned its greatest popularity in the 1960s, with no less than five soul jazz recordings hitting the Top Forty (the highest ranking going to Ramsey Lewis's "The 'In' Crowd" at Number 5 in 1965*), we will include its discussion here rather than in Chapter 3. Our attention in this next section will turn to those musicians whose primary output as solo artists or group leaders was with hard bop's more commercialized cousin, soul jazz.

Jimmy Smith

Although **Jimmy Smith** was not the first jazz organist, he created the definitive jazz organ style with his deep grooves and stunning technique, and in the process defined the sound of the contemporary organ trio. Smith (December 8, 1925–February 8, 2005) was born in Norristown, Pennsylvania, where his musical instruction began on piano, and eventually attended music college while working his way into the Philadelphia music scene. It was in the mid 1950s that he first heard the organ played in a jazz setting. His attraction was instant: "I heard Wild Bill Davis play the organ in 1955, and I bought myself an organ the next day—I had to have it."[6] Before this time, the organ had been used from time to time by a few jazz pianists as a novelty (most notably Fats Waller and Count Basie in the 1930s), but as of yet had no real tradition. Jimmy Smith made the **Hammond B3** his instrument of choice, an electric organ originally manufactured in the 1930s as a low cost and "portable" (despite weighing over 300 pounds) alternative to a church pipe organ. Its deep, growling sound, created in part by an innovative "drawbar" system to alter its tone, and the use of the rotating Leslie speaker to give it a distinctive

*The others were Mongo Santamaria's "Watermelon Man" (Number 10, 1963), Cannonball Adderley's "Mercy, Mercy, Mercy" (Number 11, 1967), Jimmy Smith's "Walk on the Wild Side" (Number 21, 1962), and Eddie Harris's "Exodus" (Number 36, 1961).

tremolo made the B3 the only instrument used by jazz organists—even to this day. (The B3 also became a popular rock instrument in the 1960s when groups such as Booker T. and the MGs, Santana, and the Allman Brothers made use of it.) After mastering the bass pedals to get a convincing walking bass sound, Smith put a trio together with a guitarist and drummer and made his debut at Harlem's Small's Paradise and the Café Bohemia in Greenwich Village in early 1956. Within a month, he

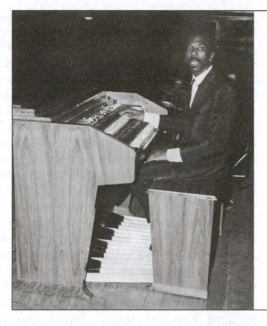

Jimmy Smith, sitting at the Hammond organ.

was recording his debut album for Blue Note, *Jimmy Smith at the Organ, Vol. 1—A New Sound—A New Star.* Among the album's songs was Smith's version of Horace Silver's "The Preacher."

MUSIC ANALYSIS

TRACK 26: "MOTORIN' ALONG"

(Smith) Jimmy Smith from the album *Home Cookin'* recorded July 15, 1958 at Van Gelder Studios, Hackensack, New Jersey (5:05). Personnel: Jimmy Smith: Hammond B3 organ; Kenny Burrell: guitar; Donald Bailey: drums

"Motorin' Along" is one of Jimmy Smith's many soul jazz standards and the final cut of the album he recorded in May and July 1958 at the Van Gelder Studio. "Motorin' Along," recorded on July 15, was joined with the Ray Charles classic "I Got a Woman" from an earlier May session, and five more songs recorded on July 16, when Smith's trio was joined by tenor saxophonist Percy France. (It was somewhat unusual for the efficient Smith to take three sessions to complete an album; he often recorded enough material for several albums in one session.) From the minute Smith exploded onto the New York scene in early 1956, he was an instant new star who combined elements of bebop, rhythm and blues, swing, and gospel into an irresistible hybrid sound. Blue Note's Francis Wolff had

this to say about his first encounter with Smith: "I first heard Jimmy at Small's Paradise in January of 1956. He was a stunning sight. A man in convulsions, face contorted, crouched over in apparent agony, fingers flying, his foot dancing over the pedals. The air was filled with waves of sound I had never heard before. The noise was shattering." Not only did Smith become a star, he made the organ trio one of the most popular of all jazz instrumental formats. (ref: *Cookin': Hard Bop and Soul Jazz 1954–65* by Kenny Mathieson; jazzdisco.org)

0.00	Track starts without introduction; head is stated twice by organist Jimmy Smith and guitarist Kenny Burrell in call and response fashion
0.27	One more chorus of call and response between Smith and Burrell
0.41	Guitar solo by Burrell
2.31	Hammond organ solo by Smith
4.21	Head is restated and repeated as track fades

Over the next few years, Smith was prolific in the studio, including one three-day session in February 1957, when he recorded five albums worth of material. Between 1958 and 1960, he recorded what are considered to be his most famous albums, *The Sermon, Home Cookin'* and *Back at the Chicken Shack,* and had a Number 21 hit in 1962 with "Walk on the Wild Side." Smith frequently used guitarist Kenny Burrell and drummer Donald Bailey, although he occasionally augmented his sessions with horn players such as altoist Lou Donaldson and trumpeter Lee Morgan. Blue Note's Francis Wolff often captured the essence of Smith's music with his classic cover photographs, including one of the organist in front of Kate's Home Cooking Restaurant on Harlem's 126th Street for *Home Cookin',* and the organist at home in Pennsylvania with a dog and rooster for *Back at the Chicken Shack.* Although Smith left Blue Note in 1963 and moved to Verve, he returned in 1986 for a few more years before spending his last years label hopping. It is his work for Blue Note in the late 1950s and early 1960s, however, which remains the most essential in defining the sound of soul jazz and the jazz organ trio. Since that time, many jazz organists, including Brother Jack McDuff, Richard "Groove" Holmes, Shirley Scott, Lonnie Smith, and most recently Joey DeFrancesco, Larry Goldings, and John Medeski, have made their mark in jazz. It is still the name Jimmy Smith, however, that is, and perhaps always will be, most closely associated with the jazz organ trio.

The Jazz Organ Trio The jazz organ trio is most often comprised of the same instrumental lineup that Jimmy Smith made famous: organ, guitar, and drums. Because the organist plays bass lines either on the foot pedals or with his left hand, typically a bassist is not needed.

Cannonball and Nat Adderley

The story of **Julian "Cannonball" Adderley's** (September 15, 1928–August 8, 1975) entrance into the New York jazz scene in June 1955 is one of the most incredible and often told of the modern jazz era. The altoist and his younger brother, cornetist **Nat Adderley,** then twenty-six and twenty-three, respectively, had come to the city from their native Florida to catch some jazz, and found their way to the Café Bohemia to hear bassist Oscar Pettiford's band. When the group's saxophonist didn't show, Pettiford noticed that the Adderley brothers had their horns with them (Nat explained that they "had their horns with us, not because we expected to sit in, but we didn't want to leave them in the car—this was New York, right?"). One thing led to another, and soon Cannonball was on stage cutting through the changes of a murderously fast rendition of "I'll Remember April," leaving "everybody with their mouths hanging open."[7] Within a month, he had a recording contract that put him in sessions as a leader with the likes of Paul Chambers, Kenny Clarke, Horace Silver, and, of course, brother Nat. In early 1958, he joined Miles Davis' band, becoming the third member of the famous front line (along with Davis and John Coltrane) that recorded *Kind of Blue.* After leaving Davis in September 1959, he turned his primary attention back to his own group, the Cannonball Adderley Quintet, which by this time included pianist Bobby Timmons, who wrote the group's first two hits, "Dis Here" and "Dat Dere." Other hits soon followed, including Nat's most famous composition "The Work Song" and Cannonball's "Sack o' Woe."

In 1961, Adderley hired Austrian pianist Josef Zawinul, who ended up staying in the group for more than nine years and contributing their most popular hits, including "Walk Tall," "The Country Preacher"

and "Mercy, Mercy, Mercy," a Number 11 hit in 1967. As the group evolved throughout the 1960s, Nat emerged as a major composer as well, although his widely played tunes such as "Jive Samba," "Hummin'," "Sermonette," "The Old Country," and, of course, "The Work Song" never received the airplay that Zawinul's songs did. Because Cannonball Adderley played with a smooth, soulful style that never strayed far from the blues, and because he enjoyed album sales that extended well beyond the normal limitations of jazz recordings, he was often subjected to criticism of selling out. Adderley was unmoved. "Our culture predisposes us to link artistry with suffering, a stereotype which Adderley gleefully pushed aside,"[8] wrote soul jazz author Kenny Mathieson. Nonetheless, this became an issue for other soul jazz artists, and as we shall see in Chapter 6, a new crop of jazz musicians in the 1970s.

Wes Montgomery

Indianapolis-born electric guitarist **Wes Montgomery** (March 6, 1923–June 15, 1968) was like Cannonball Adderley in that he was a marvelously gifted and universally peer-respected musician who enjoyed commercial success and the criticism from purists that accompanied it. Montgomery was one of three musical brothers— Monk played bass, and Buddy played piano and vibes—who were well known in the supper club circuits in their hometown. Wes was self-taught from listening to Charlie Christian records, and learned to play the guitar with his thumb rather than using a pick in the conventional way. In spite of this (or perhaps *because* of this), he developed an innovative way of playing melodies in **octaves,** a difficulty on the guitar because of the muting of the intermediate strings that is required. Throughout the 1950s, he set a grueling schedule for himself, working a full-time factory job by day and nearly every night in clubs. His break came in 1959, when Cannonball Adderley heard him while on tour in Indianapolis and was completely blown away after hearing him. Within months, Montgomery was in New York recording his debut album *Wes Montgomery Trio* for Riverside. Future albums included a collaboration with Adderley, 1960's *The Incredible Jazz Guitar of Wes Montgomery* (which is widely regarded as his best) and the amazing *Smokin' at the Half Note.* The latter album, recorded in June 1965 mostly at the Greenwich Village club with former Miles Davis sidemen Wynton Kelly, Paul Chambers, and Jimmy Cobb, is a hard-swinging, blowing session that is truly "smokin'"; no less than Pat Metheny has called it "the greatest guitar album ever made."[9]

In 1965, Montgomery also recorded two albums, *Bumpin'* and *Goin' Out of My Head,* which managed to be more listener-friendly (as in: commercial) while retaining a jazz feel. These were transitional albums; from this point on, the guitarist would record mostly pop-oriented albums that in many ways were precursors to the smooth jazz trend in the 1980s. Although there were exceptions (including two collaborations with Jimmy Smith), future albums were primarily in the pop vein, and included *California Dreaming* and 1968's *A Day in the Life,* which became Montgomery's only certified gold record in 1969. Unfortunately, he died of a heart attack in 1968 before it reached that milestone.

An **octave** is the musical interval measuring eight diatonic (scale) steps (i.e., C-D-E-F-G-A-B-C).

Bill Evans: The Art of the Trio

Jazz Zen Master

Bill Evans is the link between the jazz piano style of the 1940s and 1950s that fell into what could be called the "Bud Powell School" and the modernists of the 1960s (Herbie Hancock, Chick Corea, etc.). Like virtually every other jazz pianist who emerged in the 1950s, Evans was deeply influenced by Powell (as well as Lennie Tristano and George Shearing), but he was able to craft a new, sophisticated modern style that was, in turn, deeply influential to the next generation of jazz pianists. Evans (August 16, 1929–September 15, 1980) was born in middle class Plainfield, New Jersey. He began playing the piano at age six, but also studied the violin and flute. He first began gigging at the age of twelve, and by the time he was in high school was playing boogie-woogie and the blues, which he found to be welcome respite from the rigors of classical piano. His discipline and work ethic, which often included three hours of practice a day, was fueled by his belief that he was only moderately talented. After studying composition and piano at Southeastern Louisiana College in New Orleans and graduating with honors in 1950, Evans returned to the New York area and gigged around for a year before being drafted into the army. He then took a year off in Florida to read and study Eastern philosophy (especially Zen), but returned to New York in 1955 and enrolled at Mannes School of Music. He soon made an important connection with composer/arranger George Russell, who hired Evans to play on a series of Third Stream recordings, which earned him positive reviews and widespread respect in the jazz community. Russell was impressed enough with Evans's playing to write a feature piece for him, "Concerto for Billy the Kid," which appears on his 1956 album *The Jazz Workshop.* Evans soon became a sought after sideman, and worked for Russell, Charles Mingus, Chet Baker, and Cannonball Adderley, among others. He also recorded his piano trio debut album as a leader in 1956 titled *New Jazz Conceptions.* His break into the big time came in April 1958, when he auditioned for Miles Davis and was hired on the spot.

Pianist Bill Evans in Milan, Italy in 1965.

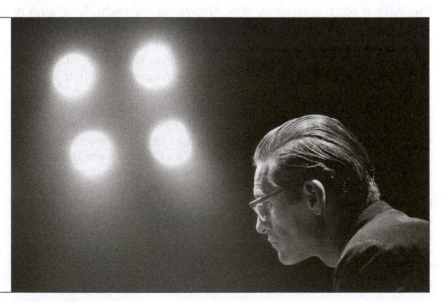

Davis was beginning to investigate the use of modal harmony, and had recently recorded his first modal composition, "Milestones." Evans's work with modal guru Russell seemingly made him the perfect fit for Davis' group. During his eight-month stay, however, the pianist found that he did not provide the power and drive that Davis was looking for, and was ostracized by black fans for being the band's only white member. "Many blacks felt that since I had the top small group in jazz and was paying the most money that I should have a black piano player," Davis remarked. "Now, I don't go for that kind of shit . . . as long as they can play what I want, that's it."[10] Although Davis did not let race become an issue, it seems to have been for Evans, who had a notoriously low self-esteem and felt as though he was an outsider in the group. It is believed that these insecurities motivated Evans to begin using heroin while playing with Davis, a habit that plagued him with health problems for the rest of his life. (Although he later switched to methadone, a medicinal substitute for heroin, Evans was often sick with hepatitis or other ailments, and his dependency certainly contributed to his early death at age fifty-one.) Evans left the group in November 1958, but Davis brought him back in the spring to collaborate on the album *Kind of Blue.* Evans's participation was crucial to the artistic success of the album, as Davis himself said: "What he did was turn me on to some classical composers and they influenced me."[11] Evans also wrote the liner notes to the album, an extraordinary gesture on Davis' part, who on previous albums had given the assignment to a critic or the producer. During 1958, Evans also recorded his second piano trio album, *Everybody Digs Bill Evans,* and managed to barely eke his way into the *Down Beat* Readers Poll at Number 20.

Triumph and Tragedy

After leaving Davis, Evans went about the task of establishing a regular working trio, one in which the bassist and drummer would play equal roles in a three-way musical conversation. This was a radical idea, post-bop piano trios, including those led by Oscar Peterson, Nat King Cole, Errol Garner, and Ahmad Jamal, had featured the pianist and relegated the bass and drums to supporting roles as timekeepers. "What was clear from the first was that Bill had something very different in mind from the normal interplay of piano with bass," said producer Orrin Keepnews. "Most so-called trio records are just an accompanied piano player. Bill was looking for something very different—a joined together kind of thing."[12] Key to the success of this concept would be finding a bassist who could play freely and melodically, and could interact instinctively with Evans. In the summer of 1959, he found that person, twenty-three-year-old **Scott LaFaro,** of whom Evans said: "I was astounded by his creativity, [he was] a virtuoso. There was so much music in him . . . he certainly stimulated me to other areas."[13] Rounding out the trio was the inventive drummer Paul Motian, who added just the right amount of spontaneous interplay to balance Evans and LaFaro.

Over the next two years, the **Bill Evans Trio** redefined small group jazz by bringing a new level of spontaneous interaction to the rhythm section, while LaFaro did nothing less than reinvent jazz bass playing. Their first two studio albums, *Portrait in Jazz* (1959) and

Members of the 1959 Bill Evans Trio

- Bill Evans–piano
- Scott LaFaro–bass
- Paul Motian–drums

MUSIC ANALYSIS

TRACK 27: "MILESTONES"

(Davis) Bill Evans Trio from the album *Waltz for Debby* recorded June 25, 1961 at the Village Vanguard, New York (6:31). Personnel: Bill Evans: piano; Scott LaFaro: bass; Paul Motian: drums

The two albums that the Bill Evans Trio recorded on their last gig together, *Sunday at the Village Vanguard and Waltz for Debby* are among the most celebrated live jazz albums in history. "Milestones," from the latter album, was a tune that Evans was very familiar with by the time of this recording, as he had played it often while a member of Miles Davis's quintet in 1958. Written by Davis, the tune is one of the trumpeter's earliest modal jazz compositions, and utilizes a standard AABA 32-bar song form, with each 8-bar A section using the same major mode and the 8-bar B section using a contrasting minor mode. In a way, this recording is more of a feature for LaFaro than Evans, who plays with an almost Zen-like calmness. LaFaro takes the opportunity Evans gives him to play inventive melodies that go beyond the conventions of jazz bass playing (not once in the song does he resort to a typical walking bass line). "Milestones" was recorded during the evening set of the final day of a weeklong engagement at the Vanguard, meaning it was one of the very last songs the trio played together—LaFaro died just 11 days later in an auto accident. (ref: *Bill Evans: How My Heart Sings* by Peter Pettinger)

0.00	First chorus: song starts without introduction with Bill Evans playing the theme in chord clusters
0.37	Second chorus: Evans begins solo with impressionistic chordal playing
1.13	Third chorus: Evans begins the second chorus of his solo with single note runs in the right hand that continue throughout much of the remaining solo (four choruses total)
3.01	Bassist Scott LaFaro solos
5.25	Evans restates head, group slowly vamps and fades

Explorations (1961), reflect these changes. The trio's enduring masterpieces, **Sunday at the Village Vanguard** and **Waltz for Debby,** were made in one day, June 25, 1961, when Riverside Records recorded the matinee and evening sets on the final day of a weeklong engagement at the venerable Greenwich Village club. The albums, which chronicle the advances the trio had been working toward for two years, have been called the greatest live albums in jazz history.[14] It is not forceful music, as critic Ira Gitler would point out in the liner notes; instead, the albums have a meditative, Zen-like quality to them. They reflect Evans's interest in Zen as well as the dues he was paying as a junkie. Tragically, the two albums also mark the trio's last performance. Just eleven days later LaFaro was killed in an auto accident on Route 20 in upstate New York. Evans was devastated, and did not work for months while he mourned. It was one of many tragedies in the pianist's life, which included the suicides of his brother Harry and girlfriend Ellaine, and his continuing addiction. However, there were many highlights, including the 1963 album *Conversations with Myself,* on which he used multi-track recording technology to record three different tracks of piano on each song. It won Evans his first of six Grammy Awards.

Miles Davis: The Second Quintet

Miles in Transition

In the months following the release of his 1959 masterpiece *Kind of Blue,* Miles Davis was at the pinnacle of the jazz world. Gushing critical reviews of *Kind of Blue* were coming in. He had a new pianist, Wynton Kelly, one of the best hard bop players ever. He was feeling healthy, and staying home, living the couple's life with Broadway dancer and future wife Frances Taylor. But then, things started to turn for the worse. First, he found out from a newspaper interview that John Coltrane wanted to quit the band, which he did in early 1960. In August, he was beaten by a police officer and arrested outside of Birdland for what amounted to not leaving when the cop told him to "move on." (Davis was on break at the club and had just finished escorting a white woman to her car. Although he spent the night in jail, his case was later dismissed.) Cannonball Adderley quit in September. Then in November, only three months after the release of *Kind of Blue,* Ornette Coleman made his debut at the Five Spot and grabbed the attention of the entire jazz world. Davis wasn't exactly pleased with Coleman's timing or his music. Among his many comments about the altoist were, "He just came and fucked up everybody," and "People will go for anything they don't understand if it's got enough hype."[15] If Ornette was the "New Thing," Miles Davis, his sextet and *Kind of Blue* were suddenly the "old thing."

The next three years were transitional ones for Davis. Although some great records were made during these years, including *Sketches of Spain* (1959) with Gil Evans and *Someday My Prince Will Come* (1961), he was unable to keep a steady band together for any length of time. However, when his longtime but on-again, off-again rhythm section of Wynton Kelly, Paul Chambers, and Jimmy Cobb left for good in early 1963, Davis finally put together a steady band, one that would rival John Coltrane's quartet as the most influential of the 1960s. It has become known as his **"60s Quintet"** or his "Second Quintet." On drums was seventeen-year-old dynamo Tony Williams from Boston, of whom Davis would say "was always the center that the group's sound revolved around." On bass, Ron Carter from Detroit. The pianist was twenty-three-year-old Herbie Hancock from Chicago, who played a Mozart piano concerto with the Chicago Symphony at age eleven, and in 1962 recorded his first solo album *Takin' Off,* which included his composition "Watermelon Man." On tenor saxophone was George Coleman, who would stay with the group for only a few months before being replaced by Wayne Shorter, who had been musical director for the Jazz Messengers from 1959 to 1964. (Sam Rivers also filled in briefly in between Coleman and Shorter for a tour of Japan.) Davis' new band got rave reviews at the jazz festival in Antibes, France, in July, and at a benefit concert for the NAACP in New York on February 12, 1964. (The latter concert was recorded and released on two albums, *Four and More* and *My Funny Valentine,* which some [author included] call the greatest live jazz albums ever made. Davis himself described the concert as such: "We just blew the top off that place that night. It was a motherfucker."[16])

Members of the Miles Davis '60s Quintet

- Miles Davis–trumpet
- Wayne Shorter–tenor saxophone
- Herbie Hancock–piano
- Ron Carter–bass
- Tony Williams–drums

E.S.P.

By the time Shorter joined the group in late 1964, it was jelling into an explosive, experimental and cohesive unit that straddled the fence

between hard bop and free jazz. Although Davis had initially dismissed the "New Thing," he was now moving toward it. At thirty-eight, he was a mentor to his younger twenty-something band members, but because they had openly embraced the "New Thing" from the beginning, Davis also learned from them. "The music we did together changed every fucking night; if you heard it yesterday, it was different tonight. Man, it was something how the shit changed from night to night after a while. Even we didn't know where it was all going to. But we did know it was going somewhere else and that it was probably going to be hip."[17] The quintet seemed to have an uncanny ability to communicate with each other at a higher level than any that came before it, enabling them to bring a great amount of flexibility to the performance of each song. Forms, tempos, styles, and rhythmic pulses were all elastic and open to new interpretations with each gig. "We didn't talk in detail about what we were doing . . . things would kind of just happen," said Hancock. "You just had to keep your ears open, keep your eyes open, and keep your heart open."[18] Although everyone wrote for the band, the largest share of the music was written by Shorter, who literally created a new catalog of jazz standards over a four-year span with compositions like "E.S.P.," "Footprints," "Nefertiti," and "Pinocchio."

MUSIC ANALYSIS

TRACK 28: "FOOTPRINTS"

(Shorter) Miles Davis Quintet from the album *Miles Smiles* recorded October 24, 1966 (9:49). Personnel: Davis: trumpet; Shorter: tenor sax; Herbie Hancock: piano; Ron Carter: bass; Tony Williams: drums.

"Footprints" is one of the many Wayne Shorter compositions that have worked their way into the standard repertoire of modern jazz musicians. The tune is a simple 12 bar blues in 3/4 time (3 beats to the bar) whose most prominent element is the **ostinato** bass line that is played by Ron Carter throughout much of the recording. Notice how Davis and Shorter paint their own abstract improvisations while Hancock, Carter and Williams provide an ever-shifting array of rhythmic and harmonic contrasts. The overall effect is an impressionistic rendering of the blues that borders on the avant-garde yet is hauntingly beautiful. By the time *Miles Smiles* was released in January 1967, his now-legendary 1960s Quintet was well on its way to embracing "The New Thing," of which Davis had previously been critical. "Footprints" shows one of the more remarkable aspects of this group: the members' almost extrasensory ability to communicate with each other. "There was empathy among those five people," noted producer Michael Cuscuna, "where they could think as one…they were free [musically] to go anywhere they wanted to, and they knew everyone else would follow. That's a luxury that few of us ever experience." (ref: *Milestones The Music and Times of Miles Davis* by Jack Chambers; *Jazz: a Film by Ken Burns*.)

0:00	Introduction consisting of Ron Carter playing ostinato bass figure with accompaniment by Herbie Hancock on piano and Tony Williams on drums
0:23	Head is stated twice by Davis on trumpet and Wayne Shorter on tenor sax in harmony
1:12	Davis plays extended trumpet solo
4:23	Wayne Shorter plays extended tenor sax solo
6.16	Pianist Herbie Hancock solos
7.17	Head is restated three times, Williams plays short solo, head is restated once more, group fades song out

Between 1964 and 1968, the Davis 60s Quintet recorded six studio albums: *E.S.P., Miles Smiles, Sorcerer, Nefertiti, Miles in the Sky,* and *Filles de Kilimanjaro.* These albums are all timeless works of art that are still magical and enlightening to listen to. This band is often mentioned, along with the Coltrane Quartet and the Charlie Parker/Dizzy Gillespie Quintet as one of the greatest small groups ever assembled in modern jazz. By 1968, however, Davis was once again ready to move on to the next phase of his life and career. His marriage to Frances was over, and he had met a twenty-three-year-old singer/songwriter named Betty Mabry who knew Jimi Hendrix and Sly Stone. She not only introduced Davis to their music, but to them personally. Although their marriage would last only a year, Mabry had no small role in changing Miles Davis' music and outlook on life. We shall look at the dramatic career changes that were forthcoming in the next chapter.

Sonny Rollins and Dexter Gordon: Tenor Titans

Detour Ahead

The 1960s were a time of uncertainty and struggle for **Sonny Rollins** and **Dexter Gordon,** two tenor saxophone titans who were approaching the midpoints of their careers. Rollins voluntarily pulled himself out of the music business in 1959 (see Chapter 3) for the stated reason that "I wanted to work on my horn, I wanted to study more harmony, I wanted to better myself."[19] Although Rollins spent hours practicing at night on the Williamsburg Bridge during his sabbatical, he perhaps wasn't being straightforward with his answer. Could it be that he dropped out because he was unsure how to react to Ornette Coleman and the "New Thing"? Or was it because he was overwhelmed by John Coltrane's sudden ascendancy? (In fact, one joke at the time asked, "What ever happened to Sonny Rollins?" The answer: "He was run over by a 'Trane.'") When Rollins returned in 1961, he formed a quartet, which included guitarist Jim Hall and a straight-ahead album of standards titled *The Bridge.* By ignoring the free jazz trend, critics said that Rollins was on a mission to save jazz. If he was on that mission, it wasn't long before Rollins abandoned it. In 1963, he released *Our Man in Jazz,* recorded with Coleman sidemen Don Cherry on cornet and drummer Billy Higgins. Sticking to standards (including "I Could Write a Book" and his own "Doxy") but done in a freer, Coleman-esque manner, the album was proof to some that Rollins *was* in touch with the new music and to others that he was pathetically *out* of touch. Other signs pointed to the latter conclusion. He started wearing his hair in a Mohawk, and took up bodybuilding and yoga. On at least one occasion, he appeared on stage at the Five Spot wearing a cowboy hat and a Lone Ranger mask. One music insider said, "It was almost a tragic period for him. Sonny was really at sea. He didn't know what to do, which way to go." Rollins later admitted that Coltrane's popularity did play a role: "I did start to resent him at one point and I feel very embarrassed by that now. I think I let his success and the attention he was receiving get to me." In any event, Rollins retreated again in 1969 ("I hated music at the time; I went to India, and had no idea if I would ever play the saxophone professionally again"[20]) and, when he

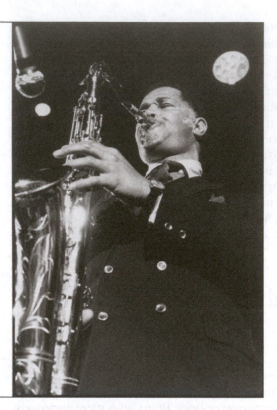

Tenor saxophonist Dexter Gordon, whose 1976 album *Homecoming: Live at the Village Vanguard* heralded his triumphant return to the U.S.

returned in 1971, he came with a fusion band with electric bass and keyboards, much to the dismay of his followers.

Homecoming

Dexter Gordon also struggled in the 1960s, but found redemption in the 1970s. Gordon (February 27, 1923–April 25, 1990) was born in Los Angeles, the son of a dentist whose patients included Duke Ellington and Lionel Hampton. Gordon worked his way up through the club scene of the city's Central Avenue and, in the early 1940s, played in the bands of Hampton and Louis Armstrong. From 1944 to 1945, he played in the innovative bop big band of Billy Eckstine with Charlie Parker and Dizzy Gillespie, and then moved to New York and became a fixture on 52nd Street. By this time Gordon had become the first bebop tenor player of note, with a huge, honking sound reminiscent of Coleman Hawkins and a bluesy, laid-back melodic style influenced by Lester Young. In 1947, he returned to Los Angeles and became a nightly presence in the after hours cutting contests on Central Avenue, which often found him pitted against tenor player Wardell Gray. "The jam-session thing was going on very heavily at that time, at several different clubs. At all the sessions, they would hire a rhythm section along with, say, a couple of horns. But there would always be about ten horns up on the stand. But it seemed that in the wee small hours of the morning—always—there would be only Wardell and myself. It became a kind of traditional thing. Spontaneous? Yeah!"[21] The Gordon/Gray rivalry was captured on Dial Records' *The Chase,* a hit record that helped establish both tenor players' fame. Gordon's fortunes dimmed in the 1950s, as he struggled with drug issues and two prison sentences. In 1962, he moved to Europe, where he lived for the next fourteen years, recording infrequently and mostly playing with amateur musicians.

Gordon moved back to the United States in 1976, and made a triumphant return at New York's Village Vanguard in December with a quintet that included trumpeter Woody Shaw. Live recordings from this engagement were released on the double album ***Homecoming: Live at the Village Vanguard,*** which became a top seller. Gordon's heroes welcome and the success of the *Homecoming* album have often been cited as the beginning of a renewed interest in mainstream acoustic jazz at a time when electric jazz/rock seemed to be in favor. (This movement, which in the 1980s would take on the Neoconservative label, will be discussed further in Chapter 7). The moment was also a personal triumph for Gordon, who left the

country in 1962 branded as a drug addict and now for the first time in his life was signed to a major label (Columbia) and leading his own band. *Homecoming* was reviewed as "a celebration of the roots of a giant. It stands as a new plateau in Dex's career and, for us, an opportunity to share in the workings of one of the great hearts and minds of improvised music."[22] Gordon also won *Down Beat's* 1977 Critics Poll on tenor saxophone. One final highlight to Dexter Gordon's career came in 1986 when he won an Academy Award nomination for his acting in the film *Round Midnight,* in which he played Dale Turner, a jazz musician living in Paris, a role based loosely on the lives of Bud Powell and Lester Young.

Freddie Hubbard

Like Wes Montgomery, **Freddie Hubbard** grew up in Indianapolis, and it was there he first studied trumpet at the Jordan Conservatory. As a teen, he began playing professionally, often with Montgomery and his brothers and later with his own group, the Jazz Contemporaries. In 1958, at age 20, Hubbard (April 7, 1938–December 29, 2008) moved to New York, where he quickly established himself among the city's elite trumpeters. During his first years in the city he worked with Eric Dolphy, Sonny Rollins, and others and recorded as a sideman on such notable LPs as Ornette Coleman's *Free Jazz: A Collective Improvisation*, Dolphy's *Out to Lunch*, and Oliver Nelson's *Blues and the Abstract Truth*. In 1960, Hubbard signed with Blue Note and released *Open Sesame,* his first of 60 albums as a leader. Then, in 1961, he joined Art Blakey's Jazz Messengers, where he worked in the front line alongside tenor saxophonist Wayne Shorter and trombonist Curtis Fuller. Hubbard stayed with the Messengers until 1966, and recorded eight albums with them, including the highly regarded *Buhaina's Delight* (from which "Backstage Sally," Track 13 in chapter 3, comes).

In 1961, Hubbard released what many consider to be his finest LP, *Ready for Freddie*, on which he assembled a stellar band that included Shorter on tenor sax, McCoy Tyner on piano, and Elvin Jones on drums. During this time he also continued to record as a sideman on LPs by John Coltrane, Herbie Hancock, Bill Evans, and Dexter Gordon, among others. By the end of the 1960s, Hubbard was one of the most recorded and sought-after musicians working in jazz, and was recognized as a fiery virtuoso capable of playing exceptionally fast while maintaining a smooth lyricism and warm, rich tone.

As well regarded as he was in the jazz world, popular success eluded Hubbard until the 1970s when he signed with Creed Taylor's CTI Records. In all, he recorded eight albums for the label, mostly in more rock or pop oriented settings, and often working with outstanding backup musicians such as pianist Hancock, tenor player Joe Henderson, bassist Ron Carter, and drummer Jack DeJohnette. His first CTI release was the highly regarded **Red Clay;** his third *First Light,* won a Grammy Award in 1973 for Best Jazz Performance by a Group. He returned to straight ahead jazz in 1977 as a member of the highly regarded V.S.O.P. Quintet, a reforming of the 1960s Miles Davis Quintet with Hubbard taking the trumpet chair for the then-retired Davis. Three albums and a well-received tour resulted from the group. During the 1980s, Hubbard once again led his own groups and continued to record prolifically and tour the world. In 1992, he ruptured his upper lip, a disastrous setback that led to a period of

MUSIC ANALYSIS

TRACK 29: "SUITE SIOUX"

(Hubbard) Freddie Hubbard from the album *Red Clay* recorded January 28, 1970 at Van Gelder Studios, Englewood Cliffs, New Jersey (3:00). Personnel: Freddie Hubbard: trumpet; Joe Henderson: tenor sax; Herbie Hancock: electric piano; Ron Carter: bass; Lenny White: drums

One of the most sought after hard bop trumpeters of the 1960s, Freddie Hubbard achieved success as a leader in his own right in the 1970s with a dozen albums on CTI and Columbia. His first CTI release, *Red Clay*, from which "Suite Sioux" comes, has all the earmarks that would make the label famous: superb recording and production (by Rudy Van Gelder); studio groups assembled using the top musicians in jazz (including in this case, Joe Henderson, Herbie Hancock, Lenny White, and Ron Carter); and exquisite packaging. The music on *Red Clay* strikes a perfect balance between hard bop and contemporary jazz, and still sounds fresh today. Hubbard's solo on "Suite Sioux" shows why he was so highly thought of by his peers and is revered by young trumpeters today: it is hard swinging, bluesy, and explosive from the very first note. *Red Clay* also offers a sampling of Hubbard's writing skills, with five of the albums six songs—including "Suite Sioux"—being originals (the sixth, "Cold Turkey," was written by John Lennon). Hubbard credits Art Blakey, with whom he played from 1961–64, as nurturing his compositional skills. "He gave us a chance to write. It was a good opportunity not just to play, but also to get your compositions together." (ref: *Hard Bop Academy: the Sidemen of Art Blakey and the Jazz Messengers* by Alan Goldsher)

Time	Event
0.00	Intro by rhythm section
0.11	Horns enter with head "A" section, played twice
0.36	"B" section of head in double time
0.50	Last statement of "A" section in regular time
1.01	Trumpet solo by Freddie Hubbard
2.44	Tenor sax solo by Joe Henderson
4.21	Electric piano solo by Herbie Hancock
6.00	Drum solo by Lenny White
7.04	White re-establishes tempo; band enters to play head and finish song

inactivity and the necessity to relearn the basics of playing the trumpet. "I had to go back, get some books, and consult with classical trumpet teachers. I couldn't play a note for a while because it was so tender. It's so frustrating not being able to blow the way I blew."[1] Hubbard did eventually return, but recorded sporadically in the 2000s. He died of a heart attack in 2008.

Keith Jarrett: Spontaneous Invention

Keith Jarrett is one of the most creative and prolific improvisers of the modern jazz era. With more than one hundred albums to his credit, he has recorded a remarkably diverse catalog of music ranging from spontaneously improvised solo piano, jazz trios and quartets, and numerous albums of baroque, classical, and contemporary piano literature. He is a prolific composer whose orchestral works have been premiered all over the world, as well as a multi-faceted pianist whose influences include bebop, hard bop funk, free jazz, rock, and classical. He has won dozens of awards, fellowships and critic's polls. Jarrett

[1]Shuster, Fred: *Down Beat*, October 1995

The Keith Jarrett "Belonging" Quartet. (Left to right) Pianist Jarrett, drummer Jon Christensen, saxophonist Jan Garbarek, bassist Palle Danielsson.

(born May 8, 1945) was born and raised in Allentown, Pennsylvania. He took piano lessons starting at age three, started gigging at age fifteen. At eighteen, he attended Berklee College of Music in Boston, where he was kicked out in his first year for playing on the strings of practice room pianos (among other things). In late 1964, he moved to New York and became a regular at the open jam sessions at the Village Vanguard, where Art Blakey first heard him and hired him on the spot. After a short stint with the Jazz Messengers, Jarrett left and in 1966 joined the Charles Lloyd Quartet. Lloyd's group, which also included future Jarrett collaborator Jack DeJohnette on drums, was trail blazing in that it could comfortably shift between straight ahead acoustic, modal, free and rock-oriented jazz, and became very popular with younger audiences at a time when most younger listeners were tuning out of jazz and listening to rock music (see Chapter 6). It was during his years with Lloyd (1966–1969), Jarrett established a reputation as a charismatic and supremely gifted performer.

In 1966, while playing with Lloyd, Jarrett put together a trio with bassist Charlie Haden and drummer Paul Motian, which was later expanded to a quartet in 1971 with the addition of tenor saxophonist Dewey Redman (Jarrett also played with Miles Davis for a year in 1970). This group, in which Jarrett often played soprano saxophone, became known as his "American" quartet and released fourteen albums between 1971 and 1976. Jarrett also put together a second "European" quartet in 1974 with two Norwegians, saxophonist Jan Garbarek and drummer Jon Christiansen, and Swedish bassist Palle Danielsson. This group is more commonly known as the **Belonging Quartet,** after their first album release of the same name. Incredibly, playing with Miles Davis and leading and writing music for two quartets was not enough of a challenge for Jarrett, who in 1971 began a highly successful career as a solo pianist. His first solo piano album, *Facing You,* recorded for the new German label ECM, went against the grain of the current electric jazz/rock trend and created a blueprint for future solo piano albums from Jarrett and other jazz pianists in the 1970s. Jarrett's next solo effort, 1973's three-album **Solo Concerts Bremen/Lausanne** is arguably one of the most remarkable achievements in modern jazz. The three discs contain more than two hours of music recorded at recitals in Bremen, Germany, and Lausanne, Switzerland, but what is most amazing is that all of the music is completely spontaneously composed. *Solo Concerts* won Jarrett an international following, and was named record of the year by *Down Beat, Time, Stereo Review, The New York Times,* and many other publications. Jarrett followed it with the even more popular *Köln Concert,* another spontaneously composed recital

Members of the Keith Jarrett Belonging Quartet

- Keith Jarrett–piano
- Jan Garbarek–saxophone (Norway)
- Palle Danielsson–bass (Sweden)
- Jon Christiansen–drums (Norway) ⚬

MUSIC ANALYSIS

TRACK 30: "SPIRAL DANCE"

(Jarrett) Keith Jarrett Belonging Quartet from the album *Belonging* recorded at Arne Bendiksen Studios, Oslo, Norway, April 24 and 25, 1974 (4:07). Personnel: Jarrett: piano; Jan Garbarek: tenor sax; Palle Danielsson: bass; Jon Christensen: drums

Pianist Keith Jarrett was busy during the 1970s performing and recording spontaneously conceived solo piano recitals and leading two separate quartets, one in America and one in Europe. The European group is commonly known as the 'Belonging' quartet after their first album release from 1974, and includes two Norwegians (Garbarek and Christensen) and a Swede (Danielsson). Most of Jarrett's recorded work in the 1970s was on the ECM label, which is based in Munich, Germany. "Spiral Dance" is a good example of the synergy that Jarrett was able to muster from his Scandinavian band mates. The song also displays Jarrett's penchant for writing soulful, melodic songs that are interesting on an aesthetic level but also accessible from a more commercial point of view. By performing solely using acoustic instruments in both trios and his solo recordings, Jarrett was one of the few jazz stalwarts in the 1970s who did not jump on the electric jazz/rock fusion bandwagon.

0:00	Pianist Keith Jarrett begins vamp; bassist Palle Danielsson and drummer Jon Christensen join in
0:53	Tenor saxophonists Jan Garbarek and Jarrett play the head in unison
1:22	Head is restated
1:41	Band vamps while Danielsson solos
3.05	Head is restated; band vamps out as Garbarek repeats a single note

recorded in 1975. He continued to release similar concert recordings into the 1990s.

CTI and ECM: Redefining Jazz Marketing

Two innovative jazz record labels were founded in the late 1960s that revolutionized the recording and packaging of contemporary jazz. Both **CTI Records** and **ECM Records** were founded by producers with individualistic visions about how music should be recorded and released. As a result, the catalogs of each company have a distinctive sound and style. CTI was the brainchild of legendary producer **Creed Taylor,** who founded the label in 1967. Taylor began producing records in 1954 at tiny Bethlehem Records before moving to ABC in 1960, where he was assigned the job of setting up the company's new jazz label, Impulse!. He immediately developed a distinctive packaging for the label, which included elegant photographs and black and orange packaging. While at Impulse!, Taylor also signed John Coltrane and produced Oliver Nelson's album *The Blues and the Abstract Truth.* Taylor soon left for Verve Records, where he produced Grammy winners *Getz/Gilberto* by Stan Getz and *Conversations with Myself* by Bill Evans. When A&M Records offered Taylor a deal to start a new jazz label in 1967, CTI was born. He brought legendary engineer Rudy

Van Gelder (see Chapter 3) and arranger Don Sebesky on board with him, ensuring that CTI's albums would sound great and have well-crafted orchestrations. He also created a distinctive look for his albums with high-quality glossy photographs and colorful, heavy, cardboard gatefold covers. He also used some of the best session players in jazz to back up his stars, such as bassist Ron Carter and keyboardists Herbie Hancock and Bob James.

CTI's stellar roster included trumpeter Freddie Hubbard, flautist Hubert Laws, guitarist George Benson, Antonio Carlos Jobim, tenor saxophonists Stanley Turrentine and Grover Washington, and Milt Jackson of the MJQ. One of Taylor's major signings was Freddie Hubbard, who released a string of popular rock influenced albums, including *Red Clay, Straight Life, Sky Dive,* and Grammy winner *First Light.* Hubert Laws released an innovative album in 1971 entitled *The Rite of Spring,* which included interpretations of classical works by Debussy, Bach, Faure, and Stravinsky, arranged by Don Sebesky. CTI declared bankruptcy in 1978, but its catalog was acquired by Columbia (Sony) and remains in print today.

Classical musician and jazz lover **Manfred Eicher** founded ECM (Edition of Contemporary Music) in Munich, Germany, in 1969. Eicher is a visionary, more enthusiast than businessman, who from the beginning gave the quality of his productions and his relationships with his artist's higher priority than profit margins. When he signed Keith Jarrett to record the seminal solo piano album *Facing You* in 1971, the fledgling label had only one album in print, no American distribution, and a total of two employees (including Eicher). The phenomenal success of Jarrett's album was the starting point in ECM's explosive growth. In the 1970s, Eicher was able to sign a remarkable stable of American jazz talent that included Chick Corea, Pat Metheny, Gary Burton, saxophonist Dave Liebman, bassist Dave Holland, and the Art Ensemble of Chicago. He was also successful in signing top European jazz musicians including Jan Garbarek, bassist Eberhard Weber, and guitarist Terje Rypdal. In 1972, Eicher suggested that Jarrett and Garbarek collaborate, which led ultimately to the formation of Jarrett's European "Belonging" quartet.

Like CTI, ECM is known for the immaculate sonic quality of their recordings and their beautiful packaging. Album covers often display minimalist artwork or photography of remote Nordic nature scenes. In the 1980s, the label expanded into classical music with its ECM New Series. Many ECM releases blur the lines between jazz, international-flavored folk, and classical music. As such, the label was at the forefront of the movement that was at the time referred to as **"world music."** Examples of this type of musical postmodernism can be found in the works of Garbarek and Brazilian composer/percussionist Naná Vasconcelos. Besides Jarrett's solo piano recordings and those of his Belonging quartet, other notable 1970s ECM releases include *Matchbook* (1974), a collaboration between Gary Burton and guitarist Ralph Towner; Burton and Chick Corea's *Crystal Silence* (1972); and Dave Holland's *Conference of the Birds* (1972), one of the decade's defining free jazz albums featuring saxophonists Sam Rivers and Anthony Braxton. Unlike CTI, ECM is still in business, and is still at the forefront of contemporary jazz, with a current artist list that includes Craig Taborn, Tord Gustavsen, Ralph Towner, and Paul Motian.

World music is an umbrella term to describe music that incorporates influences from different regions and cultures. 𝄢

Notes

1. Maggin, Donald L: *Stan Getz, A Life in Jazz,* pg 18
2. Mel Miller interview with Stan Getz; *The Saxophone Journal,* Winter 1986
3. From liner notes to the album *Antonio Carlos Jobim*
4. Quoted from the liner notes to *Stan Getz: The Girl From Ipanema; The Bossa Nova Years*
5. Maggin, pg 215
6. Mathieson, Kenny: *Cookin': Hard Bop and Soul Jazz 1954-65,* pg 55
7. Ibid, pg 127
8. Ibid, pg 133
9. Ibid, pg 177
10. Davis, Miles and Troupe, Quincy: *Miles: The Autobiography,* pg 231
11. Ibid, pg 234
12. Quoted in "That Sunday" by Adam Gopnik *The New Yorker,* 8/13/01 pg 32
13. *Jazz Journal International,* 3/85
14. Bailey, C. Michael: "Best Live Jazz Recordings," *All About Jazz,* 8/10/2005
15. Davis, Miles and Troupe, Quincy: *Miles: The Autobiography,* pg 249
16. Ibid, pg 266
17. Ibid, pg 278
18. From an interview with Herbie Hancock in *Jazz: A Film by Ken Burns*
19. Quoted in "The Colossus" by Stanley Crouch *The New Yorker,* 5/9/05 pg 69
20. Ibid, all three quotes, pgs 70-71
21. Britt, Stan: *Dexter Gordon: A Musical Biography,* pg 18
22. Berg, Chuck: *Down Beat,* 4/21/77
23. Schuster, Fred: **Down Beat,** October 1995.

Study Questions for Chapter 5

1. Describe what bossa nova is, and the roles that João Gilberto, Antonio Carlos Jobim, and Stan Getz had in its creation and subsequent popularity.

2. What is soul jazz, and how does it differ from soul music and hard bop? What were some popular soul jazz recordings?

3. Name some of the music styles, jazz musicians, writings, and other things that influenced Bill Evans in his early years.

4. Describe Bill Evans's innovative concept for putting together a piano trio. What made it possible for him to achieve his goal?

5. Describe Miles Davis' reaction to Ornette Coleman. Did his feelings about free jazz change over the course of the 1960s?

6. What was so unique about the Miles Davis 60s Quintet? What role did Wayne Shorter play in the band?

7. Describe Sonny Rollin's career during the 1960s and how he dealt with the free jazz movement.

8. Describe the ways in which the careers of Stan Getz and Dexter Gordon were similar, and compare the albums *Jazz Samba* and *Homecoming: Live at the Village Vanguard* in that regard.

9. Describe the career of Keith Jarrett in the 1970s and the various ways in which he chose to express himself musically during that time.

10. How did the CTI and ECM labels redefine jazz marketing? What were some of the major differences between the labels?

Sleeping with the Enemy

© 2011, Oscar C. Williams, Shutterstock, Inc.

Chapter **6**

Key Terms, Music, Figures and Bands

Terms

Soundstream
Jazz/rock
Fusion
Smooth jazz

Music (albums, works, etc.)

Hot Rats
The Dealer
In a Silent Way
Bitches Brew

Emergency!
The Inner Mounting Flame
Head Hunters
Romantic Warrior
Heavy Weather

Figures and Bands

Chico Hamilton
Larry Coryell
Miles Davis
Teo Macero
Tony Williams Lifetime

John McLaughlin
Mahavishnu Orchestra
Herbie Hancock
Mwandishi band
Chick Corea
Return to Forever
Josef Zawinul
Wayne Shorter
Weather Report
Jaco Pastorius
Kenny G

Jazz in the Sixties: Stuck Between a Rock and a Hard Place

Jazz Exodus

On July 17, 1967, John Coltrane, the spiritual leader of modern jazz, died of cancer. Coltrane's death left the jazz world rudderless at an inauspicious point in its history. Record sales were down, and clubs all across America that had for years booked jazz were either closing or redirecting their music policies. The audience was in exodus, and some observers began to ask again if jazz as a thriving art form was dead. It seemed the audience was disappearing partly because there was nothing new to choose from and, in part, because much of the latest trend—free jazz—just wasn't very listenable. As Mike Hennessey of *Melody Maker* put it, the reaction seemed to be "I've heard it all before or I never want to hear it again."[1] The biggest reason jazz was in trouble, however, was because of the dramatic rise in popularity of rock music. There were plenty of good reasons why rock was drawing so many fans. It was new and exciting, it spoke to the issues of the day in a way that instrumental music could never do, and it encompassed an abundance of creativity in all kinds of musical directions. These were all things that seemed to be lacking in jazz. There also was an abundance of charismatic new stars to attract fans, such as John Lennon, Mick Jagger, Jim Morrison, Jimi Hendrix, Janis Joplin, Bob Dylan, and James Brown. Young people—who willfully made the 1960s *their* decade—could choose the Beatles, the Supremes, the Grateful Dead, the Doors, The Who, and many other bands to attach their identities to. It seemed somehow prophetic that as John Coltrane lay dying in a New York hospital, the "Summer of Love" was in full bloom, *Sgt. Pepper's Lonely Hearts Club Band* was at the top of the charts, and the hippie movement was spreading its message of peace and love from its homebase in San Francisco's Haight-Ashbury district.

Jazz musicians were keenly aware that rock was slowly taking food off their table, and many had an openly suspicious if not downright condescending attitude toward it. In their view, rock was intended to be pop music rather than art, with the goal of pandering to the audience, getting on the radio, and selling records. In addition, rock musicians just weren't very good (in their opinion); it seemed that anyone could buy a guitar and an amp, learn three chords, write a song, and have a hit record—no talent required. Most jazz musicians had spent years and invested thousands of hours of practice learning the technical skills, harmony, vocabulary, and repertoire of their music. And here they were, searching for an audience and starving. Some jazz musicians, such as Stan Getz and Dexter Gordon, moved to Europe where there was still an appreciative audience (Eric Dolphy was also planning on moving there before he unexpectedly died). Some got out of music or took menial jobs while hanging on for dear life. In times like these, it's no wonder that some jazz musicians began to think the unthinkable: maybe it was time to cross over and play what the people want. Gerry Mulligan's 1965 album *If You Can't Beat Them, Join Them* seemed to sum up this line of thinking. Jazz covers of rock tunes started appearing, with the Beatles catalogue a favorite source. Some improbable examples that started creeping into jazz recordings included Ella Fitzgerald's "Can't Buy Me Love" and Chet Baker's "Got to Get You Into My Life." Even the great Duke Ellington got into the act with recordings of "I Wanna Hold Your Hand" and "All My Loving." Sadly, these records were not satisfying to anyone, let alone kids who were buying the real Beatles records.

Strange Bedfellows

On the other hand, rock musicians were already embracing jazz with generally interesting and creative results. Members of the Grateful Dead and the Doors were fans of Coltrane's extended improvisations, and in fact the drummers for both bands were originally jazz musicians. (Listen, for example, to the bossa nova beat played by drummer John Densmore on "Break on Through," the first track of the Doors' debut album.) Both bassist Jack Bruce and drummer Ginger Baker of Eric Clapton's power trio Cream were also jazzers, and that group Cream would often improvise on a single tune for an hour, like the Coltrane Quartet. Brian Wilson of the Beach Boys used jazz harmonies and instrumentation with satisfying results on the 1966 album *Pet Sounds,* while Jimi Hendrix brought a jazz-like improvisatory conception to many of his recordings, such as "Third Stone from the Sun" from his stunning 1967 debut album *Are You Experienced?* Frank Zappa's 1969 **Hot Rats** can arguably be called one of the very first successful complete albums that fused rock and jazz. Three bands that formed in the watershed year of 1967—Blood, Sweat & Tears, Chicago Transit Authority (later simply Chicago), and the Electric Flag—combined pop/rock rhythm sections with jazz-influenced horn sections with results that resonated with the buying public as well as jazz musicians. In the context of all the other experimenting that was going on in rock in the 1960s, it is only natural that jazz would be one of many sources from which rock musicians would draw upon.

MUSIC ANALYSIS

TRACK 31: "THE DEALER"

(Hamilton/Cheatham) Chico Hamilton from the album *The Dealer* recorded September 9, 1966 at Van Gelder Studios, Englewood Cliffs, New Jersey (6:21). Personnel: Larry Coryell: guitar; Arnie Lawrence: alto sax; Richard Davis: bass; Chico Hamilton: drums.

By 1966, when "The Dealer" was recorded, Chico Hamilton had long been a mainstay of the West Coast jazz scene, having grown up in Los Angeles and working his way up through the Central Avenue scene. In the 1950s, he played in the famous Gerry Mulligan "pianoless" Quartet and led his own quintets, which achieved great popularity and often included a cellist. However, in 1961, he changed directions with a new group that was more adventurous, with tenor saxophonist Charles Lloyd and Hungarian guitarist Gabor Szabo. In 1965, Hamilton edged closer to rock music with the addition of the young electric blues/rock gui-

tarist Larry Coryell, who made his recording debut on the 1966 album *The Dealer*. Critic Scott Yanow has called the album "an early missing link to the birth of fusion," an appropriate description considering its long one chord vamps and free flowing quality. Coryell's presence on the album, particularly on "The Dealer" confirms that for jazz to successfully bond with rock music, it must bring the instruments used by rock musicians into the fold, especially the electric guitar. (ref: *Jazz on Record: The First Sixty Years* by Scott Yanow)

0.00	Song starts with band vamping on jazz/rock groove
0.20	Alto saxophonist Arnie Lawrence and guitarist Larry Coryell play head
1.02	Guitar solo by Coryell
2.36	Alto solo by Lawrence
4.10	Bass solo by Richard Davis
5.35	Head is restated, track fades

That is not to say that there wasn't some tinkering with rock elements by a few jazz musicians. Many of the soul jazz records of the early sixties were drawing ever so close to rock rhythms, including Herbie Hancock's 1962 "Watermelon Man," Lee Morgan's 1963 "The Sidewinder," and Ramsey Lewis's 1965 "The 'In' Crowd." Perhaps the first successful rock conceptualization by a jazz musician was **Chico Hamilton's** 1966 album ***The Dealer.*** Hamilton used rock-influenced rhythms as well as an electric guitar, which seemed to be the essential missing link to a successful jazz/rock synthesis. Hamilton's guitarist was **Larry Coryell,** a twenty-three-year-old Texan, whose attitude was "Let's do something different! We love Coltrane but we also love the Beatles."[2] Coryell and vibraphonist Gary Burton in 1967 released *The Duster,* another early venture into fusing jazz and rock. Tenor saxophonist Charles Lloyd (a former member of Chico Hamilton's group) began adding rock elements with bebop and free jazz to create an interesting mix of sound that was not unlike some of the psychedelic bands from San Francisco. His quartet, which included drummer Jack DeJohnette and pianist Keith Jarrett, was the first jazz group to play at San Francisco's Fillmore Ballroom. At subsequent shows, they shared the billing with Hendrix, Joplin, Cream, the Grateful Dead, and Jefferson Airplane. Lloyd's two albums from 1966, *Dream Weaver* and *Forest Flower,* had huge crossover success with *Forest Flower* achieving sales of nearly one million copies and considerable FM airplay. The jazz press took notice of these developments. An August 1967 article in *Time,* titled "A Way Out Of The Muddle," expressed hope that rock

The Charles Lloyd Quartet. (Left to right) bassist Ron McClure, drummer Jack DeJohnette, saxophonist Charles Lloyd, pianist Keith Jarrett.

and jazz might eventually commingle, *Down Beat* in 1968 stated that jazz was in "crying need of a bigger audience. If rock offers a bridge, jazz would be foolish not to cross it."[3]

Miles Davis: To the Rescue

Bitches Brew

Miles Davis was also looking to the potential of crossing the bridge to expand his audience. By 1967, Davis had been one of the most admired musicians in jazz for nearly twenty years, during which time he had played a consistently pivotal role in shaping the music's evolution. His current quintet, a hard bop/free jazz hybrid that included some of the top musicians in jazz, was arguably the most forward-thinking group of his career. Davis was popular with young and old listeners; blacks as well as whites identified with him and his music, albeit for different reasons. But even he couldn't escape noticing that his audiences were dwindling. By the mid 1960s, Davis had begun listening to James Brown, Sly and the Family Stone, and Jimi Hendrix, and he was intrigued with the rhythms as well as the electric guitars, basses, and keyboards they used. Slowly, he began to integrate these elements into his own music. His first venture came in 1968 on the album *Miles in the Sky,* which he had Herbie Hancock playing an electric piano, added guitarist George Benson on one track, and included the rock-rhythmed song "Stuff." Rock rhythms and electric pianos continued on his next album, *Filles de Kilimanjaro,* which included "Mademoiselle Mabry" (written for his current wife Betty Mabry), a song whose chord progression is nearly identical to Hendrix's "The Wind Cries Mary." By years end, it was clear to Davis that this was the direction his music had to go: "I wasn't prepared to

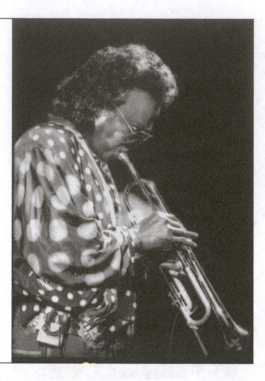

Trumpeter Miles Davis.

be a memory yet,"[4] he said. Also supporting Davis in his decision to go after a younger audience was the new president of Columbia Records, Clive Davis, who hoped to boost Davis's record sales up to near the levels of other Columbia artists such as Blood, Sweat and Tears, Sly Stone, and Bob Dylan.

At the end of 1968, Davis boldly moved forward and disbanded his famous second quintet. The following February, he recorded his most rock-oriented album to date, the ethereal *In a Silent Way.* His new group was larger, using three electric keyboardists (Herbie Hancock, Josef Zawinul, and Chick Corea), an electric bass guitarist (Dave Holland) and a rock-influenced guitarist, Briton John McLaughlin. But *In a Silent Way* was still one step away from a truly groundbreaking fusion of jazz and rock; it would be Davis's next album that finally tore down the wall that separated the two styles. In August 1969, Davis re-entered the Columbia Studios in New York and spent three days recording the double album **Bitches Brew,** which is widely credited as the first successful synthesis of jazz and rock. Davis brought together a who's who in contemporary jazz for the album, including Corea and Zawinul on electric pianos, Wayne Shorter and Bennie Maupin on saxophones and woodwinds, Dave Holland and Harvey Brooks on bass, McLaughlin on guitar and Lenny White, Billy Cobham and Jack DeJohnette on drums. For the sessions, Davis put the musicians in a semi-circle around him so he could supervise the proceedings; he also made sure that everything was caught on tape. "Miles assembled an experiment with musicians he liked," said DeJohnette. "He wrote a few sketches, but the idea was to get the spontaneity down. It was Miles conducting an orchestra in real time. He was like a painter changing the canvas by conducting his group."[5]

The Blueprint

The music that the Davis group recorded was groundbreaking in its originality, conception and realization. It is perhaps best described by author Alyn Shipton, who calls it a "**soundstream**" "in which [Miles], the other horns, and chordal instruments soloed and interacted over a rock-based accompaniment."[6] By using rock and funk rhythms exclusively, Davis made a complete break with traditional jazz swing and Latin-influenced rhythms. By using as many as fourteen musicians—most of whom were either rhythm section and/or electric instrumentalists—Davis created a postmodernist big band that was unlike anything previously heard in jazz (or rock for that matter). Instrumental in

MUSIC ANALYSIS

TRACK 32: "BITCHES BREW"

(Davis) Miles Davis and His Band from the album *Bitches Brew* recorded at Columbia Studio B in New York, August 19, 1969 (27:01). Personnel: Miles Davis: trumpet; Bennie Maupin: bass clarinet; Wayne Shorter: soprano sax; Chick Corea, Josef Zawinul: electric piano; John McLaughlin: guitar; Dave Holland: bass; Harvey Brooks: electric bass; Jack DeJohnette, Lenny White: drums; Don Alias: conga; Jim Riley: shaker

"Bitches Brew" is the title cut from the landmark double album released by Miles Davis in 1969. It is usually regarded as the first successful fusing of jazz and rock, and is the album that transitioned Miles into the final period of his career. Because *Bitches Brew* was recorded nearly 40 years ago, it is sometimes easy to forget just how revolutionary it was at the time. Ralph J. Gleason's liner notes, which included the following line, are indicative: "This music is new music and it hits me like an electric shock." *Bitches Brew* was controversial among purists and critics, in part because it was too 'commercial'. However most of the songs on the album were too long for radio play (the title track is 27 minutes long and takes up the entire

side of one disc), making the argument moot. Miles was also criticized for using studio effects on his trumpet, such as the echo heard at 0:41. *Bitches Brew* was not controversial with fans however, who made it Miles's first gold record. It also won a Grammy Award in 1970. Many of the musicians who participated in the recording of *Bitches Brew* went on to form their own jazz/rock fusion bands in the 1970s, including Josef Zawinul, Wayne Shorter, John McLaughlin, and Chick Corea.

0:00	Dramatic opening sequence played by electric pianists Chick Corea and Josef Zawinul and percussionists
0:41	Miles Davis enters on trumpet with echo effect
1:49	Overdubbed trumpet played one octave below lead part
2:51	Bassist Harvey Brooks starts bass ostinato with subtle accompaniment by bass clarinetist Bennie Maupin; Miles can be heard snapping his fingers
3:32	The rest of the rhythm section enters
3:54	Miles re-enters with an improvised solo; band gradually builds in intensity and volume; track continues

creating the soundstream concept was producer **Teo Macero,** who in postproduction sessions edited sections of tape together to construct repeating loops, extended jams, tempo changes, and other interesting effects in the creation of compositions that weren't actually performed as such in the studio. (Keyboardist Zawinul didn't even recognize the recording when he heard a secretary at the CBS offices playing the edited tracks a few weeks later. "I asked her, 'Who the hell is this?' And she replied, 'It's that *Bitches Brew* thing.' I thought, damn, that's great."[7]) Such bold applications of studio postproduction had been scarcely used in jazz up to this point, but had become *de rigueur* in rock. Davis further utilized studio technology by occasionally using an echo effect on his trumpet.

In spite of (or most likely *because of*) its groundbreaking nature, *Bitches Brew* was controversial, drawing criticism from conservative jazz fans, musicians, and the press. To them, Davis was "selling out" and abandoning the traditions of jazz for pop stardom. It made no difference to them that nearly all the songs were too long and too abstract for radio play. The purists condemned the overabundance of rock rhythms, the use of electric instruments, and the discarding of traditional jazz forms and rhythms. Macero's postproduction was also a

sticking point; such flagrant use of editing took away the spontaneity that is supposedly essential to jazz. Some traditionalists took issue with the way the album was marketed, as the surrealistic cover artwork was obviously targeted to a younger, non-traditional jazz audience. A few even complained about the use of the "B" word in the title. However, *Bitches Brew* succeeded in connecting Davis with the younger and much larger fan base that he coveted, and sold more than 400,000 copies in its first year. *Bitches Brew* eventually became his first gold record (a distinction given to records with sales exceeding 500,000; Davis's previous albums generally sold on average less than 100,000 units). It also won a Grammy Award in 1970. Today, *Bitches Brew* is considered to be the blueprint album in the creation of the styles that became known as **jazz/rock** and **fusion**. Following the release of *Bitches Brew*, Davis's band went on tour with the rock group Santana and began playing rock venues like San Francisco's Fillmore Ballroom. In the next few years, Davis recorded more jazz/rock albums, including two in 1970, *A Tribute to Jack Johnson* and *Live/Evil* on which he used a wah-wah pedal—a device normally used by guitarists—attached to his trumpet. Another influential album was 1972's *On the Corner*, whose repetitive bass and drum grooves foreshadowed the hip-hop and drum and bass styles. But Miles's mid-career rejuvenation eventually took its toll, and in 1975, in poor health and artistically drained, he stopped performing and recording. He would not appear in public or even pick up his horn for more than five years.

Jazz/Rock is the earliest form of fusing jazz and rock; most often takes the form of the soundstream approach of 1970s Miles Davis or early Weather Report recordings.

Fusion is an equal triangulation of jazz, rock, and pop; good examples are the LPs *Head Hunters* by Herbie Hancock and *Heavy Weather* by Weather Report.

Important 1970s Jazz/Rock Fusionists

Tony Williams Lifetime: The New Organ Trio

The musicians who played on *Bitches Brew* and other Davis albums from this period knew that there was no turning back from fusing jazz and rock, and wasted little time in creating their own visions of what direction jazz/rock should take. Because so many went on to start seminal jazz/rock and fusion bands in the 1970s, it could be said that Miles Davis once again spawned a musical Diaspora of sorts, much as he had done after the release of the *Birth of the Cool* and *Kind of Blue*. The first of the Davis alumni jazz/rock bands was the **Tony Williams Lifetime,** a short-lived but innovative trio formed in 1969, consisting of three of jazz's most high energy players: Williams on drums, John McLaughlin on guitar, and Larry Young on organ. During its incubation period, each of the musicians in the group drew inspiration by jamming with Jimi Hendrix, consequently, the group's debut album ***Emergency!*** (1969) is much more explosive and tightly formatted than the Davis albums of the same period. Williams even sings (or does a sort of beatnik-like rapping) on a few of the songs, bringing the band even closer to the aesthetic of rock music. Former Cream bassist Jack Bruce joined the group for their next album, but McLaughlin left soon afterward. Lifetime disbanded in 1972, although they reformed with a different lineup for a short period in 1975.

The Mahavishnu Orchestra: Jazz Goes International

Although Briton **John McLaughlin** came to America in February 1969 to join Tony Williams Lifetime, he so impressed Miles Davis with

his playing that the trumpeter asked him to join his own group. McLaughlin declined, but recorded several albums with Davis over the next two years, including *In a Silent Way* and *Bitches Brew* (on which there is a song named for him). McLaughlin had earlier become a fixture on the English jazz scene as both a performer and as a session musician, and had recently recorded the innovative solo album *Extrapolations* there. After leaving Williams's group, and with Davis's encouragement, he decided to form his own jazz/rock group. **The Mahavishnu Orchestra** (using the name given to McLaughlin by his Indian guru Sri Chinmoy) opened in July 1971 at the Gaslight in Greenwich Village to rave reviews. The group had an international lineup (an early prognosticator of the coming globalization of jazz), with Englishman McLaughlin, Panamanian drummer Billy Cobham, Irish bassist Rick Laird, Czech keyboardist Jan Hammer, and American electric violinist Jerry Goodman. What captivated audiences at the Gaslight (and won the group an extended stay) was the power, intensity, and complexity of their music. It was loud and high energy; there were numerous sudden changes in tempo and meter. The melodies were bop-like in their complexity, but with an undeniable Indian quality, and were often played by guitar, synthesizer, and electric violin in unison. Hammer skillfully used the pitch wheel on his synthesizer, enabling him to achieve a guitar-like quality. Cobham played with such ferocity and drive that the drums became one of the group's primary voices. McLaughlin himself mesmerized audiences by often dressing completely in white while playing a double-neck electric guitar—one neck having six strings and the other twelve. The music was also quite varied, ranging from bone crunching bombastic to the serene—the violent to the tender. Folk, classical and blues elements were also present, as were the influences from Eastern cultures, particularly India.

While performing at the Gaslight, the Mahavishnu Orchestra recorded their first album, *The Inner Mounting Flame.* Picking up where Tony Williams Lifetime left off, the music is more focused and structured than Davis's albums. Combining virtuosic solo improvisations, stunning ensemble playing, electronic effects (such as Hammer using a ring modulator on his electric piano), and the unusual sound of

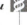

> *Members of the Mahavishnu Orchestra*
> - John McLaughlin–guitar
> - Jerry Goodman–electric violin
> - Jan Hammer–keyboards
> - Rick Laird–bass
> - Billy Cobham–drums ⤳

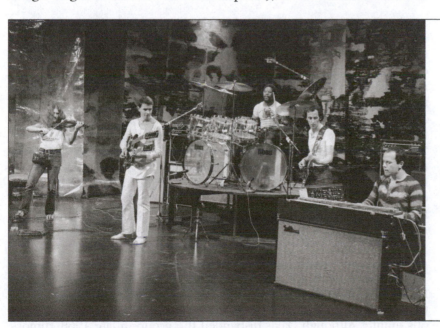

The Mahavishnu Orchestra in the early 1970s. (Left to right) violinist Jerry Goodman, guitarist John McLaughlin, drummer Billy Cobham, bassist Rick Laird, keyboardist Jan Hammer.

MUSIC ANALYSIS

TRACK 33: "CELESTIAL TERRESTRIAL COMMUTERS"

(McLaughlin) Mahavishnu Orchestra from the album *Birds of Fire* recorded August 1972 (3:02). Personnel: John McLaughlin: guitar; Jan Hammer: Fender Rhodes electric piano, Moog synthesizer; Jerry Goodman: electric violin; Rick Laird: bass; Billy Cobham: drums

Birds of Fire is the second studio album released by the Mahavishnu Orchestra, and the last by the original members of the band. With its virtuoso playing, diversity of musical styles, and great song-writing, in many respects it even outshines the group's electric debut album, *The Inner Mounting Flame*. "Celestial Terrestrial Commuters" is one of the albums hardest rocking songs, and contains two of the band's signature elements: complex, bop-like exotic unison melodies and odd time signatures (the song is in 10/8 time, with ten beats to the measure). On *Birds of Fire*, keyboardist Jan Hammer introduces the Mini-Moog (one of the first commercially sold portable synthesizers) for the first time, and expertly uses its modulation wheel on "Commuters" to create guitar-like pitch changes. After the opening head and Hammer's Moog solo, the middle section of the song

consists of guitarist John McLaughlin and violinist Jerry Goodman trading 2-bar solos. Throughout this futuristic cutting contest, the rhythm section of Hammer, drummer Billy Cobham, and bassist Rick Laird provide plenty of muscular support. *Birds of Fire* sold more than half a million copies in the US and even broke into *Billboard* magazine's Hot 100, providing evidence of the group's popularity. (ref: *Mahavishnu Orchestra: Birds of Fire* by Karl Keely, contemporary-jazz.suite101.com)

0.00	Intro groove is set up in 10/8 time signature
0.13	Head is played by guitarist John McLaughlin and violinist Jerry Goodman
0.41	Moog synthesizer solo
1.09	McLaughlin and Goodman trade fours with backing by drummer Billy Cobham and bassist Rick Laird
1.35	Hammer re-enters comping on electric piano
2.02	McLaughlin and Goodman play unison melody interspersed with brief synthesizer solos by Hammer
2.29	McLaughlin and Goodman return to head briefly before playing ending tag

an electric guitar, synthesizer, and an electric violin playing together, the album is a stunning debut that captured the intensity of their live performances. The press was also impressed. *Melody Maker* expressed a common sentiment when it said, "The effects of this album will be far-reaching."[8] In 1973, the group released two more albums that captured the electricity of the first, *Birds of Fire* and the live *Between Nothingness and Eternity*. These albums would be the last releases at the time with the group's original personnel (although one more album, *The Lost Trident Sessions*, made from a session on June 25, 1973, was released in 1999). Around this time, internal disagreements led to the breakup of the band. In 1974, McLaughlin reformed the Mahavishnu Orchestra with Jean-Luc Ponty on violin, Gayle Moran on keyboards, Ralphe Armstrong on bass, and Narada Michael Walden on drums. The new lineup released three more albums before disbanding in 1975.

Herbie Hancock: Mwandishi Turns to Head Hunting

During the mid 1960s, **Herbie Hancock** established himself as one of the foremost pianists in jazz by virtue of his tenure with Miles Davis's 60s quintet. Although Davis disbanded the group in late 1968, rumors

persist to this day that he actually fired Hancock prior to that over a personal matter. In any event, Hancock continued to record with Davis through 1972, taking part in sessions for *In a Silent Way, A Tribute to Jack Johnson,* and *On the Corner,* among others. During his time with Davis, Hancock released a number of well-received hard bop-oriented albums for Blue Note under his own name, including *Empyrean Isles* in 1964, *Maiden Voyage* in 1965, and *Speak Like a Child* in 1968. In 1969, however, he left the venerable jazz label

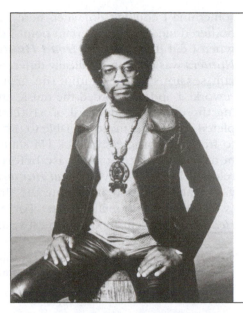

Herbie Hancock in the 1970s.

and signed a lucrative contract with the rock-oriented Warner Brothers and put together a sextet with Billy Hart on drums, Buster Williams on bass, Bennie Maupin on bass clarinet and saxophones, Eddie Henderson on trumpet, and Julian Priester on trombone. Known as the "**Mwandishi**" band for the members' use of Swahili aliases (Hancock became "Mwandishi," [composer], Hart "Jabali" [rock], Williams "Mchezaji" [player], and so on), they released three albums between 1970 and 1972. The music ranges from *Bitches Brew*-ish space funk *(Mwandishi)* to avant-garde electronica jazz *(Crossings)* to a combination of the two *(Sextant)*. On the last two albums, Moog synthesizer stylist Dr. Patrick Gleason was brought in to create an otherworldly ambience with electronic sound effects. These effects, created on the state of the art analog synthesizers of the day, were often painstaking to create and manipulate. Today they are much more easily created on digital synths and laptops, and are making their way back into contemporary jazz (Chapter 9). Hancock himself also experimented with different keyboards during this period, using the Fender Rhodes electric piano (which he occasionally modified with echo, ring modulator or wah-wah effects), the Hohner D-6 clavinet, and the Mellotron.

Warner Brothers, however, lost their patience with Hancock's "space-jazz" and dropped him after the release of *Crossings*. At this point, Hancock signed with Columbia, which released *Sextant,* but urged him to pursue a larger audience as Miles Davis had done. After disbanding the Mwandishi band, Hancock put together a quintet with funk musicians who could play jazz—rather than jazz musicians who could play funk. Not only was this exactly the opposite approach taken by Davis and others (who filled out their jazz/rock bands with established jazz musicians), it was a major *touché* statement to all the jazz musicians who looked down their noses at rock players. Known as the Head Hunters, the new band consisted of Bennie Maupin (held over from the Mwandishi band), Harvey Mason on drums, Paul Jackson on bass, and Bill Summers on percussion. Inspired by the psychedelic rhythm and blues of Sly and the Family Stone, and in particular Sly's 1970 Number 1 hit "Thank You (Falettinme Be Mice Elf Agin)," Hancock abandoned the soundstream approach and embraced tight funk grooves. "I didn't know what Sly was doing. I heard the chorus, but how could he think of that? I was afraid that that was

something I couldn't do, when here I am, I call myself a musician; it bothered me. Then at a certain point I decided to try my hand at funk when I did [the 1973 LP] ***Head Hunters.***"[14] Everything about *Head Hunters* was done in a radically different way. After recording hours of jam sessions in the studio, the group sifted through the tapes, reworked, and re-recorded the music and then added overdubs, bringing the cost to an unheard of $100,000. Once the album was completed, it was first made available to urban R&B radio stations and then to free form progressive rock FM stations, a strategy that nurtured a non-traditional customer base before it was even released. Once released in October 1973, *Head Hunters* took just six months to reach gold status. In 1986, it became the first jazz album to go platinum (with sales of one million units). For more than ten years afterward, *Head Hunters* remained the largest-selling jazz album in history.*

*Sales of Miles Davis's *Kind of Blue* eventually surpassed *Head Hunters*. *Kind of Blue* went platinum in 1997 and multi-platinum in 1999 (figures and dates from RIAA, www.riaa.com).

Music Analysis

Track 34: "Watermelon Man"

(Hancock) Herbie Hancock from the album *Head Hunters* recorded at Wally Heider Studio and Different Fur Trading Co., San Francisco in September 1973 (6:32). Personnel: Herbie Hancock: Fender Rhodes electric piano, Hohner clavinet, ARP synthesizers; Bennie Maupin: soprano sax; Paul Jackson: bass guitar; Bill Summers: percussion, beer bottle; Harvey Mason: drums

Herbie Hancock's "Watermelon Man" is one of the most standard of jazz standards. It was first released in 1962 on Hancock's Blue Note debut album *Takin' Off*. In 1963, Cuban bandleader Mongo Santamaría had a #10 hit with his version of the song, providing Hancock with ample songwriting royalties throughout much of the 1960s. The song's popularity can be traced to its simple, gospel-like piano riff and shout out melody, which Hancock said was inspired by actual watermelon street sellers of his youth. "I remember the cry of the watermelon man making the rounds through the back streets and alleys of Chicago. The wheels of his wagon beat out the rhythm on the cobblestones." The version found on *Head Hunters* is completely reworked from the original and is one of the delights of 1970s jazz/rock fusion. The song starts with the sound of percussionist Bill Summers

blowing rhythmically into a glass bottle, which was inspired by the hindewhu music of the Pygmies of Central Africa. From there, Hancock and crew turn the song into a slow pressure cooker driven by Harvey Mason's sparse, syncopated drumming, Paul Jackson's lazy bass riff, and Hancock's funky clavinet stabs. (ref: *Head Hunters: The Making of Jazz's First Platinum Album* by Scott Yanow; *Highway 61 Revisited: The Tangled Roots of American Jazz, Blues, Rock, and Country Music* by Gene Santoro)

0.00	Introduction: percussionist Bill Summers creates rhythmic groove by blowing on a bottle and with vocalizations
0.45	Bassist Paul Jackson enters with bass riff
0.59	Drummer Harvey Mason enters
1.18	Herbie Hancock enters playing Hohner clavinet
2.04	Band kicks into a second groove with Hancock on electric piano
2.31	Return to first groove; Maupin plays head
3.16	Short interlude
3.24	Head is restated as Hancock returns to clavinet
4.08	Return to the second groove
4.35	Original groove re-established; Summers re-enters on bottle; band vamps out

More than any other album in the jazz/rock fusion era, *Head Hunters* marked a "no turning back" moment. Record labels and jazz musicians could now clearly see the rewards of targeting their music toward a youthful rock audience. The trick ultimately came down to walking the line between accessibility and credibility. The music had to be listener-friendly enough to sell, but it had to have enough jazz integrity to not "sell out." Hancock managed to do this with *Head Hunters;* there are catchy riffs ("Chameleon") and soothing rhythm and blues ("Vein Melter"), as well as sweltering jazz/funk grooves ("Sly"). As popular as the hit "Chameleon" became, the highlight of the album is arguably the reworking of Hancock's 1962 soul jazz standard "Watermelon Man," which on *Head Hunters* became a slow pressure cooker that opens with percussionist Summers blowing rhythmically into a coke bottle. This recording opened up a whole new way for musicians to think about the possibilities inherent in reworking jazz standards, a practice that has become increasingly fashionable in the years since. Although Hancock suffered his share of criticism for selling out with *Head Hunters,* the years immediately following its release saw him moving in the direction that would mark the remainder of his career: that is, moving in several directions at once. Although he quickly followed *Head Hunters* with several more funk-influenced albums (and played to sold out arenas—with Miles Davis as his opening act!), he also reunited and toured with the all-acoustic Davis 1960s quintet (without Davis, who was replaced by Freddie Hubbard) became known as the V.S.O.P. Quintet. He also recorded and toured with Chick Corea, playing jazz standards on dual acoustic pianos.

Chick Corea and Return to Forever: Jazz Meets Art Rock

Chick Corea came to jazz/rock after spending much of the 1960s as the consummate sideman, working for (to name just a few) Stan Getz, Mongo Santamaria, Sarah Vaughan, Herbie Mann, and Dizzy Gillespie. Between these gigs, Corea found the time to record two notable "straight-ahead" acoustic jazz albums as a leader, *Tones for Joan's Bones* in 1966 and *Now He Sings, Now He Sobs* in 1968. Along with this impressive resume, Corea established a reputation as an extremely rhythmic player with a forceful touch and amazing technique. In the summer of 1968, he began working for Miles Davis, who immediately put him on the electric piano, beginning with the album *Filles de Kilimanjaro.* Although Corea officially left Davis in September 1970, he continued to record with him through the summer of 1972, and played on Davis's albums *In a Silent Way, Bitches Brew, Live/Evil,* and *On the Corner* (and several others). In late 1970, Corea formed the short-lived experimental free jazz quartet Circle, with saxophonist Anthony Braxton, drummer Barry Altschul, and bassist Dave Holland. In April 1972, Corea recorded the acclaimed *Piano Improvisations, Vol. 1 and 2,* albums that helped fuel the popularity of solo piano albums in the 1970s. He also recorded a remarkable duet album with vibist Gary Burton, titled *Crystal Silence.* Later that year, he formed the group that would be the focus of much of his career work in the 1970s, **Return to Forever.**

Return to Forever began as a West Coast-ish, Latin jazz group, with saxophonist Joe Farrell, bass wizard Stanley Clarke, and the Brazilian husband/wife team of Airto Moreira and Flora Purim on drums and vocals, respectively. In this rendition of the band, Corea played the electric piano exclusively. Two albums were released, *Return to*

Music Analysis
Track 35: "Medieval Overture"

(Corea) Return to Forever from the album *Romantic Warrior* recorded February 1976 at Caribou Ranch, Nederland, CO (6:10). Personnel: Chick Corea: piano, electric piano, organ, synthesizers; Al Di Meola: electric and acoustic guitar; Stanley Clarke: electric and acoustic bass; Lenny White: drums, percussion, marimba

"Medieval Overture" is the opening track on Return to Forever's 1976 LP *Romantic Warrior*. The album's medieval theme gives it a "concept album" spirit comparable to those by 1970s art rock bands such as Yes and Pink Floyd. Although it was the band's first for industry giant Columbia Records and its biggest seller at 500,000 copies, it was the last for the classic RTF lineup of Corea/Clarke/Di Meola/White. Soon after the album's release, Corea dismissed White and Di Meola and replaced them with a group that included his future wife, Gayle Moran. *Romantic Warrior* is full of music that is demanding of virtuoso performances by all four musicians, yet it is "user-friendly" for jazz and non-jazz fans alike. "Medieval Overture" is an epic piece that changes mood several times and features Corea on a variety of synthesizer sounds, complex unison melodies and ferocious support from both White and Clarke.

0:00	Song begins with chord clusters played by Chick Corea on synthesizer
0:09	Di Meola, Clarke, and White enter playing a complex countermelody
0:50	Corea introduces a new theme with the other three band members joining in at 1:01
1.37	At this point the rhythm section lays out as Corea plays a soaring synthesizer melody over sustained organ chords
2:51	Corea introduces a new tempo and synthesizer riff over which Clarke and Di Meola play a complex unison solo. White backs this up with ferocious drumming
4.17	Corea reintroduces the opening theme; Clarke and Di Meola play unison lines as the song builds to a dramatic conclusion

Forever and the highly regarded *Light as a Feather,* which includes the first recorded version of Corea's standard "Spain." The music *was* literally light as a feather, with smooth samba grooves and soothing vocals, creating a context for Corea's precise improvisations. In 1973, Corea retooled Return to Forever into a harder-edged fusion band

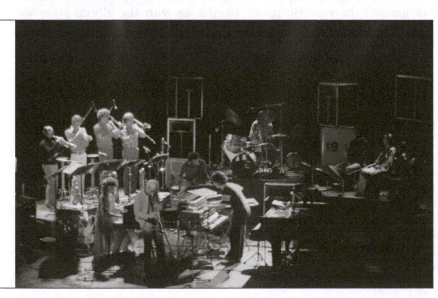

Return to Forever performing in Châteauneuf, France in 1978.

with the addition of guitarist Bill Connors and *Bitches Brew* drummer Lenny White to replace Farrell, Moreira, and Purim. After one album, Connors was replaced by the technically flashier Al Di Meola. The albums from this version of Return to Forever, *Hymn of the Seventh Galaxy, Where Have I Known You Before,* and *No Mystery* reveal a sound that has largely abandoned jazz elements (except for improvised solos) and is closer to the progressive rock bands of the era. With this version of Return to Forever, Corea made extensive use of synthesizers as well as acoustic and electric piano. With its new direction, Return to Forever's promising record sales enabled the group to sign with Columbia Records. With Columbia's clout behind them, the next album, **Romantic Warrior** (1976) became Return to Forever's biggest seller, eventually achieving certified gold status. *Romantic Warrior* is at heart an art rock concept album based around medieval themes, complete with cover illustration and composition titles like "Medieval Overture" and "Duel of the Jester and the Tyrant." The compositions are high energy, complex epics that require tremendous technical skills, with a sound reminiscent of bands such as Yes and King Crimson. Corea once again creates most of the orchestration with an ambitious use of synthesizer layering.

Despite its wide popularity, *Romantic Warrior* seemed to cross a line for some jazz fans, some of whom questioned whether it was jazz at all, or just jazzy-sounding rock. It was certainly highly if not overly produced, and perhaps a little too pretentious. In any event, it would be the last album for the second version of Return to Forever, as White and Di Meola left to pursue other projects. In the meantime, Corea reformed the group with a six-piece horn section, replacing White and Di Meola with Gerry Brown on drums and future wife Gayle Moran on keyboards and vocals. The group produced only two albums, *Music Magic* and *R.T.F. Live,* before it disbanded in late 1977. Corea continued to pursue the concept album idea from time to time as a soloist, most notably with 1978's *Mad Hatter.* The classic RTF lineup of Corea, Clarke, White, and Di Meola reunited for tours in 1953 and 2008, but did not record.

Weather Report: Heavy Weathermen

Formed in 1971 by keyboardist **Josef Zawinul** and saxophonist **Wayne Shorter, Weather Report** became the standard bearer for jazz/rock and fusion in the 1970s and early 1980s. Zawinul and Shorter met in 1959 shortly after Zawinul had moved to New York from his native Vienna, Austria (via Berklee College of Music in Boston, which he briefly attended in 1958). At the time, Zawinul could barely speak English, but he and Shorter hit it off—both personally and musically.[9] Later that year, the two played together in Maynard Ferguson's band for a short time before Shorter left to join the Jazz Messengers. In 1961, Zawinul joined the Cannonball Adderley Quintet, and became one of the group's primary writers, composing such soul jazz tunes as "Walk Tall," "The Country Preacher," and "Mercy, Mercy, Mercy," which became a Number 11 hit on the *Billboard* pop charts in 1967 and a jazz standard. "Mercy, Mercy, Mercy" was also the first recording on which Zawinul used an electric piano, making him one of the first jazz pianists to do so. Eventually Zawinul began using a ring modulator and wah-wah pedal to further modify the sound of the electric piano, effects that he would continue to use in Weather Report. Zawinul's writing and electric playing soon caught the attention of Miles Davis,

Members of Weather Report (1977)
- Josef Zawinul–keyboards
- Wayne Shorter–soprano and tenor saxophone
- Jaco Pastorius–bass
- Manolo Badrena–percussion
- Alex Acuña–drums

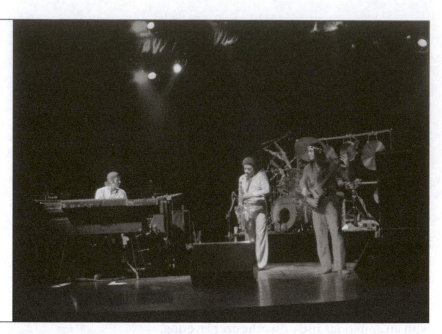

Weather Report, 1978. (Left to right) Keyboardist Josef Zawinul, saxophonist Wayne Shorter, bassist Jaco Pastorius. Drummer Alex Acuña hidden in background.

who utilized both on *In a Silent Way* (whose title track was composed by Zawinul) and *Bitches Brew* (on which Zawinul contributed the twenty-minute composition "Pharaoh's Dance"). Zawinul's presence at the Davis sessions also reunited him with Shorter, and before long, the two began talking about starting their own group. It was a partnership based on mutual respect and sense of direction, according to Shorter: "Our main connection was that independently, not knowing the other was doing it, we both started changing the form of music around . . . We were very much alike."[10] Czech bassist Miroslav Vitous, with whom both had recently recorded, was also instrumental in the creation of the group. With the addition of drummer Alphonse Mouzon and Brazilian percussionist Airto Moreira, the first lineup for Weather Report was set.

In the beginning Weather Report was cut in the "soundstream" mold of the early Davis jazz/rock albums. The most noticeable difference between their debut album *Weather Report* (recorded March 1971) and *Bitches Brew* was that the songs—all written by Shorter, Zawinul, or Vitous—were generally much shorter and more focused. Where *Bitches Brew* had generated controversy, *Weather Report* garnered a *Down Beat* Album of the Year Award. (In fact, *Down Beat* was so excited about the album that before it was even released, the magazine gave it a five-star, two-page review that opened with, "An extraordinary new group merits an extraordinary review of its debut album."[11]) Over the course of the next two years, Weather Report's music slowly put more emphasis on funk and rock rhythmic grooves and electric piano/synthesizer experimentation by Zawinul. Two more albums, *I Sing the Body Electric* (1971) and *Sweetnighter* (1973), were recorded, with drummer Eric Gravatt and percussionist Dom Um Romão joining the group, replacing Mouzon and Moreira. In 1974, the band replaced Vitous with bassist Alphonso Johnson, and continued to evolve by incorporating more listener-friendly riffs and dance grooves. *Mysterious Traveller,* released that same year, became the first of four Weather Report albums in a row to win *Down Beat* Album of the Year Awards, an indication that the group was entering into an intensely creative and commercially successful period. By this time,

the group's albums were selling exceptionally well, and the group was beginning to draw large college-aged crowds to its concerts.

In early 1976, after a concert in Florida, Joe Zawinul was introduced to a young man who proclaimed himself to be "the greatest bass player in the world." Zawinul was more than a little amused, until a local reporter nudged him and said that the kid was not lying. Today there is little argument that the kid, twenty-five-year-old **Jaco Pastorius** was indeed just that. Pastorius was one of the first important jazz musicians who came of age listening to rock music as much if not more than jazz, and in his youth had played in a number of rock and R&B bands, including Wayne Cochran and The C.C. Riders. Although by the time he joined Weather Report he was a skilled jazz virtuoso on the bass guitar as well as an accomplished songwriter, there was an unmistakable rock and roll attitude about him. "Pastorius had the long hair and the bandanna tied around his head, and he was always jumping off the stage," commented Shorter. "He had a very pronounced way of playing, and there was an immediate presence of tone on his bass, which looked like a guitar. He had everything to give the audience that rock association."[12] Pastorius energized

MUSIC ANALYSIS

TRACK 36: "PALLADIUM"

(Shorter) Weather Report from the album *Heavy Weather* recorded 1977 (4:46). Personnel: Josef Zawinul: ARP 2600 synthesizer, Fender Rhodes electric piano; Wayne Shorter: tenor and soprano sax; Jaco Pastorius: bass, mandocello; Alex Acuña: drums; Manolo Badrena: congas, percussion

"Palladium" is one of two Wayne Shorter compositions on Weather Report's highly acclaimed album *Heavy Weather*. Like most of the album's compositions, it is highly accessible to the average listener yet complex enough musically to draw the attention of serious jazz fans and musicians. The inspiration for the song comes from the Latin jazz concerts that Shorter used to attend at the Palladium Club in New York City in his youth. Much of the song built on a relentlessly powerful rhythmic groove established by the virtuoso bassist Jaco Pastorius, drummer Alex Acuña, and percussionist Manolo Badrena. Melodically the song consists of short fragments of melody punctuated by staccato (short and detached) notes played by Shorter and Josef Zawinul on electric piano. *Heavy Weather* is one of the most popular albums in jazz history, going gold in 1981 and platinum (sales of one million units) in 1991. It was named album of the

year in 1977 by virtually every music publication, was nominated for two Grammy Awards, and propelled Weather Report into the realm of playing festivals and stadiums.

0:00	After an opening riff played in unison, the band launches into a minor key groove that ends in a moment of silence
0:26	A new groove is set up by the rhythm section; tenor saxophonist Wayne Shorter introduces the first theme, which consists of short staccato phrases separated by electric pianist Josef Zawinul's rhythmic comping
2:00	Theme is restated, this time doubled by Zawinul on synthesizer
2.37	Zawinul plays dramatic pedal tone on synthesizer
3:06	A second, nursery rhyme-like theme is introduced, which Shorter uses as a springboard for improvisation as the
3.23	Shorter begins improvising as second theme continues
3.55	Zawinul begins soloing as Shorter repeats second theme; track ends abruptly

Weather Report with his playing and songwriting, and in his six-year stay with the band became a musical force equal to the co-founders. His addition, along with drummer Alex Acuña and percussionist Manolo Badrena, enabled Weather Report to leap into pop superstardom with rock concert–like live performances and the release of *Black Market* (1976) and *Heavy Weather* (1977). *Heavy Weather* is arguably the gold standard in 1970s fusion albums, with outstanding compositions from all three writers and inspired playing from the entire band. The centerpiece of the album is Zawinul's "Birdland," a cleverly written tune that incorporates catchy pop-friendly melodies, innovative use of bass harmonics, and Zawinul's use of his full arsenal of keyboards to create a synthetic big band sound. "Birdland" (named after the famous New York club) hit Number 1 on the jazz charts, became a jazz standard, and remained popular for years, helped out in part by Manhattan Transfer's popular vocal rendition, which earned that group a Grammy Award in 1980.

Heavy Weather reached Number 30 on the pop charts, sold more than half a million copies (earning a gold record) and helped elevate Weather Report to playing festivals and stadiums. The album was universally regarded as a creative masterpiece (it was named album of the year by virtually every music magazine), and came along at a time when jazz/rock was beginning to show signs of staleness. *Heavy Weather* represents the commercial and critical peak of a band that successfully integrated inventive improvisation, arranged parts, jazz, rock, ethnic influences, and technology. As Jeff Pressing notes, "Alongside Duke Ellington, Weather Report created a body of work that numbers among the most diverse and imaginative in jazz."[13] The group stayed together until 1986 and recorded sixteen albums in all. Pastorius left in 1982 and was tragically murdered in 1987 after several years of mental issues. Joe Zawinul died on September 11, 2007.

Fusion Evolves: Can We Still Call This Jazz?

As jazz/rock and fusion became the latest "New Thing," the trick for jazz musicians became to generate a larger audience for their music without sacrificing their souls to the pop world. Some did a remarkable job of maintaining a good accessibility/credibility balance; albums such as *Head Hunters, Heavy Weather,* and *The Inner Mounting Flame* are compelling to listen to even today. However, for many jazz musicians the path to increased visibility became a slippery slope to a pact with the pop "devil." Some fusion groups became overly pretentious in their use of showmanship, or as Stuart Nicholson states, "In the end this virtuosity took on a strained, dandyish quality that suggested the style had entered a narcissistic cul-de-sac."[15] Other groups became overly pop-oriented. The worst offenders of all crossed both lines. Between the late 1960s and the late 1980s, a jazz/rock to fusion to a new pop-oriented style called **smooth jazz** evolution occurred, with the lines between each style as gray as the lines between rain to sleet to snow. At one end there is *Bitches Brew;* on the other end is *Duotones,* the 1986 album by Kenneth Gorelick, better known as **Kenny G.** *Duotones* is arguably the low water mark in smooth jazz, with simple, repetitive pop melodies and chord progressions, which, to some, is better suited for

Defining Jazz/Rock, Fusion, and Smooth Jazz

■ Jazz/Rock places a high priority on jazz tradition and non-commercial elements; most often takes the form of the "soundstream" approach of early 1970s Miles Davis or early Weather Report

■ Fusion is an equal triangulation of jazz, rock, and pop; good examples are the works of Pat Metheny and the Yellowjackets; developed in the mid to late 1970s

■ Smooth Jazz is an overly commercial, pop-oriented jazz style with emphasis on catchy melodies, repetition, and danceable grooves; the best example is Kenny G

background music at shopping malls and on the Weather Channel. However, it was clearly a winner in the sales department, going gold in May 1987, platinum one month later and multi-platinum in November 1987—and eventually being certified 5× platinum in 1995. The album's opening track "Songbird" also was a hit, reaching Number 4 on the *Billboard* Hot 100 chart. *Duotones* was merely the breakthrough album for Kenny G, who as of July 2006 has sold 48 million albums (which is more than Nirvana and The Police *combined*), one of which, *Breathless,* sold 12 million copies. Although Kenny G's albums are listed on (and quite often top) the Contemporary Jazz Albums chart, it is fair to ask whether they are really jazz albums. Certainly it is for many listeners, but it is a complicated question without an easy answer. (The issue of how to draw the line between pop and jazz will be addressed in greater detail in Chapter 9.) Another more pertinent question for our current chapter is: how did we get here from there?

If *Bitches Brew* is jazz/rock and *Duotones* is smooth jazz, what is fusion? What is the difference between the three? For our purposes, jazz/rock will be defined as rock influenced jazz that places a high priority on improvisation and non-commercial elements, and most often takes the form of the soundstream approach of the early 1970s Miles Davis and Weather Report recordings. By the mid 1970s, this approach was evolving into a more focused and stylized form that became known as jazz/rock fusion, or simply fusion. Fusion can be characterized by the equal triangulation of jazz, rock and pop that places increased emphasis on studio production, memorable melodic riffs and catchy rhythmic grooves without abandoning jazz traditions. Using this definition, *Head Hunters* and *Heavy Weather* can be called early examples of fusion. Fusion became very popular with jazz musicians in the late 1970s and is so to this day; artists such as guitarists Pat Metheny and John Scofield and saxophonist Michael Brecker produced great fusion records in the 1980s, 1990s and well into the 21st century. and their work will be discussed further in chapter 7. (Even though Metheny detests the word fusion—calling it the "F" word—there is really no other way to categorize this music.)

Smooth jazz virtually eliminates the rock elements and puts its emphasis on pop: danceable beats, catchy melodies, and repetition, making sure that there is nothing that is too musically adventurous. Smooth jazz really started to emerge in the mid to late 1970s, when records like George Benson's "This Masquerade" (Number 10, 1976), Chuck Mangione's "Feels So Good" (Number 4, 1978), and Spyro Gyra's "Morning Dance" (Number 24, 1979) began appearing on AM radio. Throughout the 1980s, artists such as singer Al Jarreau, tenor saxophonist Grover Washington, Jr., and trumpeter Herb Alpert began to get considerable radio play and the corresponding increase in record sales. In 1987, Los Angeles radio station KTWV (The Wave) established smooth jazz as a radio format, which by the mid 1990s was programmed by more than 200 stations. For a few years, it seemed that jazz—at least this style of jazz—was on its way back onto the popular culture radar screen. Could this be the swing era all over again? Well, not exactly. Smooth jazz seemed to lose its luster by the end of the 1990s. Today, however, there are still more than 50 "terrestrial" radio stations that program smooth jazz, as well as a number of satellite stations.

Notes

1. Nicholson, Stuart: "Fusions and Crossovers," *The Cambridge Companion to Jazz*, pg 218
2. *Down Beat*, 10/84, pg 16; also *The Cambridge Companion to Jazz*, pg 221
3. Morgenstern, Dan: *Down Beat Yearbook 1968*, pg 13; also *The Cambridge Companion to Jazz*, pg 223
4. Davis, Miles with Quincy Troupe: *Miles: The Autobiography*, pg 298
5. Quoted in "Bitches Brew: The Making of the Most Revolutionary Jazz Album in History," by Ouellette, Dan, *Down Beat*, 12/99, pg 33
6. Shipton, Alyn: *A New History of Jazz*, pg 860
7. Ouellette, pg 37
8. *Melody Maker*, 4/1/72, pg 28
9. Mercer, Michelle: *Footprints: The Life and Music of Wayne Shorter*, pg 61
10. Ibid, pg 141
11. Morgenstern, Dan, review in *Down Beat*, 5/27/71
12. Mercer, pg 176
13. Pressing, Jeff: "Fusions and Crossovers" from *The Cambridge Companion to Jazz*, pg 230
14. Pond, Steven F.: *Head Hunters: The Making of Jazz's First Platinum Album*
15. Nicholson, Stuart: *Jazz: The 1980s Resurgence*, pg 148

Study Questions for Chapter 6

1. What were some of the reasons why jazz was losing its audience to rock music? In general, how did jazz musicians react to rock?

2. Name some examples of rock musicians and albums that were jazz-influenced.

3. Who were some of the first jazz musicians to begin incorporating rock elements into their music? Name some of the early albums that attempted to do this.

4. Describe how Miles Davis's music evolved over the course of the late 1960s, and the steps he took to incorporate those changes.

5. Describe the sound of the album *Bitches Brew*. How was it put together, both during its recording and in post-production sessions?

6. Describe the sound of the Mahavishnu Orchestra. How was it unique, both in its sound, instrumentation, and personnel?

7. How did the sound of Weather Report evolve over the 1970s? Describe the roles of Zawinul, Shorter, and Pastorius.

8. Describe the evolution of Return to Forever, both in terms of its music and its instrumentation.

9. Explain how the album _Head Hunters_ was unique in both the way it was put together and in the way Herbie Hancock assembled the band.

10. Describe the different ways in which jazz/rock evolved over the course of the 1970s and some of the issues that emerged.

Neocons, Fusionists, and the New Left

© 2011, Igor Normann, Shutterstock, Inc.

Chapter **7**

Key Terms, Music, Places, Figures and Bands

Terms

Neo-conservative movement
Young Lions
Thelonious Monk International
 Jazz Competition
Roland GR300 guitar
 synthesizer
EWI
Harmolodics
M-Base

Music (albums, works, etc.)

The Majesty of the Blues
Tutu
Bright Size Life
Orchestrion
Pilgrimage
Blue Matter
Creative Orchestra Music
New Moon Daughter

Places

Berklee College of Music
Jazz at Lincoln Center

Figures and Bands

Wynton Marsalis
Albert Murray
Stanley Crouch
V.S.O.P. Quintet
Branford Marsalis
Joshua Redman
Christian McBride
Pat Metheny
Michael Brecker
Brecker Brothers
Steps Ahead
John Scofield
David Sanborn
The Yellowjackets
Ornette Coleman
Prime Time
Anthony Braxton
Steve Coleman
Greg Osby
Geri Allen
Cassandra Wilson
World Saxophone Quartet

Morning in America

On November 4, 1980, Ronald Wilson Reagan was elected president of the United States, defeating the incumbent Jimmy Carter. Although Carter was a highly intelligent and deeply religious man who had won the 1976 election as a grassroots populist from rural Georgia, gas shortages, high interest and unemployment rates, and an Iranian hostage situation dogged his presidency. By 1979, his approval ratings bottomed out at 28 percent. Carter increasingly became a symbol of defeatism and pessimism, whereas Reagan offered a contrasting vision to voters. Reagan was folksy, easygoing, and optimistic, and he was determined to single-handedly turn things around. Reagan's vision for America was steeped in nostalgia for the 1950s, a simpler time when the roles of men and women, adults and young people, and good and evil seemed to be more clearly defined. Rugged individualism, hard work, conformity, and the pursuit of a higher standard of living were virtues back then, before the 1960s brought psychedelics and sexual experimentation and the 1970s divorce and discontentment. The country, however, had changed since the 1950s. Although Americans eagerly embraced Reagan's vision of a return to the good old days, they were definitely not willing to return to a 1950s lifestyle. Getting ahead by any means possible was the driving force for many in the 1980s, or as author Troy Gill put it, "the pursuit of happiness degenerated into an obsessive pursuit of pleasure, both indulgent experiences and beautiful things." The poster child for the era was the mythic "yuppie," or "young urban professional" whose existence seemingly was based on "consuming rather than being, on things rather than relationships, on an aesthetic life rather than ascetic living."[1] It was no accident that one of the decade's most popular films, *The Big Chill,*

was about former baby boomers who had lost their 1960s idealism and jumped on the yuppie bandwagon, and one of its most popular actors was Michael J. Fox, who played the irrepressible young Republican Alex P. Keaton on the television sitcom *Family Ties.* Although, by definition, true yuppies were almost non-existent,* their imagery defined the era. Not everyone bought into the Reagan Revolution—his administration was particularly ruthless to poor and black Americans, for instance—and, consequently, he generated a considerable amount of controversy. Nonetheless, in 1984, the man who facilitated the remarkable 1980s social transformation was re-elected by an overwhelming landslide, helped in part by his famous feel-good "Morning in America" television commercials.

Like America, jazz in the 1980s was also changing in fundamental ways. One of the most profound changes was the arrival of a new generation of young players with seemingly unlimited talent who were the products of the now well-established jazz educational system. "The institutionalization of jazz education made advanced technical skills commonplace," wrote Stuart Nicholson, "with colleges producing young musicians well-versed in the craft of improvisation who might have stunned the jazz world just twenty years before with their technical prowess."[2] Although the phenomena had really started in the 1970s, by the 1980s, it seemed as if young jazz virtuosi were coming out of the woodwork. Formal jazz education programs had begun in the 1940s and, by the 1950s, programs at North Texas State University (now the University of North Texas), the University of Miami, and **Berklee College of Music** in Boston had become leaders in the field. By the 1970s, jazz education was ubiquitous in colleges and high schools across the country. By 1981, there were by one estimate 400,000 student musicians playing in 20,000 to 25,000 junior high, high school, college, and university bands in America.[3] Berklee's reputation as a bona fide jazz trade school (with graduates that included Quincy Jones, Gary Burton, and Josef Zawinul) would be further enhanced in the 1980s with its ever more impressive list of alumni and faculty, which includes many of the musicians discussed in this chapter. There was, however, a downside to the ascendancy of the college educated jazz musician. "With so many musicians supporting the same sources of stylistic inspiration, similarity in concept and execution was inevitable . . . consequently individuality became less important than shared values of craftsmanship—technique, familiarity with the harmonic and rhythmic conventions of the music, an orthodox tone and precise articulation."[4] Guitarist Pat Metheny adds: "We're at a point now with so many great young players, it's a little like there's a thousand channels on cable but there's nothing to watch." If, he says, "it doesn't come embodied in a conception, it's 'just' good playing."[5] In other words, was jazz in the 1980s becoming an era in which technical skills trumped individuality, and youth a bigger asset than experience?

BERKLEE COLLEGE OF MUSIC

Originally founded in 1945 as the Schillinger House of Music, the Berklee College of Music in Boston has consistently been at the forefront of jazz and contemporary music education. The school's alumni include Josef Zawinul, Gary Burton, Quincy Jones, John Scofield, Bill Frisell, Joe Lovano, John Mayer, and Donald Fagen. Today, the school has an enrollment of 3,800 with a faculty of 460.

*According to *American Demographics,* Jan 1988, only 0.3 percent of the population was under forty and making at least $75,000 per year, the generally accepted requirements to yuppie-dom.

Wynton Marsalis: Jazz Messiah or Prophet of Death?

The Marsalis Invasion

All of this brings us to **Wynton Marsalis,** who became the de facto face of jazz in the 1980s. Marsalis was absolutely Reaganesque in the way he impacted the jazz scene. Like the fortieth president, Marsalis tapped into a dormant yearning for a nostalgic return to the 1950s. While the differences between these two men were obvious—one was a young, hip, urban, black, street-smart intellectual, the other an aging, uncomplicated, white, down-home Midwesterner—they were remarkably similar in the way they facilitated change in their respective arenas. Both men were image conscious. Both possessed great communicative skills. Marsalis spoke with a sense of authority that few, if any, other jazz musicians—or critics for that matter—could match. Marsalis's rise to fame and power also benefited from—and, in fact, even broadened—the 1980s trend toward emphasizing technique rather than individuality as a musician's most important asset. He was after all, universally acknowledged as one of the most technically gifted jazz musicians in history. Like Reagan, Marsalis had many followers who bought into his vision, but he also had many critics. He became a polarizing figure at the center of one of the most controversial periods in jazz history. Like American society, jazz had seen its share of turbulent times—the 1960s (descent into anarchy and chaos with free jazz), and the 1970s (over-commercialization and electrification with jazz/rock fusion)—that for many were paths into a musical wilderness. As we have seen, those who stayed the course by playing mainstream jazz often experienced hard times that seemed to get harder by the day. For many of these musicians, Marsalis was a messiah who brought a welcome rebirth to jazz. To others, however, Marsalis was an angel of death who was hastening the music's demise. To be sure, the age-old question "Is jazz dead?" began to sur-

Trumpeter Wynton Marsalis.

face again in the late 1980s. The bottom line: just as the Reagan Revolution transformed the political discussion in the 1980s, Wynton Marsalis and the neo-conservative movement he helped unleash did the same thing in the world of jazz.

Marsalis (born October 18, 1961) was born in New Orleans into a musical family led by his father Ellis, a well-respected local pianist and educator. Three of Wynton's five brothers also became musicians (saxophonist Branford, the eldest; drummer Jason; and trombonist Delfeayo). Together they ascended into the national jazz scene in the 1980s with a sense of dynasty reminiscent of the Kennedys. (In the 1990s, *The New Yorker* summed up the Marsalis invasion by running a cartoon depicting two children running into a bedroom shouting, "Dad! Dad! Wake up! They just discovered another Marsalis!") As a child, Wynton (named after former Miles Davis pianist Wynton Kelly) was a disciplined and driven trumpet student who faithfully followed a rigorous three-hour daily practice routine en route to developing prodigious abilities in both jazz and classical music. In 1978, he moved to New York to attend the Juilliard School, and began to attract the attention of the city's music elite. In the summer of 1980, Wynton—all of eighteen years old—sat in with Art Blakey's Jazz Messengers, which in turn led to a job offer. Turning to his father for advice on whether to continue school or go on the road, Ellis Marsalis recalls, "He called up and said, 'Man, I have a chance to join Art Blakey's band. What do you think?' I said, 'Well, one thing about Juilliard, man,' I said, 'Juilliard's going to be there when they're shoveling dirt in your face. Art Blakey won't.'"[6] Wynton followed his father's advice, and within a year he had become the group's musical director and was joined on the front line by brother Branford. In 1980, he signed contracts with the jazz and classical divisions at Columbia Records, and in 1981 released his eponymous debut album, which included Branford and featured the members of Miles Davis's 1960s rhythm section (Herbie Hancock, Ron Carter, and Tony Williams) on several tracks. *Wynton Marsalis* sold more than 100,000 copies, an impressive figure for a debut jazz album. In 1983, Marsalis released his third jazz album, *Think of One,* and made his classical recording debut with *Trumpet Concertos.* Both albums won Grammy Awards, making him the first artist in history to receive Grammy Awards in both categories in the same year. He repeated the feat in 1984, the year he turned twenty-three years old.

These achievements, needless to say, were nothing short of astonishing, and were duly noted in the jazz and artistic worlds. In short order, the young, stylish, incredibly talented jazz and classical musician became the beneficiary of a high-powered public relations campaign by Columbia (the largest record label in the world) that made him the darling of the "cultured" music world. "Marsalis's rise to fame while barely out of his teens was an unprecedented event in the jazz world," wrote historian Ted Gioia. "No major jazz figure—not Ellington or Armstrong, Goodman or Gillespie—had become so famous so fast."[7] But could he sustain such a high level of achievement? No problem. Marsalis won four more Grammy Awards in 1985—all in jazz—bringing his grand total at the time to eight (he now has ten). Since then, he has won a Peabody Award and the Pulitzer Prize, and has been awarded no less than *thirty* honorary doctorates and an honorary membership in England's Royal Academy of Music. To date, Marsalis has recorded more than forty jazz albums, a remarkable accomplishment considering that many of the albums

consist primarily if not solely of music that he has composed. (In addition, Marsalis has released eighteen classical albums since 1981 and estimates that he performs an average of 120 gigs per year.) Marsalis's highly prolific compositional output has resulted in four ballets, two string quartets, and two film soundtracks, all of which have evoked critical comparisons to Duke Ellington and Charles Mingus, two of jazz's greatest composers. He has also written extended works for a number of concept-themed albums, which include *Blood on the Fields* (about slavery, for which he won his Pulitzer), *Black Codes (From the Underground)* (about nineteenth century Jim Crow laws), *From the Plantation to the Penitentiary* (a critique of contemporary American society), and *The Marciac Suite* (a seventy-six-minute, thirteen-movement tribute to the medieval town of Marciac, France).

Neocon Controversy

So what is so controversial about a musician with such unlimited talent? Well, where does one start? From the beginning, Marsalis made enemies by criticizing the elder statesmen of jazz in print. For example, in the July 1983 issue of *JazzTimes Magazine* he claimed that Sonny Rollins and Ornette Coleman were "selling out;" "Bird would roll over in his grave if he knew what was going on." He went on to say (remember, he is only twenty-one at the time): "We gotta drop some bombs here. Indict some motherfuckers. I don't want to cut Freddie [Hubbard] down. I'd rather cut Miles [Davis] down than Freddie. He ain't doin' nothing. [Miles] was never my idol. I resent what he's doing [playing jazz/rock] because it gives the whole scene such a letdown. . . . He's just co-signing white boys, just tomming." To which Davis (whose influence on Marsalis's playing at the time was quite obvious) replied: "He's got a lot of technique, but that's about it," and then added "Without me, [he would] be all 'Flight of the Bumblebee'."[8] The issue that Davis alludes to, Marsalis's excessive use of technical virtuosity at the expense of creativity and sense of personal style, has also been a constant gripe with other musicians and critics. Keith Jarrett has been quoted in *The New York Times Magazine* as saying, "I've never heard anything Wynton played sound like it meant anything at all. Wynton has no voice and no presence." Pianist Joe Zawinul: "As an artist he really can't carry the stick. He's been put on a pedestal."[9] Historian Dr. Lewis Porter states that Marsalis's solos "sound, to these ears, like patchworks rather than coherent statements."[10] Respected jazz writer Whitney Balliett said, "He has never moved me as a trumpet player." To these criticisms, Marsalis replies: "If you're talking I don't play with soul, and all that, man, one thing I want to make clear about that is I'm from the neighborhood and I represent African-American culture much more than these buffoons they think are authentic Negroes."[11] (It should be noted that even the critics listed here have acknowledged that Marsalis's technique is impressive.)

Marsalis's critics have also taken issue with his apparent indoctrination by **Albert Murray** and **Stanley Crouch,** two prominent jazz writers with an agenda about what jazz is supposed to sound like and how it should reflect contemporary African-American culture. Their ideology began in 1976 when Murray published *Stomping the Blues,* a book that strongly advocates (among other things) that the blues is

an essential element of all jazz. In other words, jazz that doesn't have blues tonalities in it isn't really jazz. Crouch is a former free jazz drummer who began writing for the *Village Voice* in 1979, and over time developed an increasingly conservative and opinionated viewpoint on jazz that eventually aligned with Murray's. Building on the principles stated in *Stomping the Blues,* together they established the criterion for what has become known as the neo-traditional or **neo-conservative movement,** a narrow-minded notion stating that swing, blues tonalities, and the use of acoustic instruments, along with a technical mastery of one's instrument, are indispensable components of jazz. Murray and Crouch have also inferred in writing that one has to be black to play jazz convincingly. A literal interpretation of their canon would mean that most of the jazz played and recorded since the early 1960s is not real jazz. Free jazz? Not jazz. Jazz/rock fusion? Nope. Bossa nova? No way—it doesn't swing, and Brazilians are not African-Americans. Although most jazz before 1960 would get an endorsement from the neocons, their stylistic ideal is hard bop, which in their eyes is the style in which the requisite elements are most fully artistically realized. The hard bop era (1950s–1960s) was also the last time that jazz still played a vital role in African-American culture—before soul, Motown, funk, and rap in succession took its place. Jazz, according to Murray and Crouch, jazz must return to a place of dignity and honor in African-American life.

M-C-M

As the 1980s progressed, Wynton Marsalis seemed to increasingly fall under the spell of Murray and Crouch, and as he become more and more outspoken in supporting the Neocon cause, he became the perfect mouthpiece for their views. Together, the three wasted no opportunity to put their views across in print, television interviews, and panel discussions (prompting one writer to refer to them categorically as "M-C-M"). Although Marsalis's first several jazz albums were stylistically reminiscent of the Miles Davis 60s Quintet, he jumped on the neo-conservative bandwagon in 1988 with the release of *The Majesty of the Blues,* whose three-part "New Orleans Function" includes a spoken sermon (written by Crouch) that warns of those who preach "Premature Autopsies" on "The Death of Jazz." (These, in fact, are the titles of two of the suite's movements.) Marsalis and Crouch seemed to be using the album as a bully pulpit from which they could attack their critics, who in turn viewed their use of a sermon as patently sanctimonious. From this point on, Marsalis's album releases have been heavy on what critics have labeled "ancestral worship," and have included tributes to Jelly Roll Morton, Monk, and Ellington. These albums were extremely well-produced and well-played (all showing off Marsalis's virtuoso skills), making them easy listens for casual fans and consequently big sellers. They all also include liner notes written by Stanley Crouch, who was relentless in his praise of Marsalis as the savior of jazz. But as the Marsalis juggernaut picked up steam, protests from critics mounted. That writers (i.e., Murray and Crouch) rather than musicians were staking out the future direction of jazz (or at least attempting to) for the first time in the music's history—becoming a sort of de facto jazz police—was troubling to many. The fact that they were in effect advocating that the music's future really lay in its past was equally

Characteristics of the Neo-conservative Movement

The neo-conservative movement of the 1980s advocated the use of the following musical characteristics:
- Blues tonalities
- Swing rhythm
- Acoustic instruments
- Technical mastery of ones instrument
- Most often resembles the sound of hard bop ♩

disturbing. Isn't art by definition supposed to constantly move forward and seek new original ideas and breakthroughs, they asked? No, said the neocons, who stood their ground. In a column for *JazzTimes* in 2002, Crouch stated flatly, "The jazz tradition is not about innovation."

Marsalis also has been the subject of criticism for allegedly abusing his power in the corporate world. Once he solidified his artistic clout at Columbia, he began convincing the label to sign more artists in his mold—young, black, fashion-conscious neocons—and the label was only too eager to comply. By the late 1980s, Columbia and other jazz labels were filling their rosters with *wunderkinder* such as Roy Hargrove, Christian McBride, Terrence Blanchard, and Joshua Redman. Although these musicians were technically excellent players, by and large they had not matured artistically. To the Marsalis critics, the signing and promotion of the young lions was not only the result of the neocon agenda, it also meant that those artists who didn't fit the profile (older, more experimental, white) were pushed aside and not re-signed when their contracts expired. (In a telling sign of the times, respected trumpeter John Faddis spoke in 1993 of two well-known musicians close to their fortieth birthdays who were not

MUSIC ANALYSIS

TRACK 37: "DOWN THE AVENUE"

(Marsalis) Wynton Marsalis Septet from the album *Citi Movement* recorded at RCA Studio A in New York, July 27 and 28, 1992 (4:44). Personnel: Wynton Marsalis: trumpet; Todd Williams: tenor and soprano sax; Wes Anderson: alto sax; Wycliffe Gordon: trombone; Eric Reed: piano; Reginald Veal: bass; Herlin Riley: drums

"Down the Avenue" is the fourth piece from the first movement, *Cityscape*, of Wynton Marsalis's 1991 modern ballet *Griot New York*. The ballet was a collaboration between Marsalis and choreographer Garth Fagan, who introduced Marsalis to modern dance during a performance by his troupe in 1985. The score was composed and arranged in a one-month period in spite of Marsalis's hectic schedule of performances at night and master classes during the day – all on the road. "It was crazy. Amazing," said saxophonist Herb Harris, who was with the Marsalis band at the time. "We were working all of these gigs and Wynton was giving these talks and instructions to student musicians during the day, running to get some food before the concert and going into his

room every night to compose. With all he had to do you wouldn't have expected him to come up with this kind of music. But there it is." *Griot New York* received its premier performance in 1991 at the Brooklyn Academy of Music. (ref: liner notes to *Citi Movement* by Stanley Crouch)

0.00	Introduction with tenor sax solo by Todd Williams
0.20	Head is stated by other horns as Williams continues to solo
1.23	Wynton Marsalis solos
1.54	Head is restated on soprano sax by Williams and trombone by Wycliffe Gordon as alto saxophonist Wes Anderson solos
2.14	Collective improvisation by soprano sax and trombone
2.26	Piano solo
2.56	Head is restated by all horns
3.16	Alto sax solo
3.27	Double-time transitional section
3.54	Head is restated as Eric Reed solos on piano
4.35	Short horn chorale ends song

currently signed to recording contracts that were giving lessons to two teenage musicians who were.)[12] Racism, cronyism, and ageism also became issues for Marsalis soon after he was named the artistic director of New York's **Jazz at Lincoln Center** (JALC) program in 1987. Originally designed by the prestigious Lincoln Center for the Performing Arts as a way to fill empty concert halls in August, JALC, under Marsalis's leadership, has grown to become a phenomenal success story with an annual budget of $12 million. Marsalis, however, embroiled himself in controversy almost immediately when he published what amounted to a neocon mission statement for JALC in *The New York Times* titled "What Jazz Is—And Isn't."

One of the activities established by Jazz at Lincoln Center was an annual concert series designed to feature newly commissioned jazz works and honor jazz musicians—living and dead—who had made significant contributions to the music. Critics were quick to point out that for the first several years, the commissions all went to Wynton Marsalis. Later on, the first non-Marsalis commissions went to his acolytes. The concerts were performed by the Lincoln Center Jazz Orchestra, whose members, selected by Marsalis, were nearly all black (including forty-eight of fifty-six performers used during one week in 1996, according to Whitney Balliett). The artists featured at the concerts were also overwhelmingly black. None of this sat well with white jazz critics, who accused Marsalis of "Crow-Jim" tactics and wielding his power recklessly. "They say they have to put on all the important figures before they get to the lesser-knowns and there happen to be more important figures who are black" commented writer Peter Watrous in the *Village Voice*. "That's complete bullshit. I'd like to know what Dewey Redman or Gonzalo Rubalcaba [two black musicians who received honoring concerts in 1991 and 1993, respectively] has contributed to jazz." Another controversy arose in 1993, when JALC tried to fire all the members of the jazz orchestra who were more than thirty years old, a clear violation of age discrimination laws. Although the firing was later withdrawn in the midst of protests by musicians and the press, it was perceived as another belligerent maneuver by the M-C-M triumvirate (Crouch and Murray are both JALC artistic advisers) to control the center's agenda. In spite of the controversy, JALC has prospered, due in large part to Marsalis's fund raising and promotional efforts. In October 2004, a stunning new $128 million home for JALC opened in the Time Warner Center at Columbus Circle that includes three performance halls, an educational center, recording studio, and an interactive multimedia history of jazz installation (Chapter 9).

The Neo-Conservative Movement

Although the Marsalis-led neo-conservative movement achieved critical mass in the late 1980s, its seeds were planted as early as 1976. In the summer of that year, the **V.S.O.P. Quintet**, a reforming of the 1960s Miles Davis Quintet led by Herbie Hancock with Freddie Hubbard taking the place of the then-retired Davis, went on a well-received tour. Later in the year, Dexter Gordon returned from a fourteen-year self-imposed exile in Europe with a triumphant engagement at the Village Vanguard and the subsequent release of the best-selling *Homecoming: Live at the Village Vanguard*. In the wake of his

success, Gordon's contemporaries, including trumpeters Woody Shaw and Freddie Hubbard, also enjoyed career renewals. Gordon, Hubbard, Shaw, and Hancock were all jazz masters in their thirties or older who had well-established mainstream jazz credentials dating from the 1950s or 1960s (Gordon's going back to the 1940s). The fact that they were all returning to their roots in one way or another playing post-bop jazz—a style that had pretty much been out of fashion for a number of years—was significant and helped rekindle interest in mainstream acoustic jazz. 1976 was also the year that tenor saxophonist Scott Hamilton and cornetist Warren Vaché released debut albums that were steeped in jazz tradition. Both in their twenties at the time (making them the first true "young lions"), Hamilton and Vaché played neo-swing, putting them back stylistically even further than Gordon and the others, and both won praise for their careful attention to the nuances of that style. Hamilton, in particular, won praise for his ballad playing, an art that had certainly gone out of fashion in the era of electricity. (Ironically, it was also 1976 that Albert Murray's book *Stomping the Blues,* so influential to Stanley Crouch and Wynton Marsalis, was published.)

The Young Lions

Of course, it was not until Wynton Marsalis appeared on the scene that the neo-conservative movement really took off. With real money to be made in jazz records for the first time in years, major labels such as Columbia and smaller jazz-oriented labels such as Blue Note began signing the Marsalis acolytes, who became known as the **Young Lions.** The first generation of Young Lions, the members of Marsalis's first quintet, included older brother Branford on saxophone, drummer Jeff "Tain" Watts, bassist Robert Hurst, and pianist Kenny Kirkland, all of whom were no more than twenty-five years old in 1981. It is perhaps unfair to refer to **Branford Marsalis** as a young lion, in that his musical pursuits have been much more extensive and broad-minded than his younger brother's, although his playing style, influenced by John Coltrane and Wayne Shorter, fits into the neocon canon. Growing up, Branford, unlike Wynton, took life a little more casually and hated to practice. After playing in the Jazz Messengers from 1981 to 1982 and his brother's band from 1982 to 1985, he joined (along with Wynton's pianist Kenny Kirkland) the band of pop artist Sting for a year to tour and record. Branford has also recorded with the Grateful Dead, Bruce Hornsby, and formed his own funk band called Buckshot LeFonque. (Although the brothers profess great love and respect for each other, there is a touch of sibling rivalry. Wynton once told a Kennedy Center audience without referring to Branford by name that "There's nothing sadder than a jazz musician playing funk.") Branford was also the musical director for the *Tonight Show Starring Jay Leno* from 1992 to 1995, and has won two Grammy Awards to date.

The Young Lion tent expanded when a Kool Jazz Festival concert of the same name on June 30, 1982, featured Marsalis, Chico Freeman, Paquito D'Rivera, and other "exceptional young musicians." The next generation of Young Lions came of age at decade's end, and included Roy Hargrove, Christian McBride, Terrence Blanchard, and **Joshua Redman.** Redman came to jazz with good credentials: his father was respected saxophonist Dewey Redman, member of Keith Jarrett's American Quartet in the 1970s (see Chapter 5). Joshua took an

interest in jazz as a child, but academics always took priority, and he graduated from high school first in his class. Originally intending to become a doctor, Redman attended Harvard and graduated summa cum laude in 1991. After winning the prestigious **Thelonious Monk International Jazz Competition** on saxophone that same year, he decided to return to his first love: music. The following year, he was named Best New Artist by *JazzTimes Magazine* and signed with Warner, with whom he released his debut album in 1993. Redman was also able to parlay his good looks into a lucrative sponsorship with the DKNY clothing line, perhaps a sign that there was something to the Young Lion phenomena other than talent. **Christian McBride** has become one of the most sought after sidemen in jazz since his emergence on the scene in 1989. Like Branford Marsalis, McBride is equally comfortable playing a variety of styles, plays both acoustic and electric bass, and McBride has performed with a wide variety of artists, including McCoy Tyner, Sting, Diana Krall, and, of course, Wynton Marsalis. McBride, who turned down a contract from Blue Note when he was in his early twenties because he felt he wasn't ready, has been one of the few Young Lions to speak candidly on the downside of the M-C-M dogma. "I think some of us were kind of scared to do other things [outside of the neocon guidelines], because we were scared that Wynton Marsalis or Stanley Crouch would do a big interview in *The New York Times* and blast us, you know? A lot of the Wynton Marsalis entourage feel that way."[13]

THELONIOUS MONK INTERNATIONAL JAZZ COMPETITION

An annual Thelonious Monk International Jazz Competition is sponsored by the Thelonious Monk Institute of Jazz. A non-profit organization, the TMIJ was founded in 1986 by the Monk family and opera singer Maria Fisher to present public school–based jazz education programs for young people. Competitions are held each year on trumpet, saxophone, piano, bass, and drums. First place winners receive $20,000 scholarships.

MUSIC ANALYSIS

TRACK 38: "MISCHIEF"

(Redman) Joshua Redman Quartet from the album *MoodSwing* recorded at the Power Station, New York March 8-10, 1994 (5:50). Personnel: Joshua Redman: tenor sax; Brad Mehldau: piano; Christian McBride: bass; Brian Blade: drums

One of 11 original compositions that make up Joshua Redman's LP *MoodSwing*, "Mischief" is a great example of the Blakey-esque quality that was typical of the Young Lion phenomenon of the 1980s and 1990s. For *MoodSwing*, his third album with Warner, Redman has put together a quartet of some of the most written about young talent to come along in the last fifteen to twenty years. On bass is fellow Young Lion Christian McBride; on piano is Brad Mehldau, still a year away from his own major label debut on Warner (see chapter 9); on drums is Brian Blade, who Redman consistently has turned to for his recordings during his career. Together the quartet plays a tight, polished,

hard-driving swing that is reminiscent of the Blue Note hard bop recordings of the 1950s and 1960s. Redman is masterful and sophisticated throughout, and lets you know that he has done his homework listening to his hard-swinging predecessors: Benny Golson, Wayne Shorter, and Sonny Rollins.

0.00	Head is stated by tenor saxophonist Joshua Redman over a variety of two-beat, stop times and walking rhythms in the rhythm section
0.33	Restatement of the head
1.07	Tenor saxophone solo by Redman over "broken swing" two-beat and stop time
1:52	Sax solo continues; rhythm section breaks into 4/4 straight swing rhythm
3.22	Bassist Christian McBride solos
5.01	Head is restated

Fusion Evolves in the 1980s

Miles Returns

Although on the surface it would seem that the jazz world was preoccupied by Wynton Marsalis and his controversies, there was in reality an abundance of other creative activity going on in the 1980s. One of the most celebrated events of the decade was the return of Miles Davis in 1981 from his self-imposed retirement. His first official public performance since 1975 took place on July 5, at Avery Fisher Hall at Lincoln Center, and tickets sold out in less than two hours. According to at least one writer, "It was the most publicized event in jazz history;"[14] and in fact the media coverage in newspapers throughout the world was unprecedented for a jazz event. Sellout crowds followed Davis on subsequent tours in Japan in October and in Europe the following April and May. "Nobody else could do big long tours and sell out stadiums all over Europe," said John Scofield, Davis's guitarist from 1982 to 1985. "And these people were not jazz snobs, they just dug Miles. He could make a believer out of a non-jazz person with the beauty of his sound and the rhythm of his notes. That's pretty heavy."[15] At this point in his life, Miles Davis was standing on a pedestal that very few performers reach. Music fans knew that he was a living legend, an artist who had been at the vanguard of jazz innovation from the late 1940s until his retirement in 1975. Even though he was pushing sixty years of age, he still oozed with charisma. He could have rested on his laurels at this point in his career, but he was still willing to take risks and stir up controversy as he had done throughout his life. Among the eleven albums Davis released in the 1980s were *You're Under Arrest* (1984), which included covers of pop singer Cindy Lauper's "Time After Time" and Michael Jackson's "Human Nature," (for which Davis was, of course, criticized), and three Grammy winners, *We Want Miles* (1982), the big band *Aura* (1989), and **Tutu** (1986), in which producer Marcus Miller created synthesizer and drum machine beds in the studio over which Davis overdubbed Harmon mute solos.

Pat Metheny

As discussed in Chapter 6, in the late 1970s and 1980s some jazz/rock fusionists became entrapped in the musical cul-de-sac known as smooth jazz, an overly commercialized style that was largely unpopular with most jazz musicians and true fans. At the same time however, other fusion musicians began to emerge that took the style to new creative heights while managing to develop a huge popular fan base. One of most important new faces was guitarist **Pat Metheny,** whose willingness to experiment in different contexts and new technologies has since become a paradigm for many contemporary jazz musicians. Metheny (born August 12, 1954) was born and raised in Lee's Summit, Missouri, a suburb of Kansas City, where he started on trumpet before switching to the guitar at age twelve, "thanks mostly to the Beatles," he later recalled. "I saw *A Hard Days Night* 12 or 13 times . . . [and] the guitar was the one instrument my parents absolutely refused to let in the house. So you add it up and see that irresistible forces led me to the guitar."[16] Although rock music led him to the instrument, he soon fell in love with jazz from listening to the records of Wes

The Pat Metheny Group. (Left to right) drummer Danny Gottlieb, bassist Mark Egan, keyboardist Lyle Mays, guitarist Pat Metheny.

Montgomery, Miles Davis, John Coltrane, and Ornette Coleman. In 1972, Metheny enrolled at the University of Miami but withdrew during his first semester. He was then offered and accepted a teaching job, making him the youngest person ever to hold such a position at the school. After one year at Miami, he joined the faculty at Berklee College, becoming at nineteen the youngest ever to teach at that institution. In 1974, he joined the band led by vibraphonist Gary Burton, who also taught at Berklee and was instrumental in bringing Metheny to the school. In 1975, while still performing with Burton and teaching at Berklee, Metheny recorded his debut album for ECM, the critically acclaimed **_Bright Size Life,_** a trio setting with drummer Bob Moses and bassist Jaco Pastorius. In 1977, he released _Watercolors,_ a collaboration with pianist Lyle Mays, drummer Danny Gottlieb, and bassist Eberhard Weber. Both albums contained the breezy, listener-friendly sound that Metheny would become known for, and accordingly, both albums rose high on the _Billboard_ jazz charts. With one exception, Metheny wrote all of the songs for both albums.

In 1978, Metheny formed the Pat Metheny Group, which included keyboardist Mays (who has become a life-long composing collaborator), drummer Gottlieb, and bassist Mark Egan, and released _The Pat Metheny Group,_ sometimes referred to as _The White Album_ for its plain, Beatle-esque cover art. The group's second release, _American Garage_ (1980) was a breakout hit, reaching Number 1 on the _Billboard_ jazz chart and Number 53 on the pop album chart. Around the same time, Metheny released his first solo record, _New Chautauqua_ (1979), an adventurous mix of jazz, Spanish flamenco, folk, Indian music, and bluegrass that was realized through the creative use of multi-tracking. In 1981, Metheny and Mays released the duo album _As Falls Wichita, So Falls Wichita Falls,_ an impressionistic venture with Latin, African, and contemporary jazz influences showcasing the pair's writing and performing talents. The album also includes the beautiful "September Fifteenth," a tribute to pianist Bill Evans (the title referring to the date Evans died in 1980). The Pat Metheny Group won Grammy Awards in 1982, 1983, and 1984 for the albums _Offramp, Travels,_ and _First Circle,_ respectively, which hit the Number 1, Number 3, and Number 2 spots on the jazz album charts. Songs from these albums, including "Are You Going With Me?," "James," and "Phase Dance," exhibit the classic Metheny sound, which _Down Beat_ in 1984 called a balance of three parts, "the first being his own irrepressible Midwestern lyricism, the second a penchant for Brazilian rhythms,

MUSIC ANALYSIS

TRACK 39: "SAN LORENZO"

(Metheny/Mays) Pat Metheny Group from the album *Travels* recorded live in concert 1982 (13:35). Personnel: Pat Metheny: guitar, guitar synthesizer; Lyle Mays: piano, synthesizers; Steve Rodby: bass; Nana Vasconcelos: percussion; Danny Gottlieb: drums

Travels, the Pat Metheny Group's first live album, is a double CD containing recordings of live performances in Dallas, Sacramento, Hartford, and other places. Several of Metheny's 'hits' are included, such as "Are You Going With Me?," "Phase Dance," and "San Lorenzo." "San Lorenzo," an epic piece that first appeared as a 10-minute studio cut on *Pat Metheny Group*, the band's 1978 debut album, is stretched out to more than 13 minutes on *Travels*. The album was a popular and commercial success, winning the 1984 Grammy Award for Best Jazz Fusion Performance and hitting #3 on the Jazz Albums chart. The sound of the PMG at

this point in its life might be described as a more commercial version of Weather Report's *Heavy Weather*. One of the important cogs in the framework of the band has always been Metheny's writing collaborator Lyle Mays, who is featured prominently here on both piano and synthesizers. Also featured on *Travels* is guest percussionist Nana Vasconcelos.

0.00	Introduction chord clusters by guitarist Pat Metheny and keyboardist Lyle Mays; bass solo by Steve Rodby
0.58	Band settles into slow rock ballad groove
1.22	Synthesizer melody played by Mays
1.51	Metheny and Mays refer back to the intro chord clusters and set up a new groove
2.10	Metheny and Mays introduce new theme, then restate main theme; track continues

and the third the wild card of Ornette Coleman's jagged, insular logic." Metheny's "Midwestern lyricism" was a unique new sound in jazz, one that suggested the folk songs of the American West, and could be found in compositions such as "Last Train Home" from 1987's *Still Life (Talking)*, and even as early as "Midwestern Nights Dream" from *Bright Size Life*. Metheny has also been an active technologist who has been incorporating synthesizers such as the New England Digital Synclavier and the **Roland GR300 guitar synthesizer** into his compositions and recordings. He has also used the innovative forty-two-string Pikasso 1 guitar, custom made for him by Canadian Linda Manzer.

Pat Metheny has also been a prolific musical chameleon whose work outside the confines of the Pat Metheny Group has been tremendously varied. In light of this, one of his most refreshing attributes is his ability to restrain his prodigious virtuosity to fit any musical context in which he puts himself, and his knack for playing the right thing to compliment the music. Metheny has worked as a sideman in the touring bands of Joni Mitchell and Joshua Redman; recorded an album with his idol Ornette Coleman (1985's *Song X*, the *Down Beat* Critic's Poll Jazz Album of the Year); composed the soundtracks to several films including *The Falcon and the Snowman*; recorded *Electric Counterpoint*, an album of music by minimalist composer Steve Reich; and collaborated with fellow Missourian Charlie Haden (*Beyond the Missouri Sky*), guitar legend Jim Hall (*Jim Hall & Pat*

Metheny), and pianist Brad Mehldau *(Metheny/Mehldau).* He has won sixteen Grammys to date, most recently for the Pat Metheny Group 2005 release *The Way Up,* a sixty-eight-minute suite composed with Lyle Mays. One of Metheny's most recent ventures is the Orchestrion Project, in which he uses solenoids and pneumatics to create an ensemble-based music for acoustic and acoustoelectric instruments. The results of this ambitious concept can be heard on the 2009 LP *Orchestrion*. He has also been—like Wynton Marsalis—unafraid to express himself in print when he sees fit, most famously in his 2000 criticism of saxophonist Kenny G's overdubbing on a Louis Armstrong record, which he called "a low point in modern culture—something that we all should be totally embarrassed about."

Michael Brecker

One of the most influential tenor saxophonists of the post-John Coltrane era was **Michael Brecker,** whose remarkable talents and versatility made him an in demand session player as well as a thirteen-time Grammy Award winner for his own albums. Brecker was a sideman by one estimate on more than 900 jazz and pop recordings (including for pop artists as diverse as Frank Sinatra, Willie Nelson, Yoko Ono, Funkadelic, and Aerosmith, as well as a who's who in the jazz world) and, as a result, didn't get around to recording an album under his own name until seventeen years after his recording debut. Brecker (March 29, 1949–January 13, 2007) was born into a musical family in Philadelphia, where his father, a lawyer and jazz pianist took Michael and older brother Randy to see Miles Davis, Thelonious Monk, Duke Ellington, and others perform live. After starting on the clarinet, Michael switched to the tenor saxophone in high school after falling in love with Coltrane's playing. After graduation, he and Randy attended Indiana University for a year before moving to New York in 1970. It was there that they co-founded the short-lived but groundbreaking jazz/rock group Dreams, which recorded two albums for Columbia before breaking up in 1972. In 1973, Michael and Randy played together in the Horace Silver Quintet for a year before leaving to form the **Brecker Brothers,** one of the more innovative jazz/rock/funk groups of the 1970s. An ongoing concern, even as the brothers involved themselves in other projects, the Brecker Brothers recorded ten albums between 1975 and 1990 before dissolving. In the late 1970s, the brothers operated a popular downtown New York nightclub called Seventh Avenue South, where regular jam sessions led to the formation of the group Steps, which

Tenor saxophonist Michael Brecker.

included Michael, vibraphonist Mike Mainieri, pianist Don Grolnick (a veteran of both Dreams and the Brecker Brothers), bassist Eddie Gomez, and drummer Steve Gadd.

Steps (who later changed their name to **Steps Ahead** due to a legal issue) was arguably the leading fusion band in the early 1980s, producing innovative music that was experimental, imaginative, and demanding to play, while somehow remaining accessible. Despite enduring constant changes in personnel (which included at one time or another pianists Eliane Elias and Rachel Z, guitarist Mike Stern, and drummer Peter Erskine), the group managed to record seven albums before breaking up in 1986. During his tenure with Steps Ahead, Brecker began using the **EWI** (electronic instrument), an expressive, breath-controlled synthesizer controller that opened up new creative horizons for the saxophonist. "It gave me the sensation of being in a sax section in a big band," he said, "kind of a big band on Mars."[17] Brecker today stands as the only jazz saxophonist to have mastered the challenging instrument. After the dissolution of Steps Ahead, Brecker finally began to devote his attention to his first solo album. Released in 1987, *Michael Brecker,* which includes an all-star backing cast of Pat Metheny, keyboardist Kenny Kirkland, bassist Charlie Haden, and drummer Jack DeJohnette, won album of the year honors from both *Down Beat* and *JAZZIZ* magazines. *Michael Brecker* is a showcase for Brecker's dazzling technique, his trademark Coltrane-esque tone, and his unparalleled inventiveness. He also uses the EWI to great effect on several songs, including "Syzygy" and "Original Rays." His follow-up album, 1988's Grammy winning *Don't Try This at Home* again featured outstanding support from Herbie Hancock, Mike Stern, bassist Charlie Haden, violinist Mark O'Connor (who is featured in a wild sci-fi bluegrass duet with Brecker's EWI on "Itsbynne Real"), and others. Following *Don't Try This at Home,* Brecker went on to record six more albums as a leader, including 2002's *Directions in Music,* a tribute to Miles Davis and John Coltrane, and 2003's *Wide Angles* with a "quindectet," a thirteen-piece orchestra. However, Brecker's most poignant, and arguably his best album, was his last, recorded just five months before his death.

In mid 2004, Brecker noticed a sharp pain in his back while performing at the Mount Fuji Jazz Festival. He was later diagnosed with myelodysplastic syndrome (MDS), a blood disease that often leads to leukemia. Therapy for the disease usually involves finding a donor with matching stem cells, which Brecker was unable to do despite a well-publicized search. As his condition worsened and the disease evolved into leukemia, Brecker sought out experimental treatment, but to no avail. Terminally ill and with his strength diminishing, he wrote nine songs to be included on one more album, which he knew would be his last. Recorded in August 2006 with his close musical friends Pat Metheny, Herbie Hancock, Jack DeJohnette, pianist Brad Mehldau, and bassist John Patitucchi, **Pilgrimage** was mixed and completed in January, just two weeks before his death. It is a heroic and bittersweet last artistic statement from one of the most influential jazz musicians of the last quarter century. Despite being critically ill at the time of the recording *Pilgrimage,* Brecker's forceful tone and intense virtuosity are undiminished. After his death, a memorial service was held at New York City's Town Hall on February 20 that included musical performances by Herbie Hancock, John Patitucchi, Jack DeJohnette, Paul Simon, and others.

EWI—Electronic Wind Instrument.

Music Analysis

Track 40: "Itsbynne Reel"

(Brecker/Grolnick) Michael Brecker from the album *Don't Try This at Home* recorded 1988 at Master Sound Astoria Studios, Astoria, New York (7:43). Personnel: Michael Brecker: tenor sax, Akai EWI; Mike Stern: guitar; Don Grolnick: piano; Mark O'Connor: violin; Charlie Haden: acoustic bass; Jeff Andrews: fretless electric bass; Jack DeJohnette: drums

Michael Brecker's 1988 Grammy Award winning *Don't Try This at Home* is the second of his eight album releases as a leader, and its opening track "Itsbynne Reel" serves notice that with the album he was going to push the boundaries of jazz/rock fusion and have a little fun while he was at it. Co-written by Brecker's long time musical colleague, keyboardist Don Grolnick, "Itsbynne Reel" starts out with a high-energy Irish jig-cum-bluegrass hoedown duet with Brecker on the Akai EWI (electronic wind instrument) and fiddle virtuoso Mark O'Connor. The duet goes on for more than four minutes before Brecker launches into one of his signature Coltrane-esque solos (which album liner note writer George Varga calls "arguably the best sax solo of Brecker's recording career"). For *Don't*

Try This at Home, Brecker stated that, "We tried to stay away from obvious devices, and hoped to make a record that bears repeated listenings." "Itsbynne Reel" is certainly unlike anything else that was recorded in the late 1980s. (ref: liner notes to *Don't Try This at Home* by George Varga)

0.00	Michael Brecker, playing the Akai EWI, and violinist Mark O'Connor set up the tune
0.15	Pianist Don Grolnick enters with chords and bass line
0.54	Brecker and O'Connor start to improvise
2.12	Drummer Jack DeJohnette enters; bassists Charlie Haden and Jeff Andrews enter on pedal drone; band settles into a high-energy groove
3.16	New counter line is played by bass and piano
3.47	Return to pedal bass
4.18	Tenor sax solo by Brecker
6.30	O'Connor re-enters on new riff set up at end of saxophone solo; Brecker and O'Connor begin collective improvisation; track deconstructs, ends

Other 1980s Fusionists

Other fusionists also made contributions to jazz in the 1980s. Guitarist **John Scofield** first came into prominence when he joined Miles Davis's group in 1982 and participated both as a performer and as a composer on the three albums he recorded with Davis between 1983 and 1985. Scofield (born December 26, 1951) was first interested in rock and blues before a local teacher turned him on to jazz guitarists Wes Montgomery, Jim Hall, and Pat Martino. Eventually Scofield attended Berklee College, where he graduated in 1973, and made his recording debut in 1974 on the CTI *Carnegie Hall Concert* album by Gerry Mulligan and Chet Baker. By the time he joined the Davis band, "Sco" had developed a highly recognizable sound that effectively fused jazz, the blues, distortion, and other rock-oriented effects. "I liked the subtleties of John Scofield's playing," Davis said in his autobiography. "The blues was John's thing, along with a good jazz touch, so I felt comfortable playing the blues with him." After leaving Davis, Scofield put himself in a variety of musical settings that resulted in ten album releases as a leader, including 1986's **Blue Matter**, one of the decade's finest fusion albums, and 1987's *Loud Jazz*. The music on these two

Guitarist John Scofield.

albums is tight-knit funk/jazz (especially *Blue Matter,* which includes the high-octane funk players Dennis Chambers on drums and Gary Grainger on bass) that is exploratory enough to allow each musician to explore the boundaries of contemporary, modern jazz without becoming overly commercial or cliché-ridden. Since the 1980s, Scofield, has recorded with Herbie Hancock, Pat Metheny, Medeski, Martin and Wood, Joe Lovano, and the Grateful Dead's Phil Lesh.

Another saxophonist who became an influential and popular voice of fusion in the 1980s was alto player **David Sanborn** (born July 30, 1945). Sanborn's early influences were blues musicians, and from 1967 to 1973, he was a member of the highly regarded Paul Butterfield Blues Band. In the mid 1970s, Sanborn worked with a number of rock artists, including Stevie Wonder, the Rolling Stones, David Bowie, and Paul Simon. In 1975, Sanborn released his debut album *Taking Off,* which included the Brecker brothers, Don Grolnick on keyboards, and future *Late Night with David Letterman* bassist Will Lee. In the 1980s, Sanborn's distinctive high-energy alto sound won him two Grammy Awards for *Voyeur* and *Double Vision.* One of the most successful fusion groups to emerge in the 1980s was the **Yellowjackets,** formed in 1981 by keyboardist Russell Ferrante, bassist Jimmy Haslip, and drummer Ricky Lawson. From their first album *Yellowjackets,* the group has established themselves as a tight-knit funk/R&B/bop endeavor with strong playing and well-conceived original compositions. By 1987, and the release of their fifth and arguably best album *Four Corners,* the group's personnel had changed somewhat with the addition of Marc Russo on soprano and alto saxophone and drummer William Kennedy replacing Lawson. *Four Corners* conveys a wide variety of styles, from synth-bop to world beat to R&B–tinged fusion. The group won the first of its two Grammys in 1988 for the album *Politics.*

Ornette Coleman also experimented with fusion—albeit his own distinctive brand of the genre—in the 1980s with his group **Prime Time.** Coleman had been nearly invisible before venturing into the world of fusion, rarely performing in clubs and recording only three albums between 1969 and 1975. His first venture into electric funk-oriented jazz came in 1975 with *Dancing in Your Head,* an

album with a band (not yet known as Prime Time) that included two electric guitarists and the Master Musicians of Jajouka, an ensemble of Moroccan musicians. Coleman still played with his customary bluesy lyricism; like Miles Davis, he had simply changed the musical setting. In the 1970s, Coleman began using the word **harmolodics** (a contraction of harmony, motion, and melodic) to describe his improvisational concept of focusing on melodic development unfettered by harmony or chords. He cryptically defined the term in *Down Beat* as such: "Harmolodics is the use of the physical and mental of one's own logic made into expression of sound to bring about the musical sensation of unison executed by a single person or with a group." Whatever. Notable albums released under the Prime Time name include the 1987 double album *In All Languages,* which reunited Coleman's 1959 Five Spot quartet (Don Cherry, Charlie Haden, and Billy Higgins) on disc 1 with Prime Time (including son Denardo on drums) on disc 2; and 1988's *Virgin Beauty,* which includes Grateful Dead guitarist Jerry Garcia on two cuts.

Harmolodics—Ornette Coleman's improvisational concept, a contraction of the words harmony, motion and melodic.

The New Left: Avant-Garde Jazz in the 1980s

Anthony Braxton

Although his work will be discussed here in the context of the 1980s, the career of composer/saxophonist **Anthony Braxton** cannot in any way be confined to just one decade. Since making his recording debut in 1968, Braxton has recorded well over 150 albums as a leader, and appeared as a sideman on many others by such notable artists as Chick Corea, Dave Brubeck, and Max Roach. He has written more than 100 compositions that encompass everything from music for solo alto saxophone to a composition for 160 musicians arranged in four separate orchestras. Braxton has also been a musical anarchist and provocateur throughout his career, creating new and challenging music that explores the boundaries of postmodernism. Braxton (June 4, 1945–) was born in Chicago, and first began playing music as a teen. His musical studies commenced at Wilson Junior College and Roosevelt University, and it was at Wilson that he met Roscoe Mitchell of the Art Ensemble of Chicago. Braxton released his first two LPs in 1968, *Three Compositions of New Jazz,* which featured Association for the Advancement of Creative Musicians founder Muhal Richard Abrams on piano, and *For Alto,* a double album of compositions written for solo alto saxophone, believed to be the first jazz album of its kind.

In the 1970s, Braxton became active in a number of progressive avant-garde groups, including the Creative Construction Company, a trio with a violinist and trumpeter; Circle, a quartet featuring pianist Chick Corea; and the Dave Holland Quartet, featuring bassist Holland and New York Loft veteran Sam Rivers. In 1973 the latter group released one of the defining avant-garde albums of the decade, *Conference of the Birds.* Braxton also continued releasing his own albums at a frenetic pace (31 in the 1970s alone!), and won the 1977 *Down Beat* Critics Poll Jazz Album of the Year for *Creative Orchestra Music,* which was recorded by a postmodernist big band. That same year the critics also named him Best Jazz Clarinetist in their poll. 1978 saw the release of *For Four Orchestras,* which, according to the liner notes requires "303 pages of notated music for

four orchestras and four conductors. Each orchestra is positioned to have the optimum sonic possibilities for a three dimensional spatial music." Much oof Braxton's work in the 1980s and 1990s was focused around his group the Forces in Motion Quartet, which also included pianist Marilyn Crispell, bassist Mark Dresser, and drummer Gerry Hemingway. Prominent among the group's recorded output are three live albums from a European tour in 1985, one of which, *Quartet (Coventry)* 1985 includes two 30-minute interviews with Braxton.

Braxton's compositions are heavily influenced by composers of the European classical avant-garde tradition such as John Cage, Harry Partch, Steve Reich, and Karlheinz Stockhausen. He has used graphic notation in his scores, and in some cases titled his pieces with diagrams. Most of his other compositions are titled with numbers and letters rather than words. Braxton's compositions seem to embrace a scientific approach and therefore do little in the way of conveying emotion, which seems to be contradictory to the jazz tradition and has annoyed many in the jazz field. "I never talk about feeling or haven't tried to address the emotional aspects of the music," he has said. To which jazz critic Greg Tate replies, "Braxton's talent for inspiring antipathy may be unrivalled by any living jazz creature." He may have his detractors, but Braxton also has many who support his artistic vision, including the MacArthur Foundation, which awarded him with its "Genius" Fellowship in 1994. Since the 1990s, he has been a music professor at Wesleyan University in Connecticut.

Steve Coleman and M-Base

M-Base—(short for "macro-basic array of structured extemporization") is a concept of how to create modern music which reached its peak in the mid-to-late-80s and early 90s.

Another keeper of the flame in the 1980s avant-garde jazz community was alto saxophonist **Steve Coleman** (September 20, 1956–). Coleman preferred to give his creative concept a name, **M-Base,** which is an acronym for Macro—Basic Array of Structured Extemporizations. Although the exact definition of M-Base is, like Ornette Coleman's harmolodics, a little fuzzy, the M-Base website describes it as "a way of thinking about creating music, it is not the music itself. One of the main ideas in M-Base is growth through creativity. As we learn through our experiences then the music will change and grow to reflect that. The idea is not to develop some musical style and play that forever." Coleman (no relation to Ornette) hitchhiked to New York in 1978 from his native Chicago, where he first began playing music at fourteen and improvising at eighteen. After spending three to four years playing on the streets of New York and staying at the YMCA, he began working his way up through the local scene by playing in the big bands of Thad Jones/Mel Lewis, Sam Rivers, Cecil Taylor, and Dave Holland. At the same time, he was working with a more improvisational unit called the Five Elements, which ultimately became a workshop for the incubation of M-Base. By definition, M-Base draws on a wide variety of influences, but generally the most pronounced are free jazz, bebop, and funk. "I'd like to have all those elements in the music," Coleman said in 1995. "Something for people who want to dance, something for people who are intellectual and want to find some abstract meaning and something for people who just want to forget their troubles."[18] Coleman also has approached his musical growth with the same passion as one of his heroes. "For me, the main point, when I see someone like John Coltrane, who I know was not satisfied with his own thing, when I see that, what I see is a person on a

certain path. His goal was more about the search than it was the actual finding of. It was just putting yourself in a certain mode, a certain mentality. That's more of what I'm about. That's why I keep striving for it, to do it at a higher level."[19]

Others in the M-Base camp include alto saxophonist **Greg Osby,** who, after graduation from Berklee College in 1983, began working in short order with Jack DeJohnette, the World Saxophone Quartet, John Scofield, Pat Metheny, and Herbie Hancock. In 1987, Osby signed with what was at the time the de facto M-Base

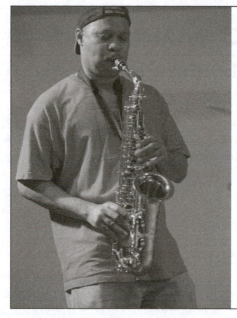

Alto saxophonist Steve Coleman performs at the Brecht Forum, October 7, 2007.

record label JMT (Jazz Music Today, based in Munich, Germany), and has been with Blue Note since 1990. The career of pianist **Geri Allen** has spanned everything from involvement with the M-Basers to introspective mainstream jazz. Born in Detroit, Allen received a bachelor's degree from Howard University and a master's degree from the University of Pittsburgh. After moving to New York in 1982, she worked with Steve Coleman on several albums while releasing her first album *The Printmakers* in 1984. Although much of Allen's later work is in the mainstream mold, her avant-garde credentials are impeccable, having recorded with Ornette Coleman, Greg Osby, Charlie Haden, and Bobby Hutcherson. She is currently an assistant professor at the University of Michigan School of Music, Theatre, and Dance.

The M-Base artist to achieve the widest recognition so far is vocalist **Cassandra Wilson** (born December 4, 1955). Born in Jackson, Mississippi, Wilson sang everything from folk to funk and began writing her own music before moving to New Orleans in 1981, where she performed with, among others, Ellis Marsalis. In 1982, Wilson moved to New York and began working with Steve Coleman, with whom she made her recording debut in 1985. She also worked with alto saxophonist Henry Threadgill's avant-garde trio New Air. By this time, Wilson was expanding her early influences from singers Abbey Lincoln and Betty Carter to include freeform improvisation. In 1985, *Down Beat* described her low, throaty, gospel, and blues-drenched voice as "the most

Vocalist Cassandra Wilson.

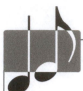

MUSIC ANALYSIS

TRACK 41: "ENTRUPTION"

(Osby) Greg Osby from the album *Inner Circle* recorded April 22, 1999 at Systems Two Studio in Brooklyn, NY (4:58). Personnel: Greg Osby: alto sax; Jason Moran: piano; Stefon Harris: vibes; Tarus Mateen: bass; Eric Harland: drums

"Entruption," from Greg Osby's album *Inner Circle*, is exemplar of the M-Base style that emerged in New York City in the 1980s through the work of Osby, Steve Coleman, and others. M-Base draws on many influences, but generally the most pronounced are free jazz, bebop, and funk—which reflect the musical backgrounds of its architects. According to Osby, "M-Base is a collective that Steve Coleman and I started in 1985, out of the need for some kind of a musical situation that young musicians could write and create compositional and improvisational directives. There was no hangout scene in New York at the time when I got to town. There was no real dominating jam session situation where cats could talk shop and exchange information, informally get together once or twice a week amongst ourselves, the people that we pooled and talk about music, talk about music business, talk about production and music presentation, specifics. It was something that we felt was necessary because the music was in retrograde at that point. People were really looking to the past and more concerned with historical values as opposed to pushing the envelope and propelling themselves as a group into the future. Plus, we didn't want to discard any of our resource material that was fundamental in our musical make-up. We all come from R&B and soul music and funk, other types of jazz expression, other types of folk music, and we wanted to incorporate that in a contemporary offering, as opposed to a lot of our peers who just dismissed everything that was a part of their make-up, which we didn't think was honest." M-Base "worked out really well."

0:00	Track begins with alto saxophonist Greg Osby and vibraphonist Stefon Harris playing the head in unison
1:17	Pianist Moran solos
2:29	Osby solos
3:40	Head is restated, track ends

strikingly sensual, warmly cunning set of vocal chords to hit the jazz world in years." In 1986, she signed with JMT, and made her album debut as a leader with *Point of View.* Wilson made a radical change in direction with 1988's *Blue Skies,* an album of jazz standards backed with a conventional piano trio that achieved wide acclaim. Since then, her musical output has been eclectic. After signing with Blue Note in 1993, she had released several notable albums, including 1993's *Blue Light 'Til Dawn* and 1996's Grammy-winning ***New Moon Daughter.*** In addition to writing her own material, Wilson has covered songs by such disparate composers as Hank Williams, Robert Johnson, Joni Mitchell, and Bono. She won the *Down Beat* Critics Poll Vocalist of the Year award for seven consecutive years from 1996 to 2002.

Members of the World Saxophone Quartet

- Julius Hemphill–alto saxophone
- Oliver Lake–alto saxophone
- David Murray–tenor saxophone
- Hamiet Bluiett–baritone saxophone

The World Saxophone Quartet

As one of the most innovative and unique ensembles in modern jazz, one could say the **World Saxophone Quartet** marches to the beat of a different drummer; the only problem is that they *have* no drummer. The roots of the World Saxophone Quartet go back to the mid 1960s and the St. Louis–based Black Artists Group (see Chapter 4), a free jazz and artists collective whose members included Julius

MUSIC ANALYSIS

TRACK 42: "STRANGE FRUIT"

(Allan) Cassandra Wilson from the album *New Moon Daughter* recorded 1995 (5:22). Personnel: Cassandra Wilson: vocals; Chris Whitley: Dobro; Graham Haynes: cornet; Lonnie Plaxico: bass

The fact that Cassandra Wilson chose to record one of the most controversial songs in history and one that is so closely identified with another singer, the great Billie Holiday, is a testament to her willingness to take musical risks. "Strange Fruit" was written by a Jewish high school teacher named Abel Meeropol going under the pseudonym Lewis Allan, who presented it to Holiday in 1937 while the singer was engaged at the Café Society in Greenwich Village. After singing the anti-lynching song once, she was hooked. "Billie . . . abandoned herself to the song," writes Charles Denison. "She immersed herself in it. It became the cry of her soul, the cry of Black America. In her autobiography, she said she wrote it; it had become, '*her song*.'" As striking as Holiday's original recording was, Wilson completely reinvents the song in part by using an unconventional instrumental group of Dobro, cornet, and bass, and in part with her own ominous and plaintive vocals. "Strange Fruit" is the opening track on Wilson's album *New Moon Daughter,* which won the 1997 Grammy Award for Best Jazz Vocal Performance. On the album, Wilson also covers artists as diverse as Son House ("Death Letter"), the Monkees ("Last Train to Clarksville") and Hank Williams ("I'm So Lonesome I Could Cry"). (ref: *The Great American Songbook: The Stories Behind the Standards* by Charles Denison)

0.00	Song opens with the sound of a match lighting; bassist Lonnie Plaxico begins playing a repeating ostinato figure; over time, cornetist Graham Hayes and Dobro player Chris Whitley enter
0.51	Vocalist Cassandra Wilson enters with first verse
1.50	Open-ended jam with Plaxico, Whitley, and Haynes
2.42	Wilson re-enters with second verse
4.37	Instruments drop out momentarily and re-enter after last vocal line

Hemphill, Oliver Lake, and Hamiet Bluiett. Coming to St. Louis from different hometowns, each of the three moved independently to New York by the early 1970s to participate in the city's thriving loft scene. The fourth and youngest member of the World Saxophone Quartet's original lineup, David Murray moved to New York in 1975, where at age twenty (the other three were in their mid thirties at this

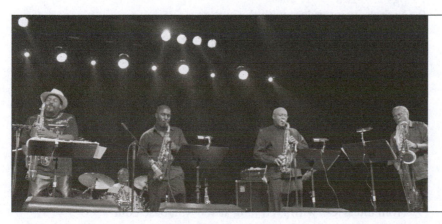

The World Saxophone Quartet. (Left to right) tenor player David Murray, alto players Julius Hemphill and Oliver Lake, baritone player Hamiet Bluiett.

point) opened Studio Infinity, where he often performed with future neocon writer Stanley Crouch. Although all four musicians knew each other and had occasionally played chance gigs with each other, they did not all perform on the same stage together until 1976, when they were all invited to perform in concert at Southern University in New Orleans. Performing some of their material with rhythm section and some without, the nascent group drew the most enthusiastic audience response at the concert when playing alone as a quartet. Playing without a rhythm section was more challenging for the group but, at the same time, brought a keener sense of artistic satisfaction. After the concert, a mutual decision was made to make the group permanent.

With such a novel concept—an avant-garde improvisational jazz band with no rhythm section—the World Saxophone Quartet was an acquired taste for many listeners, but their novelty soon became an attraction. In the early years, a typical instrumentation had Lake and Hemphill playing alto, Murray on tenor, and Bluiett on baritone, although doublings by each member on soprano, clarinet, bass clarinet, and flute were common. Early recordings by the band, including their debut album *Point of No Return* (1977), were on the Italian independent label Black Saint, but in 1986, they signed with the American label Electra and released *World Saxophone Quartet Plays Duke Ellington*, which made the *New York Times* Best Albums of 1986 list. By this time, the World Saxophone Quartet was consistently rating highly on the *Down Beat* Critic's Poll. Today, the group is signed with Justin Time Records. After a number of personnel changes in the 1990s, the group has stabilized its membership with Bluiett, Lake, Murray, and John Purcell. Julius Hemphill left the group in 1990 and died in 1995.

Notes

1. Both quotes from Gill, Troy: *Morning in America: How Ronald Reagan Invented the 1980s,* pg 119, pg 122
2. Nicholson, Stuart: *Jazz: The 1980s Resurgence,* pg 252
3. Simon, George T.: *The Big Bands*
4. Nicholson, pg 252
5. Nicholson, Stuart: *Is Jazz Dead? (Or Has It Moved to a New Address),* interview with the author, pg 18
6. Quote from "Wynton's Blues," by David Hajdu, *The Atlantic Monthly,* 3/03
7. Gioia, Ted: *The History of Jazz,* pg 385
8. Quotes from Lees, Gene: *Cats of Any Color: Jazz, Black and White,* pgs 227–228
9. Nicholson: interview with the author, pg 25
10. Porter, Lewis: *Jazz: A Century of Change*
11. Nicholson: interview with the author, pg 44
12. Nicholson: *Jazz: The 1980s Resurgence,* interview with the author, pg vii
13. Nicholson: *Is Jazz Dead? (Or Has It Moved to a New Address),* interview with the author, pg 47
14. Ibid, pg 2
15. Interview in *Wire* magazine, 1991
16. Digitalinterviews.com, 6/99
17. Nicholson: *Jazz: The 1980s Resurgence,* interview with the author, pg 202
18. Ibid, pg 258
19. From interview with Fred Jung at www.m-base.com

Study Questions for Chapter 7

1. Describe the mood of the country in the 1980s. How might one compare Wynton Marsalis to Ronald Reagan?

2. In what ways were the effects of the jazz education system manifesting themselves in the 1970s and 1980s?

3. Name some of the achievements of Wynton Marsalis.

4. Describe some of the ways in which Wynton Marsalis made himself controversial.

5. Who are Stanley Crouch and Albert Murray? Why are they controversial? Give some examples.

6. Why was 1976 an important year in the resurgence of mainstream acoustic jazz?

7. Describe the sound of the Pat Metheny Group and some characteristics of Pat Metheny's guitar style.

8. In what ways was Michael Brecker's career path unusual? In what ways was he innovative?

9. In what ways are harmolodics and M-Base similar? In what ways are Ornette Coleman and Steve Coleman alike, and how are they different?

10. Explain how the paths of the members of the World Saxophone Quartet crossed in the 1960s and how they managed to come together as a group.

Going Downtown

© 2011, Galushko Sergey, Shutterstock, Inc.

Chapter 8

Key Terms, Music, Places, Figures and Bands

Terms

Recording Industry Association of America (RIAA)
Repertory bands
Downtown music
Jump-cut
Tzadik
ArtistShare

Music (albums, works, etc.)

Naked City
History Mystery
Don Byron Plays the Music of Mickey Katz
Combustication

Evanescence

Places

The Knitting Factory
The Stone

Figures and Bands

Michael Dorf
John Zorn
Naked City
Masada
Bill Frisell
Dave Douglas
Parallel Worlds
Tiny Bell Trio

Brass Ecstasy
Wayne Horvitz
Zeena Parkins
Don Byron
Medeski, Martin, and Wood
Don Ellis Orchestra
Thad Jones/Mel Lewis Orchestra
Vanguard Jazz Orchestra
Toshiko Akiyoshi Jazz Orchestra
Maria Schneider
Maria Schneider Orchestra
Joe Lovano
Kenny Garret
Chris Potter

Jazz in the Nineties: A Brave New World

Canonic Breakdown

Jazz history has often been told in terms of a canonic evolution; one style is predominant until another one comes along to replace it. This method works well in telling the story of the music's early years but, in the aftermath of the bebop revolution, it becomes somewhat problematic. Nevertheless, a case could be made that a canonic telling of jazz history could still be used to describe the 1950s through the 1980s, as the stylistic lineage moved from cool to hard bop to free jazz to jazz/rock fusion to neo-conservative. Other styles and movements (Third Stream, modal, bossa nova, M-base, etc.) were certainly part of the story but, in this point of view, served more as ancillaries to the mainstream rather than the mainstream itself. As jazz entered the 1990s, however, the canonic model finally did begin to break down for good and could no longer be used. Looking back, it is clear that by then there was no longer any one style, movement, or artist dominating the evolutionary process. Not only were there not any mythic figures like Bird, Ornette, or Davis who willingly or unwillingly were "calling the shots," as it were, it began to appear that there may never again be such a person. Around the start of the 1990s, an ethos of anything goes was setting in, a sort of free-for-all, patchwork quilt of artistic activity that set the tone for the decade, and maybe for the foreseeable future. Partly created by the restless need of the most creative musicians to move in new directions and partly due to economic forces beyond their control, jazz in the 1990s seemed to be embarking on uncharted waters. Saxophonist Joshua Redman summed up the decade in a 2003 interview by saying, "You can't tell the story of jazz in those neat, simple evolutionary terms now. But that doesn't mean that the music today is

stagnant, or that it is not developing or any less creative. It may just mean that we have to view it through a different lens, and use a different paradigm to describe it."[1]

To be sure, the 1990s state of pluralism really started in the 1980s. Behind all the bluster and controversy of Wynton Marsalis and the neo-conservatives were musicians operating out of all sorts of platforms, creating music that in one way or another fit under the increasingly large jazz tent. To start with, as discussed in Chapter 7, there were the neocons, the fusionists, and the avant-gardists. Smooth jazz, whether or not one wanted to call it jazz, was at the height of its popularity in the late 1980s and early 1990s, with more than 200 FM radio stations using it as their program format. A neo-swing craze was started in 1988 with the release of the film *When Harry Met Sally,* which included newcomer Harry Connick Jr.'s swinging Sinatra-esque version of "It Had To Be You." Suddenly, there were neo-swing bands all over the country with names like the Squirrel Nut Zippers, the Cherry Poppin' Daddies, and the Brian Setzer Orchestra (led by the former rockabilly star), playing to neo-bobby soxers and hepcats who were making the jitterbug popular all over again. Two major films were also made in the 1980s: *Round Midnight* (1986), a fictional biography of Dale Turner, a character based on the lives of Lester Young and Bud Powell played by real-life saxophonist Dexter Gordon (who won an Oscar nomination for best actor); and *Bird* (1988), Clint Eastwood's telling of the Charlie Parker story, starring Forest Whitaker (who was named best actor at Cannes). Although neither film tore up the turnstiles at movie houses, one could not help but get the feeling that with jazz on the radio, in the cinemas, and in the dancehalls, there seemed to be a popular jazz renaissance in the works.

Death of a Legend

Things, however, weren't all they were cracked up to be. One of the first major events of the 1990s was the death of Miles Davis on September 28, 1991, from pneumonia and respiratory failure. Suddenly, the only remaining bona fide jazz superstar—and perhaps the *last* jazz superstar—was gone. "Jazz was already short of marquee names when the '90s began," wrote Francis Davis. "The loss of [Davis] threatened to become a permanent void at the top of the bill."[2] Although Davis had briefly retired in the late 1970s and was increasingly beset by health issues in the last ten years of his life, he represented the one common thread that wove its way through the modern jazz era. Since the beginning of his career, when he played next to Charlie Parker in 52nd Street clubs, until his triumphant and sentimental final performance at the Montreux Jazz Festival less than three months before his death, Davis had been at or near the frontiers of jazz. He recorded three of the most important albums in history (*Birth of the Cool, Kind of Blue,* and *Bitches Brew*), one of which, *Kind of Blue,* was also one of the most popular, eventually going triple platinum in 2002 after forty-three years of steady sales. He profoundly influenced nearly every jazz musician of his era and led several of the most important bands during his career, making him arguably the most important jazz musician in the last half of the twentieth century. Coming at the tenuous time in jazz history that it did, the death of Miles Davis was as traumatic to the soul of jazz as any single event in its history.

As the 1990s unfolded, it was also becoming clear that as charismatic and extraordinarily gifted as Wynton Marsalis was, he and the neo-conservatives were leading jazz down a dead-end street. As Columbia and other major labels began drinking the neocon Kool-Aid, a new business model began to unfold. Their thinking went, "We signed the young, up-and-coming jazz artists so they could record music that sounded like Art Blakey, Miles Davis, and Sonny Rollins. Why not just *reissue* the music Art Blakey, Miles Davis, and Sonny Rollins on compact disc? That way, we don't have to bother with contracts or recording costs, and we don't have to educate the public on the new artist or what they should be buying." A case in point: curious as to why Danilo Pérez's *Panamonk,* a highly acclaimed album of Latinized Thelonious Monk tunes was selling poorly, a *Boston Globe* reporter told of a record distributor who informed him, "Look, you've got Danilo Pérez in one bin selling for $16.99. You've got a reissue by Monk himself right next to it selling for $10.99. Which one would you buy?"[3] Bruce Lundvall, president of Blue Note Records, put it this way: "Let's say [consumers] buy their first record when they hear Wynton or Joshua Redman or whoever it might be. Then they want to get the history. They start to buy catalogue, and that's exactly what the active, current roster is fighting. I remember [saxophonist] Javon Jackson saying to me, 'I'm not competing with Joshua Redman so much as [with] Sonny Rollins and John Coltrane and Lester Young and Stan Getz'—the whole history of jazz saxophone players, which is available [on CD]." Veteran jazz writer and industry insider Jeff Levenson added, "The Frankenstein monster has turned on its creators. In paying homage to the greats, Wynton and his peers have gotten supplanted by them in the minds of the populace. They've gotten supplanted by dead people."[4] Levenson was right; by the end of the 1990s, many of the Young Lions, including Wynton Marsalis himself, no longer had contracts with major labels.

No Man's Land

Although sales of jazz CDs received a bump in the late 1980s and early 1990s, by mid decade they had returned to the usual state of affairs—dismal. According to the **Recording Industry Association of America (RIAA),** jazz sales figures went from 4 percent of the industry total in 1991 to 2.9 percent in 2000, a drop of nearly 28 percent in market share. Although the dollar figures of jazz CD sales increased from $312 million to $415 million between 1991 and 2000, these figures barely kept up with inflation, and came at a time when the overall industry saw sales figures nearly double. (Things were going to get even worse: between 2000 and 2006, industry sales figures shrank by 20 percent, with the jazz portion going from 2.9 percent to 2 percent.[5]) During the 1990s, it was becoming clear that one of the traditional income sources for jazz musicians—record sales—was disappearing, leaving most rank and file musicians to increasingly rely on the other traditional source—live performance. Unfortunately, news on that front wasn't much better, as jazz clubs around the country increasingly either catered to tourists and their nostalgic notion of the halcyon days of the Five Spot and Birdland—a notion that fit perfectly with the neocons—or closed down altogether. Middle aged (40+ years old) and more adventurous jazz musicians, even well known and respected ones, faced rapidly diminishing opportunities

Recording Industry Association of America (RIAA) Founded in 1952, the Recording Industry Association of America (RIAA) is the trade organization that tracks record industry sales and trends; it also certifies gold (500,000 units sold) and platinum (1,000,000 units sold) records. In recent years, the RIAA has been aggressively pursuing illegal music downloaders with threats of fines and lawsuits.

for club gigs, even in New York City. With the evaporation of record contracts and club gigs, the jazz economic structure began to move out of the popular music marketplace. But where would it go? The growing number of repertory bands around this time seemed to suggest that the future might lie in the artistic marketplace. **Repertory bands,** such as the Lincoln Center Jazz Orchestra, Mingus Dynasty, Carnegie Hall Jazz Band, American Jazz Orchestra, and the Smithsonian Jazz Masterworks Orchestra functioned very much like symphony orchestras, in that they played a repertoire of music from traditional (as in, *dead*) composers, with seasonal concert series supported by ticket subscriptions.

But symphony orchestras and opera companies have always operated in the marketplace of high culture, and have long captured the bulk of whatever corporate funding and public subsidies were available. However, many were now having difficult economic times themselves. Would jazz be able to fit into this world? With the increasingly conservative mood of the country in the 1990s, it was highly unlikely that substantial new sources of revenue from either the private or public sectors would open up. Although jazz musicians had long found themselves straddling the fence between the artistic and popular marketplaces, they seemed to figure out a way of fitting into whatever market they could to get by. Now, they were increasingly finding themselves in a no man's land of no economic opportunities. With very few exceptions, jazz in the 1990s was neither popular music nor high culture, at least from the perspective of major funding sources. It seemed to be caught between a musical rock and a hard place. Would jazz, as we know it, even make it through to the next century? Would it become a sort of benign sideshow attraction to the local tourist trade, as it had in New Orleans? Would it succumb to economic pressures and lose its sense of spontaneity and self-expression, the very foundations upon which it was built? *Was jazz dead?*

Uptown/Downtown

No, jazz was not dead; it was simply going through a period of transition. One of the surest signs that jazz was very much alive was the rebirth of the downtown music scene—of which jazz was an essential element—in New York City in the late 1980s. In New York, "Downtown" is a somewhat ambiguous term. To some, it is a geographical description of the older, lower extremity of Manhattan Island below a randomly chosen street, say 14th or 20th. To others, downtown refers to an attitude of self-pride held by a constituency of those marginalized by society, those that don't fit in and have nowhere else to go. During the late 1980s, downtown increasingly came to define everything that wasn't "uptown" in the arts world. **Downtown music** was that which was too experimental or avant-garde to make it into the world of Lincoln Center or Carnegie Hall. "The premise of downtown music is that music, like all other art, is a symbolic language of personal expression that each individual artist brings up from his or her soul," writes composer and critic Kyle Gann. "It is, of course, helpful and inspiring to know techniques and devices from the past used by other great musical minds. But even these potentially helpful techniques [can] become impediments to sincere personal expression. . . . Very often it is conducive to a

Important Repertory Bands

- Lincoln Center Jazz Orchestra
- Carnegie Hall Jazz Band
- Smithsonian Jazz Masterworks Orchestra
- American Jazz Orchestra
- Mingus Dynasty

Repertory Band—bands dedicated to playing the music of a specific artist or jazz style.

more sincere creativity to distance oneself from traditional forms—work with computers or weird instruments or hybrid genres—in order to escape of past and invariably foreign personalities."[6] There had long been a lively avant-garde scene in lower Manhattan—witness the Five Spot in the 1950s and the loft scene in the 1970s—but, by the mid 1980s, it had atrophied, leaving the more adventurous and younger players hungry for an alternative space in which to perform. Then, in 1987, the same year that Wynton Marsalis was appointed artistic director of the very pinnacle of uptown-ness, Jazz at Lincoln Center, a club opened at 47 East Houston Street that quickly and almost single-handedly revived the downtown jazz scene. It was called the **Knitting Factory.**

> **The Knitting Factory** Opened in February 1987 at 47 East Houston Street in New York by Michael Dorf, the Knitting Factory quickly established itself as the most important venue for the performance of avant-garde music. With its success, in 1994 the club moved to a larger facility at 74 Leonard Street, where there are four performance spaces. A second location is also now operating in Hollywood. ∾

The Knitting Factory

Michael Dorf was a twenty-three-year-old from Madison, Wisconsin, when he moved to New York in 1986 to open an art gallery/performance space that sold coffee, tea, and a few food items. The original plan was to bring in enough money to live on and to keep his fledgling label, Flaming Pie Records, alive. Once he and his partner, Louis Spitzer (who was soon replaced by Bob Appel), found a space they could afford, a tiny dilapidated Avon office in the run-down Bowery section of Lower Manhattan, they began renovation and making plans for setting up a music program. Once they opened in February 1987, they first offered jazz on Thursday nights. Recognizing his naivety about jazz ("I didn't know too much about what was really happening in jazz, besides what I had learned in my college history of jazz class"), Dorf answered keyboardist Wayne Horvitz's ad in the *Village Voice* offering "jazz band available." Together, Horvitz and Dorf set up a Thursday jazz night program that drew the city's young and adventurous jazz musicians, including Horvitz, guitarists Bill Frisell and Fred Frith, cornetist Butch Morris, and saxophonist John Zorn, among others. It was an immediate hit. On one of the first nights, Zorn premiered a work titled "Hu Die," which consisted of two guitarists and a narrator reading in Korean. The show had a standing-room-only crowd. "The 120 people in the room, squished like sardines, hot and sweaty, were the most beautiful thing I had ever seen," Dorf observed.[7] From that night on, the Knitting Factory was off and running, and so was the soon to be newly invigorated downtown music scene.

Without knowing it, Dorf had created a desperately needed new venue for "the improvisers, the freer-jazz players, the new generation of funk/groove-influenced players, the world-beat-influenced players, the new generation of artists who weren't playing swing or fusion or weren't famous enough to fill a club."[8] With the success of the Knitting Factory, clubs such as Tonic, Smalls, and the Stone; new record labels, such as Thirsty Ear and Dorf's own Knitting Factory (one of seven now owned by Knitting Factory Entertainment); and events, such as New York's Vision Festival, jazz musicians in New York were able to create an environment of experimentation identified with the phrase *downtown jazz* that soon spread to other cities across the country. The downtown jazz tent was large enough to encompass all sorts of styles and platforms. It only had to be experimental, alternative, individual, and *original*. It was as much about attitude as anything else. "Straight ahead players would say that they have felt marginalized by the modishness of the downtown scene,"

observed pianist Brad Mehldau. "If you just show up with an acoustic band, playing tunes [jazz standards], you're not 'avant-garde' enough."[9] Many downtowners expressed an interest in traditional Eastern European and Jewish music. The downtown scene also galvanized an audience of young fans whom jazz had sorely lacked for years. It was a similar, if not the same audience, that was simultaneously tuning into indie rock bands such as Radiohead and Sonic Youth. (It is of interest to note that the Knitting Factory, which also programmed experimental rock bands, was just a stone's throw from CBGB's, the cutting-edge punk rock club.) The blossoming of the downtown scene also allowed a new generation of jazz musicians, including John Zorn, Bill Frisell, and Dave Douglas, a creative environment in which to thrive and propel jazz into the twenty-first century.

Important Downtown Performers

John Zorn

The career of alto saxophonist/composer **John Zorn** has been so chameleon-like and jam-packed full that it is difficult to know where to begin. Zorn (born September 2, 1953) was raised in New York City, where early on he was exposed to his mother's favorite music (classical and world music), his father's (jazz and country), and his older brother's (doo wop). By the age of fourteen, he became interested in avant-garde classical composers such as Igor Stravinsky, Charles Ives, and Karlheinz Stockhausen but, at the same time, "I was listening to the Doors and playing bass in a surf band."[10] Once in high school, Zorn often found himself spending hours at movie houses and fell in love with film composers such as Ennio Morricone and Bernard Herrmann. He especially loved composer Carl Stalling's soundtracks to Bugs Bunny, Daffy Duck, and Road Runner cartoons. Stalling followed "the visual logic of screen action rather than the traditional rules of musical form," and, by doing so, created "a radical compositional arc unprecedented in the history of music."[11] After briefly living in St. Louis where he attended Webster College and was

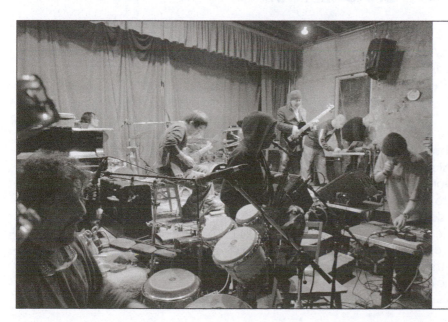

John Zorn (center, with hood) and his group Painkiller performing at Tonic on January 1, 2006.

introduced to free jazz improvisation by hearing the Black Artists Group, Zorn returned to New York and began working his way into the local avant-garde music scene, using all of his influences as if they were ammunition in a musical cannon.

Among his first works were a series of "game pieces" in which performers were free to play whatever they wanted, within a predetermined structure. "My first decision . . . was never to talk about language or sound at all. I left that completely up to the performers. What I was left with was *structure*. I can talk about *when* things happen and when they *stop*, but not *what* they are. I can talk about *who* and in what *combinations*, but I can't say what goes on. I can say, 'A change will happen *here*,' but I can't say what *kind* of change it will be."[12]

By the mid 1980s, Zorn was bringing this approach to integrating composition and improvisation to a series of highly acclaimed concept albums that began with *The Big Gundown*, in which he reinterpreted the music of spaghetti Western composer Ennio Morricone. In 1987, Zorn released the mind-boggling *Spillane*, which consisted of three compositions: the title cut, which evokes the imagery of the eponymous pulp novelist and includes sixty **jump-cuts** (moving quickly from one musical style to another) in its twenty-five minutes; "Two Lane Highway," a "concerto" for bluesman Albert Collins; and "Forbidden Fruit (Variations for Voice, String Quartet, and Turntables)" featuring the Kronos Quartet.

In 1989, Zorn released *Spy vs. Spy,* consisting of free jazz/speed metal versions of Ornette Coleman compositions, and ***Naked City,*** which, with twenty-six tracks was described by a critic from British music publication *Wire* as "jump-cutting micro-collages of hardcore, country, sleazy jazz, covers of John Barry and Ornette Coleman, brief abstract tussles—a whole city crammed into two or three minute bursts." Zorn also has led a number of groups that served as

Jump-cuts is a method of composing that involves stringing together a number of seemingly unrelated musical snippets into a complete composition.

MUSIC ANALYSIS

TRACK 43: "SNAGGLEPUSS"

(Zorn) John Zorn's Naked City from the album *Naked City* recorded 1989 (2:20). Personnel: John Zorn: alto saxophone; Bill Frisell: guitar; Wayne Horvitz: keyboards; Yamatsuka Eye: vocals; Fred Frith: bass; Joey Baron: drums

"Snagglepuss" is a good example of John Zorn's "jump cut" method of composing, which involves stringing together a number of seemingly unrelated, short musical snippets into a complete piece. Zorn and his band Naked City do such a good job performing the difficult piece that it gives the impression that it was edited together in the recording studio, which is not the case. *Naked City* the album is a wonder to behold, with twenty-six

tracks that range in length from eleven seconds to nearly five minutes. Although Zorn wrote most of the album's tracks, he has (as is his custom) also included very idiosyncratic covers of music from respected mainstream composers, including Ornette Coleman ("Lonely Woman"), Henry Mancini ("A Shot in the Dark" from the 1964 movie *The Pink Panther*), and Ennio Morricone ("The Sicilian Clan," the title cut from the 1969 French Gangster film). "Snagglepuss" is made up of dozens of jump-cuts; in the first minute alone, the "cuts" occur at :02, :10, :19, :23, :28, :40, :47, :51, and :59. The song starts with an explosion of sound; it really doesn't have an ending, it just stops.

workshops for his music, including **Naked City,** a rock/jazz band together from 1989 to 1992 that included Wayne Horvitz on keyboards, Bill Frisell on guitar, Fred Frith on bass, Joey Baron on drums, and Yamatsuka Eye on vocals; **Masada,** a four-piece jazz band together from 1994 to 1997 that included Baron on drums, Dave Douglas on trumpet, and Greg Cohen on bass; and a one-shot saxophone-bass-drums trio called Painkiller that Zorn described as playing "the most annoying free-jazz heavy metal you can imagine."[13] Masada, named after the hill in Judea where Jewish resistance fighters committed suicide rather than fall to the Romans, is a reflection of his interest in Jewish music and culture. Zorn's other musical ventures include soundtracks for independent films; chamber music written for a variety of classical music ensembles, ranging from solo cello to full orchestra; and a number of solo albums. To date, he has released nearly one hundred albums. In 1995, Zorn founded **Tzadik,** a record label dedicated to avant-garde and experimental music, which now has more than 400 albums in its catalogue. On April 1, 2005, he opened **The Stone,** a not-for-profit performance space at the corner of Avenue C and Second Street, less than a mile east of the original location of the Knitting Factory, which has been supplanted by Zorn's new space as *the* experimental venue in the city.

John Zorn is quite possibly the most prolific recording artist in history. In 2010 alone, he has released at least ten albums, including the darkly beautiful *The Goddess—Music for the Ancient of Days*, a "collection of Odes in celebration of Women in Myth, Magick, and Ritual throughout the Ages," and *Dictée/Liber Novus*, recorded with an 8-piece ensemble that includes a Japanese shakuhachi player, a sound effects person, three players whose duties include reciting narration in French, German, and Korean, and Kenny Wollesen on "wollesonics."

Bill Frisell

In many ways, guitarist **Bill Frisell**'s career has mirrored that of John Zorn in terms of its protean qualities. Unlike Zorn, Frisell is an in-demand session player who has played on more than one hundred albums for artists as diverse as Zorn, Elvis Costello, and jazz vocalist Norah Jones. Frisell's own albums, as either leader or co-leader, number more than thirty. He has honed a startlingly unique sound that is nearly impossible to categorize, but yet is instantly recognizable. In addition, he has developed into one of the foremost composers of progressive jazz. Frisell (born March 18, 1951) grew up in Denver, Colorado. His early years were not unlike many jazz musicians of his generation, with early influences from watching television and hearing records of the Beatles, Beach Boys, and

The Stone Noted downtown musician John Zorn opened the Stone on April 1, 2005, at the corner of Avenue C and Second Street in New York's Lower East Side. Patrons quickly figure out that the venue is all about the music and the musicians. The only signage consists of small letters on the door. There is nothing to eat or drink (not even water). The small bathroom is inaccessible once the music starts. Flimsy plastic chairs are arranged in rows. In spite of this, the former grocery store has great acoustics, and is widely recognized as the most important space for the performance of avant-garde music in New York today. 🎵

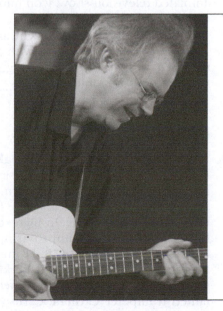

Guitarist Bill Frisell.

surf bands such as the Ventures. He played the guitar, but also the tenor saxophone and the clarinet, mastering the latter instrument sufficiently well to play in the McDonald's All-American High School Band and march in the Rose Bowl and Macy's Thanksgiving Day parades in 1968. As he got older, Frisell was exposed to blues and jazz records, which led him to eventually drop the saxophone and clarinet and focus on the guitar. His interest in jazz intensified after moving to the New York City area with his parents in 1969, and he eventually attended Berklee College in Boston from 1975 to 1977. In 1979, he moved to New York and began to work his way into the local club scene. His break came in 1981, when Pat Metheny recommended him as a replacement for a session with drummer Paul Motian for ECM Records. Frisell played so well that he became the de facto session guitarist for ECM and joined Motian on tour. (Memory refresher: Motian was the drummer in the influential 1959 Bill Evans Trio.) In 1982, Frisell recorded his first album as a leader, titled *In Line.*

After spending the next several years touring and recording, Frisell became a fixture in the downtown Knitting Factory scene, and was a member of John Zorn's band that debuted "Hu Die" there in early 1987. By the end of the decade, Frisell's numerous ventures both in the clubs and recordings were earning him recognition as one of the brightest new stars in jazz. His albums as a leader or co-leader have been consistently diverse in their conception and musical direction. Among his most notable albums are 1990's *Is That You?,* on which Frisell plays guitar, bass, banjo, ukulele, and clarinet on the nine original tunes; 1992's *Have a Little Faith in Me,* an album of very personal interpretations of tunes by Muddy Waters, Bob Dylan, Sonny Rollins, Stephen Foster, and others; two 1994 albums of music written for silent Buster Keaton films, *The High Sign, One Week* and *Go West;* and 1997's *Nashville,* recorded in Nashville with members of Allison Krauss's Union Station band. *Nashville* won the *Down Beat* critic's poll Album of the Year. Frisell won Guitarist of the Year in the poll in both 1998 and 1999. He has also written music for various film projects, including Gus Van Sant's films *Finding Forrester* and the remake of *Psycho.* His album *Unspeakable,* music written for a Gary Larsen animated television show, won him the 2005 Grammy Award for Best Contemporary Jazz Album.

One of Frisell's most recent albums is 2008's serenely beautiful *History Mystery,* recorded with an 8-piece ensemble that included trumpet, clarinet, and three string players. It was nominated for Best Instrumental Jazz Album.

Dave Douglas

Trumpeter/composer **Dave Douglas** has been a major artistic force in New York's downtown scene since moving back to his hometown in the mid 1980s. Douglas (born March 24, 1963) grew up in the greater New York City area, where he studied piano before picking up the trumpet at age nine. In high school, he studied jazz and classical harmony, and began improvising while an exchange student in Barcelona, Spain, in 1978. From 1981 to 1983, Douglas lived in Boston, where he studied at Berklee College and the New England Conservatory. In 1984, he returned to New York City to study with famed trumpeter Carmine Caruso and began working his way into

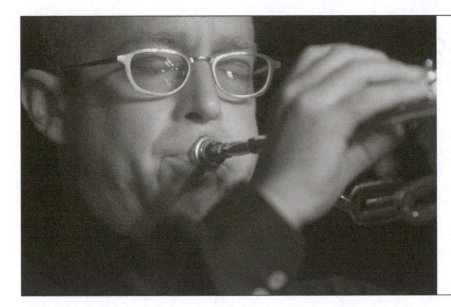

Trumpeter Dave Douglas.

the city's club scene. Between 1987 and 1990, he was busy playing with respected hard bopper Horace Silver, as well as more experimental groups such as Dr. Nerve (with whom he made his recording debut in 1985), New and Used, and the Bread and Puppet Theater. By the early 1990s, Douglas was writing music for the various groups he was performing and recording with, citing his primary compositional influences as John Coltrane, Russian composer Igor Stravinsky, and Stevie Wonder. Around this time, he also began assembling the first of his many performing and recording groups, each designed to fulfill a different compositional or conceptual purpose. With his group **Parallel Worlds,** Douglas made his recording debut as a leader in 1993 with the album of the same name. *Parallel Worlds* is a typical Douglas album in that, while most of the compositions are his, a few others are thrown in from pop, classical, or jazz composers (in this case, Kurt Weill and Igor Stravinsky). The group Parallel Worlds was also typical of Douglas in its use of an eclectic instrumental makeup: trumpet, violin, cello, bass, and drums. Formed to investigate the merging of improvised and contemporary classical music, the group recorded three albums between 1993 and 1997. Around this time, Douglas formed another idiosyncratic group, the **Tiny Bell Trio,** a trumpet, drums, and guitar ensemble with the purpose of melding jazz and Balkan music. The group recorded four albums over a ten-year period. In the mid 1990s, Douglas also performed with John Zorn's Masada.

Other Douglas groups include Charms of the Night Sky, a trumpet, accordion, violin, and bass quartet; Witness, an experimental electric seven-piece group with trumpet, tenor saxophone, two keyboards, bass, drums, and electronic percussionist Ikue Mori, formed to play "music celebrating positive protest against the misuse of money and power;" and Sanctuary, an electric double quartet, inspired by Ornette Coleman's *Free Jazz* and Coltrane's *Ascension,* consisting of two trumpets, tenor saxophone, two basses, drums, and two digital sampler players. Douglas has also performed in more conventional quartet, quintet, and sextet settings, often using his sextet as a "legacy" band to play tributes to past jazz artists. Albums in this

MUSIC ANALYSIS

TRACK 44: "SHARDS"

(Douglas) Dave Douglas Tiny Bell Trio from the album *Tiny Bell Trio* recorded 1993 at Sear Sound in New York City (4:08). Personnel: Dave Douglas: trumpet; Brad Shepik: electric guitar; Jim Black: drums

One of trumpeter/composer Dave Douglas's many musical project bands is the Tiny Bell Trio, which he formed in 1991 with guitarist Brad Shepik and guitarist Jim Black. In the beginning, the group's material consisted of traditional East European folk music, but as the group evolved, they began composing their own material that blended the Euro folk ethos with their own improvisational skills. Adding to the development of the group was a steady gig on Friday nights at the Bell Café in the Soho district of New York, whose limited space and name became the inspiration for the group's own name. *Tiny Bell Trio,* from which "Shards" comes, was the first of four albums the group released in the 1990s. "Shards" is typical of much of the music of the New York downtown scene in the 1980s and 1990s, in that it is completely *untypical* in almost every way. For one thing, although there have been many trio formats used in jazz throughout the years, it is likely that this particular instrumental format was the first of its kind. Then there is the music itself: East European folk music, mixed with improvisational jazz, with a healthy dose of humor thrown in for good measure? Somehow it works—really well! (ref: davedouglas.com)

0.00	Head is played by trumpeter Dave Douglas
0.12	Repeat
0.24	New theme is stated four times
0.58	Guitar solo by Brad Shepik
1.17	Trumpeter Douglas and guitarist Shepik exchange short solos
2.19	Douglas and Shepik exchange short solos with drummer Jim Black
2.34	Theme and variations of the head
3.22	Second half of head is restated

category include *In Our Lifetime,* a tribute to 1960s trumpeter Booker Little; *Stargazer,* a tribute to Wayne Shorter; and *Soul on Soul,* a tribute to pianist Mary Lou Williams. Douglas has also been keenly interested in the possibilities presented by electronic instruments and sound processing, as evidenced by his 2003 album *Freak In,* in which tracks were electronically manipulated after the sessions were completed. "The idea of *Freak In* was to create a sense of flow, of fluency that live bands get but with additional freedom of being able to really work the electronics in ways that their technology was created for. I think there is a big future for the use of this process in the music that's coming out of jazz."[14] This line of thinking is leading him into further experimentation with electronics. Douglas explained: "In one of my last sessions . . . I recorded about an hour of solo trumpet . . . I started transforming the tracks, turning raw trumpet sounds into grooves, textures and melodies. Home-made miniatures started to take shape from the sounds of these raw tracks."[15] Douglas has also taken control of the business end of his career with the founding of his own label in 2004, Greenleaf Music. Two of his latest endeavors include performing with and writing for the 8-piece SFJAZZ Collective, and his own group **Brass Ecstasy,** a 5-piece group consisting of trumpet, French horn, trombone, tuba, and drums. In 2009, the group released its debut LP *Spirit Moves.*

Other Downtown Artists

Of course, downtown jazz encompassed more than just Zorn, Frisell, and Douglas, and throughout the late 1980s and 1990s, a number of other instrumentalists and composers associated with the New York scene made significant contributions to avant-garde music. Like many musicians from his generation, composer/keyboardist **Wayne Horvitz** grew up (in New York City) listening to everything from jazz and classical, to Hendrix and Motown. Since the mid 1980s, Horvitz has led a number of experimental groups, including the electric fusion The President, which included Elliot Sharp and Bill Frisell on guitars and Bobby Previte on drums; and the New York Composers Orchestra, a workshop for composers co-led by his wife, pianist/vocalist Robin Holcomb. He was also a member of John Zorn's Naked City during this time. In 1985, he released the quirky *This New Generation,* which established his place in the downtown scene. In 1988, Horvitz and Holcomb moved to Seattle after having a daughter, and in his new environs, Horvitz formed Zony Mash, an electric acid jazz quartet; Ponga, a jazz jam band; and the Gravitas Quartet, a chamber jazz ensemble that includes trumpet, cello, bassoon, and keyboards, which released their debut album *Way Out East* in 2006.

Two drummers, Bobby Previte and Joey Baron, have also been part of the downtown scene. Previte has established himself as an original composer as well as a dynamic percussionist since moving to New York in 1979. One of his early recordings, *Pushing the Envelope,* was called "one of the finest releases by a New York artist in 1987" by the *Village Voice.* His 1990 release *Empty Suits,* by the band of the same name, was written up in *JAZZIZ:* "*Empty Suits* takes you someplace new, with jazz as a compass and the whole of music as a map." Since 2002, Previte has been working steadily with guitarist Charlie Hunter in a duo in which he plays electronic drums. Joey Baron has seemingly been the "go to" drummer for avant-garde as well as more mainstream artists since emerging in the New York scene in the mid 1980s. In addition to playing with John Zorn's Naked City, Baron has performed with such disparate musicians as Chet Baker, Dizzy Gillespie, Philip Glass, and David Bowie. Among his many recording credits are two solo quartet albums, *We'll Soon Find Out* and *Down Home,* both recorded with Bill Frisell, saxophonist Arthur Blythe, and bassist Ron Carter.

Other downtown artists include cornetist/composer Butch Morris, who calls his method of organizing group improvisations into compositions "comprovisation;" alto saxophonist/composer Tim Berne, whose compositions have been performed by the Kronos String Quartet and the Rova Saxophone Quartet; English bassist/guitarist Fred Frith, whose 1979 debut album *Gravity* predated his membership in Naked City as its bassist; and guitarist Elliot Sharp, whose many projects include Carbon, formed to link his interest in nuclear disarmament politics with music; Terraplane, which explored his interest in electric blues; and Tectonics, a drum and bass electronica ensemble. A good example of Sharp's work can be found on the 1995 Carbon album *Interference,* which is performed by an ensemble consisting of electric harp, drums, bass, sampler player, and Sharp, who plays guitar, saxophone, samples, and does "computer processing." One of the more far-reaching downtowners has been electric harpist **Zeena Parkins,** whose improvised works often

extend outside the world of even an extended definition of jazz. Working with both the traditional acoustic harp and one-of-a-kind electric harps, Parkins aims to "deconstruct the instrument, creating a blizzard of sound one minute and a delicate sparse requiem the next," and "investigate the creative process in performance, installation, and composition in collaborations in film and dance."[16] Parkins has worked in one way or another with nearly all the downtown musicians previously listed. One of Parkins' more "inside" works is the 1996 album *Mouth=Maul=Betrayer,* recorded with her Gangster Band, which includes her sisters Sara and Maggie on violin and cello, respectively, as well as a percussionist, an additional string player, and a didgeridoo performer.

Other Important Jazz Artists from the 90s

Don Byron: Attacking Stereotypes with a Clarinet

Don Byron: if you've heard of him, you may be thinking, "Oh yeah, he's the black guy that does klezmer." Which is exactly the opposite of what Byron would like you to think of him. "Sometimes it's like I'm going to be the klezmer man for the rest of my life. I just didn't think it was going to get this big,"[i] says Byron, referring to the typecasting that followed the release of his second album, 1993's ***Don Byron Plays the Music of Mickey Katz.*** In the 1950s, Katz was a sort of Jewish Spike Jones, a comedian who used klezmer—the Yiddish music of 19th century Eastern Europe—as a vessel for his humor. The sight of a dreadlocks-wearing African American playing klezmer on a clarinet was too much for some people, but Byron knew exactly what he was doing. "I don't want to be the mainstream guy. I just want to be the weird guy," Byron says. "I want to be the guy who's got the weird thing of his own, and I want to be that in several different contexts."[ii] Byron (November 8, 1958–) has been breaking down preconceptions and stereotypes—sometimes racial—his whole life, like the ones from his music teachers at school. "I'd show up and they'd say

[i] Sherrill, Stephen: "Don Byron," *New York Times Magazine*, 1/16/94
[ii] Ibid.

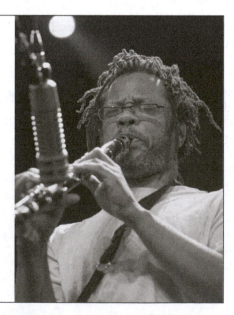

Clarinetist Don Byron.

MUSIC ANALYSIS

TRACK 45: "TUSKEGEE EXPERIMENT"

(Schumann) Don Byron from the album *Tuskegee Experiments* recorded November 1990 at Clinton Studios and July 1991 at Power Station, New York (6:30). Personnel: Don Byron: clarinet; Joe Berkovitz: piano; Richie Schwarz: marimba; Kenny Davis: bass; Pheeroan akLaff: drums; Sadiq: poet

In 1992, clarinetist Don Byron released his debut album *Tuskegee Experiments,* which helped win him the *Down Beat* magazine Artist of the Year Award and effectively put him on the map. The album is a political commentary of sorts on the infamous and controversial Tuskegee syphilis experiments conducted on poor African American sharecroppers in Tuskegee Alabama from 1932 to 1972. The album contains a wide variety of musical explorations and strong performances by downtown guitarist Bill Frisell, drummers Ralph

Peterson, Jr. and Pheeroan akLaff, bassists Reggie Workman and Lonnie Plaxico, and of course Byron. The music of the cut "Tuskegee Experiments" is a reworking of a song by classical composer Robert Schumann with a provocative poem written by Detroit poet Sadiq. Pianist Joe Berkovitz is also featured on the song.

0.00	As the drummer Pheeroan akLaff sets up a groove, Sadiq begins reciting poem
0.33	Pianist Joe Berkovitz and marimba player Richie Schwarz begin repeating 10-beat riff
0.50	Sadiq continues poem
1.23	Clarinet solo by Don Byron
2.30	Sadiq continues poem
3.12	Piano solo by Berkovitz

'You want to play jazz.' In the classical pedagogy, I had teachers telling me my lips were too big."[iii] After growing up in Manhattan and the Bronx, where "my folks were almost militant about me checking out all different kinds of music,"[iv] Byron attended the New England Conservatory, where his aspirations of becoming a classical musician began to change as his interest in jazz grew. He graduated from NEC in 1984, but stayed in Boston until 1987 as a member of the Klezmer Conservatory Band. After moving to back New York and working his way into the downtown scene, he released his debut album *Tuskegee Experiments* in 1992. It garnered him the *Down Beat* Artist of the Year Award.

Tuskegee Experiments takes its title from a series of highly questionable psychological experiments performed on African American men by the U.S. government in 1932. The album contains invigorating music, played by a 10-piece ensemble that includes Bill Frisell and former Coltrane sideman Reggie Workman on bass. The title cut includes a poem by the poet Sadiq that lends commentary to the subject. After releasing *Mickey Katz,* in 1995 Byron released *Music For Six Musicians,* an album that includes more social commentary along with the Afro-Cuban music he heard in the Bronx in his youth. Among it's songs are "Uh-Oh, Chango/White History Month" (with poetry once again by Sadiq), "(The Press Made) Rodney King (Responsible for the LA Riots)," and "Sex/Work (Clarence/Anita)," a commentary on the 1991 accusations/counter accusations of sexual

[iii] Ibid.
[iv] Davis, Francis: *Bebop and Nothingness: Jazz at the End of the Century*, pg 175

harassment between Supreme Court nominee Clarence Thomas and his former colleague Anita Hill. Byron's eclecticism has surfaced repeatedly in his more recent LP releases, which include 1996's *Bug Music,* a collection of music by the 1930s orchestras of Raymond Scott, John Kirby, and Duke Ellington; *Nu Blaxploitation,* which the *San Francisco Chronicle* categorizes as "reminiscent of Frank Zappa's satirical extramusical excursions;" *A Ballad For Many* with the Bang on a Can All-Stars, which includes Byron's "Eugene," the accompaniment he wrote to accompany a silent episode of the *Ernie Kovacs Show;* and his latest LP *Do the Boomerang,* a tribute to soul tenor man Junior Walker with a tight-knit 6-piece funk band. Perhaps because Byron is a black jazz musician who resisted the Marsalis-era narrow-minded worldview, he has attracted criticism from jazz policeman Stanley Crouch, who has said, "I really don't consider Byron a jazz musician." Byron's response: "Me and most of the cats I hang with, we're too left wing to be around Lincoln Center. They should be presenting the freshest, baddest stuff. I don't even exist in jazz as these people perceive it to be."[v]

Jam Session Warriors

The jam session—it has been a part of jazz culture since the earliest days in New Orleans. Before the music even had a name, musicians were getting together to work out ideas, hear what others were playing, and put a little competitive juice into the act of making music. Jam sessions continued in Chicago in the 1920s, and in New York and Kansas City in the 1930s, by which time the competitive element had grown to such importance that they became known as cutting contests. Being "cut" by a superior player was tantamount to losing the gunfight at the OK Corral. Although no one died at cutting contests, reputations often did. Jam sessions have always played an essential role in developing new jazz styles, including and perhaps most significantly bebop, which as discussed in Chapter 1, emerged from the jam sessions held at small out-of-the-way clubs in Harlem in the late 1950s. By this time, jam sessions also had an entrance requirement: one had to know the tunes and the new reharmonizations, and be able to play them in any key and at any tempo. It was a way to keep out the wannabes and outsiders, or as guitarist Biddy Fleet said, "to separate the sheep from the goats . . . to get them no-players out of your way. If and when they *do* know what's going on, they become one of you. A commune brother."[17]

By the time John Coltrane put his quartet together in the 1960s, the jam session had moved out of the back streets of Harlem to top tier jazz clubs such as the Village Vanguard and the Half Note. Coltrane's solos, sometimes lasting thirty minutes or longer, drew condemnation from the critics and some fans, but his explorations in atonality, musical ideas, and sheer endurance had a lasting effect on the most progressive jazz musicians. Young, inquisitive rock musicians were also listening to John Coltrane, and before long, guitarists such as Eric Clapton and Carlos Santana and bands like the Doors and the Allman Brothers were including long, extended jams in their sets. Coltrane was more than a musical influence to Carlos Santana, who once told an interviewer, "I heard the Supreme One playing music through John Coltrane's mind."[18] The Coltrane influence in rock was

[v] Sherrill

most visible in the psychedelic bands of the Haight-Ashbury scene in San Francisco—in particular, with the Grateful Dead. For Dead guitarist Jerry Garcia, Coltrane's influence was not about stealing licks (which were undoubtedly beyond his ability), but was instead conceptual. Garcia said, "I've been influenced by Coltrane, but I never copped his licks . . . I've been impressed with that thing of flow, and of making statements that to my ears sound like paragraphs."[19] Thrown into the milieu of the LSD parties known as the "acid tests," where the entertainment was the hallucinations and the antics of the other tripping guests rather than the band, the Grateful Dead were able to freely experiment with whatever inspiration came to mind during their long, Coltrane-esque jams (like everyone else the Dead were drinking the LSD-dosed Kool-Aid). As one of the most famous road bands in history that continued to tour until Garcia's death in 1995, the Dead became an inspiration to a whole new generation of free-form improvisational rock bands who, by the early 1990s, were becoming known as jam bands. It was in Austin, Texas, on October 14, 1995, that one of the most popular jam bands, Phish, brought three young musicians on stage to jam with them. Their names were John Medeski, Billy Martin, and Chris Wood.

Their band, **Medeski, Martin, and Wood,** formed in New York in the summer of 1991. Although each of the three members was a downtown jazz musician, the group's concept was right out of the Grateful Dead playbook. "In the beginning, as it is now, we went by gut instinct," said Wood. "We have a natural connection between us, as people and as musicians, and we just let things flow in whatever direction they went."[20] Keyboardist Medeski and bassist Wood first met in Boston in the late 1980s as students at the New England Conservatory. After moving to New York, the two began doing duo gigs at the Village Gate. Martin, a veteran of tours with the Lounge Lizards and New York's Brazilian music scene, came into the fold when Medeski and Wood decided to expand into a trio. The synergy was immediately palpable. Applying the 1959 Bill Evans Trio egalitarian approach to improvisation using funk and hip-hop beats and chord structures, Medeski, Martin, and Wood not only were able to flourish musically, but soon found an audience. After releasing two albums on independent labels, *Notes from the Underground* (1992) and *It's a Jungle in Here* (1993), the band toured for several months in a newly purchased recreational vehicle. Blessed with a personal chemistry that equaled that of the Grateful Dead, Medeski, Martin, and

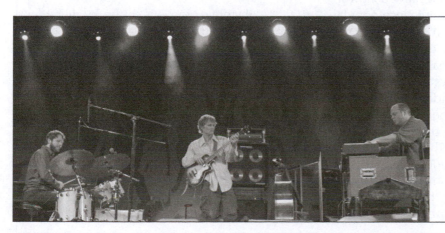

Medeski, Martin, and Wood: (Left to right) drummer Chris Wood, bassist Billy Martin, keyboardist John Medeski.

Wood thrived on the road, with Medeski serving as cook, Martin as fix-anything handyman, and Wood as bookkeeper. "We have a strong friendship that goes beyond the music," said Martin. "Even when we have ups and downs, the music and our friendship carries us through."[21] Being on the road also forced Medeski to start using electric keyboards, including the Hammond B3, which became an essential part of the Medeski, Martin, and Wood sound. By the mid 1990s, the band's popularity brought tours of the United States, Europe, and Japan. By 2000, they were on the cover of *Down Beat*.

The late 1990s also saw the release of four more albums, including 1997's *Bubblehouse*, an album that exemplifies the band's willingness to move into new directions by including production work by DJ/turntablists DJ Olive, Loop, Once 11, and DJ Logic. *Bubblehouse* was also the first collaboration with producer Scott Harding (aka Scotty Hard), who has called Medeski, Martin, and Wood's increasingly experimental sound as "a cross between Booker T. & the MGs and the Art Ensemble of Chicago."[22] After signing with Blue Note in 1998, the band released **Combustication** and two albums in 2000: *Tonic*, recorded live at the experimental New York nightclub of the same name, and *The Dropper*. The all-acoustic *Tonic* includes renditions of Coltrane's "Your Lady," Lee Morgan's "Afrique," as well as the Hendrix standard "Hey Joe." Around this time, the band completed work on its own Brooklyn recording studio called Shacklyn. Medeski, Martin, and

Music Analysis

Track 46: "Coconut Boogaloo"

(Medeski/Martin/Wood) Medeski, Martin, and Wood from the album *Combustication* recorded 1998 at The Magic Shop, New York City (3:57). Personnel: John Medeski: Hammond B3 organ, Hohner clavinet, Wurlitzer electric piano; Chris Wood: bass; Billy Martin: drums

After forming in 1991, Medeski, Martin and Wood parlayed musical chemistry, innovative songwriting and a heavy touring schedule into popular success. After releasing six albums throughout the decade, they made their major label debut in 1998 with *Combustication,* released on Blue Note Records. The group has always invited guests to appear on their albums, and *Combustication* includes appearances by DJ Logic on three tracks, and poet Steve Cannon on the experimental "Whatever Happened to Gus." The album also features "one of the greatest recorded piano solos by John Medeski" on "Latin Shuffle." "Coconut Boogaloo" is classic MMW&W; the song starts off with the Billy Martin's drumbeat setting the

tempo, followed by Medeski's simple Hammond B3 organ riff. Medeski expertly balances playing the B3 and the Hohner clavinet throughout the song's first minute and a half before switching to the Wurlitzer electric piano for an extended solo. After returning to the head, the song vamps out. (ref: mmw.net; interview with Billy Martin at jambands.com; appliedmicrophone.com)

0.00	Rhythmic groove is set up by drummer Billy Martin
0.10	Keyboardist John Medeski enters with opening riff on Hammond organ and Hohner clavinet; bassist Chris Wood enters soon after
0.52	Opening riff is repeated
1.11	Wood and Martin set new groove for electric piano solo by Medeski
2.24	Medeski returns to organ and opening riff, then slowly develops new cross-rhythmic element; eventually the group fades out the song

Wood has since released five more albums, including 2002's *Uninvisible,* which the band describes as "Back to the GROOVE! Horns. Turntables. Classic MMW with a future twist."[23] In addition to a five-piece horn section and percussionist Eddie Bobe, the band involved DJ Olive and Scotty Hard on turntables and "feedback." Medeski, Martin, and Wood have also collaborated with guitarist John Scofield on two albums, Scofield's 1998 *A Go Go* and their own *Out Louder* from 2006.

In 2008 they announced on their website: "Medeski Martin & Wood are planning three tours, plus three albums in 2008. Each tour and subsequent album will consist of all NEW MUSIC. The plan: *Write > Tour > Record > Repeat.*" The result was the three-album set *The Radiolarian Series.*

MMW helped set the style and tone for other jazz groups that would fall under the jam band umbrella. Common characteristics of jazz jam bands include an emphasis on a deep groove; hip-hop elements, which include the use of turntables, laptops, and remixes, as well as hip-hop rhythms; and a primary focus on the rhythm section. Although jam bands occasionally add horn players, typically they are instrumental endeavors that rarely include vocalists. Groups from the 1990s who more or less fit into the jam band category include Soulive, a Woodstock, New York organ trio that at times sounds like an update of the Jimmy Smith Trio *(Get Down!)* to a soulful Memphis-based revue *(Break Out);* Galactic, led by New Orleans drummer Stanton Moore, formed in 1994; and Sex Mob, led by slide trumpeter Steven Bernstein (who also leads the Millennial Territory Orchestra), a band that often uses tongue-and-cheek humor and whose first album *Din of Inequity* includes covers of "House of the Rising Sun," the James Bond theme "Live and Let Die," and a whacked out version of "The Macarena."

Continuing the Big Band Tradition

Even though the end of swing era relegated big bands to near-dinosaur status for many years, they have managed to stave off extinction, and in many ways, are flourishing today, at least creatively if not economically. For sure, traditional big band music has been kept alive by "ghost" bands, such as those formerly led by Duke Ellington, and Count Basie, and from high school, college, and repertory bands. The genre has also maintained a strong tradition of innovation from new bands that have come along over the years, including those led by Buddy Rich, Maynard Ferguson, Gil Evans, Charlie Haden, and Rod McConnell. Two of the more interesting big bands from the 1960s formed on opposite coasts from each other. The band of Los Angeles-based trumpet player **Don Ellis** started out—like most post-swing era big bands—as a

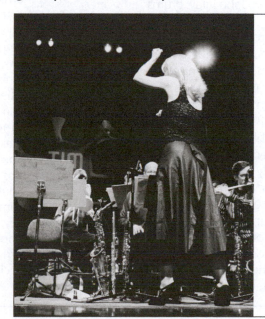

Composer/bandleader Maria Schneider conducting her orchestra.

rehearsal band in 1965 but, over time, built up a strong following through local club appearances. By late 1967, they had signed with Columbia and released their debut album *Electric Bath,* which was nominated for a Grammy and was named the *Down Beat* Album of the Year in 1968. The Ellis orchestra was noted for combining influences from Indian music, odd time signatures, unusual instrumentation (such as two drummers or three bassists), and the use of electronic instruments such as electric pianos. Ellis also often processed his trumpet through devices such as echoplexes or ring modulators. The much more famous **Thad Jones/Mel Lewis Orchestra** debuted as a temporary filler for a few open Monday nights at New York's Village Vanguard on February 7, 1966. Led by trumpeter Jones, one of the finest big band arrangers in jazz and brother of Coltrane drummer Elvin Jones, and drummer Lewis, the band from the beginning had an all-star cast of New York's finest jazz musicians. It quickly became known for its hard-swinging yet distinctively orchestral sound.

MUSIC ANALYSIS

TRACK 47: "CENTRAL PARK NORTH"

(Jones) Vanguard Jazz Orchestra from the album *Thad Jones Legacy* recorded May 1 and 2, 1999 at Edison Recording Studios, New York City (8:28). Personnel: Earl Gardner, Joe Mosello, Glenn Drewes, Scott Wendholt: trumpets; John Mosca, Ed Neumeister, Jason Jackson: trombones; Douglas Purviance: bass trombone; Dick Oatts, Billy Drewes: alto and soprano saxophones; Rich Perry, Ralph LaLama: tenor saxophones; Gary Smulyan: baritone saxophone; Jim McNeely: piano; Dennis Irwin: bass; John Riley: drums

The Vanguard Jazz Orchestra is one of the jazz world's unique and most venerable institutions. Formed in 1966 as the Thad Jones/Mel Lewis Orchestra, the band was co-led by its two namesakes until Jones left in 1978 to become director of the Danish Radio Big Band in Copenhagen. Lewis stayed on until his death in 1990, at which time the band changed to its present name and appointed Jim McNeely as composer in residence. 1999's *Thad Jones Legacy* is a tribute to Jones, who not only played trumpet and flugelhorn with the band, but gave it its signature sound with his original compositions, all of which he also arranged. "Central Park North," written in 1969, is "Jones's attempt to come to grip with funk," stated Francis Davis in the album's liner notes. "Similar in heft and

mobility to some of George Russell's pieces in the same vein, "Central Park North" is a wonderful blend of things—dissonance with swiveling hips. On balance, it's a near-masterpiece." (ref: liner notes to *Thad Jones Legacy* by Francis Davis)

0.00	Tracks opens with a guns blazing, full throttle introduction
0.55	Bassist Dennis Irwin sets up funk groove; piano and drums enter briefly before the horns enter with main melody
2.02	Scott Wendholt solos lyrically on flugelhorn as the funk groove comes to a complete stop
2.45	New, ballad tempo is established as Wendholt continues soloing
3.48	Dirtier funk groove is set up by drummer John Riley to support Glenn Drewes's plunger trumpet solo over a 12-bar blues
5.12	Funk groove continues as Dick Oatts solos on soprano saxophone
6.32	Shout chorus, with full scoring for horns
7.07	Drum solo by Riley
7.20	Riley, then Irwin re-establish same up-tempo funk groove from 0:55
7.33	Horns re-enter, song comes to dramatic conclusion

Although Jones left in 1978 and Lewis died in 1990, the band is today known as the **Vanguard Jazz Orchestra,** and continues to perform at its namesake club on Monday nights.

Other innovative contemporary big bands include the **Toshiko Akiyoshi Jazz Orchestra,** which was formed in Los Angeles in 1973 by Japanese pianist/composer Akiyoshi and her husband, tenor saxophonist Lew Tabackin. Inspired by Duke Ellington, who "was very conscious of his race," and the idea that "maybe that was [his] role, to portray [his] heritage within jazz,"[29] Akiyoshi released *Kogun,* the following year, a suite portraying a Japanese army officer living in the Burmese jungle in the 1970s, unaware that World War II had ended. Over the next ten years, Akiyoshi released a dozen more albums that often had tie-ins to her ethnic heritage. She became a perennial winner in the Big Band, Arranger, and Composer categories of the *Down Beat* Critics Polls. Another inventive big band, the New York Composers Orchestra (NYCO), was formed in 1986 by composer/keyboardist Wayne Horvitz and his wife Robin Holcomb as a workshop for experimental composers and arrangers. The NYCO's repertoire comes from Horvitz and other members including drummer Bobby Previte, as well as other notable composers such as Anthony Braxton and Elliot Sharp. To date, the band has released two albums, *The New York Composers Orchestra* (1990) and *First Program in Standard Time* (1992). As for now, "We have not been active for a while, [but] we have the material for a new CD,"[30] according to Horvitz. New York is also the home base for other contemporary big bands, including the Millennial Territory Orchestra, which got its start with an extended engagement at the Greenwich Village nightclub Tonic and is led by slide trumpeter Steven Bernstein, and Jason Lindner and the Ensemble, which had a long residency at Smalls and is led by pianist/composer Lindner.

Undeniably the most important of the new big bands is the **Maria Schneider Orchestra,** led by one of the most charismatic and brilliant arranger/composers in jazz today. **Maria Schneider** (born December 27, 1960) grew up in Minnesota, studied piano and music theory, and eventually attended the University of Minnesota. After hearing a collegiate performance of Leonard Bernstein's ballet *Fancy Free,* she realized her calling. "I was hoping to be a composer of some sort, but I wasn't sure if I had the talent," she recalled. "But that night . . . I remember thinking, 'Oh, my God. This is what I want to do.'" After graduating from University of Minnesota and attending the University of Miami, Schneider earned a master's degree in jazz writing and contemporary media from the Eastman School of Music in 1985. That same year she moved to New York City, where she received a grant to study with composer/arranger Bob Brookmeyer, with whom she would continue to work until 1991. "He was the person who made my career happen. And he's still the man I go to when I get stuck or frustrated."[31] With Brookmeyer's help, Schneider was able to get her foot in the door writing arrangements for the Vanguard Jazz Orchestra. In 1985, Schneider also began an apprenticeship with legendary composer/arranger Gil Evans, after an offhand remark to one of his friends about how much she admired his work resulted in an interview with Evans. Evans' ability to musically convey emotion was the most appealing thing about his compositions and arrangements, in Schneider's eyes. "When I first heard Gil's music, I heard the passion of music," she later told *Down Beat.* "I realized that this was

the emotion I wanted to express in my own music."[32] She worked with Evans on several projects, including the film *The Color of Money,* until his death in 1988.

After co-leading a rehearsal band with then-husband, trombonist John Fedchock from 1989 to 1992, she started the Maria Schneider Orchestra in 1993. Early on, the band was able to secure a regular Monday night residency at the now defunct Greenwich Village club Visiones, which lasted until the club closed in 1998. The first album release of the Maria Schneider Orchestra, *Evanescence,* a tribute to Schneider's mentor Gil Evans, displays her ability to write beautifully impressionistic compositions and arrangements, and earned her two Grammy nominations. The Maria Schneider Orchestra's second album, *Coming About,* (1995), features a thirty-minute, three-movement suite titled "Scenes from Childhood" that starts with the sound of a theremin and ends with "iridescent clouds of sound that shimmer into silence."[33] *Coming About,* as well as its follow-up *Allégresse* (2000), were both nominated for Grammy awards. The latter album was also named by both *Time* and *Billboard* as one of the top ten recordings of 2000. Schneider finally won a Grammy for her 2004 album *Concert in the Garden,* which was also named Album of the Year by the Jazz Journalists Awards and the *Down Beat* Critics Poll. Both groups also named her Arranger of the Year (her fourth such award from *Down Beat*) and Composer of the Year. Her latest recording, *Sky Blue,* was released in July 2007.

Schneider has always been able to attract the cream of New York's jazz crop, including saxophonists Steve Wilson and Rich Perry, trumpeters Ingrid Jensen and Laurie Frink, guitarist Ben Monder, and pianist Kenny Werner. She has also taken complete control of her business affairs. She releases her music through **ArtistShare,** an innovative music collaborative in which artists release their music through Internet sales only. *Concert in the Garden* was the first ArtistShare album to win a Grammy. Schneider has also launched a "Live" project on ArtistShare, in which her fans are able to download pictures, interviews, outtakes, and video that document the band as it goes out on tour. Her schedule is filled with constant touring as well as writing works commissioned by orchestras from around the world, including the Orchestre National de Jazz (Paris), the Norrbotten Big Band (Sweden), and the Metropole Orchestra (Netherlands), and a commissioned work for the Pilobolus Dance Theatre. She is also in great demand as an educator and clinician at institutions of higher learning.

ArtistShare Founded in 2001 by Brian Camelio, ArtistShare is a service enabling musicians to circumvent the established music industry and have more control over their music sales. According to its website, ArtistShare is "a place where fans fund the projects of their favorite artists in exchange for the privilege of 'participating' in the creative process."

Saxophone Superiority: Lovano, Garrett, and Potter

Three saxophonists who emerged in the 1990s, Joe Lovano, Kenny Garret, and Chris Potter, helped define the new mainstream direction of jazz. For **Joe Lovano,** playing jazz is all about being attentive to the music's history while creating your own history along the way. Lovano (born December 29, 1952) grew up in Cleveland, where his father, Anthony "Big T" Lovano was a professional tenor saxophonist and a central figure in the local jazz scene. Joe immersed himself in his dad's jazz records as a teen, and was gigging by age sixteen (often subbing for Big T), earning enough to put himself through college. He also developed what *Down Beat* has called a "broad shouldered, hairy-chested, tenderhearted sound."[34] After attending Berklee College in Boston in the early 1970s, Lovano began working the chitlin circuit with groups led by organists Dr. Lonnie Smith (with whom he made his recording debut) and Brother Jack McDuff. In 1976, Lovano

moved to New York, and worked with the big bands of Woody Herman and Mel Lewis before joining Bill Frisell in the Paul Motian Trio in 1981. During the 1980s, Lovano worked with a who's who list of musicians in New York (most notably the John Scofield Quartet) and recorded several albums for European independent labels, winning rave notices from critics and fans all along the way, including Blue Note head Bruce Lundvall: "The first time I heard Joe Lovano I felt that he was the most creative and hard swinging tenor player I'd heard in years." In 1991, he made his major label debut as a leader on Blue Note with the album *Landmarks,* and has since recorded more than 25 albums for the label. Among Lovano's more interesting album projects are *Universal Language* (1992), one of several album collaborations with his wife, vocalist Judi Silvano, and *Rush Hour* (1994), a collaboration with arranger Gunther Schuller.

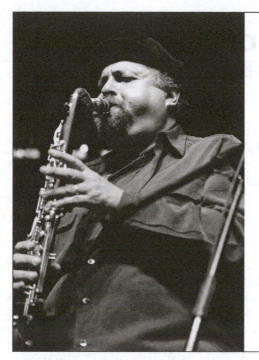

Tenor saxophonist Joe Lovano.

The resume of Detroit native and alto saxophonist **Kenny Garrett** (born October 9, 1960) is one of the most stellar in contemporary jazz. After a three-year stint with the Mercer Ellington Orchestra (the son of Duke) right out of high school, Garrett went on to play in the bands of Freddie Hubbard, Woody Shaw, and Art Blakey before joining Miles Davis's band in 1986, where he stayed until the trumpeters death in 1991. "Miles always wanted his musicians to push the envelope," Garrett told *Down Beat.* "He wanted you to find your own way, but if you didn't . . . he'd push me to think about another way to play the song." Garrett has taken Davis's advice to heart, developing a risk-taking approach to improvisation and an edgy sound that is unique among contemporary alto players. Garrett made his recording debut as a leader with 1984's *Introducing Kenny Garrett* and has since recorded thirteen more albums, primarily on Atlantic and Warner. One of Garrett's more interesting albums is 1996's *Pursuance: The Music of John Coltrane,* on which he interprets the music of Coltrane with a band that includes guitarist Pat Metheny. The album won the *Down Beat* Reader's Poll Album of the Year Award. "I'm trying to tell a story in a different way with the same jazz language my heroes employed—express Kenny Garrett through my own voice in this music."[35]

Chicago native **Chris Potter** (born January 1, 1971) played his first jazz gig at age thirteen in South Carolina where he grew up. During his high school years, while absorbing music on record from such diverse sources as J. S. Bach, Arnold Schoenberg, Miles Davis, and Dave Brubeck, Potter studied the soprano, alto, and tenor saxophones; the bass clarinet; and alto flute. In 1989, he moved to New York to study at the New School and the Manhattan School of Music,

Music Analysis

Track 48: "Shaw"

(Garrett) Kenny Garrett from the album *African Exchange Student* recorded 1990 at RCA Studios, New York (6:40). Personnel: Kenny Garrett: alto sax; Mulgrew Miller: piano; Ron Carter: bass; Elvin Jones: drums

"Shaw" is Kenny Garrett's tribute to Woody Shaw, one of the foremost post-hard bop jazz trumpeters in the 1960s, 1970s, and 1980s. Shaw was a bandleader as well as a sought-after sideman who played with such notable figures as Art Blakey, Horace Silver, Eric Dolphy, and Dexter Gordon. His 1978 album *Rosewood was nominated* for two Grammy Awards and was voted the Best Jazz Album in that year's *Down Beat Readers* Poll. He died in 1989, just weeks after a fall into the path of a subway train in Brooklyn, New York severed his left arm. On "Shaw," Kenny Garrett has assembled an amazing group consisting of John Coltrane Quartet drummer Elvin Jones, Miles Davis 1960s Quintet bassist Ron Carter, and one of the 1990s hottest new young pianists (and a relative newcomer compared to Jones and Carter), Mulgrew Miller. Together the four musicians have created an exciting and dynamic tribute to the great trumpet player on Garrett's fourth album as a leader.

0.00	Introduction: alto saxophonist Kenny Garrett briefly improvises while a modal groove is set up by drummer Elvin Jones, bassist Ron Carter, and pianist Mulgrew Miller
0.10	Head is stated by Garrett
0.46	Restatement of head
1.23	Piano solo by Miller
2.35	Alto saxophone solo by Garrett
4.08	Head is restated
4.44	As rhythm section returns to opening modal groove, Garrett solos; band slowly winds song down

where he graduated in 1993. In New York, Potter quickly established himself as an inventive and versatile saxophonist and secured a four-year gig with veteran trumpet player Red Rodney. Subsequent sideman gigs were with such artists as Dave Douglas, Paul Motian, and the Mingus Big Band. In 1992, Potter released his first album as a leader, *Presenting Chris Potter,* which, with six original compositions, shows off his talents as a composer and player. Potter has since released twelve more albums as a leader. One noteworthy album from Potter's discography is a 1994 live duet with pianist (and his former New School professor) Kenny Werner at the Maybeck Recital Hall in San Francisco, titled *Chris Potter and Kenny Werner.* His most recent projects have been with a more electric-oriented band that includes Craig Taborn on keyboards and Wayne Krantz on guitar.

Notes

1. Interview with Joshua Redman, published at www.jerryjazzmusician. com, 10/2/03
2. Davis, Francis: "Like Young," *The Atlantic Monthly,* 7/96
3. Kaplan, Fred: *The Boston Globe,* 2003, as reported in Nicholson, Stuart: *Is Jazz Dead? (Or Has It Moved to a New Address),* pg 15
4. Lundvall and Levenson quotes from Hajdu, David: "Wynton's Blues," *Atlantic Monthly,* 3/03
5. All figures from www.riaa.com
6. Gann, Kyle: "Breaking the Chain Letter: An Essay on Downtown Music," www.kylegann.com
7. Dorf, Michael: *Knitting Music,* pgs 10–11
8. Dorf, pg 10
9. Nicholson, Stuart: *Is Jazz Dead? (Or Has It Moved to a New Address),* pg 4
10. Davis, Francis: *Bebop and Nothingness: Jazz and Pop at the End of the Century,* pg 187
11. From the liner notes of *The Carl Stalling Project: Music from Warner Brothers Cartoons 1936–1958*
12. Mandel, Howard: *Future Jazz,* pg 172
13. Quote from omnology.com
14. Nicholson, pg 143
15. Interview from Auskern, Leonid: "Dave Douglas: My Favorite Album Is Always the One Which Is About to Be Released," *Jazz News,* 8/9/05
16. From the program notes to the Lincoln Center Festival 2007, at which Parkins appeared with Dave Douglas, Matmos, and So Percussion
17. Gitler, Ira: *Swing to Bop: An Oral History of the Transition in Jazz in the 1940s,* pg 70
18. Nisenson, Eric: *Ascension: John Coltrane and His Quest,* pg 230
19. Ibid.
20. Quote from www.mmw.net
21. Ibid.
22. Quote from Myers, Mitch: "Anti-Mercenary Improvisation," *Down Beat,* 11/00, pg 29
23. Quote from mmw.net
24. Sherrill, Stephen: "Don Byron," *New York Times Magazine,* 1/16/94
25. Ibid.
26. Ibid.
27. Davis, Francis: *Bebop and Nothingness: Jazz at the End of the Century,* pg 175
28. Sherrill
29. Stewart, Zan: "A Non-Traditional Arrangement," *The Los Angeles Times,* 11/14/93
30. Email correspondence with Wayne Horvitz
31. Both quotes from Protzman, Bob: "Maria Schneider's Composing Pains," *Down Beat,* 11/96, pg 36
32. Marantz, Bart: "To Gil, With Love," *Down Beat,* 6/92, pg 24
33. From the liner notes to *Coming About,* written by Terry Teachout
34. Mandel, Howard: "Joe Lovano's Sound of the Broad Shoulders," *Down Beat,* 3/93
35. Both quotes from Mandel, Howard: "Kenny Garrett: Mission Possible," *Down Beat,* 9/97

Study Questions for Chapter 8

1. Give a rough overview of some of the events and issues that shaped the jazz world in the late 1980s and early 1990s.

2. Define the term *downtown* as it applies to music (not specifically jazz).

3. Why was the Knitting Factory so important? What impact did it have on the New York jazz scene?

4. Describe the important musical influences on John Zorn, and how they manifested themselves in his compositions.

5. Both John Zorn and Dave Douglas have led a variety of narrowly focused musical groups in their careers. Why?

6. What are some musical and career characteristics that downtown jazz musicians seem to have in common?

7. Describe why jam sessions have been so important to the evolution of jazz and the incubation of experimental music in general.

8. What is the most unusual aspect of Don Byron's career, and how has it affected the way he has been perceived by the press?

9. What were some of the important big bands from the 1960s through the 1990s? Name some interesting or unique aspects of a few of them.

10. Describe the differences in way Joe Lovano, Kenny Garrett, and Chris Potter each worked their way up and first achieved notice.

Nu Jazz

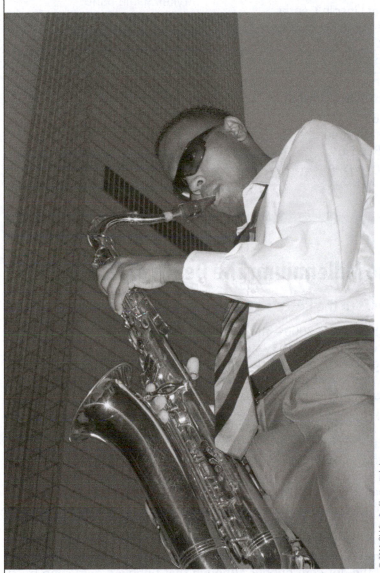

© 2011, OLJ Studio, Shutterstock, Inc.

Key Terms, Music, Places, Figures and Bands

Terms

Jazz: A Film by Ken Burns
Wordless vocal
Vocalese
Norah Effect
Acid jazz
Thirsty Ear Records' Blue Series
Glocalization

Music (albums, works, etc.)

Art of the Trio Series
These Are the Vistas
Historicity
TEN
Reverse Thread
Come Away with Me

Live in Chicago
Future Shock
Dis

Places

Jazz at Lincoln Center
Frederick P. Rose Hall
Tonic
The Stone
55 Bar

Figures and Bands

Ken Burns
Brad Mehldau
The Bad Plus
Ethan Iverson
Vijay Iyer

Jason Moran
Ben Monder
Kurt Rosenwinkel
Dave Stryker
Stryker/Slagle Band
Ingrid Jensen
Regina Carter
Terri Lyne Carrington
Nora Jones
Diana Krall
Karrin Allyson
Kurt Elling
Kenny Werner
Matthew Shipp
Jan Garbarek

At the Millennium: The Death of Jazz

Ken Burns to the Rescue

It was January 1, 2000—the beginning of the twenty-first century.* The preceding months had been a time to reflect on the past hundred years and all of the advancements in technology, the arts, and civilization in general. Magazines and television networks were busily gathering experts to make Top 100 lists of the most important this or the most influential that. Topping the various lists were such people and things as the Beatles, the personal computer, the first moon landing, World War II. There had also been fears that all of the world's computers would crash once their clocks hit 12:00:00 A.M. on 01/01/00—the dreaded Y2K Bug. Although nothing happened, millions of dollars were spent upgrading systems and millions of hours were spent in worry and analysis on CNN. Above and beyond the lists and preparing for the parties, Americans were finally getting over the sordid affairs that led to the impeachment of President Clinton and enjoying the rising stock market as it rode the wave of the dot com bubble. Although that bubble would soon burst and the attacks on September 11, 2001, would soon "change everything," for the moment times were good. As the Irving Berlin lyrics from the 1920s, a time eerily similar to the 1990s, said, "Blue skies smiling at me; Nothing but blue skies do I see."

One end-of-the-century list that was not made was the Top 100 Jazz Records. Come to think of it, there weren't any jazz end-of-the-century lists. In fact, outside of the musicians who were trying to make a living

*In reality, the 21st century began on January 1, 2001, a fact that nearly everyone chose to disregard in the excitement to get on with the business of millennium advancement.

by it, it seemed nobody was really thinking about jazz all that much. Jazz CD sales were at an all-time low of 2.9 percent of total CD sales, and were destined to get worse (the most recent figures available from 2006 put the number at 2 percent). Before the oft-asked rhetorical question "Is jazz dead?" could get asked once again, a knight in shining armor appeared on the horizon in the persona of filmmaker **Ken Burns.** Burns had already made a number of widely viewed public television documentaries that had renewed interest in their topics, most notably *The Civil War,* which was watched by approximately forty million people in 1990. When it was announced that he would make a documentary about the history of jazz, many felt that Burns would work his magic once again and revive the struggling art form. In January 2001, the highly anticipated nineteen-hour *Jazz: A Film by Ken Burns* was shown over seven nights during prime time, accompanied by the publishing of a coffee table book and the release of nearly thirty compilation "best of" CDs of various artists. Rich in archival and never-before seen film footage and bathed in a soundtrack of memorable jazz recordings, Burns made *Jazz* the final segment in his trilogy on the American experience: the strength of our constitution *(The Civil War),* the nature of our pastimes *(Baseball),* and the beauty of our art *(Jazz.)* Critics, however, began their attacks almost before the first episode was over. Among the complaints was Burns's "Crow-Jim" racism (black musicians are portrayed as "innovators," whereas whites are "appropriators"), his decisions on whom to leave out (including Lennie Tristano, Keith Jarrett, Weather Report, and Michael Brecker), and the preachiness and overexposure of "talking head" Wynton Marsalis. Burns was also widely criticized for packing the last forty years of jazz history into the final two-hour episode and completely ignoring anything past *Bitches Brew.* Was it Burns' statement writ large that he too thought jazz was dead? In the end, none of it mattered, as the resurgence in the music's popularity that *Jazz* was supposed to bring just didn't happen.

So, Is Jazz Really Dead This Time?

The lack of interest in Burns' program added fuel to the "Is jazz dead?" debate that had once again become a hot topic with writers, critics, and musicians. In his book *Blue: The Murder of Jazz* (1997), Eric Nisenson lays the blame for jazz's presumed demise on the neocon philosophy of stressing technique over creativity with statements such as, "Jazz without innovation is a dead art form."[1] Gene Lees also holds Wynton Marsalis and company responsible, but for a different reason. "Either jazz has evolved into a major art form," he writes in *Cats of Any Color* (1995), "or it is a small, shriveled, crippled art useful only for the expression of the angers and resentments of an American minority. If the former is true, it is the greatest artistic gift of blacks to America, and America's greatest aesthetic gift to the world. If the latter is true, it isn't dying. It's already dead."[2] Jazz critic Francis Davis also indirectly points his finger at Marsalis, but for still another reason. " 'In jazz, the Negro is the product,' Ornette Coleman once sagely observed," he writes in *Bebop and Nothingness: Jazz and Pop at the End of the Century* (1996). "But not anymore, or not exactly. The new 'product' in jazz is youth."[3] Davis notes how jazz bands playing in New York clubs began to get younger and sound more traditional (as in "hard boppish") and less experimental after articles ran in *The New York Times* and *Time* magazine in 1990 reporting on the "jazz rebirth" and profiled

a number of young lions recently signed to record contracts. To Davis, these pieces only served to "foster the illusion that nothing much was happening in jazz until the arrival of these neophobic youth. But if *Time* and *The New York Times* say that jazz is experiencing a renaissance, it is. That's how it works."[4]

In *Blue,* Eric Nisenson said, "The cry that 'jazz is dead' has been so ubiquitous throughout jazz history that it has almost become a tradition in itself."[5] John P. McCombe correctly states that this is only half of the equation, for "tales of jazz's demise usually feature the promise of jazz rebirth." In his essay "Eternal Jazz: Jazz Historiography and the Persistence of the Resurrection Myth," McCombe suggests, "the jazz master-narrative of resurrection is part and parcel of jazz's academic apotheosis."[6] Among the death/rebirth scenarios in jazz history are the closing of Storyville in 1917, and the subsequent birth of a new scene in Chicago in the early 1920s; the supplanting of 'traditional' jazz by swing in the 1930s; the "Moldy Figs versus Moderns" debate as the swing era died out at the onset of the bebop revolution; the "New Thing" that emerged just as hard bop was getting stale; the rise of jazz/rock fusion at the expense of acoustic jazz; and most recently, the debate over Wynton Marsalis and the neocons. At each juncture of this narrative, critics weighed in with warnings of jazz's death, using such phraseology as "nihilistic, cynically destructive" (Rudy Blesh, on swing), "an irresponsible exploitation of technique in contradiction of human life as we know it" (Philip Larkin, on bebop), or "a horrifying demonstration of what happens to be a growing 'anti-jazz' trend" (Neil Leonard, on free jazz). Add Ken Burns to the list of doomsayers. In the final episode of *Jazz,* his narrator states "for a long time [in the 1970s], the real question would become whether this most American of art forms could survive in America at all." As McCombe points out, Burns also feeds the resurrection myth with the quasi–New Testament flavor in which he describes Marsalis near the end of the program: "No musician in jazz history has ever *risen* so far so fast [. . .] Because his climb seemed so meteoric, because he was born in New Orleans and *the son* of one jazz musician and the brother of three more, and because for many people he would become the symbol of the rebirth of mainstream jazz, his success seems to have been almost *preordained.*"[7] (Italics added)

City of Glass

As discussed in Chapter 7, the Marsalis controversy further heated up after the trumpeter was named artistic director of **Jazz at Lincoln Center** in 1987. As it turned out, Marsalis became a much more valuable asset than his title would suggest. In 2003, as their new performance center was under construction with some $28 million yet to be raised, *Atlantic Monthly* writer David Hajdu asked Jazz at Lincoln Center Board Chairperson Lisa Schiff the following question: "What strategy does the board of directors have for raising the necessary funds?" Her answer: "Wynton."[8] Schiff's simple, straightforward—and ultimately highly successful—approach illustrates the position of power and influence that Marsalis holds in the cultural and corporate worlds today. On October 18, 2004, the $128 million **Frederick P. Rose Hall,** a spectacular complex of performance halls, educational center, and state-of-the-art recording studio opened in the Time Warner Center on New York's Columbus Circle. Included in the facil-

ity is the 1,200-seat Rose Theater, designed so that no audience member is more than 90 feet from the stage; the 400+ seat Allen Room, which boasts a 50 foot by 90 foot wall of glass behind the stage that dramatically overlooks Central Park and the New York skyline; and the intimate Dizzy's Club *Coca-Cola,* which is a bona fide jazz club featuring live jazz seven nights a week. Although the programming of Lincoln Center events drew extreme criticism in its early years, the rigid parameters have been relaxed in recent years. One recent example of this was a July 2007 performance in the Allen Room by the four-piece ensemble So Percussion and the electronic laptop duo Matmos, accompanied by Dave Douglas on trumpet and Zeena Parkins on harp—hardly the stuffy "uptown" type of repertory concert that critics were carping about in the late 1980s and early 1990s.

But before Jazz at Lincoln Center can be congratulated for giving jazz its long overdue seat next to classical music in the world of high culture, there is a new controversy to consider. Jazz at Lincoln Center has turned out to be the 800-pound gorilla in the room of funding for jazz events, tours, and festivals, sucking up huge amounts of the available resources that formerly went to other smaller, west-of-the-Hudson organizations. Because the survival of jazz is increasingly dependent on funding from public and private sources rather than the open marketplace, when a highly visible organization like Jazz at Lincoln Center grabs the lion's share of what is available everyone else must stand in line for the leftovers. Longtime jazz business professional Marty Khan points out that "all this new income going to them has restructured the industry into big fish and minnows."[9] This sort of restructuring is disruptive in two ways. When a highly visible artist like Wynton Marsalis or Herbie Hancock can get $20,000 or more for a single concert appearance, it limits the number of venues that can afford the price and gives that artist little incentive to play for less in smaller out of the way places. In addition, there are fewer funds available for the Oliver Lakes and Art Ensemble of Chicagos of the world, artists who are highly respected but have lower profiles. Khan calls it an "elitist mentality [that] is being replicated all over the country," resulting in "the virtual elimination of the mid-range gig in America."[10]

Important Jazz Musicians at the Turn of the Century

The Pianists: Mehldau, Iverson, Iyer, and Moran

In spite of the controversies over *Jazz: A Film by Ken Burns* and the Jazz at Lincoln Center, contemporary jazz musicians continue to reinvent and redefine the music in new and compelling ways, including a number of young and strikingly original pianists. In 1988, Connecticut native **Brad Mehldau** moved to New York City to enroll at the new school and study with pianists Fred Hersch and Kenny Werner. Mehldau quickly became an active participant in the local club scene, and made his recording debut in 1991 on an album by alto saxophonist Christopher Hollyday. Recording prolifically as a sideman with saxophonists Joshua Redman and Mark Turner and guitarist Peter Bernstein (among others), Mehldau formed his own trio in 1994 with bassist Larry Grenadier and drummer Jorge Rossy.

The Frederick P. Rose Hall/Jazz at Lincoln Center

Opened on October 18, 2004, the Frederick P. Rose Hall is located in the Time Warner Building at Columbus Circle (60th and Broadway) in New York City. It is the home of Jazz at Lincoln Center, which was established in 1987. Included in the facility are:

- The Rose Theatre, a 1,200-seat auditorium
- The Allen Room, a 400-seat space with a dramatic glass wall behind the stage
- Dizzy's Club *Coca-Cola,* a small jazz club
- Irene Diamond Education Center
- A 96-track, 2,400 square foot state-of-the-art digital recording studio
- Nesuhi Ertegun Jazz Hall of Fame, a multimedia installation that features an 18-foot video wall and interactive computer kiosks

Pianist Brad Mehldau.

Since his 1995 major label debut *Introducing Brad Mehldau* on Warner, Mehldau has released thirteen more albums as a leader, including the five-album *Art of the Trio* series, and has made a number of collaborative albums, including the highly acclaimed *Metheny—Mehldau* in 2006. Mehldau's influences come primarily from Bill Evans and Keith Jarrett, but his style is distinctively original. He is completely ambidextrous, and often switches the traditional roles of the left and right hands. He also employs complex polyrhythms, and is comfortable playing in odd meters. Although Mehldau often reaches into the standard jazz repertoire and is a prolific composer, he has also drawn attention for his covers of songs written by rock bands, including Radiohead's "Exit Music (For a Film)" from *The Art of the Trio Volume Three—Songs.* One of Mehldau's most recent albums is 2010's *Highway Rider,* on which his small group is augmented by a chamber orchestra.

Covering rock songs is also a commonly used tactic by **The Bad Plus,** a trio comprised of three Midwesterners: pianist **Ethan Iverson,** bassist Reid Anderson, and drummer Dave King. After playing a chance gig together in 1990, the three went their own ways—King to Los Angeles and Anderson and Iverson to New York, where Iverson studied with Fred Hersch and famed classical teacher Sophia Rosoff. When the three reunited for a one-night gig in 2000, the chemistry was just too good to ignore, so they decided to stay together and record, ultimately releasing their eponymous debut album on the Fresh Sound label. At their first gig, the trio played a cover of Nirvana's "Smells Like Teen Spirit," and have since become known for covering the music of other rock bands, including Black Sabbath, Blondie, and Björk. Because The Bad Plus sticks to using traditional acoustic instruments, recreating the energy of rock tunes can be a challenge. "Obviously, if Black Sabbath set up and played, it would be very intense," comments Iverson. "Despite [having] the completely wrong instrumentation for it, I do think we go for that. I mean, we hit hard, and we're proud of hitting hard."[11] After a period of struggle in which the band claimed both New York and Minneapolis as hometowns, the group secured a one-night gig at the Village Vanguard in 2002 as part of the JVC Jazz Festival, which in turn led to a contract with Columbia. Beginning with 2003's *These Are the Vistas,* the band has released five albums, most recently 2007's *Prog.* As one might expect, their high-energy covers of rock tunes have been controversial, but that's fine with Iverson. "The Bad Plus [is clearly not] Bob Dylan plugging in, we're not that big a deal, but a big enough deal that there's an angry article in *JazzTimes.* Its like, 'well alright

MUSIC ANALYSIS

TRACK 49: "HEART OF GLASS"

(Harry/Stein) The Bad Plus from the album *These Are the Vistas,* recorded at Real World Studios, Box, England, between September 30 and October 5, 2002 (4:45). Personnel: Ethan Iverson, piano; Reid Anderson, bass; David King, drums.

"Heart of Glass," from The Bad Plus album *These Are the Vistas,* is an example of the band's trademark abstract renderings of popular rock tunes. Written by Deborah Harry and Chris Stein of 1970s punk band Blondie, the song was originally recorded with a disco beat and released in the middle of the disco craze. It became a Number 1 hit in 1979. Of course, there is nothing disco about The Bad Plus's version. *These Are the Vistas* is the band's third album, and its first with a major label, Columbia. The album was recorded at Peter Gabriel's Real World Studios in England, with noted indie rock producer/engineer Tchad Blake. In addition to "Heart of Glass," *These Are the Vistas* includes covers of Nirvana's "Smells Like Teen Spirit" and Aphex Twin's "Flim," as well as eight originals. The Bad Plus's version of "Heart of Glass" gives every member of the band an opportunity to shine at one time or another in the constantly shifting, rhythmically turbulent arrangement. Holding everything together is pianist Ethan Iverson's constant fragmented reference to the song's theme, which eventually becomes a repeating vamp that closes out the song. (ref: the-badplus.com)

0:00	Four-note melody played by pianist Ethan Iverson followed by crashing chord; drummer Dave King and bassist Reid Anderson set up the tempo
0:17	Iverson plays two verses of the melody, eventually ending with a descending spiral of chords
0:53	In abstract rubato fashion, the band plays the chorus of the tune
1:16	Back in tempo, the band plays another verse and chorus
2:07	Iverson plays a frantic solo with both hands that eventually leads to an abstraction of the song's melody
3:20	Iverson sets up the repeating vamp of the song's chorus, which bassist Reid Anderson and drummer King eventually pick up; recording ends with a drum cadence

man, look at that, I'm fuckin' controversial.' And that's pretty cool."[12] In September 2010, the Bad Plus released their seventh studio album, *Never Stop,* their first to consist entirely of original compositions.

Rochester, New York, native **Vijay Iyer** has successfully fused jazz with musical influences from his Indian heritage into a highly original style. Iyer is one of the most highly educated musicians in jazz today, having received undergraduate degrees in math and physics from Yale and a doctorate in music and cognitive sciences from University of California–Berkeley. While in the Bay area in the mid-1990s, Iyer began playing jazz gigs and making connections in the local scene. During this time, he met alto saxophonist Rudresh Mahanthappa, who shares Iyer's Indian ancestry and would become a regular collaborator in the future. Iyer's solo debut came in 1995 on the independent Asian Improv label with *Memorphilia,* an album that featured his three working groups: the Vijay Iyer Trio, the four-piece Poisonous Prophets, and the five-piece Spirit Complex. Iyer's major break came in 2003 with the release of two imaginative albums, *Blood Sutra* and *Reimaging,* using his quartet of Mahanthappa, Stephan Crump on bass, and Marcus Gilmore on drums. 2004 saw the release of the *In What Language?,* a collaboration with poet/hip-hop artist Mike Ladd.

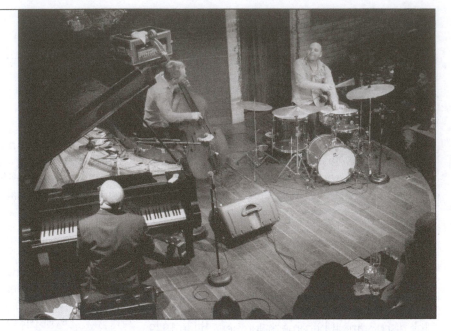

The Bad Plus. (Left to right) pianist Ethan Iverson, bassist Reid Anderson, drummer Dave King.

The album is a genre-defying commentary on post-September 11 America where ordinary citizens are subjected to wiretapping, illegal searches, and interrogations, which includes spoken word commentary throughout.

Iyer's 2009 album *Historicity* features his trio of Stephan Crump on bass and Marcus Gilmore on drums playing original compositions mixed in with interpretations of music by Leonard Bernstein, Stevie Wonder, and hip-hop artist M.I.A. Among the many awards it has won are Album of the Year by the *Down Beat* Critics Poll and the *Village Voice* Critics Poll, and the Jazz Album of the Year by both *The New York Times* and National Public Radio.

Jason Moran came to New York from Houston to attend the Manhattan School of Music, where he studied with such progressive pianists as Jaki Byard, Muhal Richard Abrams, and Andrew Hill. He joined Greg Osby's band in 1997, and made his recording debut on Osby's album *Further Ado.* Moran's own debut, *Soundtrack to Human Motion,* came in 1999 after he signed with Blue Note. In quick succession, Moran has recorded six more diverse and interesting albums for Blue Note, including the solo *Modernistic,* which includes a cover of Afrika Bambaataa's "Planet Rock" and a complete reworking of the standard "Body and Soul;" *Same Mother,* an homage to the blues; and *The Bandwagon,* recorded live at the Village Vanguard. A recent release of Moran's is *Artist in Residence,* which employs a number of unusual concepts,

Pianist Jason Moran.

including the mimicking of an artist's monologue on piano ("Artists Out to Be Writing"); and a piano rendition of a Carl Maria von Weber tune ("Cradle Song") accompanied by pencil scribbling in memory of his mother, who used to take notes when he practiced as a child. The album also includes a rollicking version of the civil rights anthem "Lift Every Voice." One might say that Moran's star is rising: in 2010, he released his seventh album *TEN,* was appointed to the faculty of the New England Conservatory, and was awarded one of the year's $500,00 MacArthur Fellowship Grants.

The Guitarists: Monder, Rosenwinkel, and Stryker

Three guitarists who have followed divergent paths on the contemporary scene are also deserving of a closer look. **Ben Monder** is a native New Yorker who, after attending the University of Miami and Queens College returned to the city in 1984. For the next two years, Monder "spent most of his time working with R&B and wedding bands and practicing jazz in his room," according to his website. (Monder offers three different bios on his website, so it's hard to tell where the truth lies . . .) His break came in 1986 with organist Brother Jack McDuff's band, after which Monder lived in Vienna for a while. On returning to New York, Monder became a sought-after sideman, and worked with (among others) Paul Motian, Lee Konitz, and Maria Schneider. His debut album as a leader came with 1995's *Flux,* a trio recording on the indie Songlines label. He has since released five more albums on his own and played on more than ninety for other artists. Monder's latest release is *At Night* (2007), a duet with vocalist Theo Bleckmann (and occasional added percussionist), with whom Monder has worked with since 1995 and has recorded three other albums. Bleckmann's role is often to sing **wordless vocal** lines, because as Monder says, "I don't hear other instruments playing those parts . . . I guess maybe the voice makes the complexity a little more accessible."[13] One of Monder's more noteworthy albums is 2005's *Oceana,* a beautiful, atmospheric quartet recording with Bleckmann once again on vocals. According to Monder, 90 percent of *Oceana* is "through composed," rather than the usual head-solos-head format. The mood throughout can perhaps be described as Metheny with a European flavor.

Wordless Vocal—a written vocal line sung without words, using instead simple monosyllabic "oohs" or "aahs."

Perhaps slightly more traditional in direction than Monder, **Kurt Rosenwinkel** is nonetheless a remarkable young talent who is not afraid to take chances musically. Rosenwinkel grew up in Philadelphia, became interested in jazz through the music of Pat Metheny, Bill Frisell, and John Scofield, and ultimately attended Berklee College in Boston for two years before leaving school to tour with Gary Burton. After moving to New York in the early 1990s, Rosenwinkel went about putting together his own quartet, which included tenor player Mark Turner, bassist Ben Street, and drummer Jeff Ballard. After making his recording debut as a leader in 1996 *(East Coast Love Affair),* Rosenwinkel signed with Verve in 1999, with which he has now released five albums. Like Monder, Rosenwinkel likes wordless vocals, but supplies them himself as a doubling to his guitar solos, and sees them as an integral part of his sound. "For a long time I felt that I never got my sound on records. Then I realized that the vocal is actually part of the sound. So I began . . . really exploring it as a possibility."[14] Rosenwinkel also often employs alternate tunings, with purposely unpredictable results, as on "A Shifting Design" from *The Next Step*

MUSIC ANALYSIS

TRACK 50: "ECHOLALIA"

(Monder) Ben Monder from the album *Oceana* recorded at Brooklyn Recording, Brooklyn, NY between January and October 2004 (8:04). Personnel: Ben Monder: guitar; Theo Bleckmann: voice; Kermit Driscoll: bass; Ted Poor: drums

Ben Monder's *Oceana* is the third and most satisfying of his collaborative efforts with vocalist Theo Bleckmann. The album is a moody dreamscape that evokes images of other worlds, perhaps below the sea. "Echolalia" is a showcase for the talented Bleckmann, whose pure-toned voice adds a magical quality to the mix of instruments. Notes Nils Jacobson of allaboutjazz.com, "Bleckmann is a rare and notable exception in the jazz vocalist world because he has turned his voice into an effective instrument with its own characteristically clean, thin resonance." On "Echolalia" these qualities are brought to the foreground beautifully by Monder and band with their skillful, sensitive accompaniment. Monder's own solo, starting at

3:20, is another highlight of the piece. (ref: *Oceana* review by Nils Jacobson in allaboutjazz.com, October 27, 2005)

0.00	Guitarist Ben Monder sets up the brooding, mid-tempo groove with support from drummer Ted Poor and bassist Kermit Driscoll
0.08	Vocalist Theo Bleckmann enters with the melody, sung as a wordless vocal line
1.04	Melody repeats
1.56	New theme is introduced as Poor and Driscoll gradually evolve into a semi-samba groove
2.59	Main theme re-introduced
3.20	Monder begins guitar solo with staccato muted guitar
5.07	Bleckmann re-enters
6.04	Main theme re-introduced; track vamps out as Bleckmann sings variations of the theme

(2001): "It's an alternate tuning, so when I play the guitar I have no idea what chords or notes I'm playing. The tune is all shapes to me."[15] Rosenwinkel's latest release, *Deep Song* (2005), contains mostly original compositions (like his other albums), and uses Brad Mehldau on piano and Joshua Redman on tenor saxophone.

For Omaha native **Dave Stryker,** the blues have always been a primary source of inspiration around which he has built a solid career as a jazz guitarist. Stryker got into music via the Beatles and Rolling Stones, but soon found himself gravitating toward blues-oriented groups such as the Allman Brothers and, from there, to soulful jazz guitarists like Wes Montgomery, Grant Green, and the under-appreciated Billy Rogers. Stryker moved to New York in 1980, and got his first big break in 1984 when organist Brother Jack McDuff asked him to join his band. "We played up at this place in Harlem called Dude's Lounge from 10–4 in the morning. He was the old school, and there's really not too much of that around anymore, which was really a great experience."[16] While with McDuff, Stryker met his long-time musical collaborator, alto saxophonist Steve Slagle. After leaving McDuff in 1985, Stryker played in tenor saxophonist Stanley Turrentine's band from 1986 to 1995. In the meantime, he released his debut album *First Strike* in 1988 (featuring drummer Billy Hart) and signed with SteepleChase in 1990, with which he has released fifteen albums. Stryker has several ongoing groups: the **Stryker/Slagle Band,** a hard blowing post-bop quartet co-led by alto player Steve Slagle; the Blue to

Guitarist Dave Stryker performs in Omaha, Nebraska on July 14, 2005.

the Bone Band, an eight-piece four-horn blues/funk band; The Shades Project, reminiscent of 1970s Miles Davis recordings that includes *Bitches Brew* drummer Lenny White; and Trio Mundo, which Stryker describes as "world music meets jazz trio" and includes former Weather Report drummer Manolo Badrena. One of Stryker's most recent recordings, *Big City,* was voted one of the top recordings of 2005 by *Down Beat,* and includes fellow former Omahan Victor Lewis on drums. In 2010, Stryker released *One for Reedus,* dedicated to the late jazz drummer Tony Reedus and featuring Stryker along with Jared Gold on Hammond B3 and Steve Williams on drums.

Women in Jazz: Jensen, Carter, and Carrington

Throughout the history of jazz, the role that women have played has generally been as vocalists: Billie Holiday, Ella Fitzgerald, Sarah Vaughan, Betty Carter, Anita O'Day, Carmen MacRae, and Dianne Reeves are just a few of the many names that come to mind. However, when it comes to instrumentalists, jazz has traditionally been a men's club. Many of the important women instrumentalists, including Lil' Hardin Armstrong, Mary Lou Williams, Marian McPartland, Alice Coltrane, and, more recently, Toshiko Akiyoshi and Carla Bley, have been pianists. Until recently, except for a few "all-girl" novelty bands in the swing era and a few others (such as trombonist Melba Liston), women, because of the many factors that have traditionally suppressed them from achieving their rightful place in the workplace, have largely stayed away from careers as jazz musicians. Today, largely due to changing societal attitudes that have resulted in a large influx of women into the workforce and jazz education programs in high school and college, more and more women are making careers for themselves as jazz musicians. One sign of the progress women have made is the annual Mary Lou Williams Women in Jazz Festival held at the Kennedy Center, an event that is always enthusiastically received and sold out. Among the most prominent women jazz musicians in recent years (whom are not already mentioned in this text) include soprano saxophonist Jane Ira Bloom; pianists Michele

MUSIC ANALYSIS

TRACK 51: "ARTISTIYA"

(Doumbia) Regina Carter from the album *Reverse Thread* recorded at the Barber Shop Studios 2010 (3:56). Personnel: Regina Carter: violin; Gary Versace: accordion; Chris Lightcap: bass; Alvester Garnett: drums, percussion

Since Regina Carter made her recording debut as a leader in 1995, she has earned a reputation as a fearless musical experimentalist. With her latest release *Reverse Thread*, Carter explores the boundaries where jazz and African folk melodies meet. Using an unconventional backup group of bass, accordion, drums, and percussion, occasionally augmented by the West African kora, Carter achieves her mission with satisfying results. "Artistiya" was written by Mariam Doumbia, one half of the Malian duo Amadou and Mariam; Carter stays faithful to the original recording by achieving a remarkably vocal-like quality to her violin playing. After stating the head, Carter launches into a jazz improvisation that at one

point briefly quotes Copland's "Hoedown." Throughout the recording, accordionist Gary Versace, bassist Chris Lightcap, and drummer Alvester Garnett provide inspired support. (ref: *Reverse Thread* liner notes; *Finding Her Groove in Africa and a Violin* by Nate Chinen, *New York Times*, March 24, 2010)

0.00	Drummer Alvester Garnett and bassist Chris Lightcap set up groove
0.11	Violinist Regina Carter enters with solo ad-libs; accordionist Gary Versace quietly enters in supporting role
0.32	Carter plays head
1.18	Violin solo by Carter
1.52	Violin breakdown; Carter quotes Aaron Copland's "Hoedown"
2.32	Carter restates head
3.16	Group returns to opening groove, song winds down and ends

Rosewoman, Eliane Elias, Renee Rosnes, Hiromi Uhera, and Patrice Rushen; trumpeter Laurie Frink; guitarist Leni Stern; drummer Sherrie Maricle; trombonist Sarah Morrow; and tenor saxophonist Anat Cohen. Three that deserve our attention are trumpeter Ingrid Jensen, violinist Regina Carter, and drummer Terri Lyne Carrington.

Canadian **Ingrid Jensen** first came to the United States to attend Berklee College in Boston, from which she graduated in 1989. After moving to New York and working her way up from playing in the subways, Jensen has established a solid resume working with Maria Schneider and Dave Douglas (among others), and now teaches at the Peabody Conservatory in Baltimore. She has released six albums on Enja and ArtistShare, including *Vernal Fields,* which won a Canadian Juno Award. Detroit native **Regina Carter** made her recording debut as a leader in 1995, with Regina Carter on the Atlantic subsidiary Wea. Since then she has released five more albums, including *Motor City Moments,* her homage to Detroit musicians and *Paganini: After a Dream,* on which she used Niccoló Paganini's famous Guarneri violin. In 2006, she was awarded a $500,000 MacArthur Fellows "Genius" Award. Carter's latest release is 2010's **Reverse Thread,** on which she explores the boundaries between jazz and African folk music. Former child prodigy **Terri Lyne Carrington** started playing the drums at 7, received a full scholarship to Berklee College at age 10, and moved to New York at 18, where she began playing with such artists as Stan Getz, James Moody, and Dave Sanborn. At 24 she moved

Trumpeter Ingrid Jensen.

to Los Angeles and became the drummer on the nationally syndicated Arsenio Hall Show. That same year (1989) she released her debut album, the Grammy nominated *Real Life Story,* which featured Carlos Santana, John Scofield, and Grover Washington, Jr. She is most in demand as a session musician, and has recorded for Wayne Shorter, Herbie Hancock, Cassandra Wilson, and Danilo Pérez, among others. Her latest LP is 2010's soulful *More to Say,* which features a stellar supporting cast that includes keyboardist George Duke, vocalist Nancy Wilson, and bassist Christian McBride, among others.

The Norah Effect

Is It Jazz, or Is It Pop?

As jazz moves into its second century, it is an appropriate time to consider some of the many changes that are rapidly reshaping the nature of the music. One of the areas where jazz is being redefined is in the boundaries that it shares with pop music. Among the explorers of this frontier are a new breed of quasi-jazz vocalists whose styles and choice of material are hard to categorize. The poster child for this issue is **Norah Jones,** whose 2002 blockbuster Blue Note debut album **Come Away with Me** has sold somewhere in the vicinity of 20 million copies and won five Grammy Awards. Although *Come Away with Me* includes only one song that is considered a jazz standard ("The Nearness of You"), Jones' soft, wistful singing style and soulful piano playing transforms non-jazz tunes such as Hank Williams' "Cold, Cold Heart" into jazz or something *jazz-like.* Much of Jones' success can be attributed to her popularity with the thirty to sixty age group, which by the time *Come Away* was released had become the fastest growing and largest segment (56 percent) of music buyers. This age group, many of whom were not necessarily die-hard jazz fans, nonetheless identified jazz as cool and hip through the way it was projected in Hollywood movies and in television commercials hawking such lifestyle items as diamond rings, luxury cars, and perfume. "In an increasingly affluent consumer society," wrote Stuart Nicholson in *Is*

Singer Norah Jones performing at Tonic on May 15, 2003.

Jazz Dead? Or Has It Moved to a New Address, "people were becoming defined not so much by how much money they earned, but the lifestyle choices they made, and jazz singers plugged into this."[17] In the wake of Jones' success, major record labels began throwing money at other "jazzy" singers with abandon, including Jamie Cullum (signed by Universal for nearly $2 million), Clare Teal and Jane Monheit (both signed by Sony), Michael Bublé (Warner), and Peter Cincotti (Universal). "It might have started off as something novel and new," says Sony's Adam Seiff, but "suddenly there's an audience who listens and appreciates these singers. What started off as a small area of the business is now the mainstream."[18] But are they jazz singers? Who cares—the labels are happy, and so are the thirty to sixty-somethings. "Call it almost jazz, easy listening or just plain pop," says columnist Neil Spencer. "Part of the Norah effect has been to move the parameters of 'jazz' beyond the reach of its self-appointed guardians."[19]

Although Jones and Co. were the beneficiaries of the big dollar contracts resulting from the **"Norah effect,"** their successes came in part by virtue of their following other singers who had already successfully crossed the line between jazz and pop. Before Jones (the daughter of Indian sitarist Ravi Shankar), the most recent jazz singer to achieve pop-like record sales was Canadian **Diana Krall,** whose major label debut, 1995's *Only Trust Your Heart,* hit Number 8 on the jazz charts. Her next album, *All for You,* stayed in the Jazz Top Ten for seventy weeks and won a Grammy nomination. Krall's popularity continued to grow, and by 1999, she had two platinum albums to her credit, *Love Scenes* and *When I Look in You Eyes,* the latter album garnering two Grammy Awards. Krall, who is married to rock icon Elvis Costello, sticks much closer to the jazz tradition than Jones by singing standards such as "All or Nothing at All" and "I Remember You," but never strays too far from cultivating the perfect mood for a baby boomer dinner party or a romantic evening. Before Krall's success, the early 1990s also brought stardom to Natalie Cole, whose overdubbed "duet" with her late father Nat King Cole on 1991's "Unforgettable" went gold, as well as veteran jazz vocalist Tony Bennett. Bennett had successfully managed the

jazz/pop crossover in the 1950s and 1960s, but had fallen off the map until resurrecting his career in the 1990s with appearances on MTV and a heavy touring schedule. His albums *Perfectly Frank* (1992) and *Steppin' Out* (1993) both went gold, won Grammy Awards and helped him connect with a brand new youthful audience.

Beyond Norah: Karrin and Kurt

The Norah effect has also translated into success for a new wave of bona fide jazz singers. Omaha native **Karrin Allyson** released her self-produced debut album *I Didn't Know About You* in 1992 from her adopted hometown of Kansas City, where she had relocated after briefly living in Minneapolis. By chance, a copy of the recording ended up in the hands of San Francisco DJ Stan Dunn of KJAZZ, who got such an overwhelming listener response to it that he forwarded it to the president of Concord Records, Carl Jefferson, who personally signed Allyson to a contract. Since then, her career has taken off like a rocket. To date, Allyson has released ten albums that display her willingness to take risks and explore every corner of the musical universe. Firmly entrenched in the jazz tradition, she is an exceptional scat singer and swings as hard as any bebopper. This side of Allyson has recorded songs written by Charlie Parker, Thelonious Monk, Charles Mingus, and Wayne Shorter. Her 2001 album *Ballads: Remembering John Coltrane* is a track-by-track recreation of Coltrane's 1962 album *Ballads,* which garnered the singer a Grammy nomination. More recently, Allyson released *Footprints* in 2006, an album of jazz instrumental classics (such as Wayne Shorter's title cut, rechristened here as "Follow the Footprints") adapted for vocals. Allyson is not afraid to cross over into the world of cabaret (Melissa Manchester's "I Got Eyes") or pop (Carole King's "It's Too Late"), and gives each a distinctive styling that is immediately recognizable. Her slight rasp and sassy attitude has put her albums high on the jazz charts, in rotation on jazz radio stations, and has attracted notice from the critics. "Allyson coolly stakes her claim," writes *Village Voice* critic Gary Giddins. "She brings a timbre that is part ice and part grain . . . incisive, original, and emotionally convincing."[20] One of Karrin's most recent releases is *Imagina: Songs of Brasil,* from 2008.

Vocalist Karrin Allyson.

Vocalese—technique of composing lyrics to fit existing recorded jazz improvised solos or instrumental arrangements. 𝄢

Another jazz vocalist who has emerged as "the real deal" is Chicago native **Kurt Elling.** One might call Elling old school—and not just because of his choice to stay true to his jazz calling and eschew pop stardom (which he surely could have attained had he chosen). Some examples of his retro-ness: a conversation with Elling is full of hepcat vernacular—"groovy," "dig it," "you cats," etc.—that comes across as genuine rather than contrived; he is a master at **vocalese,** the mostly forgotten art of adding lyrics to recorded instrumental solos; and he has succeeded in expanding on the art of scat singing, something that has largely been avoided by the "Norah" school of jazzy pop singers. Elling's life and career has been anything but routine. After graduating from college in Minnesota, he enrolled in divinity school in Chicago in 1989, but quit in 1992 one credit shy of his degree. By this time he had found his true calling: singing jazz. After two years of tending bar and moving furniture while gigging at night, Elling self-produced an album that somehow found its way into the hands of Bruce Lundvall of Blue Note, who wasted no time in signing him to a contract (a discovery story eerily similar to Allyson's). His Blue Note debut, 1995's *Close Your Eyes,* was the first of six consecutive albums to be nominated for a Grammy Award (he now has seven nominations). *Close Your Eyes* includes vocalese lyrics set to solos by Wayne Shorter and Paul Desmond, and features pianist Laurence Hobgood, the brilliant, under-recognized Chicago pianist who continues to work with Elling to this day.

Music Analysis

Track 52: "Downtown"

(Ferrante) Kurt Elling from the album *Live in Chicago* recorded July 14–16, 1999 at the Green Mill Jazz Club, Chicago (3:45). Personnel: Kurt Elling: vocal; Laurence Hobgood: piano; Rob Amster: bass; Michael Raynor: drums

"Downtown" is the exciting opening cut on Kurt Elling's fourth album *Live in Chicago,* recorded at the legendary Green Mill Jazz Club. The club, opened in 1907, has an illustrious past, including once being a watering hole for 1920s Chicago mobsters such as Al Capone, and also as the inspiration for the 1957 movie *The Joker is Wild* starring Frank Sinatra. Elling's performance on "Downtown" is absolutely scorching, and displays the tremendous flexibility of his voice as well as his innovative scat singing technique. He also has a killer-tight band on the date, led by his longtime associate Laurence Hobgood. Other highlights from the album include the mesmerizing "My Foolish

Heart," which includes the reading of a poem written by St. John of the Cross, and guest appearances from vocalese legend John Hendricks and Chicago tenor saxophonists Von Freeman, Eddie Johnson and Ed Petersen. (ref: kurtelling.com; greenmilljazz.com)

0.05	syncopated intro vamp is set up by pianist Laurence Hobgood, bassist Rob Amster, and drummer Michael Raynor; Kurt Elling adds introductory and welcoming remarks
0.33	head is played in unison by Elling on vocal and Hobgood on piano
1.20	return to intro vamp, including vocal and bass line at 1:34
1.48	Elling begins scat vocal
2.35	intro vamp
2.49	drum solo built around syncopated stabs by voice, bass and piano
3.16	return to head and coda ending

In 1997, Elling released the adventurous album *The Messenger,* on which he dips into the pop catalog (the Zombies' "The Time of the Season"); incorporates hip, street-smart spoken word ("It's Just a Thing"); takes extreme improvisational risks ("Endless"); and employs his signature vocalese (Dexter Gordon's "Tanya Jean"). In 2000, Elling expanded the definition of adventurous with **Live in Chicago** and the accompanying *Live in Chicago Out Takes,* recorded at the famous Green Mill Restaurant. On *Live in Chicago,* Elling evokes his divinity school training with an extended version of the standard "My Foolish Heart," which includes a trance-like reading of a poem by St. John of the Cross, a sixteenth century Christian mystic. Elling also gets spiritual with his original tune "Esperanto," in which he asks, "When I die, where does time go?" and then pronounces that all things are holy in a song-ending repetitive chant. He also covers Sting ("Oh My God"), Wayne Shorter ("Night Dreamer"), sings a gutbucket blues ("Going to Chicago"), and does a duet with the "musical godfather of vocalese" John Hendricks ("Don't Get Scared"). *Live in Chicago* also includes more beat-style poetry ("The Rent Party") and innovative renditions of standards ("My Foolish Heart" and "Smoke Gets in Your Eyes"). Since 2000, Elling has topped the Readers Poll of *Jazz Times* and the Critics Poll of *Down Beat* every year, recorded three more solo albums, and collaborated with artists as diverse as Fred Hersch *(Leaves of Grass),* Liquid Soul *(Make Some Noise),* and the Yellowjackets *(Club Nocturne).* His latest album is 2009's *Dedicated to You: Kurt Elling Sings the Music of Coltrane and Hartman,* a tribute to the 1963 album *John Coltrane and Johnny Hartman,* in which Elling re-records the six songs from that album and adds six other songs associated with either Coltrane or the late vocalist Hartman. The album was recorded live at the Allen Room at Jazz at Lincoln Center's Frederick P. Rose Hall and won the 2010 Grammy Award for Best Vocal Jazz Album.

Jazz + Technology

A New Guy in the Band

Another area in which jazz is being redefined is in the use of technology. Jazz musicians have always incorporated new and innovative technology in their quest to expand their musical palette, but the last ten years have seen a marked increase in the use of new instruments, computers, and software that are beginning to radically redefine not only the sound of jazz, but also the creative process itself. And with the new technology came a new member of the jazz band. Since the late 1990s, "what began as a trickle had become, if not a flood, then a small but noticeable flow of ensembles that included a musician handling 'electronics' in their lineup," states Stuart Nicholson. "Albums began appearing with credits for mysterious tasks such as 'sequencing,' 'programming,' 'sampling,' 'DJ,' or 'electronics'."[21] According to Nicholson, the rapid advances in the use of technology in jazz have been influenced by two developments in the non-jazz musical universe. The first of these was the art of DJing, which since its beginnings in the 1970s had evolved quickly and under the radar screen of most jazz musicians. The second was the enormous advancements in computer science and its musical applications, which by the early 2000s was allowing musicians to be much more creative and sophisticated in sound design and manipulation. "Now the improviser's art could be played

out against new sonic backdrops colored by fragments of electronic sounds, rhythms, and samples swimming through the music, while digital computer editing—also known as 'hard disc editing', where sounds are chopped up and rearranged inside the computer's virtual space—allowed for juxtapositions never dreamed of in Charlie Parker's day."[22]

Incorporating new technologies into the creative process has been an essential part of jazz tradition throughout its history. After the Original Dixieland Jass Band made the first jazz recordings in 1917, jazz musicians quickly began to understand the importance of making records to document their work. Beginning in the 1950s they were also among the first musicians to take advantage of the freedoms that the 33-1/3 rpm LP allowed them in recording extended works. (Many people consider the Beatles *Sgt. Pepper's Lonely Hearts Club Band* the first "concept" album; however, Charles Mingus did two concept albums in 1957 alone [*The Clown* and *Tijuana Moods*], a full ten years *before* the Beatles' magnum opus.) By the early 1960s, many jazz musicians were taking advantage of the editing and over-dubbing possibilities afforded by recording on magnetic tape, years before the well-documented experiments of the Beatles. By the 1960s, jazz musicians were routinely overdubbing solos (a practice Lennie Tristano was using as early as 1953) and incorporating electric organs, pianos, and bass guitars. By 1969, Miles Davis was using wah-wah pedals and delay units to enhance the sound of his trumpet. In the early 1970s, Herbie Hancock added designated synthesist Dr. Patrick Gleason to add sound effects and ambience to his band. Hancock also introduced the next quantum leap forward in the use of technology in 1983 with his album **Future Shock,** which incorporated industrial sounds and turntable scratching on the opening track "Rockit," courtesy of producer Bill Laswell and turntablist Grand Mixer D.ST. However, Hancock, seemingly drew a line in the sand, as few other jazz musicians were willing to follow his lead. Indeed, Hancock himself only occasionally used DJs after *Future Shock,* but perhaps this was more a result of his musical restlessness than anything else.

DJs next impacted jazz in the late 1980s, when a group of innovative turntablists in London, including Gilles Peterson and Paul Murphy began using funk/jazz records to entertain dancers in the city's club culture. Peterson called it **"acid jazz"** as a joke, but the name stuck. The mixing of jazz and hip-hop elements seemed a natural, and it wasn't long before jazz musicians began jumping on the bandwagon and began performing their own groove-oriented jazz in an attempt to capture the feel of what Peterson and Murphy were doing, and it was a case of the cart preceding the horse. "The whole acid jazz scene came out of jazz musicians being inspired by DJs, not the other way around,"[23] states London Jazz Café programmer Adrian Gibson. "Acid jazz" soon became a somewhat undefinable catchall phrase to describe anything from disco to smooth jazz that sounded contemporary and commercial, but its bubble burst. Not before, however, London DJ Geoff Wilkerson put together a recording project he called Us3 that released the 1993 album *Hand on the Torch,* a skillful mix of samples from vintage Blue Note recordings, rap vocals, and real jazz musicians, which became the label's best-selling album up to that point in time. The album's signature track "Cantaloop (Flip Fantasia)" was built on a sample of Herbie Hancock's piano riff from his 1964 song "Cantaloupe Island" and hit Number 9 on the *Billboard* charts.

Acid Jazz—a style originally created by London DJs from 1960s and '70s soul jazz and funk records.

Turntablists, DJs, and Laptops

Although acid jazz didn't last, as Nicholson points out, "The genie was out of the bottle." Rapid advancements in musical software, including sequencers, samplers, and loop-based production software, caused many jazz musicians in the late 1990s to take another look at the possibilities that technology was now presenting them. This was especially true of younger musicians who had grown up with computers and video games, and were less reluctant to be bound to traditional jazz conventions. The central players in the use of the new technology are DJs, musical collage artists who have opened up a whole new world of creativity by scratching rhythms, manipulating samples from a variety of sources and recombining them in various ways, creating tape loops, and producing fantasy sounds. In essence, they have come a long way since the early days when they simply made scratching noises to accompany dance beats. "Whatever one's position, DJ culture marks out a fundamentally new cultural space," write Christoph Cox and Daniel Warner. "It has altered the very nature of musical production, opened up new channels for the dissemination of music and activated new modes of listening."[24] DJ culture has become so popular that music retailers report that sales of turntables are surpassing sales of guitars. In 2004, Berklee College of Music became the first music school ever to offer a class in turntablism, called "Turntable Technique." "Turntablists are musicians," says professor Stephen Webber, who teaches the class. "Many of them, like DJ QBert, are virtuoso musicians, who practice hours a day and constantly strive to push their art further. I recently saw QBert perform, and he transported the entire audience; made us forget where we were and who we were."[25] In a jazz performance, DJs can either integrate the sounds they create into the music as any other member of the ensemble, or they can create a backdrop sound environment on which the other musicians play and improvise. The possibilities are endless. "There are no rules anymore," states saxophonist/composer Bob Belden. "There is a sense of freedom one gets from dealing in the new world of artificial reality."[26]

Today, much of the process of sound creation and manipulation has moved to the laptop computer, both in performance and in postproduction. Artists such as Craig Taborn *(Junk Magic);* Medeski, Martin, and Wood *(Uninvisible);* Dave Douglas *(Freak In);* and **Kenny Werner** *(Lawn Chair Society)* have experimented with recording albums in which the DJ/producer acts as a co-composer of sorts by freely restructuring the music either while or after it was recorded. Norwegian saxophonist Jan Garbarek constructed the framework for his 2004 album *In Praise of Dreams* entirely on his laptop and added musicians later. One of the most innovative electronic experimenters is pianist **Matthew Shipp,** who was hired to lead **Thirsty Ear Records'** new subsidiary label **Blue Series** and responded with his albums *Nu-Bop* (2002) and *Equilibrium* (2003). For Shipp, jazz has always reflected the artist's environment, whether that artist was Louis Armstrong, Duke Ellington, Charlie Parker, or himself. "I live in an urban setting. There's lots of things I take in—sounds and the ambience of the street—that I soak into my subconscious . . . There's things in the environment . . . that I'm trying to connect to, and I've been feeling that making jazz albums as we've known had not been adequate for me personally to connect to those things."[27] New technology is not only a reflection of Shipp's contemporary environment, but also a

MUSIC ANALYSIS

TRACK 53: "WEST_COAST_VARIANT"

(Pickett) Kenny Werner from the album *Lawn Chair Society* recorded at Charlestown Road Studios, Hampton, New Jersey 2007 (3:31). Personnel: Kenny Werner: piano, keyboards, computer; Chris Potter: tenor sax; Dave Douglas: trumpet, cornet; Scott Colley: bass; Brian Blade: drums

Kenny Werner's 2007 album *Lawn Chair Society* has been hailed as a breakthrough for the pianist, who has been a fixture of the New York jazz scene since the late 1970s. In addition to having provided sensitive supporting roles for such luminaries as the Mel Lewis Orchestra, trumpeter Tom Harrell, saxophonist Joe Lovano, and harmonica virtuoso Toots Thielemans, Werner has made a name for himself with his acoustic piano trio as well as his exploratory solo piano albums. With *Lawn Chair Society*, Werner has combined traditional jazz elements with some far-reaching new ideas and technology that will surely provide a launching pad for further musical development. Supported by a

strong cast that includes saxophonist Chris Potter and trumpeter Dave Douglas, Werner also brings on board former Tower of Power saxophonist Lenny Pickett as producer, songwriter, and occasional instrumentalist. Werner's use of "keyboards and computer" add a futuristic touch that makes the album "sit atop this year's best-of list for its innovation, its ties with tradition, and for the quintet's superb musicianship." (ref: *Lawn Chair Society* by Jim Santella, allaboutjazz.com)

0.00	Rhythmic groove is created with occasional electronic effects that continues throughout song
0.16	Trumpeter Dave Douglas plays a single note
0.45	Tenor saxophonist Chris Potter begins noodling in lower register
3.11	Rhythm section drops out, Douglas and Potter briefly engage in collective improvisation, track ends

way for him to "connect to those things." With his own records and those of others he has produced, Shipp has propelled the Blue Series into the forefront of the use of new electronic technology.

Globalization: Outsourcing Jazz

The World Is Flat

In *The New York Times* columnist Thomas Freidman's book *The World Is Flat: A Brief History of the Twenty-First Century,* he describes how a number of "flatteners" have changed the way the work of the world gets done and the new opportunities that are being created for people in China, India, and other places who can now compete in the international marketplace. He gives his flatteners names like "uploading," "offshoring," "outsourcing," and "insourcing," but they all fall under the broad heading of "globalization." According to Friedman, the world is increasingly no longer a place where innovation comes from a few at the top (in the United States and Western Europe) that eventually trickles down vertically to everyone else, but is instead a place where many people from all over the world can interconnect and collaborate together "horizontally." In other words, the playing field is leveling and becoming less exclusive and more inclusive. *The World Is Flat,* first published in 2005, became a runaway best seller and opened many people's eyes

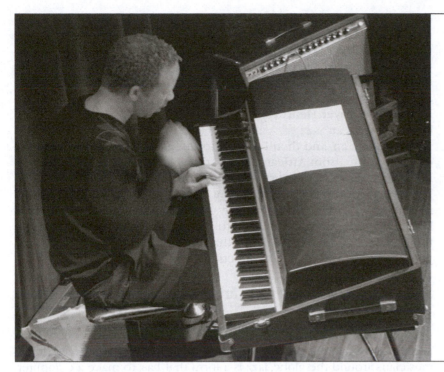

Keyboardist Craig Taborn playing the Fender Rhodes electric piano.

(especially in the United States) as to the high degree of interconnectedness that exists in the world today. (One interesting story told of how an airborne surveillance camera in Iraq was being remotely controlled by a technician in the United States while military officers on several continents were watching and conversing in an online chatroom about how to attack the target!) Globalization has touched nearly every aspect of life in the twenty-first century, and jazz is no exception. Increasingly, the old model of American jazz (and for the last fifty years or so, jazz from New York City) being a template for jazz musicians from all over the world to try to emulate is slowly being replaced by a new world order where jazz musicians in other countries incorporate musical influences from their own cultures to create their own localized style of jazz. The vertical model, where innovation comes from the top (New York), is being replaced by the horizontal, where innovation comes from many places. For jazz in the twenty-first century, the world is indeed flattening.

Of course, jazz is a uniquely American art form. It was created primarily from the musical traditions from Africa and Europe that began to commingle in the Southern states in the eighteenth and nineteenth centuries. Although the primary cultural dynamic in jazz has always been the interplay between these two musical traditions, other outside influences began showing up early on, most noticeably from Latin American rhythms (what Jelly Roll Morton called the "Spanish tinge"). As jazz matured and became more popular in the 1920s and 1930s, its open immigration policy of outside musical influences slowed, and arguably came to a halt. Propelled by the dissemination of phonograph records throughout the world, American jazz became what Stuart Nicholson calls a musical *lingua franca*—a common language—for musicians in other countries, primarily in Europe. Thus, jazz became one of the many aspects of American culture, from Americanized English language, to movies, television, and McDonald's to infiltrate the rest of the globe. Just as these aspects of American

Glocalization The term *glocalize* was coined by author Thomas Friedman and first used in his book *The Lexus and the Olive Tree* (1999). In a musical sense, glocalization refers to the ability of musicians around the world to absorb global music styles, such as jazz or pop, into their own musical traditions, while retaining a strong sense of local identity. Or as Friedman describes it, "To be able to assimilate aspects of globalization into your country and culture in a way that adds to your growth and diversity, without overwhelming it." 🎵

culture have been **"glocalized"** as Friedman calls it—taken on distinctly local characteristics throughout the globe to suit the needs of those who have adopted them—so has jazz been glocalized. Musicians around the world are increasingly finding jazz to be an open receptacle in which to assert their own cultural identities, just as American musicians did throughout the twentieth century. As French bass player Henri Texier put it: "I know I was influenced first by Afro-American jazz . . . and then I realized I *wasn't* black and I *wasn't* American, and then I started to integrate some elements from oriental music, from African music, from North African music. I still respect [American jazz] very much . . . but . . . in an instinctive way I started to play something different." Swedish pianist Bobo Stenson says about his trio's music: "We play in the language of American jazz but I guess we put other things into the music. We don't need to play the American way; we can leave that and come back to it. It allows you to take the music in new directions."[28]

Scandinavian Jazz: Dangerous Art

As glocalized jazz styles start to appear and prosper, the same process of pluralism that occurred in America in the 1980s and 1990s is now happening on a scale many hundreds of times greater around the world. To musicians around the globe, jazz is a form that has, to make a computer science analogy, an open source code, making it more like Linux than

Music Analysis

Track 54: "Evening Land"

(Garbarek/Boine) Jan Garbarek from the album *Visible World* recorded at the Rainbow Studio, Oslo, Norway June 1995 (12:31). Personnel: Jan Garbarek: soprano sax, keyboards, percussion; Mari Boine: vocals; Marilyn Mazur: percussion

Jan Garbarek is today easily the most widely recognized jazz musician in Scandinavia, if not all of Europe. Since his recording debut in the late 1960s, he has famously been a member of Keith Jarrett's Belonging Quartet in the 1970s and been a mainstay of ECM Records, both as a sideman and as the leader on at least thirty albums. *Visible Land*, from 1995, is one of Garbarek's most successful efforts in the sense that it essentially encapsulates the elements of his highly recognizable work: his soaring, edgy tone, effective use of silences in his improvisations, and contemplative compositions that emphasize folk-like melodies and world music sensibilities. "Evening Land," the albums final and most exploratory cut, is almost entirely Garbarek's work, with vocals provided by Norwegian Mari Boine and

additional percussion by Denmark-based Marilyn Mazur. "This is quiet, contemplative music for the most part—attractive, but not superficially pretty. Its grooves are less celebratory than melancholic. There's an intensity here borne of deep concentration and commitment to beauty." (ref: Chris Kelsey, *All Music Guide*)

0.00	4-note synthesizer riff opens track; soprano saxophonist Jan Garbarek and percussionist Marilyn Mazur soon enter with atmospheric fills
0.59	Rhythmic groove is set up
1.10	Vocalist Mari Boine enters
2.18	New rhythmic groove starts; synthesized strings enter with sustained notes as Garbarek continues adding atmospheric fills
3.40	Boine continues singing
4.55	Rhythm stops briefly; strings continue
5.22	Boine re-enters with wordless vocal
5.57	4-note synthesizer riff re-enters; track continues

Windows. Nicholson states that today, one can "go to Africa or Brazil and you will hear music that takes American jazz as its starting point, but is shaped, both consciously and unconsciously, by elements from local culture."[29] One of the most fertile areas for the growth of an independent, parallel jazz scene is Europe, which eagerly welcomed American jazz musicians as far back as the nineteen-teens and has enthusiastically supported touring and expatriate jazz musicians every since. Today, the European jazz scene encompasses many strains that range from those that are highly evocative of American jazz to those that are highly glocalized. Arguably the most important contemporary European jazz scene is in Scandinavia, where the majestic tranquility of open spaces and uninhabited natural beauty has produced an artistic culture of seeking a path of self-expression that seems well suited to jazz. "Nordic art is dangerous," states Danish artist Asger Jorn, describing the homeland of Norwegian painter Edvard Munch, Danish philosopher Soren Kierkegaard, and Swedish filmmaker Ingmar Bergman. "It compresses all its power *inside* ourselves." Norwegian bassist Arild Andersen adds that in Nordic jazz, "The sound is very important, the space in the music is very important," but perhaps what sets it apart most from American jazz is that it is "not how clever you can play your instrument, how fast you can play or how impressive you could be but how expressive you are."[30] One can certainly get a sense of this when listening to Andersen albums such as *Hyperborean* (2000) or *Karta* (2001) or the music of his fellow countrymen, pianists Tord Gustavsen and Bugge Wesseltoft.

Scandinavian jazz was first introduced to many around the world in the 1970s through the ECM albums of Keith Jarrett's "Belonging" quartet, which contained Norwegians Jan Garbarek and Jon Christiansen and Swede Palle Danielsson. Saxophonist **Jan Garbarek,** Europe's most famous jazz musician, has a style that exhibits influences from Americans John Coltrane and Albert Ayler, but also contains an element of calm and deep spirituality. "I can't say what extent growing up in Norway would influence you, but I imagine deep down it must have some influence."[31] One of Garbarek's most famous (of perhaps at least one hundred) albums is 1976's **Dis,** in which his haunting tenor and soprano saxophones create atmospheric environments that evoke images of the fjords and tundra of his native country. Another noteworthy Nordic jazz musician is Finnish drummer Edward Vesala, who has collaborated with Arild Andersen, Garbarek, and Polish jazz trumpeter Tomasz Stanko. Vesala's 1990 album *Ode to the Death of Jazz* is a denouncement of the state of 1980s American neocon jazz. On the liner

Norwegian saxophonist Jan Garbarek.

notes, he asks, "This empty echoing of old styles—I think it's tragic. If that is what the jazz tradition has become then what about the tradition of creativity, innovation, individuality, and personality?"

Future Jazz

The Challenges Ahead

Ask any jazz musician to describe the future of the music, and you will get responses as varied as the music itself. Jazz music sales are down, but sales are also down for the entire record industry. Online file sharing is forcing the music industry to slowly abandon the old brick-and-mortar model of putting a limited selection of physical product in stores for consumers to choose from. In an effort to reduce inventory, many record stores only stock the biggest sellers, so you can guess which category is often the first to go. As a result, jazz musicians have begun aggressively marketing their work in new and creative ways. "The record business is changing everyday," says guitarist Dave Stryker. "The Internet is changing everything. Young people have no concept of going to a record store to buy a CD. They just order off the Internet, or usually download it for free."

With many labels cutting back or eliminating their jazz catalog, many lesser-known musicians find that self-producing an album and promoting it online or at gigs is increasingly becoming a cost of doing business. Yet in spite of the withering away of record contracts, more jazz than ever is being recorded and made available on personal websites, MySpace, the iTunes Music Store, CD Baby, and other places.

Still, Stryker, who for many years was signed to SteepleChase and is currently with ZOHO, argues that the brick-and-mortar model continues to be necessary. "The Internet hasn't taken over completely yet. You still need to have your CD in stores and have the promotional push of being with a label."[32] While traditional labels with jazz divisions, such as Warner, Sony, and Blue Note, have obvious built-in advantages with their high visibility in record stores, what about the smaller, more progressive jazz/avant-garde labels such as John Zorn's Tzadik, Dave Douglas's Greenleaf, Thirsty Ear's Blue Series, and ZOHO? Although these labels have websites where music can be purchased in both CD and downloaded form, it's unlikely that their products will be found in suburban shopping mall stores. But the bottom line is that jazz musicians, especially those who are not highly-visible stars, are by necessity slowly taking control of their music, and that is a positive trend.

What about making a living as a working musician in the twenty-first century? As discussed in Chapter 8, the traditional jazz club is disappearing. Even in New York, where such mainstream clubs such as Visiones, Bradley's, and Sweet Basil's have closed in recent years, operating a jazz venue has become risky business, as people today have an ever increasing number of entertainment choices available to them. In some cases, however, the problem for clubs is not a lack of patrons but neighborhood gentrification. Such was the case of **Tonic,** the progressive New York performance space that was forced to close in April 2007. In recent years, the Lower East Side, the traditional home of the city's bohemian crowd, has undergone a "schmattes to hipsters to bulldozers to tourists"[33] transformation, where clubs and coffee shops are replaced by $400-per-night hotels. Tonic fell victim to this trend, but

Tonic Opened in 1998 by Melissa Caruso and John Scott at 107 Norfolk Street in New York, Tonic became one of the leading performance spaces for cutting-edge rock and jazz. Formerly a kosher winery, Caruso and Scott took over the space to expand the experimental music program they had been presenting at their nearby cyber café Alt Coffee. One of the club's first performers was John Zorn, whose two-month stretch of programming put it on the map in its first year. With many experimental musicians feeling that the Knitting Factory was becoming "too corporate" in the late 1990s, Tonic stepped in to fill the void. It closed on April 13, 2007.

didn't go out without a fight. On its final night, a music vigil, led by guitarist Marc Ribot, ended with Ribot's arrest after he refused to leave the club. One of Ribot's last songs, played with a wry sense of gallows humor as workers dismantled the sound system only a few feet away, was a solo guitar rendition of Hank Williams's "Cold, Cold Heart."

On a more positive note, in May 2006 the city saw the reopening of the legendary Minton's Playhouse in Harlem as a nightclub and museum. Other jazz clubs operating in New York are the Village Vanguard, the celebrated basement club that opened in 1935; Small's, the aptly named sixty-seat club operating in the same location and once occupied by the folk watering hole Café Wha? in the 1960s; and the Jazz Standard, a relatively new spot on East 27th Street. Recently, the jazz scene in Brooklyn has also revitalized with clubs like Barbés and Issue Project Room opening. Two notable Manhattan clubs that are carrying the torch for cutting edge jazz and improvised music are John Zorn's **The Stone** (Chapter 8) and **55 Bar** in the West Village.

Old School/New School

But the reality of making a living playing jazz in New York is "not a pretty picture," according to Michael Blanco, a talented young bassist who moved to the city in 2000 from San Diego. "There is a joke floating around jazz circles that pay for jazz musicians is like pi in mathematics . . . it remains constant (at $50/gig) while everything around it changes!" He adds that much of the problem is due to the law of supply and demand. "There are so many accomplished jazz musicians on every instrument in the city, and new ones arriving all the time who are hungry to play." Blanco supplements his income by working in pit orchestras on Broadway, an economic trade-off that, while necessary, has its bright side. "The money I make in the commercial music world can be used to fund my creative jazz projects. My album *In the Morning* was initially self-financed before it got picked up by Fresh Sound Records."[34] While Blanco has worked relentlessly to establish himself in the city, that process is itself undergoing changes as "old school" bandleaders such as Miles Davis, Horace Silver, and Art Blakey retire or are no longer with us. "Unfortunately, we have lost many of the older bandleaders that hired young players where you could learn on the gig from them," says Stryker, who cut his teeth playing with Brother Jack McDuff and Stanley Turrentine. "McDuff would have a band (sax, guitar, drums, and maybe a singer), and you would have a book and do a tight set that was arranged and kicked ass. We would go on the road and play little clubs, mostly in black neighborhoods across the country, and when we weren't on the road we would play 3–4 nights a week at Dude's Lounge on 146th and St. Nicholas in Harlem."

Today, many younger players who come to New York learn the ins and outs of playing jazz by studying at local colleges and universities such as The New School, Manhattan School of Music, William Paterson, and Rutgers. But the disappearance of the trial by fire "old school" apprenticeship is a loss for today's young players, according to Stryker. "You can't really learn some things in school, you have to experience life and pay your dues. It's not for the faint of heart . . . you need to just experience the scene, hang out, meet people, play as many sessions as you can, get a day gig, and live life."

Jazz education today has its detractors, despite having an enormously successful track record of building skill levels across the board and demystifying the process of learning how to play the music. Critics

complain that the foundation of jazz pedagogy, a bebop-based common language that is taught in assembly-line fashion, shortens the process but also encourages homogenization and conformity. Creativity and self-expression suffer as study is increasingly focused on technical skills. "The standard of playing among so many young musicians today is remarkably high," states drummer and educator John Marshall. But by teaching rules of what to do and what not to do, "idiosyncrasies get ironed out, or not valued, or get lost in a mish-mash of bland, but well played stuff."[35] Rather than going to classes and playing in well-supervised school ensembles, Stan Getz and John Coltrane, to name but two examples, arrived at their highly individualistic—and today widely copied—styles by trial and error in the practice room and on the bandstand. The problems of homogenization and conformity, the result of a system that focuses on building technical skills at the expense of creativity, and so on, are the great challenges facing jazz education today. However, there are promising signs emerging that some educators are beginning to address these issues.

Beyond the Big Apple/The Promise of the Future

Some musicians have circumvented the problem of making a living in New York by simply leaving the city and establishing roots elsewhere. Wayne Horvitz moved to Seattle in 1988 with his wife, singer Robin Holcomb, and their young daughter. Horvitz established himself as a major player in the downtown Knitting Factory scene in the late 1980s as a member of John Zorn's Naked City and with his own projects. "I moved to Seattle for a number of reasons: family, 'get out of Dodge', the chance to have more space, and [because] I have always loved the Northwest." Horvitz has thrived in his new environment and says, "The music scene here is exactly the same as NYC; sometimes it is very happening and sometimes it has low points. Musicians come and go, venues come and go, etc. The only real difference I can see is how the outside world perceives it."[36] Of course, the case could be made (and was earlier in this chapter) that New York is no longer the center of the jazz universe. As the world flattens out, thriving scenes exist in several cities in America and Europe today, with opportunities for accomplished jazz musicians to find work performing and recording. Even Asian cities such as Tokyo and Seoul, South Korea can claim prospering scenes. In Seoul, where American jazz drummer and educator Chris Varga has been rooted since the 1990s, the scene exploded after a mid-1990s Korean TV program became popular in which the main character was a jazz musician. "There are many places to play now, some of them actually resembling an 'American' style jazz club," Varga notes. Echoing Blanco and Stryker, he adds, "And there are many, many fine musicians." Although Varga laments that there is "no sense of history/tradition . . . no foundation," and that "everything is derivative," he also says, "it's starting to improve, but *very* slowly." According to Varga, one of the reasons for the improvement is—ironically—that "there are more and more people studying in the states"[37] at American universities that offer jazz programs.

All of this brings up the question of what role jazz should play in the culture of its birth country, and if it is no longer self-supporting, then how should it be funded and by whom? Since its very early years, jazz has contributed to America's cultural diversity, and has historically been a symbol to the rest of the world of American ideals, culture, and freedom. The federal government once thought so: in the 1950s and 1960s, the State Department sponsored highly successful international tours by jazz musicians that were used as a diplomatic tool during the Cold War. Back then, jazz represented the richness of the fabric of life in America—of freedom itself. But in the "read my lips—no new taxes" conservative environment that is currently so pervasive it's hard to imagine federal funds being used to support jazz. Recent attempts to downsize government programs thought to be superfluous, such as the National Endownment for the Arts, and eliminate funding for National Public Radio and the Public Broadcasting System, are illustrative of the mood in Washington DC today.

Conversely, state sponsorship for jazz clubs, festivals, recordings, and other ventures is common in many European countries, which in the post-WWII years, began to realize that the music contributed to their culture, and interestingly national identity. Listen to Ferdinand Dorsman, the head of the Department of International Cultural Policy of the Dutch Ministry of Foreign Affairs: "The sort of things people associate with the Dutch are liberty, tolerance, a certain playfulness, not liking everything within set limits or following the rules, and I think jazz is a very good example of this image."[38] Substitute "America" for "the Dutch" and you can perhaps see how the tables have turned, creating the interesting paradox that exists in the way jazz is perceived today both at home and abroad.

Jazz as an art form may be left to figure out its own path to survival. In spite of long odds, its vital signs are good. It's clear that creativity is up—way up. The diversity and originality of improvised music today is astonishing. As this text illustrates, the umbrella of contemporary jazz is big and getting bigger. Today there is mainstream Neocon jazz, big band jazz, avant-garde, Miles tribute bands—you name it, it all co-exists in today's world. And young musicians today, entering into a career in jazz with an increasingly clear understanding that fame and fortune will probably not materialize, are nonetheless committed to their art. Bassist Michael Blanco is exemplar, and could be talking about himself when he states, "There are so many accomplished young jazz musicians who are passionate about the art form. These musicians will define the future of jazz, and hopefully find ways to translate their experiences living in contemporary society into improvised music that resonates with current and future generations."

Notes

1. Nisenson, Eric: *Blue: The Murder of Jazz,* pg 220
2. Lees, Gene: *Cats of Any Color,* pg 246
3. Davis, Francis: *Bebop and Nothingness: Jazz and Pop at the End of the Century,* pg xi
4. Ibid, pg xi
5. Nisenson, pg 1
6. McCombe, John P.: Extend Jazz: Jazz Historiography and the Persistence of the Resurrection Myth, from Genre XXXVI, pg 86
7. Ward, Geoffrey and Burns, Ken: *Jazz: A History of America's Music,* pg 459
8. Hajdu, David: "Wynton's Blues," *The Atlantic Monthly,* March 2003
9. Nicholson, Stuart: *Is Jazz Dead? Or Has It Moved To a New Address,* pg 72
10. Khan, Marty: *Straight Ahead: A Comprehensive Guide to the Business of Jazz*
11. Ward, Eric: "The Bad Plus: Give and Take," *Glide Magazine,* 3/23/04
12. Ibid
13. Olson, Paul: "Ben Monder: Surprise from Cohesion," *All About Jazz,* 2/6/06
14. Adler, David: "Kurt Rosenwinkel: Emerging Brilliance," *All About Jazz,* 5/16/06
15. From liner notes to *The Next Step*
16. Scheer, Jennifer: "Dave Stryker: The Interview," *Jazz Review,* 2/05
17. Nicholson, pg 87
18. Ibid, pg 78
19. Spencer, Neil: "Keeping up with Jones," *The Observer,* 1/18/04
20. Giddins, Gary: "Spelunking and Crooning in 2001," *The Village Voice,* 1/16/01
21. Nicholson, pg 129
22. Ibid, pg 130
23. Ibid, pg 141
24. Cox, Christoph and Warner, Daniel: *Audio Culture: Readings in Modern Music*
25. "Turntablism to Be Taught at Berklee College of Music," synthtopia.com, 3/1/04
26. Nicholson, pg 138
27. Ibid, pg 144
28. Ibid, both quotes, pg 175 and 179
29. Ibid, pg 194
30. Ibid, pg 198
31. Ibid, pg 207
32. All quotes from email correspondences with Dave Stryker
33. Salkin, Allen: "Lower East Side is Under a Groove," *New York Times,* January 3, 2007
34. All quotes from email correspondences with Michael Blanco
35. Nicholson, pg. 101
36. All quotes from email correspondences with Wayne Horvitz
37. All quotes from email correspondences with Chris Varga
38. Nicholson, pg. 230

Study Questions for Chapter 9

1. Describe the state of jazz at the turn of the century and why some observers were proclaiming that it was dead.

2. Explain why expectations about *Jazz: A Film by Ken Burns* were so high, and why it ultimately generated so much controversy.

3. Discuss the positive and negative aspects of the success of Jazz at Lincoln Center and the opening of the Frederick P. Rose Hall.

4. Name one unique musical achievement or interesting aspect from each: The Bad Plus, Vijay Iyer, and Jason Moran.

5. Both Kurt Rosenwinkel and Ben Monder make prominent use of the human voice in their recordings. Describe both.

6. Why are more and more women making major contributions to jazz today? Give some examples.

7. What is the "Norah effect," and what impact is it having on jazz?

8. Describe some of the characteristics of Kurt Elling's style. What is unusual about his background, and how has it manifest itself in his music?

9. What are some of the ways in which technology is changing the way jazz is conceived, performed, and recorded in the twenty-first century?

10. Explain the term *glocalization* and how it relates to jazz in the international scene today.

Performance

Review Sheet

Remember to:

1. Staple or stamp proof of attendance onto this sheet.
2. Turn it in within one week of the performance date.
3. Make sure that your name and student ID number are printed neatly.

Name: _____

Student ID #: _____

Section #: _____

Circle one: This is Jazz Review: 1 2 3 4 5

Date of Performance:

Location of Performance:

Name of Group/Performer:

Instruments used:

Name some of the songs/pieces that were performed:

Name some of the musical techniques that were used:

What was your overall impression of the performance? Write a brief summary or description.

© Kendall/Hunt Publishing Company

Performance

Review Sheet

Remember to:

1. Staple or stamp proof of attendance onto this sheet.
2. Turn it in within one week of the performance date.
3. Make sure that your name and student ID number are printed neatly.

Name: _____

Student ID #: _____

Section #: _____

Circle one: This is Jazz Review: 1 2 3 4 5

Date of Performance:

Location of Performance:

Name of Group/Performer:

Instruments used:

Name some of the songs/pieces that were performed:

Name some of the musical techniques that were used:

What was your overall impression of the performance? Write a brief summary or description.

© Kendall/Hunt Publishing Company

Name _____ Date _____

Performance

Review Sheet

Remember to:

1. Staple or stamp proof of attendance onto this sheet.
2. Turn it in within one week of the performance date.
3. Make sure that your name and student ID number are printed neatly.

Name: _____

Student ID #: _____

Section #: _____

Circle one: This is Jazz Review: 1 2 3 4 5

Date of Performance:

Location of Performance:

Name of Group/Performer:

Instruments used:

Name some of the songs/pieces that were performed:

Name some of the musical techniques that were used:

What was your overall impression of the performance? Write a brief summary or description.

Performance

Review Sheet

Remember to:

1. Staple or stamp proof of attendance onto this sheet.
2. Turn it in within one week of the performance date.
3. Make sure that your name and student ID number are printed neatly.

Name: _____

Student ID #: _____

Section #: _____

Circle one: This is Jazz Review: 1 2 3 4 5

Date of Performance:

Location of Performance:

Name of Group/Performer:

Instruments used:

Name some of the songs/pieces that were performed:

Name some of the musical techniques that were used:

What was your overall impression of the performance? Write a brief summary or description.

© Kendall/Hunt Publishing Company

Performance

Review Sheet

Remember to:

1. Staple or stamp proof of attendance onto this sheet.
2. Turn it in within one week of the performance date.
3. Make sure that your name and student ID number are printed neatly.

Name: _____

Student ID #: _____

Section #: _____

Circle one: This is Jazz Review: 1 2 3 4 5

Date of Performance:

Location of Performance:

Name of Group/Performer:

Instruments used:

Name some of the songs/pieces that were performed:

Name some of the musical techniques that were used:

What was your overall impression of the performance? Write a brief summary or description.

© Kendall/Hunt Publishing Company

Appendix A

Understanding and Defining Jazz

Jazz is America's art form. It is as much a part of our cultural heritage as baseball and our Constitution. It was created and continues to be shaped, like America itself, by risk takers and rule breakers, men and women who put everything on the line for the sake of their art. Jazz is an art form of individual expression, but unlike many art forms, it is spontaneous. What is created now will be recreated differently later. It is an art of human interaction and, like democracy, the individual is free to express himself, as long as the responsibilities to the group are maintained. Jazz is a celebration of the American spirit, and a reflection of our changing culture. To study jazz is to study twentieth century America. Jazz, however, is sometimes hard to grasp by the casual listener, so the study of jazz should take a look at how it is defined and how it is performed to develop a deeper understanding of the music. This appendix will assist you in understanding what jazz is and how it is typically performed, and provide the definitions of some commonly used terms.

Understanding Jazz

The Origins

Jazz is American music that was created out of the social conditions present in the southern United States, where musicians first began synthesizing the oral traditions of African music and the literal traditions of Western European music. The South contained the largest concentration of Americans of African ancestry (as a result of the institution of slavery), who around 1900 began the process of creating a new kind of music out of the resources they had available to them. These resources included the music styles with which they were familiar and could play, the instruments that were readily available, and the political and cultural situations that dictated where and with whom they could play. The incubation period for the creation of jazz goes back to the very beginnings of slavery in the early 1600s. It was only after nearly 300 years of the two musical traditions—African and European—coming in contact with each other that the birth of jazz took place. It is important to remember that it was nineteenth century African-Americans who were motivated for various reasons to incorporate elements of European music into their own musical tradition. This is why jazz was born in New Orleans and other cities in the South, not in the northern states.

Defining Jazz

Jazz, especially today, is difficult to define. Because it is performed in so many styles and its influence can be heard in so many other types of music, it is nearly impossible to come up with a set of hard and fast

rules. Instead, to define jazz, it is helpful to think of a set of loose guidelines that are followed to one degree or another during the course of a jazz performance. Here are five basic guidelines:

1. **Improvisation:** Improvisation is defined as the act of simultaneously composing and performing. It is an essential element in the performance of most, but not all jazz. For instance, most of what you hear when you listen to a jazz big band is written down and *not* improvised. Generally speaking, jazz is an art form of individual expression, and most jazz contains a great deal of improvisation. When you listen to a small jazz group, you can usually tell which member of the group is improvising a solo. It is, however, important to remember that the other members of the group are also improvising within the framework of their responsibilities to the group sound.

2. **Rhythm:** Jazz rhythm is usually defined in terms of swing rhythm and syncopation. These two elements, like improvisation, are sometimes used only minimally or not at all in a jazz performance (for instance, Latin or rock-influenced jazz does not usually swing). **Swing rhythm** is best described by a loosening of the rigid adherence to the beat of the music, which is accomplished by slightly delaying the notes played between beats, creating a momentary tension that is resolved on the next beat. When this rhythmic momentum drives a piece of music, the music is said to "swing." If you can tap your foot or snap your fingers to it, you are most likely listening to swing. **Syncopation** is rhythmically placing or accenting notes away from the beat and in unexpected places. It is almost always present in any jazz performance.

3. **Dissonance:** Jazz musicians are continually "pushing the envelope" to incorporate non-harmonious, dissonant tonalities into their music. Jazz dissonance can be subtle and barely noticeable, or sometimes very pronounced, which can make the music difficult to listen to. Like swing rhythm, dissonance creates tension for the listener. An experienced jazz musician will use tension and its eventual resolution often in a jazz performance to give the listener a sense that the music has forward motion.

4. **Jazz Interpretation:** Jazz interpretation is best described as the unique way that jazz musicians produce sound. For instance, jazz saxophonists often slur or bend notes when playing a melody. Trumpeters might put a plunger mute on their horn to create a wah-wah effect. A pianist might "crush" two notes together to create a bent note effect. Although these ways of changing sound production are frowned upon in much of European influenced music (for instance, classical or church music), they are a vital part of most jazz performances.

5. **Interaction:** Although jazz can be performed by a single musician, it is usually performed by several in an ensemble of some sort. Although it is true that any musical group requires the musicians to carefully listen to each other to stay together and to keep the music focused, it is especially important in a jazz performance. Because the musicians are usually all improvising to some degree, communication must be open and honest. A jazz quartet is no different than a panel discussion with four speakers: the conversation must be interactive, with each participant responding in turn to something another said. In a jazz performance, if one musician is soloing, he is still interacting with the other musicians in the group.

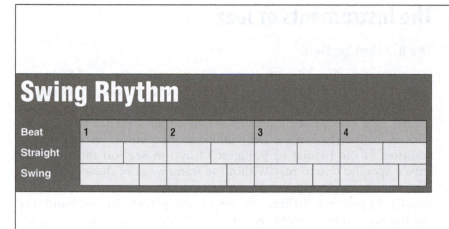

Swing Rhythm

Beat	1		2		3		4	
Straight								
Swing								

Swing rhythm differs from "straight" rhythm in the placement of the notes that fall between the beats (which in music terminology are called eighth notes). In straight rhythm, which is typically found in rock, classical, and other music styles, those notes fall exactly halfway between the beats. In swing rhythm, which today is common not only in jazz but the blues, hip-hop, country, rock, and other styles, the notes between the beats are delayed slightly, creating a momentary tension that is resolved at the next beat.

The Jazz Soloist

The highest form of individual expression in a jazz performance is the improvised solo. In modern jazz, only one musician solos at a time. The other members of the group either "lay out" (stop playing), or continue playing in a role supportive to the soloist. Because the soloist is composing on the spot while performing, his or her technical skills on the instrument must be developed to a high level of proficiency. The soloist must also have "good ears"—in other words, be able to conceptualize melodies in his or her head before actually playing them, and be able to interact and respond to support and input from other musicians in the ensemble.

Unlike other types of music, jazz musicians are essentially free to develop their own sound that they are identified with during a solo. In fact, creating a unique musical personality is a must for a jazz musician. One way a player can accomplish this is by the choice of which notes to play when improvising. For instance, Dizzy Gillespie, a trumpeter who came into prominence in the 1940s, loved to play notes in the very highest register of the horn, which is one way we can identify his style. Miles Davis, on the other hand, often played very low notes, and far fewer of them than Dizzy. Another way players, especially saxophonists, develop their own sound is by the tonal quality of their instrument. Stan Getz, a tenor saxophonist who became famous in the 1960s, played with a very light and pretty tone that sounded very romantic. John Coltrane, another tenor player from the same era, had a tone that could hardly be described as pretty—harsh and penetrating are better descriptions. Jazz musicians can also use syncopation and rhythmic variety, as well as varying amounts of dissonance in their solos to create their own sound.

Because most jazz uses established rules of melody, harmony, and rhythm—the three essential elements of music—a soloist must have a thorough understanding of those principles. A soloist must also know the jazz repertoire, the songs, and compositions that are most often played in a jazz performance (i.e., jazz standards).

The Instruments of Jazz

The Rhythm Section

Jazz can be performed with just about any type of ensemble, from a solo clarinet to a seventeen-piece big band. However, most jazz ensembles generally have a rhythm section whose members usually consist of a bass player, a drummer, and either a pianist or guitarist. (Occasionally a rhythm section will use a vibraphonist instead of or in addition to the pianist or guitarist.) Rhythm section musicians all have a specific role to play. Within the framework of those roles, they also have a tremendous amount of freedom as to what they play exactly. In general, if there are also horn players in the band, the rhythm section instruments are always playing, even as the horn players take turns soloing. If a trumpet player is soloing, the role of the rhythm section players is to provide interactive support for that solo. While they are playing supporting roles to the soloist (as described below), the rhythm section players are also improvising, but in a different and much more limited way. Rhythm section players also can take turns soloing, so their roles will change at those times. The basic duties of each of the rhythm section instruments are outlined below:

- **Piano** (or guitar): The pianist or guitarist plays the chords that accompany the melody of the song, usually in a syncopated and interactive manner that is called comping (short for accompanying). The pianist or guitarist often spontaneously "feeds" the soloist rhythmic or melodic ideas with his comping as well. How he structures those chords and the rhythm he uses is up to him. When it is the pianist's turn to solo, often he will comp with the left hand while soloing with the right hand.
- **Bass:** The bassist might be the most important member of the rhythm section (just ask any bass player) because it is his job to provide a foundation for the chords and to keep a steady beat. In swing rhythm, bass players usually play what is called walking bass—the playing of a note on every beat that outlines the chord in some way. Because the walking bass line is improvised, bassists are free to also spontaneously interact with rhythmic or harmonic ideas from the other musicians.
- **Drums:** The modern drum set is a set of instruments put together in such a way that the performer can play with both his hands and both feet. A typical drum set consists of a bass drum, a high-hat cymbal, a snare drum, one or more "rack" tom-toms (mounted on a metal rack above the bass drum), a floor tom, and at least one ride cymbal and one crash cymbal. In jazz, drummers help keep the beat (or "keep time") by playing the swing rhythm on either the high-hat or the ride cymbal with their right hand. Because drummers often use the ride cymbal to play swing rhythm, it is often called "ride rhythm." The left hand and both feet are used to provide improvised, syncopated accents on the various drums and cymbals. When a drummer plays a spontaneous, syncopated accent on the bass drum to add energy to the performance, it is called "dropping bombs."

Commonly Used Wind Instruments

The most commonly used wind instruments in jazz today are the saxophone and the trumpet. Four different saxophones are used, ranging from the highest pitched soprano, to the slightly lower alto, to the even lower tenor, down to the very low baritone. (Rule of thumb: The bigger the saxophone, the lower its pitch.) The tenor and alto are the most commonly used, with the baritone most commonly found only in a big band. The trumpet is actually one of a family that includes the flugelhorn, which has a larger bell and wider tubing, and the cornet, a more compact version of the instrument. The first jazz trumpeters played the cornet, which went out of style in the 1920s and is rarely used today. The flugelhorn produces a warmer and mellower tone than the trumpet, and is used most often on ballads or more intimate music. Trumpets and trombones often employ various mutes to color the sound, giving these instruments a greater variety of tonal shadings. Among those used are the cup, straight, plunger, and the Harmon. Another instrument related to the trumpet and a fellow member of the brass family is the trombone. Trombones use a slide and the player's embouchure (the adjustment of the lips, tongue, and mouth muscles on the mouthpiece) to vary the pitch. It is a difficult instrument on which to play jazz, but it offers a degree of flexibility in pitch that other wind instruments cannot match.

Flutes and clarinets are also common in jazz, although they are most often found in big bands. Flutes, clarinets, bass clarinets, and soprano saxophones are often used as doubling instruments, which saxophone players might be called on to play for a specific part on a recording or an arrangement or as a secondary instrument. Other conventional acoustic instruments that are less commonly used in jazz are the violin, harmonica, banjo, and tuba.

Electronic Instruments

Since the 1930s, electronic instruments have found their way into jazz. The first was the electric guitar, followed in the 1950s by the electronic organ and electric bass guitar. These instruments are ubiquitous in jazz today. Since the 1970s, when many jazz musicians began experimenting with rock rhythms and instruments, synthesizers have also played an increasingly large role in jazz performance. When the MIDI (musical instrument digital interface) protocol was agreed upon by musical instrument manufacturers in 1983, the way was cleared for the creation of keyboards, digital samplers, drum machines, and other digital instruments that could "talk" to each other and interconnect with computers. When a MIDI controller, such as a keyboard or drum pad is played, it sends out a digital signal containing such information as what note was played, how hard it was struck, and so on. This information can be recorded on computer sequencing software, where it can be edited in powerful ways and played back on any other MIDI instrument. Today, musicians using MIDI technology are literally redefining jazz with the use of laptop computers in performances and software to edit and reconstruct performances in the studio after they have been recorded. MIDI controllers are also made for guitar players and wind players, allowing them to take advantage of this technology.

Melody, Harmony, Rhythm, and Form

Melody, Harmony, and Rhythm

To understand jazz, it helps to have a basic understanding of how music is put together. The three basic elements of music are melody, harmony, and rhythm. A brief discussion of them follows.

- **Melody:** Most everyone knows what a melody is—simply, a succession of notes that are played or sung in a specific order and rhythm. Sometimes melodies are referred to as tunes, although usually in jazz the word tune refers to the entire composition.
- **Harmony:** Nearly every piece of music has harmony, or a set of chords (or the implication of chords) that accompany the melody. Chords are defined as three or more notes played simultaneously, and they, like melody notes, are played sequentially in a specific order called a "chord progression." (Chord progressions are called "changes" in jazz.) Melodies are usually written with a specific chord progression in mind that will always accompany it.
- **Rhythm:** The relationship of notes and sound with time. Rhythm is what gives music forward motion. Usually rhythm is measured in beats. Some notes last for one beat, whereas others may last for several beats or even fractions of beats. Beats (or pulses) are organized into a unit called a measure, or bar. Most music has four beats to a bar, but it is not uncommon to find music that has two or three beats to a bar (for example, "Happy Birthday" has three beats to the bar).

Form

Most music is organized into a basic structure or form. A simple form would be one time through the melody and chord progression. A good example would be to think of singing the first verse of "Silent Night." With three beats to each bar, it takes twenty-four bars to get through the verse; so it is said to have a twenty-four bar form. Some music has very complex forms, like a Beethoven symphony or a Frank Zappa composition; however, most jazz performances are very simple in concept and easy to explain.

Usually a jazz performance consists simply of the form (chord progression or verse) of the tune, whether it is twelve, twenty-four, or thirty-two bars (or whatever) in length, played over and over. Each statement of the form is called a "chorus." Almost always, in the first chorus, the melody is played. This is called "the head." When the head is finished, the musicians start over at the beginning of the chord progression and play another chorus (think of moving on to the second verse of "Silent Night"), but this time, one of the performers creates an improvised solo using notes selected from the chords of the chord progression as it advances. The soloist is free to solo over as many choruses as he chooses. When he is done, other solos are improvised in the same fashion until the head is played one more time to finish the song. This format of head-solos-head is called the "Jazz Performance Form." A chart of a typical jazz performance might look something like this:

Chorus 1	Chorus 2	Chorus 3	Chorus 4	Chorus 5	Chorus 6
Head	First solo	First solo continues	Second solo	Second solo continues	Head

Some Commonly Used Jazz Terms

Although there are definitions of words and phrases throughout this book, following are a few terms that are commonly used to describe jazz performance.

Melody

- **Riff:** A short melodic phrase or melody. Some jazz tunes are nothing more than simple riffs repeated several times. A riff may also describe a short phrase in an improvised solo. Also sometimes called a line, lick, phrase, or motif.
- **Phrasing:** The combining of melodies with silence, or rests. Think of human speech. When someone talks, each sentence or expression is followed by a pause of some sort. Some people talk rapidly with few pauses; others talk slowly with many pauses. Phrasing in jazz improvisation works in the same fashion.
- **Embellishment/Ornamentation:** Simply, the improvised decoration or "jazzing up" of a melody, whether in the head or in a solo.
- **Hot/Cool:** Terms used to describe an improvised solo or an individual performer's style of improvising. A hot soloist tends to add a lot of drama to his solo by playing lots of notes, playing high in the instruments range, or using interesting rhythmic effects, etc. A cool soloist plays in a more laid-back and relaxed style.
- **Lyrical:** A melody that is very singable or melodic. Cool soloists tend to play more lyrically than hot soloists.

Rhythm

- **Pulse:** The fundamental beat driving the music that creates the tempo.
- **Tempo:** The speed of the music. Fast music is said to have a fast tempo; slow music has a slow tempo.
- **Bar/Measure:** Repeated groupings into which beats are organized. Most music in Western culture has four beats to the measure, although some have two, three, or even five, six, or seven. "Someday My Prince Will Come," for example, has three beats to each bar.
- **Downbeat:** Beat one of each measure.
- **Backbeat:** Beats two and four of each measure. The backbeats are usually accented in swing rhythm.
- **Syncopation:** Placing notes or accents off the beat or in unexpected places.
- **Polyrhythm:** Using two or more rhythms simultaneously.

Harmony

- **Chord:** The fundamental building block of harmony created when three or more notes are played simultaneously.
- **Chord Progression:** The sequential order of the chords of a tune. In the jazz world, the word *changes* refers to the chord progression of a song.

- **Chord Symbols:** Notational representations of chords, or a kind of shorthand used to quickly communicate the harmonic content of a chord.
- **Lead Sheet:** A notated roadmap of a tune using only the melody and chord symbols. Lead sheets give only the most basic information to allow the performers maximum leeway in the performance of a tune.
- **Fake Book:** A book made up of tunes in lead sheet form.

Some Other Jazz Terms

- **Jazz Standard:** A jazz or pop tune that is widely known by jazz musicians and often played. "Someday My Prince Will Come" is a good example of a jazz standard.
- **Gig:** A jazz performance.
- **Call and Response:** A melodic phrase played or sung by one performer that is answered by the rest of the group.
- **Trading Fours:** The technique of exchanging four bar solos, often between a soloist and a drummer. In a performance, trading fours most often occurs (if at all) near the end of a tune, before the head is restated.
- **Double Time:** In an improvised solo, the technique of playing rhythmically twice as fast as the established tempo.

Appendix B

A Timeline of Events

Chapter 1

1938	Minton's Playhouse opens at 210 West 118th Street in Harlem
December 1939	Charlie Parker has his "breakthrough" playing "Cherokee" with guitarist Biddy Fleet at Dan Wahl's Chili House on Seventh Avenue between 139th and 140th in Harlem
1940	Teddy Hill hired at Minton's; Monday "Celebrity Night" jam sessions start
June 24, 1940	Charlie Parker and Dizzy Gillespie are believed to have met at a jam session in Kansas City
August 1, 1942	A recording ban called by the American Federation of Musicians goes into effect and lasts for nearly two years
November 1943	Dizzy Gillespie and bassist Oscar Pettiford lead a group at the Onyx that includes drummer Max Roach; it is the first bebop group to appear on 52nd Street
February 16, 1944	The first bebop recording session in NYC; band is listed as Coleman Hawkins and His Orchestra, and includes Hawkins, Dizzy Gillespie, bassist Oscar Pettiford and drummer Max Roach; Gillespie's "Woody'n You" is among the songs recorded
November 26, 1945	Charlie Parker's famous "Koko" recording session at the WOR Radio studios in NYC; band includes Dizzy Gillespie on trumpet and piano and Max Roach
July 29, 1946	Charlie Parker suffers breakdown in Los Angeles after an infamous recording session, is arrested and committed to the Camarillo State Hospital for six months
September 29, 1947	Dizzy Gillespie's big band premiers "Cubana Be, Cubana Bop" at Carnegie Hall; Chano Pozo is introduced to the world
Oct/Nov 1947	Thelonious Monk makes his first recordings as a leader for Blue Note
December 15, 1949	Birdland opens in New York with performances by Charlie Parker, Lester Young, Stan Getz and others broadcast live on radio
May 15, 1953	Massey Hall concert in Toronto featuring Charlie Parker, Dizzy Gillespie, Max Roach, Bud Powell and bassist Charles Mingus
March 12, 1955	Charlie Parker dies in the NYC apartment of Baroness Pannonica de Koenigswarter
June 1957	Thelonious Monk begins six-month engagement at the Five Spot in Greenwich Village

Chapter 2

September 1944	Miles Davis moves to NYC from his hometown of East St. Louis, Illinois
1948	The Stan Kenton Orchestra premiers *City of Glass* in Chicago

January 21, 1949	1st of three sessions by the Miles Davis Nonet; other sessions follow on April 22, 1949 and March 9, 1950; the songs are later released on the LP *Birth of the Cool*
May 1949	Howard Rumsey begins jam sessions at the Lighthouse in Hermosa Beach, CA
May 16, 1949	Lennie Tristano records "Intuition" and "Digression," widely regarded as the first free jazz recordings
1951	Lennie Tristano opens New School of Music, the first school dedicated to the study of jazz
1952	Modern Jazz Quartet forms
July 1952	Gerry Mulligan Quartet debuts at The Haig in LA
1953	Lennie Tristano records "Descent Into the Maelstrom" at his home studio, possibly the first jazz recording made using overdubbing
June 1954	The Newport Jazz Festival debuts in Newport, Rhode Island
January 19, 1957	Art Pepper records *Art Pepper Meets the Rhythm Section* with the Miles Davis Quintet rhythm section
1957	Gunther Schuller coins the term Third Stream during a lecture at Brandeis University; Lenox School of Jazz summer program opens in Lenox, Massachusetts, and operates through the 1960 season
June 25, 1959	The Dave Brubeck Quartet's first recording session for the album *Time Out*
1960	The film *Jazz on a Summer's Day* is released, featuring footage shot at the 1958 Newport Jazz Festival

Chapter 3

1939	Blue Note Records is founded
1952	Charles Mingus founds Debut Records and the Jazz Workshop
March 2, 1952	Rudy Van Gelder records for Blue Note for the first time; recording is made in his parent's home studio in Hackensack, NJ
April 1954	Clifford Brown-Max Roach Quintet makes first recording
May 17, 1954	*Brown v. Board of Education* ruling makes racial segregation in public schools unconstitutional
November 13, 1954	Jazz Messengers record first studio album, *Horace Silver and the Jazz Messengers*
July 17, 1955	Miles Davis's star making debut at Newport; his 1950s quintet debuts at Café Bohemia a few days later
January 30, 1956	Charles Mingus records "Pithecanthropus Erectus"
May 11, 1956	Miles Davis Quintet first session for the Prestige albums *Workin'*, *Steamin'*, *Cookin'* and *Relaxin'*; second session follows on October 26, 1956
June 22, 1956	Sonny Rollins records *Saxophone Colossus*
July 2, 1956	First recording session of the Horace Silver Quintet; songs from this and sessions on July 17 and 18 are released on the album *Silver's Blue*

February 12, 1957	First recording session for Charles Mingus' *The Clown*; second session, which includes the first studio recording of "Haitian Fight Song" follows on March 13
July 26, 1956	Clifford Brown dies in an auto accident on the Pennsylvania Turnpike
March 2, 1959	First recording session for Miles Davis's LP *Kind of Blue*; second session follows on April 22, 1959
May 4, 1959	John Coltrane records *Giant Steps*
May 5, 1959	First recording session for Charles Mingus' *Mingus Ah Um*; second session follows on May 12, 1959
July 20, 1959	Rudy Van Gelder records for Blue Note for the first time at his new studio in Englewood Cliffs, NJ
June 30-July 3, 1960	The Cliff Walk Manor 'anti' festival at Newport, Rhode Island
August 31, 1960	First recording session for the Max Roach/Oscar Brown, Jr. album *We Insist! The Freedom Now Suite*; second session follows on September 6, 1960
October 12, 1962	Charles Mingus's Town Hall Concert
January 20, 1963	Charles Mingus records *Black Saint and the Sinner Lady*

Chapter 4

February 10, 1958	First of three recording sessions for the Ornette Coleman debut album *The Music of Ornette Coleman - Something Else!!!!* in Los Angeles for Contemporary Records
May 22, 1959	The Ornette Coleman Quartet records *The Shape of Jazz to Come*; it is the first recording to feature the personnel that would appear at the Five Spot later that year
November 17, 1959	The Ornette Coleman Quartet debuts at the Five Spot Café in Greenwich Village
Spring 1960	John Coltrane Quartet debuts at the Jazz Gallery
October 21, 1960	First of two recording sessions for John Coltrane's *My Favorite Things*
December 21, 1960	Ornette Coleman records *Free Jazz: A Collective Improvisation*; Eric Dolphy records *Far Cry*
December 21, 1962	Ornette Coleman's Town Hall Concert
February 25, 1964	Eric Dolphy records *Out to Lunch*
July 10, 1964	Albert Ayler records *Spiritual Unity*
July 29, 1964	Eric Dolphy dies in Berlin
October 1-4, 1964	The October Revolution in Jazz is staged at the Cellar Café in New York
December 9, 1964	The John Coltrane Quartet records the album *A Love Supreme*
June 18, 1965	John Coltrane records the album *Ascension*
May 19, 1966	Cecil Taylor records *Unit Structures*
April 23, 1967	John Coltrane's last performance at the African Arts Center in Harlem
July 17, 1967	John Coltrane dies in New York City
November 5, 1970	Albert Ayler disappears; his body is found in the East River 20 days later

Chapter 5

June 1955	Cannonball Adderley sits in at the Café Bohemia, his first New York appearance; within a month he makes his album debut with *Introducing Cannonball Adderley* on Savoy
January 1956	Jimmy Smith Trio makes its New York City debut at Smalls Paradise in Harlem
September 18, 1956	First recording session for Bill Evans's debut album *New Jazz Conceptions*; second session follows on September 27
June 25, 1961	Bill Evans Trio records *Sunday at the Village Vanguard* and *Waltz For Debby* at the Village Vanguard; Scott LaFaro dies 11 days later
January 30, 1962	First of three sessions for Sonny Rollins's album *The Bridge*
February 13, 1962	Stan Getz records *Jazz Samba*
March 18-19, 1963	Stan Getz records *Getz/Gilberto*
February 12, 1964	Miles Davis in concert at Philharmonic Hall, NYC is recorded, yielding the albums *Four and More* and *My Funny Valentine*
May 9, 1964	Louis Armstrong's "Hello Dolly" becomes the #1 rated song on the *Billboard* charts
January 20-22, 1965	Miles Davis records *E.S.P.*, the first studio album with the "60s" quintet
June 1955	Wes Montgomery records *Smokin' at the Half Note*
1967	Creed Taylor founds CTI Records
January 28, 1967	Cannonball Adderley's "Mercy, Mercy, Mercy" debuts in the Top 40 and stays for 8 weeks, peaking at #11
1969	Manfred Eicher founds ECM Records in Munich, Germany
March 20, 1973	Keith Jarrett concert in Lausanne, Switzerland recorded for *Solo Concerts Bremen/Lausanne*; a second concert in Bremen, West Germany is recorded for the album on July 12, 1973
April 24-25, 1974	Keith Jarrett records *Belonging* with his European 'Belonging' Quartet
December 11-12,1976	Dexter Gordon records *Homecoming* at the Village Vanguard in New York

Chapter 6

June 1, 1967	The Beatles release *Sgt. Pepper's Lonely Hearts Club Band*, a cultural milestone for the 1960s youth culture; the Monterey International Pop Festival opens 15 days later
1969	Tony Williams Lifetime founded; their debut album *Emergency!* is recorded
February 18, 1969	Miles Davis records the album *In a Silent Way*
August 19-21, 1969	Miles Davis records the album *Bitches Brew*
1970	Herbie Hancock records the album *Mwandishi*
1971	Weather Report founded
July 1971	The Mahavishnu Orchestra debuts at the Gaslight Café in Greenwich Village

August 1971	The Mahavishnu Orchestra releases it debut album, *The Inner Mounting Flame*
1972	Return to Forever founded
October 13, 1973	Herbie Hancock releases the album *Head Hunters*
1977	Weather Report records the album *Heavy Weather*

Chapter 7

1975	Pat Metheny records his debut album *Bright Size Life*; Brecker Brothers formed; Ornette Coleman's Prime Time releases the album *Dancing in Your Head*
1976	Albert Murray publishes *Stomping the Blues*; VSOP Quintet tours; the World Saxophone Quartet is founded
November 4, 1980	Ronald Reagan elected President
1978	The Pat Metheny Group is founded
1979	Steps (later known as Steps Ahead) is founded
1981	The Yellowjackets founded
July 5, 1981	Miles Davis performs at Avery Fisher Hall in New York, his first public appearance since 1975
June 30, 1982	Young Lions concert at the Kool Jazz Festival presents Wynton Marsalis and other "exceptional young musicians"
1984	Wynton Marsalis wins Grammy Awards in both jazz and classical categories, the first person to accomplish such a feat
1985	Pat Metheny and Ornette Coleman release the album *Song X*; Cassandra Wilson releases her debut album *Point of View*
1986	John Scofield releases the album *Blue Matter*
1987	Michael Brecker releases his eponymous debut album; Wynton Marsalis is appointed Artistic Director of Jazz at Lincoln Center
1988	Wynton Marsalis releases the album *The Majesty of the Blues*
January 13, 2007	Michael Brecker dies of leukemia; on May 22 his final album *Pilgrimage* is released

Chapter 8

February 7, 1966	The Thad Jones/Mel Lewis Orchestra debuts at the Village Vanguard
1973	The Toshiko Akiyoshi Jazz Orchestra is founded
1982	Bill Frisell releases his debut album *In Line*
1985	John Zorn releases the album *The Big Gundown*
1986	Dexter Gordon stars in the film *Round Midnight* and receives an Oscar nomination
February 1987	Michael Dorf opens the Knitting Factory
1988	Clint Eastwood releases the film *Bird*

1991	Joe Lovano releases his major label debut album *Landmarks* on Blue Note
Summer 1991	Medeski, Martin and Wood founded
September 28, 1991	Miles Davis dies of pneumonia and respiratory failure
1992	Chris Potter releases his debut album *Presenting Chris Potter*
1993	Dave Douglas releases his debut album *Parallel Worlds*; Don Byron releases the album *Don Byron Plays the Music of Mickey Katz*; the Maria Schneider Orchestra is founded
1995	John Zorn founds Tzadik Records
1996	Kenny Garrett releases the album *Pursuance: The Music of John Coltrane*
1997	Bill Frisell releases the album *Nashville*
2000	Jazz CD sales fall to 2.9% of total sales
2004	Dave Douglas founds his label Greenleaf Music

Chapter 9

1976	Jan Garbarek releases the album *Dis*
1983	Herbie Hancock releases the album *Future Shock* accompanied by a music video for the opening track "Rockit"
1992	Karrin Allyson releases her debut album *I Didn't Know About You*
1993	Us3 releases the album *Hand on the Torch*; the song "Cantaloop (Flip Fantasia)" from the album reaches #9 on the *Billboard* charts
1995	Brad Mehldau releases his major label debut album *Introducing Brad Mehldau* on Warner
1996	Kurt Rosenwinkel releases his debut album *East Coast Love Affair*
1997	Kurt Elling releases the album *The Messenger*
1998	Experimental music club Tonic opens at 107 Norfolk Street in New York
1999	Jason Moran releases his debut album *Soundtrack to Human Motion*
2000	The Bad Plus forms and releases their debut album *The Bad Plus*; Thirsty Ear Records establishes the Blue Series label
January 2001	*Jazz: a Film by Ken Burns* is broadcast over 10 nights on PBS
2002	Norah Jones releases the album *Come Away with Me*; Matthew Shipp releases the album *Nu Bop*
2004	Vijay Iyer releases *In What Language*; Berklee College of Music begins offering a class entitled "Turntable Technique"
October 18, 2004	The new home of Jazz at Lincoln Center, Frederick P. Rose Hall opens on Columbus Circle, New York City
2005	Ben Monder releases the album *Oceana*; Dave Stryker releases the album *Big City*
April 1, 2005	John Zorn opens the experimental music performance space The Stone
April 13, 2007	Tonic closes
August 16, 2007	Max Roach dies
September 11, 2007	Josef Zawinul dies

Appendix C

Rhapsody Playlists

Chapter 1

http://rhap.com/mp.146505595
Track 1. "King Porter Stomp"—Benny Goodman Orchestra
Track 2. "Swing to Bop"—Charlie Christian
Track 3. "Koko"—Charlie Parker and His Re-Boppers
Track 4. "Manteca"—Dizzy Gillespie and His Orchestra
Track 5. "Thelonious"—Thelonious Monk, *Thelonious Monk—Genius of Modern Music Volume 1*
Track 6. "Long Tall Dexter—Dexter Gordon Quintet

Additional Recordings Relevant to This Chapter

"West End Blues"—Louis Armstrong and the Hot Five
"Clarinet Marmalade"—Bix Beiderbecke
"Black Bottom Stomp"—Red Hot Peppers
"Black and Tan Fantasy"—Duke Ellington and His Orchestra
"One O'clock Jump"—the Count Basie Orchestra
"Swingmatism"—the Jay McShann Orchestra
"Lover Man"—Charlie Parker
"Scrapple from the Apple"—Charlie Parker
"Woody 'N' You"—Coleman Hawkins
"A Night in Tunisia"—Dizzy Gillespie
"'Round Midnight"—Thelonious Monk
"Brilliant Corners"—Thelonious Monk
"Evidence"—Thelonious Monk, *Thelonious Monk at Carnegie Hall*
"Seven Come Eleven"—Charlie Christian
"Anthropology"—Bud Powell, *Live in Lausanne, 1962*

Chapter 2

http://rhap.com/mp.146505686
Track 7. "Venus de Milo"—Miles Davis Nonet, *The Birth of the Cool*
Track 8. "City of Glass—Dance Before the Mirror (Second Movement)"—the Stan Kenton Orchestra
Track 9. "Line for Lyons"—the Gerry Mulligan Quartet
Track 10. "Blue Rondo á la Turk"—the Dave Brubeck Quartet, *Time Out*
Track 11. "You'd Be So Nice to Come Home To"—Art Pepper, *Art Pepper Meets the Rhythm Section*
Track 12. "Vendome"—the Modern Jazz Quartet

Additional Recordings Relevant to This Chapter

"Tea for Two"—Anita O'Day, *Jazz On a Summer's Day*
"Black, Brown, and Beige, Part 1"—Duke Ellington Orchestra, *Black, Brown, and Beige*
"Waltz from Outer Space"—George Russell, *Jazz in the Space Age*
"General Cluster"—Shorty Rogers, *Modern Sounds*
"My Funny Valentine"—Chet Baker
"Fugue on Bop Themes"—Dave Brubeck Octet
"Take Five"—the Dave Brubeck Quartet, *Time Out*
"Digression"—Lennie Tristano, *Intuition*
"Turkish Mambo"—Lennie Tristano, *The New Tristano*

Chapter 3

http://rhap.com/mp.146505758
Track 13. "Backstage Sally"—Art Blakey and the Jazz Messengers, *Buhaina's Delight*
Track 14. "St. Thomas"—Sonny Rollins, *Saxophone Colossus*
Track 15. "Giant Steps"—John Coltrane, *Giant Steps*
Track 16. "Flamenco Sketches"—the Miles Davis Sextet, *Kind of Blue*
Track 17. "Freedom—Part Two (aka Clark in the Dark)"—Charles Mingus, *The Complete Town Hall Concert*
Track 18. "Triptych: Prayer/Protest/Peace"—Max Roach, *We Insist: The Freedom Now Suite*

Additional Recordings Relevant to This Chapter

"Shake, Rattle, and Roll"—Joe Turner
"Tenor Madness"—Sonny Rollins, *Tenor Madness*
"Song for My Father"—Horace Silver, *Song For My Father*
"Jacqui"—Clifford Brown/Max Roach Quintet
"Black Pearls"—John Coltrane, *Black Pearls*
"'Round Midnight"—Miles Davis, *'Round About Midnight*
"Milestones"—Miles Davis, *Milestones*
"Fables of Faubus"—Charles Mingus, *Mingus Ah Um*
"Goodbye Porkpie Hat"—Charles Mingus, *Mingus Ah Um*
"The Freedom Suite"—Sonny Rollins, *The Freedom Suite*

Chapter 4

http://rhap.com/mp.146505827
Track 19. "Lonely Woman"—the Ornette Coleman Quartet, *The Shape of Jazz to Come*
Track 20. "With (exit)"—the Cecil Taylor Unit, *Conquistador!*
Track 21. "Chasin' the Trane"—the John Coltrane Quartet, *Live at the Village Vanguard*
Track 22. "Acknowledgement"—the John Coltrane Quartet, *A Love Supreme*
Track 23. "The Baron"—the Eric Dolphy Quartet, *Out There*
Track 24. "Nonaah"—the Art Ensemble of Chicago, *Fanfare for the Warriors*

Additional Recordings Relevant to This Chapter

"Invisible"—Ornette Coleman, *Something Else!!!! The Music of Ornette Coleman*
"Free Jazz"—Ornette Coleman, *Free Jazz: A Collective Improvisation*
"Foreigner in a Free Land"—Ornette Coleman
"Crossing, Pt. 2 (Fourth Movement, Pt. 1)—Cecil Taylor, *Silent Tongues*
"My Favorite Things"—the John Coltrane Quartet, *My Favorite Things*
"Ascension"—John Coltrane, *Ascension*
"'Round Midnight"—the George Russell Sextet, *Ezz-thetics*
"A Call For All Demons"—Sun Ra, *Music From Tomorrow's World*
"Rufus"—Archie Shepp, *Four For Trane*
"Ghosts: Second Variation"—Albert Ayer, *Spiritual Unity*

Chapter 5

http://rhap.com/mp.146506100
Track 25. "Corcovado (Quiet Nights of Quiet Stars)"—Stan Getz and João Gilberto, *Getz/Gilberto*
Track 26. "Motorin' Along"—Jimmy Smith, *Home Cookin'*
Track 27. "Milestones"—the Bill Evans Trio, *Waltz for Debby*
Track 28. "Footprints"—the Miles Davis Quintet, *Miles Smiles*
Track 29. "Suite Sioux"—Freddie Hubbard, *Red Clay*
Track 30. "Spiral Dance"—the Keith Jarrett Belonging Quartet, *Belonging*

Additional Recordings Relevant to This Chapter

"Hello Dolly"—Louis Armstrong
"Four Brothers"—the Woody Herman Orchestra
"Night Rider"—Stan Getz, *Focus*
"Desafinado"—Stan Getz, *Jazz Samba*
"The 'In' Crowd"—Ramsey Lewis, *The "In" Crowd*
"Watermelon Man"—Mongo Santamaria
"The Sermon"—the Jimmy Smith
"Mercy, Mercy, Mercy"—the Cannonball Adderley Quintet, *Mercy, Mercy, Mercy*
"Four on Six"—Wes Montgomery, *Smokin' at the Half Note*
"Peace Piece"—Bill Evans, *Everybody Digs Bill Evans*
"Concerto for Billy the Kid"—Bill Evans
"Concierto de Aranjuez"—Miles Davis, *Sketches of Spain*
"Stella by Starlight"—the Miles Davis Quintet, *My Funny Valentine*
"Without a Song"—Sonny Rollins, *The Bridge*
"Gingerbread Boy"—Dexter Gordon, *Homecoming: Live at the Village Vanguard*
"The Köln Concert (Part I)"—Keith Jarrett, *The Köln Concert*
"Krusning"—Jan Garbarek, *Dis*

Chapter 6

http://rhap.com/mp.146506154
Track 31. "The Dealer"—Chico Hamilton, *The Dealer*
Track 32. "Bitches Brew"—Miles Davis and His Band, *Bitches Brew*
Track 33. "Celestial Terrestrial Commuters"—the Mahavishnu Orchestra, *Birds of Fire*

Track 34. "Watermelon Man"—Herbie Hancock, *Head Hunters*
Track 35. "Medieval Overture"—Return to Forever, *Romantic Warrior*
Track 36. "Palladium"—Weather Report, *Heavy Weather*

Additional Recordings Relevant to This Chapter

"Third Stone From the Sun"—the Jimi Hendrix Experience, *Are You Experienced?*
"Spinning Wheel"—Blood, Sweat & Tears, *Blood, Sweat & Tears*
"Sorcery"—the Charles Lloyd Quartet, *Dreamweaver*
"It's About That Time"—Miles Davis, *In a Silent Way*
"Black Satin"—Miles Davis, *On the Corner*
"Emergency"—the Tony Williams Lifetime, *Emergency*
"Awakening"—the Mahavishnu Orchestra, *The Inner Mounting Flame*
"A Lotus on Irish Streams"—the Mahavishnu Orchestra, *The Inner Mounting Flame*
"Cantaloupe Island"—Herbie Hancock, *Empyrean Isles*
"Water Torture"—Herbie Hancock, *Crossings*
"Spain"—Chick Corea/Return to Forever, *Light As a Feather*
"Waterfall"—Weather Report, *Weather Report*
"Birdland"—Weather Report, *Heavy Weather*
"Songbird"—Kenny G
"Morning Dance"—Spyro Gyra, *Morning Dance*

Chapter 7

http://rhap.com/mp.146517983
Track 37. "Down the Avenue"—Wynton Marsalis Septet, *Citi Movement*
Track 38. "Mischief"—Joshua Redman Quartet, *MoodSwing*
Track 39. "San Lorenzo"—the Pat Metheny Group, *Travels*
Track 40. "Itsbynne Reel"—Michael Brecker, *Don't Try This at Home*
Track 41. "Entruption"—Greg Osby, *Inner Circle*
Track 42. "Strange Fruit"—Cassandra Wilson, *New Moon Daughter*

Additional Recordings Relevant to This Chapter

"R.J."—Wynton Marsalis, *Wynton Marsalis*
"Work Song (Blood on the Fields)"—Wynton Marsalis, *Blood On the Fields*
"From the Plantation to the Penitentiary"—Wynton Marsalis, *From the Plantation to the Penitentiary*
"Red"—Miles Davis, *Aura*
"Omaha Celebration"—Pat Metheny, *Bright Size Life*
"The Way Up: Opening"—Pat Metheny, *The Way Up*
"Some Skunk Funk"—the Brecker Brothers, *Heavy Metal Be-Bop*
"Trains"—Steps Ahead, *Magnetic*
"Broadband"—Michael Brecker, *Wide Angles*
"Blue Matter"—John Scofield, *Blue Matter*
"Out of Town"—the Yellowjackets, *Four Corners*
"Composition 69C (+32+96)/Percussion Solo from Composition 96/Composition 69F—Anthony Braxton, *Quartet (Coventry) 1985*
"Death Letter"—Cassandra Wilson, *New Moon Daughter*
"Blues"—the World Saxophone Quartet, *Requiem for Julius*

Chapter 8

http://rhap.com/mp.146506409
Track 43. "Snagglepuss"—John Zorn's Naked City, *Naked City*
Track 44. "Shards"—Dave Douglas Tiny Bell Trio, *Tiny Bell Trio*
Track 45. "Tuskegee Experiment"—Don Byron, *Tuskegee Experiments*
Track 46. "Coconut Boogaloo"—Medeski, Martin, and Wood, *Combustication*
Track 47. "Central Park North"—Vanguard Jazz Orchestra, *Thad Jones Legacy*
Track 48. "Shaw"—Kenny Garrett, *African Exchange Student*

Additional Recordings Relevant to This Chapter

"It Had To Be You"—Harry Connick, Jr., *When Harry Met Sally Soundtrack*
"Pendet"—John Zorn, *Cobra: Game Pieces, Vol. 2*
"Gevurah"—John Zorn, *Masada: The Circle Maker*
"Enchantress"—John Zorn, *The Goddess—Music for the Ancient of Days*
"Struggle Pt. 2"—Bill Frisell, *History Mystery*
"Mirrors"—Dave Douglas, *Five*
"Great Awakening"—Dave Douglas, *Spirit Moves*
"This New Generation"—Wayne Horvitz, *This New Generation*
"Frailach Jamboree"—Don Byron, *Don Byron Plays the Music of Mickey Katz*
"Your Name is Snake Anthony"—Medeski, Martin, and Wood, *Uninvisible*
"Luvin' Blume"—Sex Mob, *Sexotica*
"Kogun"—Toshiko Akiyoshi Jazz Orchestra, *Let Freedom Ring*
"Bird's Eye View"—Joe Lovano, *Joyous Encounter*
"Sing a Song of Song"—Kenny Garrett, *Songbook*
"Boulevard of Broken Time"—Chris Potter, *Chris Potter & Kenny Werner: Concord Duo Series, Volume Ten*

Chapter 9

http://rhap.com/mp.146506682
Track 49. "Heart of Glass"—The Bad Plus, *These Are the Vistas*
Track 50. "Echolalia"—Ben Monder, *Oceana*
Track 51. "Artistiya"—Regina Carter, *Reverse Thread*
Track 52. "Downtown"—Kurt Elling, *Live in Chicago*
Track 53. "west_coast_variant"—Kenny Werner, *Lawn Chair Society*
Track 54. "Evening Land"—Jan Garbarek, *Visible World*

Additional Recordings Relevant to This Chapter

"Blackbird"—the Brad Mehldau Trio, *The Art of the Trio, Volume One*
"Never Stop"—The Bad Plus, *Never Stop*
"Somewhere"—Vijay Iyer, *Historicity*
"RFK in the Land of Apartheid"—Jason Moran, *Ten*
"A Shifting Design"—Kurt Rosenwinkel, *The Next Step*
"All Night Long—Dave Stryker, *Big City*
"Human Revolution"—Terri Lyne Carrington, *Real Life Story*
"Don't Know Why"—Norah Jones, *Come Away with Me*

"Cry Me a River"—Diana Krall, *The Look of Love*

"Unforgettable"—Natalie Cole, *Unforgettable with Love*

"All You Need to Say (Never Say Yes)"—Karrin Allison, *Footprints*

"Tanya Jean"—Kurt Elling, *The Messenger*

"Rockit"—Herbie Hancock, *Future Shock*

"Cantaloop (Flip Fantasia)"—Us3, *Hand on the Torch*

"Eastern Parkway"—Dave Douglas, *Freak In*

"Space Shipp"—Matthew Shipp, *Nu Bop*

"All My Life"—Bobo Stenson Trio, *War Orphans*

"Rambler"—Arild Andersen, *Hyperborean*

"Premonition—Earth"—the Esbjorn Svensson Trio, *E.S.T Leucocyte*

Glossary

Acid Jazz—a style originally created by London DJs from 1960s and '70s soul jazz and funk records.

Afro-Cuban—a jazz style that incorporates musical influences from Africa and Cuba, first made famous by Dizzy Gillespie's big band in 1947.

Arrangement—notated rendition of a song or composition.

ArtistShare—founded in 2001 by Brian Camelio, ArtistShare is a service enabling musicians to circumvent the established music industry and have more control over their music sales.

Atonal—refers to music without a tonal key center.

Avant-Garde—denoting artistic endeavors that are experimental, new and unusual or cutting edge.

Backbeat—beats two and four of each measure.

Bar/Measure—repeated groupings that beats are organized into.

Bebop—the first modern jazz style; it emanated from jam sessions in Harlem in the late 1930s and early 1940s.

Berklee College of Music—an independent jazz and contemporary music college founded in 1945 in Boston.

Black, Brown and Beige—an orchestral suite written by Duke Ellington that premiered at Carnegie Hall on January 23, 1943.

Blues—a form characterized by the use of a 12-bar chorus and an AAB lyrical verse that can be incorporated into jazz, rock, and other styles. The blues is also a separate style in and of itself that comes in many different forms.

Bossa Nova—a Brazilian jazz style developed by Antonio Carlos Jobim and João Gilberto in the 1950s.

Cabaret Card—a card issued by the city of New York which allowed a performer to work in an establishment that sold liquor.

"Cherokee"—a popular standard from the swing era; Charle Parker achieved a musical epiphany while playing this song in 1939; he later rewrote the melody and named it "Koko."

Chicago Style—a style of jazz that emerged from white bands in Chicago in the 1920s.

Chord—3 or 4 notes played simultaneously; the fundamental unit of harmony.

Chord Progression/Changes—the sequential order of the chords of a tune. In the jazz world, the chord progression is called the changes.

Chord Symbol—notational representations of chords, a kind of shorthand used to quickly communicate the harmonic content of chord.

Chorus—each statement of the form.

Civil Rights Movement—the political struggle for racial equality that was led by Dr. Martin Luther King Jr. and others.

Clavinet—an electric harpsichord-like keyboard instrument that was widely used by Stevie Wonder and other funk artists in the 1970s.

Collective Improvisation—the distinctive characteristic of the New Orleans Style of jazz in which the front line instruments improvise simultaneously.

Comping—the interactive and syncopated way in which a pianist or guitarist plays in a jazz rhythm section; short for accompanying.

Contrapuntal—of, relating to, or marked by counterpoint.

Cool—a term to describe a jazz soloist who plays in a more laid back, lyrical fashion.

Cool Jazz—a jazz style from the 1950s that is characterized by restraint and European influences. Sometimes known as West Coast Jazz.

Counterpoint—two or more melodic lines occurring simultaneously, sometimes referred to as polyphony.

Creoles of Color—people in New Orleans with a European (usually French) and African ancestry.

Cutting Contest—an informal competitive duel where musicians try to outplay each other by showing more technique creativity and originality.

Dissonance—a musical term to describe non-harmonious notes or intervals.

Double Time—in an improvised solo, the technique of playing rhythmically twice as fast as the established tempo.

Down Beat—a jazz and contemporary music magazine first published in 1935.

Downbeat—beat one of each measure.

Downtown—a designation given to experimental and avant-garde music from the Lower East Side of New York City in the 1980s.

Dropping Bombs—spontaneous, syncopated accents played by a drummer on the bass drum.

ECM Records—(Edition of Contemporary Music) started in 1969 by German jazz and classical musician Manfred Eicher. ECM has been one of the leading labels for World and jazz fusions.

Embellishment/Ornamentation—simply the improvised decoration of "jazzing up" of a melody, whether in the head or in a solo.

EWI—Electronic Wind Instrument

Fake Book—a book made up of tunes in lead sheet form.

Fender Rhodes Electric Piano—a popular brand of electric keyboard with a bell-like sound and whose keys simulated the feel of a real piano.

Free Jazz—a jazz style from the 1960s that is characterized by a willingness to break conventional rules and norms.

Front Line—the wind instruments in a small jazz group.

Fugue—a formal structure first used during the Baroque Era that makes extensive use of counterpoint based on an opening theme or subject.

Fusion—an equal triangulation of jazz, rock, and pop that emerged in the mid 1970s.

Glocalization—the term glocalization refers to the ability of musicians around the world to absorb global music styles, such as jazz or pop, into their own musical traditions, while retaining a strong sense of local identity.

Gig—a jazz performance.

Hard Bop—a jazz style popular in the 1950s and 1960s that incorporates influences from R&B, gospel and the blues.

Harmolodics—Ornette Coleman's improvisational concept, a contraction of the words harmony, motion and melodic.

Harmon Mute—a trumpet mute that gives the instrument a buzz-like whisper.

Harmony—the simultaneous sounding of two or more tones, esp. when satisfying to the ear.

Head—the melody of a song.

Head Arrangement—an arrangement that is created in a spontaneous fashion without written music.

Hot—a term to describe a soloist who plays in a dramatic and virtuosic manner.

Improvisation—the act of simultaneously composing and performing.

Improvised Solo—the highest form of individual expression in a jazz performance.

"Intuition" and "Digression"—two spontaneously composed songs recorded by Lennie Tristano and his group on May 16, 1949 that are considered to be the first free jazz recordings.

Jam Band—a designation given to bands that emphasize improvisation, deep grooves, and hip hop elements; are primarily instrumental (without vocals).

Jam Session—an informal, improvisational playing session where musicians play for fun and often without pay.

Jazz: A Film by Ken Burns—the 10-episode, 19-hour long documentary first broadcast in January 2001.

Jazz at the Philharmonic—Norman Granz's concert and tour series that began in 1944 and continued into the 1960s.

Jazz Interpretation—the unique way that jazz musicians produce sound.

Jazz Performance Form—the standard head-solos-head form of a jazz performance.

Jazz Standard—a jazz or pop tune that is widely known by jazz musicians and is played often.

Jump-Cut—a method of composing that involves stringing together a number of seemingly unrelated musical snippets into a complete composition.

Jazz/Rock—the earliest form fusing jazz and rock; most often takes the form of the soundstream approach of 1970s Miles Davis or early Weather Report recordings.

Kansas City Style—the jazz style that evolved in Kansas City in the 1920s and 1930s that is characterized by the use of 12-bar blues forms and head arrangements.

Klezmer—originally the music of East European Jews from medieval times. Klezmer is up-tempo folk-dance music that is usually played by ensembles of violin, clarinet, accordion, drums, and other instruments.

Lay Out—when a musician, such as a horn player, does not play during a performance.

Lead Sheet—a written down notation of a tune using only the melody and chord symbols.

Legislative Code No. 111—a discriminatory code enacted in Louisiana in 1894 that formally legalized discrimination and segregation.

Let's Dance—a radio program broadcast on the NBC radio network from October 1934 to May 1935 that featured the Benny Goodman Orchestra.

Lyrical—a melody that is very singable or melodic. Cool soloists tend to play more lyrically than hot soloists.

M-Base—(short for "macro-basic array of structured extemporization") is a concept of how to create modern music which reached its peak in the mid-to-late-80s and early 90s.

Melody—a sequence of notes that are played or sung in a specific order and rhythm.

MIDI (Musical Instrument Digital Interface)—a digital protocol that allows the transfer of musical information between digital instruments and computers, where it can be manipulated by sequencing software.

Modal Jazz—style in which the harmonic focus is on modes, or scales, rather than chord progressions.

Multiphonics—a technique in which a player produces more than one note at a time on a wind instrument, often creating unusual intervals that sound dissonant.

Multi-track Recording—tape recording technology that allows for multiple tracks to be recorded in sync all at once, or at different times.

Neo-Conservative Movement—a popular movement from the 1980s advocating the use of swing rhythm, blues tonalities, the use of acoustic instruments, and the technical mastery of one's instruments as indispensable components of jazz.

Neo-Traditional—see Neo-Conservative Movement.

New Orleans Style—the first style of jazz that emerged in New Orleans in the early years of the 20th century characterized by the use of collective improvisation.

New Thing, The—the term first applied to the style that became known as free jazz.

Newport Jazz Festival—the first outdoor jazz festival, started in 1954 by George Wein in Newport, Rhode Island.

Octave—interval measuring eight diatonic steps.

Odd Time Meter—unusual groupings such as 5, 7, or 9 beats to the measure.

Overdub—a feature of multi-track tape recorders that allows musicians to record additional parts independently of each other while listening to already recorded tracks with headphones.

Phrasing—combining of melodies with silence, or rests.

Playing Outside—a term describing a jazz musician's willingness to play in a fashion beyond the conventional rules.

Polyrhythm—using two or more rhythms simultaneously.

Publishing Royalties—payments collected from record companies that are distributed to publishing companies and song composers.

Pulse—fundamental beat driving the music that creates the tempo.

Recording Ban—a prohibition of all recordings made by members of the American Federation of Musicians that went into effect on August 1, 1942. The ban was rescinded in 1944.

Recording Industry of America (RIAA)—Founded in 1952, the Recording Industry Association of America (RIAA) is the trade organization that tracks record industry sales and trends; it also certifies gold (500,000 units sold) and platinum (1,000,000 units sold) records.

Reharmonization—the process of inserting new chords into the existing chord progression of an established tune, also known as chord substitution.

Repertory Band—bands dedicated to playing the music of a specific artist or jazz style.

Rhythm—the relationship between notes and sound with time that gives music a forward motion.

Rhythm and Blues (R&B)—a more commercial, dance-oriented version of the blues, often utilizing coordinated costumes and dance steps by performers.

Riff—short melodic phrase or melody.

Session Musician—a musician used on a recording session; session musicians must be able to sight-read music and play fluently in a variety of styles.

Sheets of Sound—an improvisation technique associated with John Coltrane in which notes are played in an extremely fast and arrhythmical fashion.

Smooth Jazz—a melodic and pop-oriented style of jazz that evolved from jazz/rock fusion in the 1980s and 1990s.

Soundstream—a style, best exemplified by Miles Davis's 1970s and early Weather Report recordings, in which soloists improvise over a rock based accompaniment.

Soul Jazz—a popular substyle of hard bop that drew heavily from R&B and soul music influences.

Spanish Tinge—Jelly Roll Morton's term for utilizing the rhythms of the tango and other Spanish dances in jazz compositions.

Swing—the name that was given to the jazz music played by the dance bands of the 1930s and 1940s.

Swing Rhythm—the loosening of the rigid adherence to the beat, accomplished by slightly delaying the notes played between the beats.

Syncopation—rhythmically placing or accenting notes away from the beat and in unexpected places.

Tempo—the speed of the music.

Third Stream—a term coined by Gunther Schuller in 1957 to describe the combining of jazz and classical music into a new style.

33⅓ rpm Album—the long playing (LP) format introduced by Columbia Records in 1948 that allowed up to 23 minutes of music on each side of a disc.

Time Signature—the designation of the meter, or the number of beats in each measure in music.

Tin Pan Alley—describes the music publishing business in the first half of the 20th century and the songs and composing style that resulted from it.

Trading 4s—the technique of exchanging four-bar solos, usually between a soloist and a drummer.

Vertical Style—an improvisational style based on using chord tones, which are stacked vertically in notated music; first associated with Coleman Hawkins.

Vocalese—technique of composing lyrics to fit existing recorded jazz improvised solos or instrumental arrangements.

Walking Bass—a technique of playing one note per beat to outline chords that is used in swing rhythm by bass players.

West Coast Jazz—a jazz style from the 1950s that is characterized by restraint and European influences. Sometimes known as Cool Jazz.

World Music—an umbrella term to describe music that incorporates influences from different regions and cultures.

Wordless Vocal—a written vocal line sung without words, using instead simple monosyllabic "oohs" or "aahs."

References

Adler, David: "Kurt Rosenwinkel: Emerging Brilliance," *All About Jazz*, May 16, 2006

Albertson, Chris: liner notes to *Charlie Christian: Genius of the Electric Guitar*

akamu.net/braxton/biography.htm

All About Jazz

Anderson, Iain: *This is Our Music: Free Jazz, The Sixties, and American Culture*; University of Pennsylvania Press 2006

appliedmicrophone.com

arildandersen.com

Auskern, Leonid: "Dave Douglas: My Favorite Album Is Always the One Which Is About to Be Released," *Jazz News*, August 9, 2005

Bailey, C. Michael: "Best Live Jazz Recordings," *All About Jazz*, August 10, 2005

Balliett, Whitney: *Collected Works: A Journal of Jazz, 1954-2001*

Baraka, Amiri: *Blues People: Negro Music in White America*; William Morrow & Company, 1963

billfrisell.com

Blumenfeld, Larry: "Abbey Lincoln in Command," *The Wall Street Journal*, July 18, 2007

bradmehldau.com

The Boston Globe

Britt, Stan: *Dexter Gordon: A Musical Biography*; Da Capo Press 1989

Brubeck, Darius: "1959: The beginning of beyond," *The Cambridge Companion to Jazz*

bryanaaker.net

Burns, Ken: *Jazz: a Film by Ken Burns*

Carr, Ian: *Keith Jarrett: The Man and His Music*; Da Capo Press 1992

Carr, Ian: *Miles Davis: The Definitive Biography*

Chambers, Jack: *Milestones The Music and Times of Miles Davis*; Thunder's Mouth Press 1999

Chénard, Marc: "Third Stream Jazz: Musical Crossroads or Parallel Worlds," scena.org

Chinen, Nate: "Requiem for a Club: Saxophone and Sighs," *New York Times*, April 16, 2007

Coltrane, John: liner notes to *A Love Supreme*

Cox, Christoph and Warner, Daniel: *Audio Culture: Readings in Modern Music*; Continuum International Publishing Group 2004

Crouch, Stanley: "The Colossus," *The New Yorker* May 9, 2005

Davis, Francis: *Bebop and Nothingness: Jazz and Pop at the End of the Century*; Schirmer Books 1998

Davis, Francis: "Like Young," *The Atlantic Monthly*, July 1996

Davis, Francis: liner notes to Vanguard Jazz Orchestra album *Thad Jones Legacy*

Davis, Miles and Troupe, Quincy: *Miles: The Autobiography*; Simon and Schuster 1989

DeMichael, Don, "John Coltrane and Eric Dolphy Answer the Jazz Critics," *Down Beat*, April 12, 1962

Denison, Chuck: *The Great American Songbook: The Stories Behind the Standards*; Robert D. Reed 2004

DeVeaux, Scott: *The Birth of Bebop: A Social and Musical History*; University of California Press 1997

Dorf, Michael: *Knitting Music*; Knitting Factory Works 1992

Do The Math

Down Beat magazine

ecmrecords.com

Ellison, Ralph: *Shadow and Act*; Vintage 1995

Evans, Bill: liner notes to the Miles Davis album *Kind of Blue*

Figbi, J. B. "Cecil Taylor: African Code, Black Methodology," *Down Beat*, April 10, 1975

Fitterling, Thomas: *Thelonious Monk: His Life and Music*; Berkeley Hills Books 1997

Friedman, Thomas: *The Lexus and the Olive Tree*; Anchor Books, 1999

Friedman, Thomas: *The World is Flat: A Brief History of the Twenty-First Century*; Farrar, Straus and Giroux 2005

Gann, Kyle: "Breaking the Chain Letter: An Essay on Downtown Music," www.kylegann.com

Gelly, Dave: *Stan Getz: Nobody Else But Me*; Backbeat Books 2002

Gerard, Charley: *Jazz in Black & White: Race Culture, and Identity in the Jazz Community*; Praeger Paperback 2001

Giddins, Gary: *Rhythm-a-ning: Jazz Tradition and Innovation*; Da Capo Press 2000

Giddins, Gary: "Post-War Jazz: An Arbitrary Road Map," *Best Music Writing 2003*

Giddins, Gary: "New York's Lofty Intentions," *JazzTimes*, September 2006

Giddins, Gary: "Spelunking and Crooning in 2001," *The Village Voice*, January 16, 2001

Giddons, Gary: *Visions of Jazz: The First Century*; Oxford University Press 1998

Gil, Troy: *Morning in America: How Ronald Reagan Invented the 1980s*; Princeton University Press 2005

Gioia, Ted: *The History of Jazz*; Oxford University Press 1997

Gioia, Ted: *The Imperfect Art: Reflections on Jazz and Modern Culture*; Oxford University Press 1990

Gioia, Ted: *West Coast Jazz: Modern Jazz in California 1945-1960*; University of California Press 1998

Gitler, Ira: *Swing to Bop: An Oral History of the Transition in Jazz in the 1940s*; Oxford University Press 1987

Gitler, Ira: "'Trane on the Track," *Down Beat*, October 16, 1958

Goldberg, Joe: *Jazz Masters of the 50s*; Macmillan Publishing 1973

Goldsher, Alan: *Hard Bop Academy: the Sidemen of Art Blakey and the Jazz Messengers*; Hal Leonard 2002

Gopnik, Adam: "That Sunday," *The New Yorker* August 13, 2001

Gordon, Robert: *Jazz West Coast: The Los Angeles Jazz Scene of the 1950s*; Quartet Books 1987

Gourse, Leslie: *Straight, No Chaser: The Life and Genius of Thelonious Monk*; Schirmer Trade Books 1998

greenleafmusic.com

greenmilljazz.com

Hajdu, David: "Wynton's Blues," *The Atlantic Monthly*, March 2003

Harrison, Max, Charles Fox, Eric Thacker and Stuart Nicholson: *The Essential Jazz Records, Vol 2: Modernism to Postmodernism*; Mansell Publishing 2000

Hawes, Hampton and Don Asher: *Raise Up off Me: A Portrait of Hampton Hawes*; Thunder's Mouth Press 2001

Hentoff, Nat: "An Afternoon with Miles Davis," *Jazz Panorama*

Hentoff, Nat: "Jazz in Print," *Jazz Review*, November 1960

Hentoff, Nat: liner notes to *Charles Mingus-A Modern Jazz Symposium of Music and Poetry*

Hentoff, Nat: liner notes to the Charles Mingus album *Pithecanthropus Erectus*

Hentoff, Nat: liner notes to the Max Roach album *We Insist!: The Freedom Now Suite*

Hentoff, Nat: liner notes to the John Coltrane album *Meditations*

Hentoff, Nat: *The Jazz Life*; Da Capo Press 1988

Hoskins, Barney: *Waiting for the Sun: Strange Days, Weird Scenes, and The Sound of Los Angeles*; St. Martins Press 1996

Jazz Central Station

jazzdisco.org; Jazz Discography Project

Jazz Journal International

JazzTimes magazine

jerryjazzmusician.com

Jung, Fred, m-base.com

Kahn, Ashley: *A Love Supreme: The Story of John Coltrane's Signature Album*; Viking Press 2002

Kahn, Ashley: *Kind of Blue: The Making of the Miles Davis Masterpiece*; Da Capo Press 2000

Katz, Mark: *Capturing Sound: How Technology Has Changed Music*; University of California Press 2004

Kelly, Robin D. G.: *Thelonious Monk: The Life and times of an American Original*; Free Press 2009

Kelman, John: "Junk Magic," *All About Jazz*

Kernfeld, Barry Dean: *The Blackwell Guide to Recorded Jazz*; Blackwell Publishing 1995

Khan, Marty: *Straight Ahead: A Comprehensive Guide to the Business of Jazz (Without Sacrificing Dignity or Artistic Integrity)*; Outward Vision Books 2004

kurtelling.com

Laing, Dave: "The Jazz Market," *The Cambridge Companion to Jazz*

Larson, Thomas: *The History and Tradition of Jazz (3rd Ed.)*; Kendall/Hunt Publishing 2008

Lee, William F.: *Stan Kenton, Artistry in Rhythm*; Creative Press 1980

Lees, Gene: *Cats of Any Color: Jazz, Black and White*; Da Capo Press 2001

Leland, John: *Hip: the History*; Ecco 2004

Litweiler, John: *The Freedom Principle: Jazz After 1958*; Da Capo Press 1990

Los Angeles Mirror

MacLaren, Trevor: "The Tony Williams Lifetime: Emergency!" *All About Jazz*, November 16, 2005

Maggin, Donald L: *Stan Getz, A Life in Jazz*; Harper Perennial 1997

Mandel, Howard: *Future Jazz*; Oxford University Press 2000

Mandel, Howard: "Jazz: Who, What, Where, Why—Jazz Great John Zorn's the Stone Club," *New York Press*

Mandel, Howard: "Joe Lovano's Sound of the Broad Shoulders," *Down Beat*, March 1993

Mandel, Howard: "Kenny Garrett: Mission Possible," *Down Beat*, September 1997

Marantz, Bart: "To Gil, With Love," *Down Beat*, June 1992

Mathieson, Kenny: *Cookin': Hard Bop and Soul Jazz 1954-65*; Canongate 2002

McCombe, John P.: "'Eternal Jazz': Jazz Historiography and the Persistence of the Resurrection Myth," *Genre XXXVI*

Melody Maker magazine

Mercer, Michelle: *Footprints: The Life and Music of Wayne Shorter*; Tarcher 2004

Micklin, Bob: "Chet Baker Knows the Blues," *Milwaukee Journal*

Miller, Mel interview with Stan Getz, *The Saxophone Journal* Winter 1986

Mingus, Sue: *Tonight at Noon: A Love Story*; Westview Press 2003

Mix magazine

mmw.net

Morgenstern, Dan; *Down Beat Yearbook 1968*

Myers, Mitch: "Anti-Mercenary Improvisation," *Down Beat*, November 2000

myspace.com/mikeladd

New York Times

Nicholson, Stuart: "Fusions and Crossovers," *The Cambridge Companion to Jazz*

Nicholson, Stuart: *Is Jazz Dead? (Or Has It Moved to a New Address)*; Routledge 2005

Nicholson, Stuart: *Jazz: The 1980s Resurgence*; Da Capo Press 1995

Nisenson, Eric: *Ascension: John Coltrane and His Quest*; Westview Press 2005

Nisenson, Eric: *Blue: The Murder of Jazz*; Da Capo Press 1997

Nisenson, Eric: *'Round About Midnight: A Portrait of Miles Davis*; Da Capo Press 1996

npr.org

Olson, Paul: "Ben Monder: Surprise from Cohesion," *All About Jazz*, February 6, 2006

Ouellette, Dan "Bitches Brew: The Making Of The Most Revolutionary Jazz Album In History," *Down Beat*, December 1999

patmetheny.com/orchestrioninfo

Pepper, Art and Laurie: *Straight Life: The Story of Art Pepper*; Westview Press 1994

Pettinger, Peter: *Bill Evans: How My Heart Sings*; Yale University Press 2002

Pond, Steven F.: *Head Hunters: The Making of Jazz's First Platinum Album*; University of Michigan Press 2005

Porter, Dr. Lewis: *Jazz: A Century of Change*; Schirmer 1997

Porter, Dr. Lewis: *John Coltrane: His Life and Music*; University of Michigan Press 2004

Pressing, Jeff: "Free Jazz and the Avant-Garde," *The Cambridge Companion to Jazz*

Priestley, Brian: liner notes to *Charles Mingus: The Complete Town Hall Concert*

Priestly, Brian: *Mingus: A Critical Biography*; Da Capo Press 1988

Protzman, Bob: "Maria Schneider's Composing Pains," *Down Beat*, November 1996

Race, Steve: liner notes to the Dave Brubeck Quartet album *Time Out*

Randall, Edward L.: "The Voice of American Jazz," *High Fidelity*, August 1958

restructures.net; Anthony Braxton Discography

riaa.com

Rosenthal, David H., *Hard Bop: Jazz & Black Music 1955-1965*; Oxford University Press 1992

Russell, George: *The Lydian Chromatic Concept of Tonal Organization*; Concept Publishing 2001

Russell, Ross: *Bird Lives!*; Da Capo Press 1973

Santoro, Gene: "Town Hall Train Wreck: Why Charles Mingus Came to Grief in 1962," *Village Voice*, June 7, 2000

Saul, Scott: *Freedom Is, Freedom Ain't: Jazz and the Making of the Sixties*; Harvard University Press 2003

Scheer, Jennifer: "Dave Stryker: the Interview," *Jazz Review*, February 2005

Schneider, Maria: liner notes to her album *Evanescence*

Shadwick, Keith: *Bill Evans: Everything Happens to Me-A Musical Biography*; Backbeat Books 2002

Sherrill, Stephen: "Don Byron," *New York Times Magazine*, January 16, 1994

Shipton, Alyn: *A New History of Jazz*; Continuum 2001

Shipton, Alyn: *Groovin' High: The Life of Dizzy Gillespie*; Da Capo Press 1999

Shuster, Fred: "When Your Chops Are Shot," *Down Beat*, October 1995

Simon, George T.: *The Big Bands*; Schirmer 1981

Simosko, Vladimir and Barry Tepperman: *Eric Dolphy: A Musical Biography and Discography*; Da Capo Press 1979

Spellman, A.B.: *Black Music: Four Lives*; Schocken Books 1970

Spencer, Neil: "Keeping up with Jones," *The Observer*, January 18, 2004

Stearns, Marshall: *The Story of Jazz*; Oxford University Press 1956

Stein Crease, Stephanie: *Gil Evans—Out of the Cool: His Life and Music*; A Cappella Books 2002

Stewart, Zan: "A Non-Traditional Arrangement," *The Los Angeles Times*, November 14, 1993

synthtopia.com

Szwed, John F: *Space Is the Place: The Lives and Times of Sun Ra*; Da Capo Press 1998

Teachout, Terry: liner notes to the Maria Schneider Orchestra album *Coming About*

Teachout, Terry: *Pops: A Life of Louis Armstrong*; Mariner Books 2010

thebadplus.com

Twomey, John: "The Troubled Genius of Stan Getz," jazzsight.com

Tynan, John, "Take Five," *Down Beat*, November 23, 1961

tzadik.com

Varga, George: liner notes to the Michael Brecker album *Don't Try This at Home*

vijay-iyer.com

Ward, Eric: "The Bad Plus: Give and Take," *Glide Magazine*, March 23, 2004

Ward, Geoffrey and Burns, Ken: *Jazz: A History of America's Music*; Alfred A. Knopf 2000

Weather Report Annotated Discography

Williams, Martin: "Letter from Lenox, Massachusetts," *Jazz Review*, 1959

Wire magazine

Woodford, John: "Non-Piano Man," *Michigan Today*

Yanow, Scott: *Afro-Cuban Jazz*; Backbeat Books 2000

Yanow, Scott: *Jazz: A Regional Exploration*; Greenwood Press 2005

Yanow, Scott: *Jazz on Record: The First Sixty Years*; Backbeat Books 2003

Yost, Ekkehard: *Free Jazz*; Da Capo Press 1974

Photo and Art Credits

Cover and title page image used under license from Shutterstock, Inc.

Chapter 1

Page 1 Saxophone. Copyright © 2011, francesco riccardo iacomini. Under license from Shutterstock, Inc.

Page 5 Duke Ellington Orchestra. Photo courtesy Institute of Jazz Studies, Rutgers University.

Page 12 Charlie Parker with Tommy Potter, Miles Davis, Duke Jordan and Max Roach. Photofest.

Page 15 Trumpeter Dizzy Gillespie. Photofest.

Page 18 Thelonious Monk, Howard McGhee, Roy Eldridge, and Teddy Hill. © William P. Gottlieb; *www.jazzphotos.com*

Page 20 Max Roach. Photo courtesy of Photofest.

Chapter 2

Page 29 Man holding trumpet. Copyright © 2011, Jason Keith Heydorn. Under license from Shutterstock, Inc.

Page 32 Gerry Mulligan and Anita O'Day. Photo Galaxy Attractions/Photofest.

Page 37 Stan Kenton with Gene Roland, Lennie Niehaus, and Bill Holman. Photo courtesy Institute of Jazz Studies, Rutgers University.

Page 42 Chet Baker. Zeitgeist Films/Photofest.

Page 45 Dave Brubeck Quartet. Dave Brubeck Quartet, Brubeck Collection, Holt-Atherton Special Collections, University of the Pacific Library. Copyright Dave Brubeck.

Page 49 Modern Jazz Quartet. Photo courtesy of Tad Hershorn.

Chapter 3

Page 57 Man playing clarinet. Copyright © 2011, emin kuliyev. Under license from Shutterstock, Inc.

Page 63 Art Blakey. Photofest.

Page 67 Miles Davis Quartet. Photo courtesy Institute of Jazz Studies, Rutgers University.

Page 67 Sonny Rollins. Photo courtesy Institute of Jazz Studies, Rutgers University.

Page 74 Charles Mingus. Photo courtesy Institute of Jazz Studies, Rutgers University.

Chapter 4

Page 85 Shot of man's face playing clarinet. Copyright © 2011, Mark Yuill. Under license from Shutterstock, Inc.

Page 90 Ornette Coleman. Photo courtesy Institute of Jazz Studies, Rutgers University.

Page 94 Cecil Taylor. Photo courtesy Institute of Jazz Studies, Rutgers University.

Page 96 John Coltrane Quartet. © Duncan Schiedt Photography.

Page 101 Eric Dolphy. Photo courtesy Roberto Polillo.

Page 103 Sun Ray. Photo courtesy Institute of Jazz Studies, Rutgers University.

Page 107 Art Ensemble of Chicago. Photo courtesy Institute of Jazz Studies, Rutgers University.

Chapter 5

Page 115 Bass player. Copyright © 2011, DeshaCAM. Under license from Shutterstock, Inc.

Page 117 Stan Getz. Photo courtesy Institute of Jazz Studies, Rutgers University.

Page 121 Jimmy Smith. Photo courtesy Institute of Jazz Studies, Rutgers University.

Page 124 Bill Evans. Photo courtesy Roberto Polillo.

Page 130 Dexter Gordon. Photo courtesy Roberto Polillo.

Page 133 Keith Jarrett Quartet. Photo courtesy Institute of Jazz Studies, Rutgers University.

Chapter 6

Page 141 Black man playing saxophone. Copyright © 2011, Oscar C. Williams. Under license from Shutterstock, Inc.

Page 145 Charles Lloyd Quartet. Photo courtesy Institute of Jazz Studies, Rutgers University.

Page 146 Miles Davis. Photo courtesy Tad Hershorn.

Page 149 Mahavishnu Orchestra. Copyright © David Redfern/Redferns.

Page 151 Weather Report. Photo © Hans Arne Nakrem.

Page 154 Return to Forever. Photo © Hans Arne Nakrem.

Page 156 Herbie Hancock. Photo courtesy Columbia/Photofest.

Chapter 7

Page 165 Woman playing saxophone. Copyright © 2011, Igor Normann. Under license from Shutterstock, Inc.

Page 168 Wynton Marsalis. ABC/Photofest.

Page 177 Pat Metheny Group. Photo courtesy Institute of Jazz Studies, Rutgers University.

Page 179 Michael Brecker. Photo by Steven Sussman, *www.sussmanphotography.com*

Page 182 John Scofield. Photo by Steven Sussman, *www.sussmanphotography.com*

Page 185 Steve Coleman. Peter Gannushkin/
 DOWNTOWNMUSIC.NET
Page 185 Cassandra Wilson. Photo by Steven Sussman,
 www.sussmanphotography.com
Page 187 World Saxophone Quartet. Copyright ©
 Dragan Tasic-*www.nga.ch*

Chapter 8

Page 193 Drums. Copyright © 2011, Galushko Sergey.
 Under license from Shutterstock, Inc.
Page 199 John Zorn and Painkiller. Peter
 Gannushkin/DOWNTOWNMUSIC.NET
Page 201 Bill Frisell. Photo by Steven Sussman,
 www.sussmanphotography.com
Page 203 Dave Doulas. Photo by Steven Sussman,
 www.sussmanphotography.com
Page 206 Don Byron. Copyright © Dragan
 Tasic-*www.nga.ch*
Page 209 Medeski, Martin, and Wood. Copyright
 © Dragan *Tasic-www.nga.ch*
Page 211 Maria Schneider. Photo courtesy
 Dani Gurgel.
Page 215 Joe Lovano. Photo by Steven Sussman,
 www.sussmanphotography.com

Chapter 9

Page 223 Man with sunglasses playing saxophone.
 Copyright © 2011, OLJ Studio. Under license
 from Shutterstock, Inc.
Page 228 Brad Mehldau. Photo by Steven Sussman,
 www.sussmanphotography.com
Page 230 Bad Plus. Photo courtesy of Andrea Canter.
Page 230 Jason Moran. Photo by Steven Sussman,
 www.sussmanphotography.com
Page 233 Dave Stryker. Photo courtesy Thomas Larson.
Page 235 Ingrid Jensen. Photo by Steven Sussman,
 www.sussmanphotography.com
Page 236 Norah Jones. Photo courtesy Peter
 Gannushkin/DOWNTOWNMUSIC.NET
Page 237 Karrin Allyson. Photofest.
Page 243 Craig Taborn. Photo courtesy Andrea Canter.
Page 245 Jan Garbarek. Photo © Hans Arne Nakrem.

Index